3/9

Photographs

Sheldon Memorial Art Gallery Collections, University of Nebraska-Lincoln

Published by the Nebraska Art Association with the assistance of the
University of Nebraska Foundation and the National Endowment for the Arts

1977

Publication data:
Copyright, 1977
LC No: Library of Congress Catalog Card Number 77-89862
Designer: George Meininger
ISBN 0-8032-7644-3
0-8032-5877-lpbk.
Printer: Jacob North Printing Company Inc., Lincoln, Nebraska

Distributed by the University of Nebraska Press, Lincoln

This project is supported by a grant from the National Endowment for the Arts
in Washington, D.C., a federal agency.

The photography collection at the University of Nebraska-Lincoln was established in 1943 with the allocation by the Work Projects Administration of a group of paintings, sculptures, prints and fifty-five photographs; among them prints by Berenice Abbott and Edward Weston. The next acquisition of photographic prints took place in 1958 with the purchase of additional prints by Weston and Ansel Adams. In 1963, with the completion of the Sheldon Gallery, the development of a collection of photographs was undertaken in a systematic way and photographic exhibitions became a regular component of the exhibition program.*

It was also at about this time that the recognition of photography as one of the arts, fought for since the early decades of the century, became a matter of general acceptance. Public interest, stimulated by such projects as Ivan Dimitri's *Photography in the Fine Arts* and Edward Steichen's *Family of Man,* demonstrated beyond any quibble the universal appeal of the photographic image. Museum exhibitions increased in frequency. Dealers specializing in photography entered the art market. Art schools and universities added instruction in photography to their curricula. Claiming no prescience in the matter, it can be said that the establishment and growth of the photography collection at Nebraska has been part of a general, nation wide change of mind. Through half a century photography, apart from the advocacy of its champions, has enjoyed at best the condescension of that part of the American public concerned with art. Now, possibly as the result not only of the lifelong personal battles fought by pioneers such as Peter Henry Emerson, Alfred Stieglitz and others, but also as a result of the pressures exerted by the success of photography in commerce and its acceptance as the popular art of our time without peer, the struggle for recognition is ended. Photography is the focus of a massive public interest that embraces not only the photographer as an artist among artists, but also the private collector, the publisher, the dealer and the museum whose function it is

*See Appendix B, page 211

to collect, display and interpret the visual arts of our time.

At the University of Nebraska, photography had been offered as part of the curriculum in art in the thirties under the direction of Dwight Kirsch, former Chairman of the Department and Director of the University Art Galleries. For somewhat more than ten years following his departure, photography existed only in an auxiliary sense. Reestablished in 1965 as an area in which an undergraduate major and a graduate degree might be earned, instruction since has been under the direction of Michael McLoughlin, James Alinder and, for a brief period, Ellen Land-Weber, all of them gifted artists and teachers. The first graduate degree in photography was granted in 1972. Among the graduates are individuals of high creative promise and it is gratifying to report that most of them have been assiduous students of the Gallery's collection. In this sense the program of instruction served as a stimulus to the growth of the Gallery's collection.

The creation of a collection which would be completely representative of an art, even one with little more than a hundred years of history, is not to be accomplished easily. The Weston prints acquired in 1958 were almost literally excavated from the storage boxes of a well known print dealer and were purchased for twenty-five dollars apiece, but within a little less than two decades the market value of such photographs has risen to a point beyond even the most generous expectation. Admittedly, photographs are still bargains if compared with works of art in the media of painting or sculpture but the usual considerations of intrinsic value in process and craftsmanship, of condition and rarity, of historical importance, of aesthetic quality have been accompanied by the demands of a boom market. The work of the founding masters of the art is now all but impossible to obtain except at a very high price, and more critical perhaps is the phenomenon of work by young artists of the

present day, some of them having no more than a season or two of public exposure, being sought after as the commodity of high fashion.

The collection of photography at the Sheldon Gallery came into being while it was still possible to secure material of primary importance, but the future growth of the collection will be conditioned by considerations such as the following:

In accordance with the basic policy laid down for the University's art collection as a whole, it is expected that the primary emphasis will be put on the work of American photographers. Special circumstances have brought notable groups of prints by Josef Sudek, Eikoh Hosoe and Ara Guler into the collection, but it will not be an objective to represent, in any comprehensive way, the photography of other countries.

It is agreed, however, that the collection should include examples by the major contributors to American photography, but this acquisition process will, of necessity, be a long time in the accomplishment. Fortunately, the purchase grant from the National Endowment for the Arts and matching funds from the Nebraska Art Association have made it possible to undertake a search for some of this *classical* material. Prints by Strand and Sommer have been acquired with these Endowment funds, others by Bourke-White, Sheeler and Arbus from the F. M. Hall Fund. But, putting aside the acquisition of prints by acknowledged masters, it is recognized that the special strength and distinction of the Nebraska collection can be more readily and appropriately achieved in the acquisition of the work of younger contemporaries. To this end the Sheldon Gallery has presented one or more photographic exhibitions annually and in 1975 a gallery was set aside for the continuous exhibition of photographs, alternating invitational shows with selections from the permanent collection. Prints are selected from most of these invitational exhibitions for addition to the permanent collection.

The Sheldon Gallery is also concerned with the history and activity of those photographers native to, or associated with, our state and region and, in a special sense, with those who have emerged from the training offered by the University itself. Our recent collaboration with the Mid-America Arts Alliance in the production of *Crying for a Vision—A Rosebud Sioux Trilogy, 1883-1976* resulted in the addition to our collection of a substantial group of prints by the photographers involved, Eugene Buechel, John A. Anderson and Don Doll. Even more recently, as a result of the Nebraska celebration of the nation's bicentennial we have received a deposit of two hundred prints prepared for the *Nebraska Photographic Documentary Project* by two gifted Nebraskans, Robert Starck and Lynn Dance.

Naturally, in a collection intended to serve as a resource for teaching, it will be important, within the historical chronology, to have some concern for representing technical history as well, with examples made in all the principal processes by which photographers have achieved their objectives. At this point the most critical gap in the collection exists in this area. With the single important exception of the University's ambrotype portrait of Abraham Lincoln, the collection is almost entirely lacking in examples of the early processes. Of the post-Daguerreotype masters, examples by Talbot, Hill and Adamson, Cameron and Frith have been acquired; and of the Americans, token representation of Muybridge and Jackson, but it is to be hoped that the collection can be expanded to include more nineteenth century material, European and American. In any case it is unlikely that we will ever equal in any way the already well-established collections of this kind of material.

If the preceding provides some idea of our objectives and accomplishment to date, what, one might ask, have been the findings of the cataloging process itself, surely an occasion to assess the state of the art, its history and prospects? As we have said, the appearance and growth of collections

such as ours is very much part of a national activity and as a preliminary to our work we solicited a list of the holdings of eighty institutions; schools, libraries and museums. Each was asked to check a list of the names of the photographers included in our collection to indicate holdings of their own. It was certainly no surprise to learn that Ansel Adams is represented in all but thirteen of the total. Perhaps of greater interest was the information that twenty-four photographers are apparently represented only in the Nebraska collection. In any case, it is evident that aside from the major collections in New York, Washington, D.C., Rochester, Chicago and San Francisco, these institutions are, like ourselves, building from ground level.

What, then, are these public institutions buying? First of all, obviously they are acquiring the masters of the medium as identified for us by Gernsheim and Newhall. A kind of pantheon has been established, perhaps first embodied in the Newhall's *Masters of Photography* which lists nineteen individuals of the generation of the inventors and pioneers, with only two of the group still active as the elders of the art.

> *Hill* and *Adamson, Southworth* and *Hawes, Nadar, Gardner* and *O'Sullivan, Cameron, Emerson, Stieglitz, Steichen, Atget, Strand, Weston, Solomon, Lange, Evans, Cartier-Bresson, Adams.*

There is no need to quibble with this list, as yet unchallenged by the slowly rising tide of monographs and dissertations devoted to photographers whose activities and achievements might be said to fill the interstices of the history of the art.

There is, however, an additional list of artists, at least as long, to whom the word *master* might well be applied without any considerable argument. This list, which is not meant to be exclusive, can be divided into sub-lists representing the basic differences in point of view which have come to characterize the art; the documentary photograph, the "straight" photograph, the "manipulated" photograph, and on and on into the increasing intricacy of contemporary practice.

> *Lewis Hine, Jacob Riis, Doris Ullman, Arnold Genthe, Berenice Abbott, Margaret Bourke-White, W. Eugene Smith / Imogen Cunningham, Wynn Bullock, Barbara Morgan, Charles Sheeler, Harry Callahan, Frederick Sommer, Aaron Siskind / Laszlo Moholy-Nagy, Man Ray, Henry Holmes Smith, Clarence John Laughlin, Edmond Teske*

At this point one encounters those artists who might be considered front line if not avant garde; those whose position may not be so much determined by their use of the medium as by their attitude to their subject or their view of themselves, conscious or unconscious. This is the area of contemporary "action," where photographic truth may be variously identified in commitment or non commitment, in self indulgence or self denial. It is an area into which historians, critics and curators should move with care.

Underlying all this activity which might be considered as containing the main thrust of creative development, there is the even larger body of picture-taking which embraces the sometimes disdained photographs of commerce and fashion; the products of photo-journalism, and lastly, but by no means negligibly, the ground level *popular* art of the amateur taker of snapshots.

Embedded in the information gathered for the present catalog there are some additional considerations which may help to clarify the character of contemporary photography. Consider the following.

We have, for example, an art of universal scope in which, perhaps for the first time, Americans have played a seminal role. Painting, sculpture, architecture, graphic art are all artistic activities to which Americans have brought the contribution

of leadership only very recently. In photography Americans have contributed a significant and continuing leadership from almost the beginning.

Similarly, can it be unimportant that "self taught in photography" occurs as often as it does in our description of the artist's education? Some artists have come to photography from earlier training in painting, sculpture or music, and others have come to it from engineering, medicine, literature or from nowhere in particular. It would appear as a possibility that by virtue of the very nature of the camera, the education of the photographer is peculiarly a matter of the education of the eye and the mind behind the eye, and much less a matter of technique, which is traditionally necessary to the painter, the sculptor or the printmaker. To be sure there are numerous instances of "studied under" or "worked with" or "influenced by," but the suspicion is strong that these relationships were more in the realm of ideas than in matters of how to do it.

Another striking fact that is perhaps not so directly reflected in our research, but is vigorously implicit in all our contacts with photographers, is their awareness of the history of the medium. Indeed it is apparent that the study and clarification of the history of photography is, to a notable degree, indebted to the research of practicing photographers, a situation that would, I think, be difficult to match in other areas of artistic activity. The concept of photography as a kind of visual parallel to oral history is equally strong in the widespread attention given the anonymous photography of the past. In our own collection, for example, the eleven prints discovered by Roger Williams and reprinted from the glass plates are extraordinary examples of the snapshot idea long before the arrival of the Brownie and, more importantly, are delightful revelations of the more informal social mores of the time. The sequences of prints from the book and exhibition, *Crying For A Vision,* by Anderson, Buechel and Doll, are, aside from their quality as photography, telling

testimony of the temporal changes taking place within a social structure. Another example of the problems involved in photographic history is contained in our effort to document the prints allocated to the Gallery by the Work Projects Administration. A few of the photographers in the group, Berenice Abbott, Ruth Bernhard, Brett and Edward Weston, have obviously survived the experience of the thirties on their own, but others, eight in all, despite the existence of their names and the presence of their prints, have seemingly dropped into oblivion with only vague recollections; "a pupil of Weston," "went into commercial photography"—to sustain the fact of their existence. Perhaps the present catalog will produce the information needed to bring them back to life.

Another consideration of interest is the multiple existence of the photographic image. As the catalog will show, the proliferation of exhibitions within the past decade, the increasing frequency of reproduction and the appearance of the photobook, give encouragement to the idea that the photographic print, as an object of craftsmanship, and ultimately of connoisseurship, is perhaps of no more, and possibly less, importance than the image it embodies, which seems to have its own life and exerts an impact on a vastly greater audience than will ever experience the actual print itself. Such images, for instance, as Stieglitz' *Steerage* or Lange's *Migrant Mother* or such portraits as Karsh's *Churchill,* Cunningham's *Morris Graves* or Arbus' *Boy with a Hand Grenade* are already part of the visual vocabulary of our time. The importance attached to the photograph in book form, and to the sequential and cumulative effect of a series of images, can be illustrated in such publications as Les Krims' *Little People of America,* Robert Adams' *The New West* or Duane Michal's *Sequences.* Individual prints from these collections, seen alone, would seem to have something of the status of a by-product, carrying the implication that the single print is somehow incomplete.

We also find ourselves considering with all due seriousness the photographic assimilation of, not only the "commercial" techniques of silkscreen, photo-offset and office duplicating processes, but also a full range of textural, painterly and three dimensional sculptural possibilities. The impact of photography on the other arts, visual and performing, has been considerable from the day of its invention and, in a sense, it can be seen as only one of the many component elements in the intermingling of all the arts that is a primary characteristic of today's artistic activity.

All of these considerations are represented to some degree in the Sheldon collection. All these efforts, different or alike as they may be, have combined to produce a photographic aesthetic of enormous complexity in which it is frequently difficult to apply standard canons of quality. But,

such difficulties aside, one is led to conclude that very possibly no other art of our time is so thoroughly enmeshed in the fabric of our society and no other is so potentially productive, throughout its structure, of a genuinely creative statement.

The Sheldon Gallery's interest in photography is a commitment of many parts, including the creation of a collection of prints of high quality, the instruction of students, the education of the public and the support of the creative photographer. The accomplishment of these objectives is still incomplete, of course, but the present publication will serve a useful purpose if it demonstrates nothing more than the fact of this commitment in the photographs which it contains.

Norman A. Geske

Ezra Stoller

The present catalog is a product of the traditional collaboration of the Nebraska Art Association and the University of Nebraska, which, with the coming year, will reach its ninetieth anniversary. This experience has taken permanent form in the art collections owned by the University and the Association and, in 1963, in the establishment of the Sheldon Gallery. With this initial catalog the importance of this collaboration will acquire a new dimension in making available to the widest possible audience the works of art which constitute one of the University of Nebraska's most important assets.

Acknowledgement should go, first of all, to the Trustees of the Art Association and, in particular to Jack Campbell (President, 1973-75) and to Lorraine Rohman (President, 1975-77) for their support of the idea of such a series of catalogs. Special thanks are also due to the other members of the Board and the members at large who worked to secure the matching funds which were necessary to the project.

The initiative taken by the Sheldon Gallery in proposing the publication of the collections was seconded and supported by the President of the University and the Chancellor of the Lincoln campus and accomplished through the University of Nebraska Foundation. Such support within the institution was, naturally, essential and should be seen as an affirmation of the educational mission of the Gallery and as recognition of the interests of the University's constituency.

The third important element in the project is the support provided by the National Endowment for the Arts through its Museum program. Fortunately, grants for acquisition and for publication could be utilized together. The scope and quality of the Gallery's collection has been enormously enhanced with the addition of ninety-five prints by fifty-five photographers. Not only have we been able to acquire recognized masterpieces of the art but also a generous representation of younger contemporaries. These acquisitions, including additions made from the F. M. Hall Fund and a number of gifts inspired by the occasion itself, are among the most important in the Gallery's history.

It should be pointed out that the character and strength of the collection is due, in large part, to those who have had a direct personal role in its creation. First of all, the discernment of former staff members, Tom V. Schmitt and Gerald Maddox, and presently, Jon Nelson, has contributed to its quality. In much the same sense we have had the advantage of the expertise of our colleagues in the Department of Art, Michael McLoughlin and Jim Alinder. Within the collection somewhat more than a third of the total number of prints have been acquired for the F. M. Hall Collection and we are indebted to all the professional consultants who have endorsed these purchases.*

I would like especially to thank the Gallery staff whose skills, energies and patience have been again put to a test which has been handsomely met. At the outset of the project Patricia Bartels and Martha Richardson, as volunteers, laid the groundwork for the catalog and in the final stages Ron Geibert, Gary Goldberg, Anthony Montoya and Gary Porter, all graduate students in photography, assisted in the last minute round up of factual details.

There were others as well who helped us achieve the final product; the photographers who, in many instances, generously supplemented our purchases with the gift of additional prints; dealers, curators and, again, photographers who tolerated our repeated requests for information; and the designer of the book who assimilated our requirements into an aesthetic unity, to all these individuals thanks is gratefully extended.

N.A.G.

12

Plate 1—Berenice Abbott, catalog no. 4

14

Plate 2—Ansel E. Adams, catalog no. 23

Plate 3—Robert Adams, catalog no. 25

16

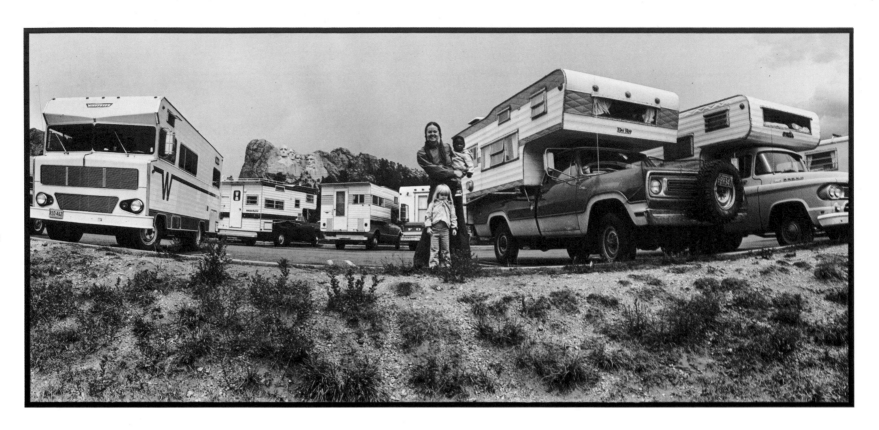

Plate 4—James Alinder, catalog no. 40

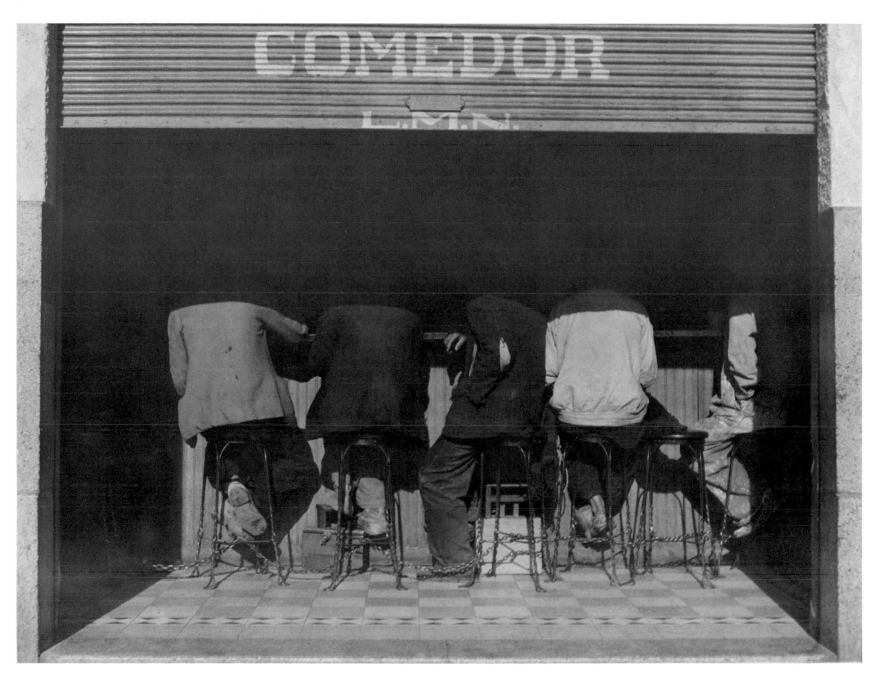

Plate 5 — Manuel Alvarez Bravo, catalog no. 45

18

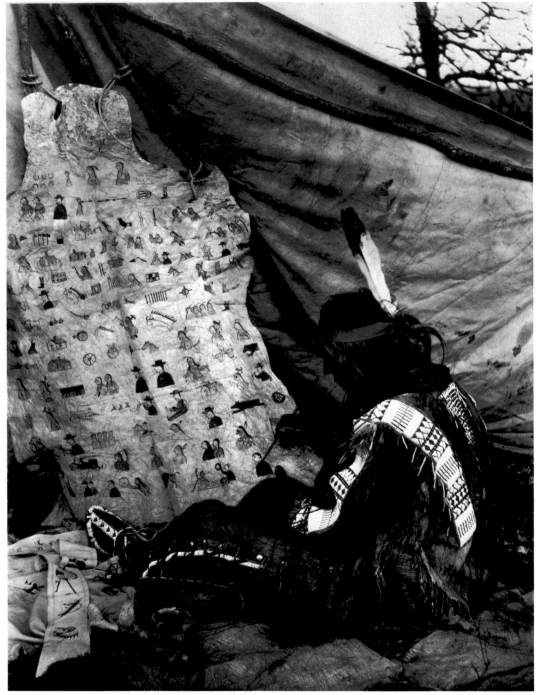

Plate 6—John Anderson, catalog no. 94

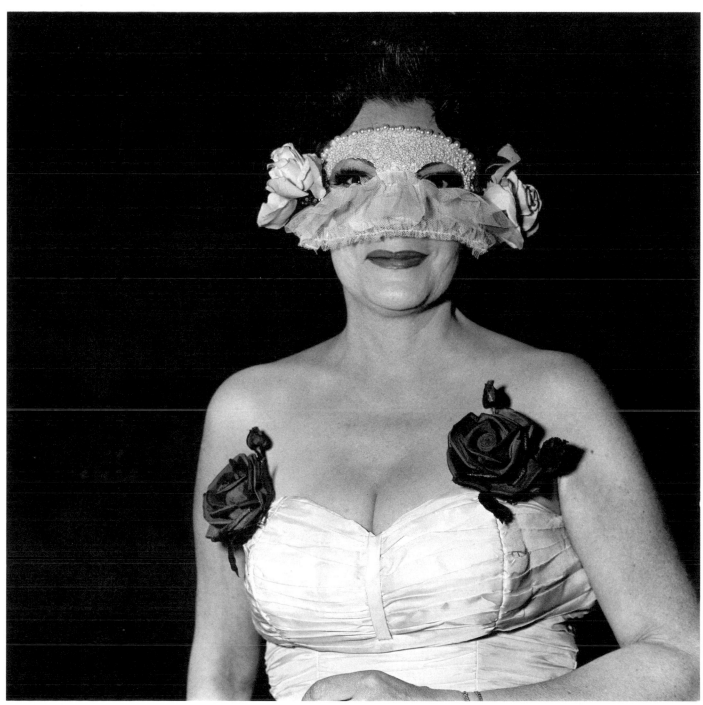

Plate 7—Diane Arbus, catalog no. 104

20

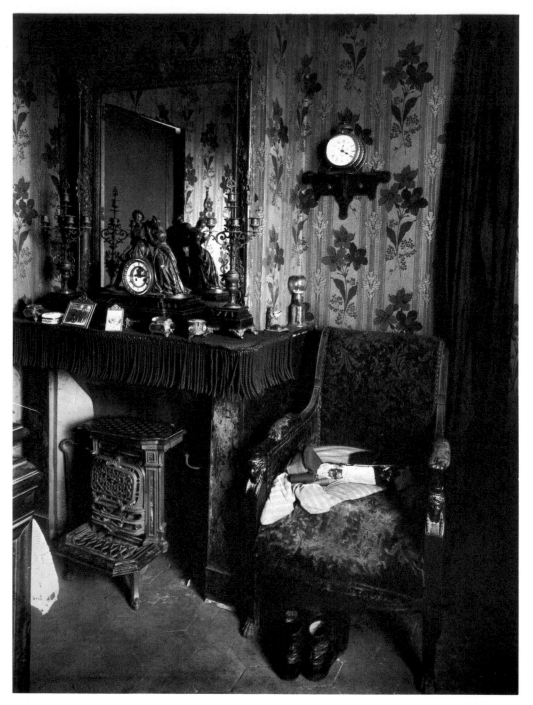

Plate 8—Eugene Atget, catalog no. 110

Plate 9—Lewis Baltz, catalog no. 125

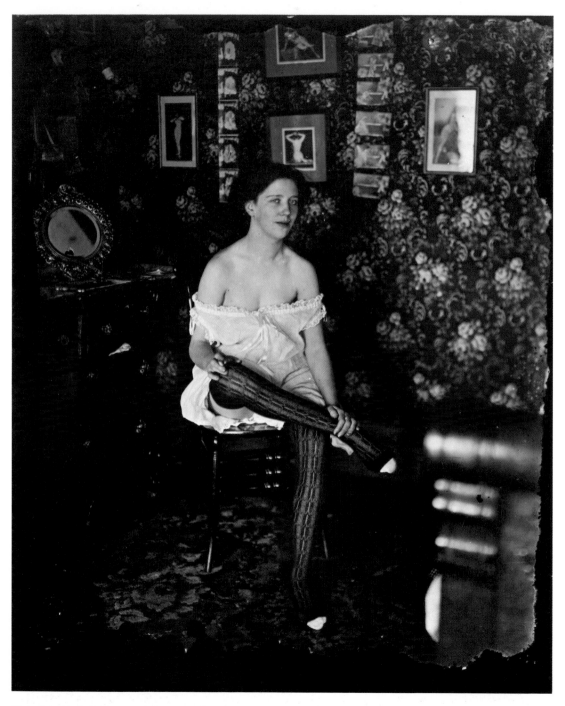

Plate 10—E. J. Bellocq, catalog no. 135

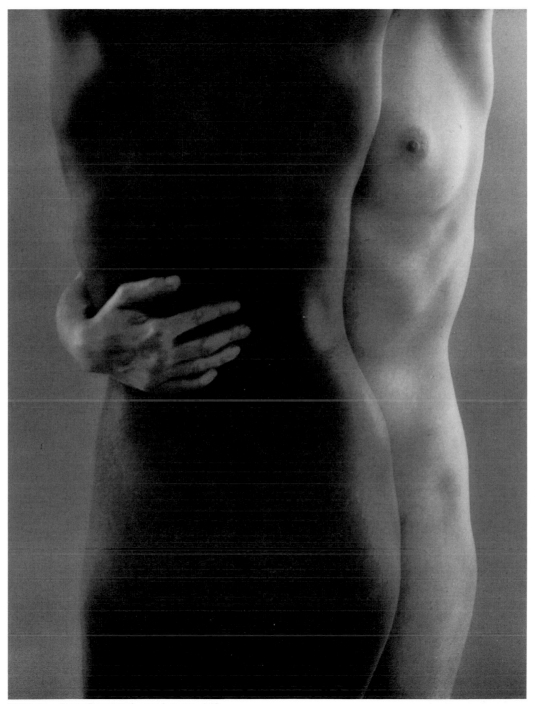

Plate 11—Ruth Bernhard, catalog no. 140

24

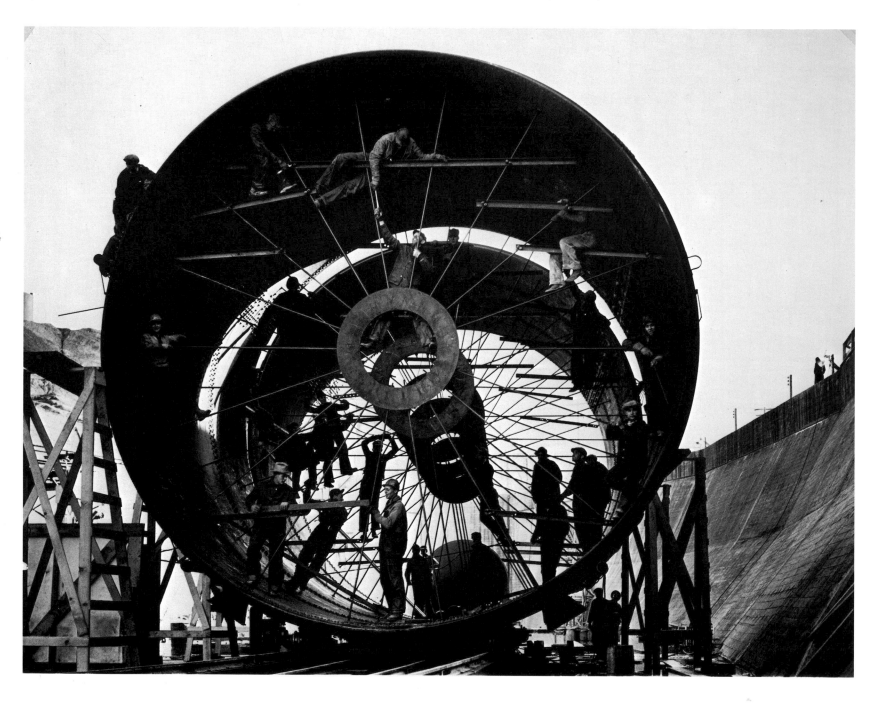

Plate 12—Margaret Bourke-White, catalog no. 142

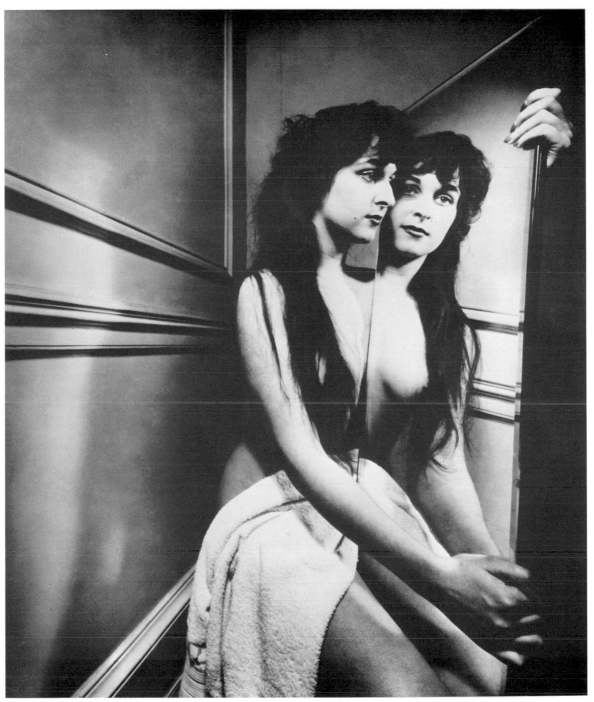

Plate 13—Bill Brandt, catalog no. 144

26

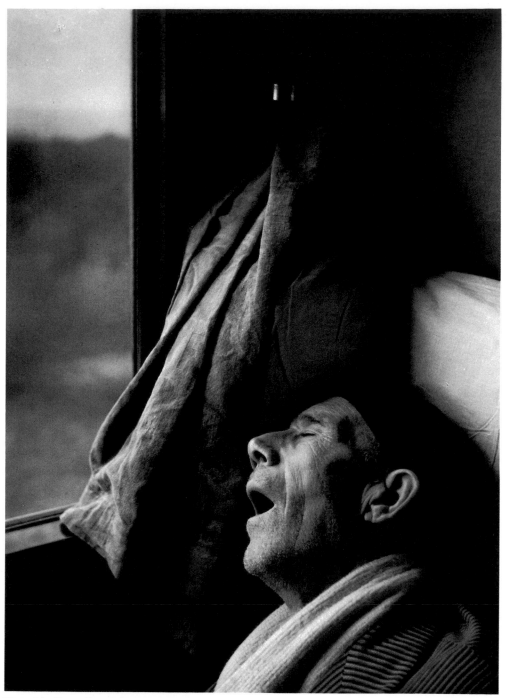

Plate 14—Brassai, catalog no. 147

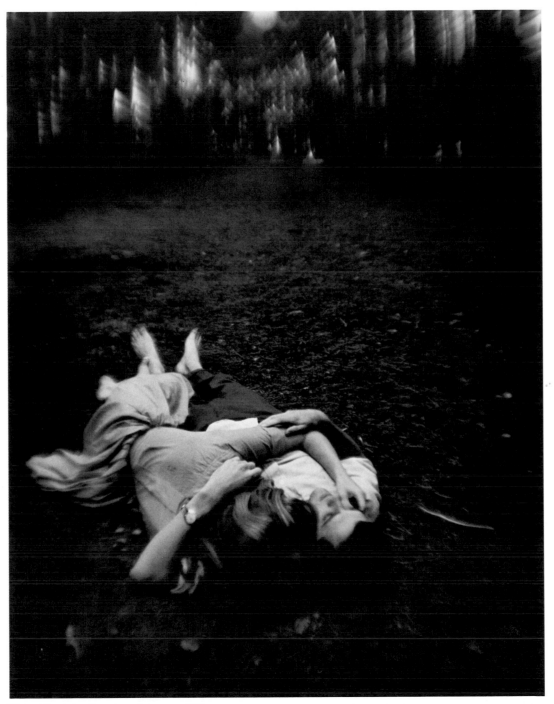

Plate 15—John Brook, catalog no. 152

28

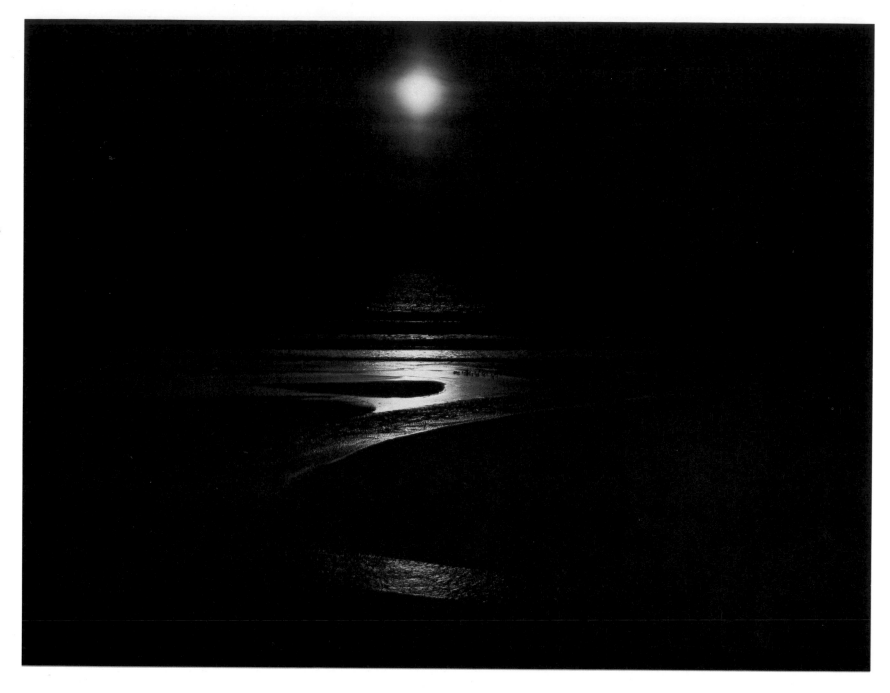

Plate 16—Wynn Bullock, catalog no. 166

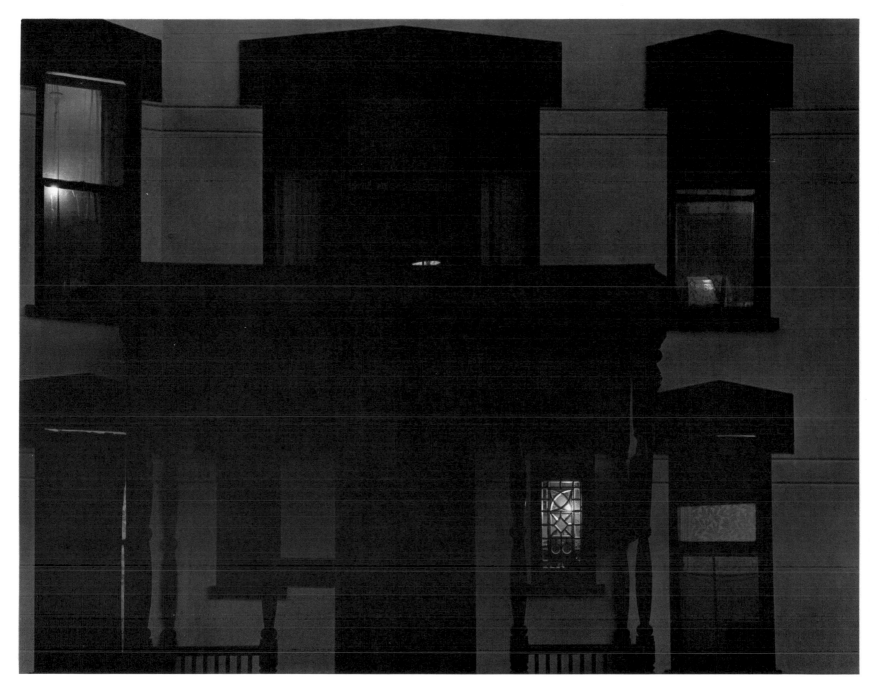

Plate 17 — Harry M. Callahan, catalog no. 174

30

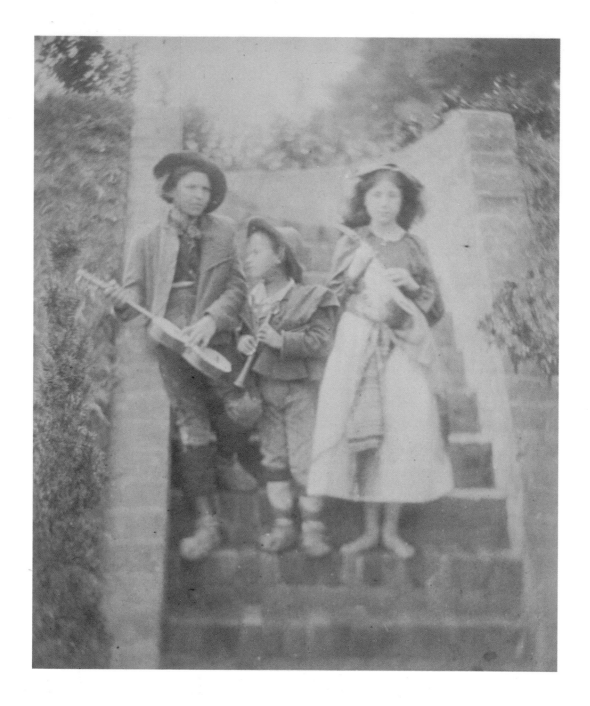

Plate 18—Julia Margaret Cameron, catalog no. 191

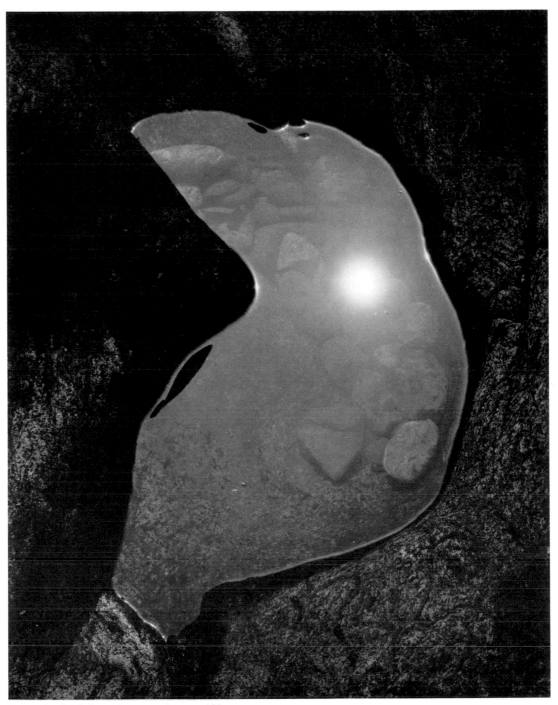

Plate 19—Paul Caponigro, catalog no. 193

32

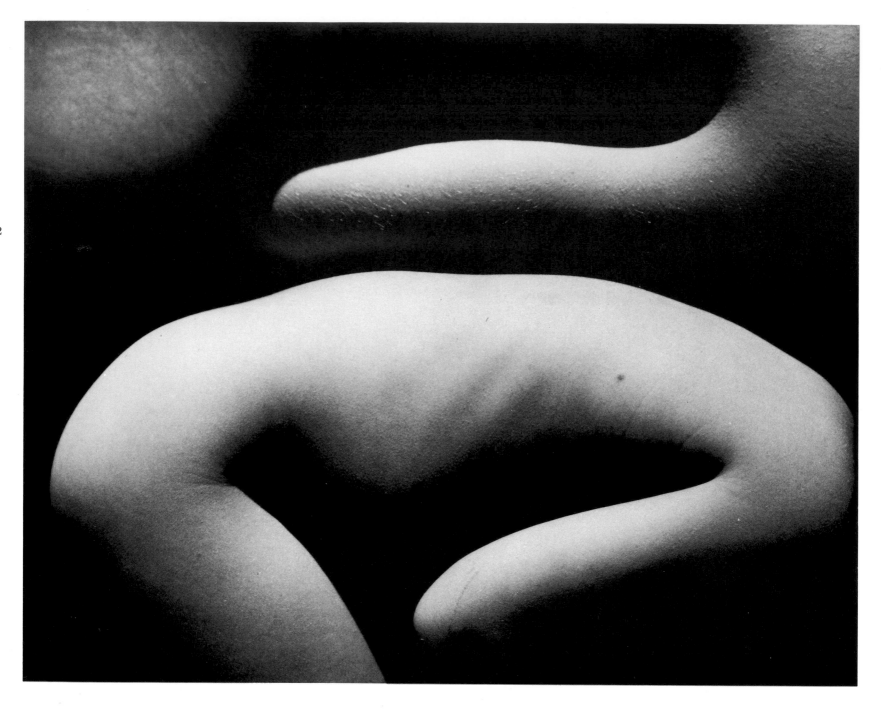

Plate 20—Walter Chappell, catalog no. 195

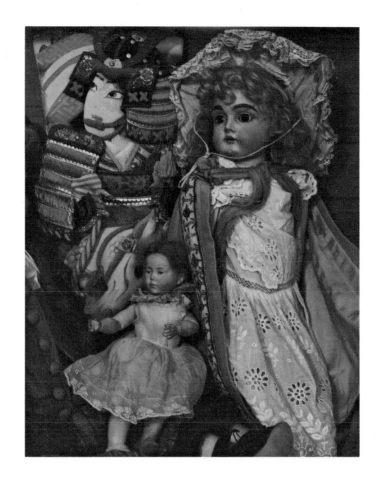

Plate 21—Marie Cosindas, catalog no. 205

34

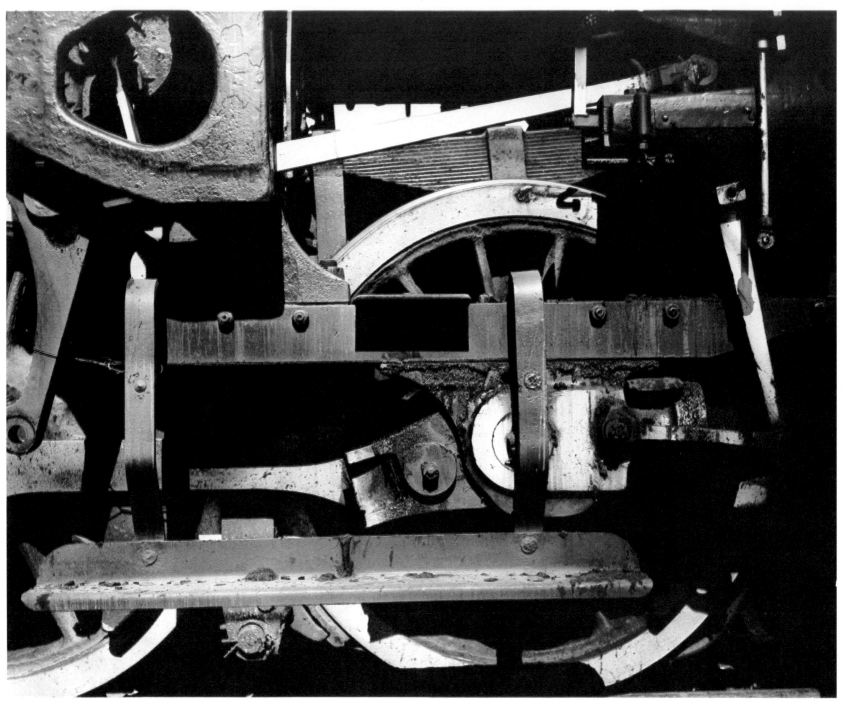

Plate 22—Ralston Crawford, catalog no. 212

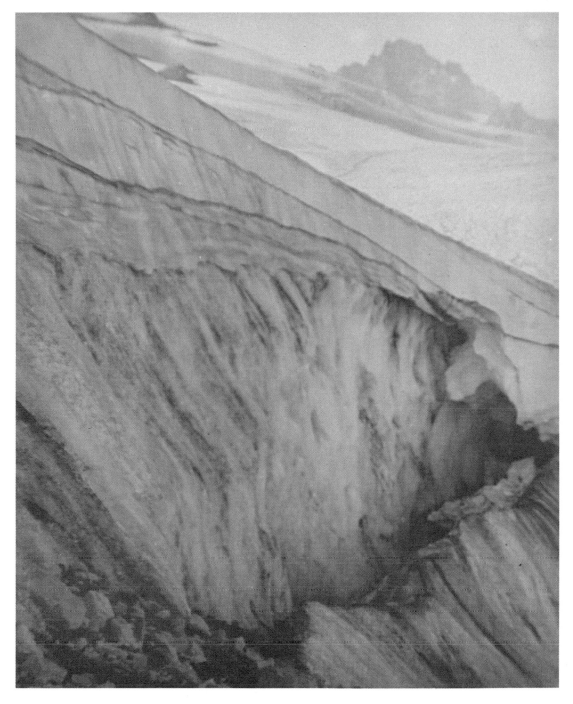

Plate 23 — Imogen Cunningham, catalog no. 218

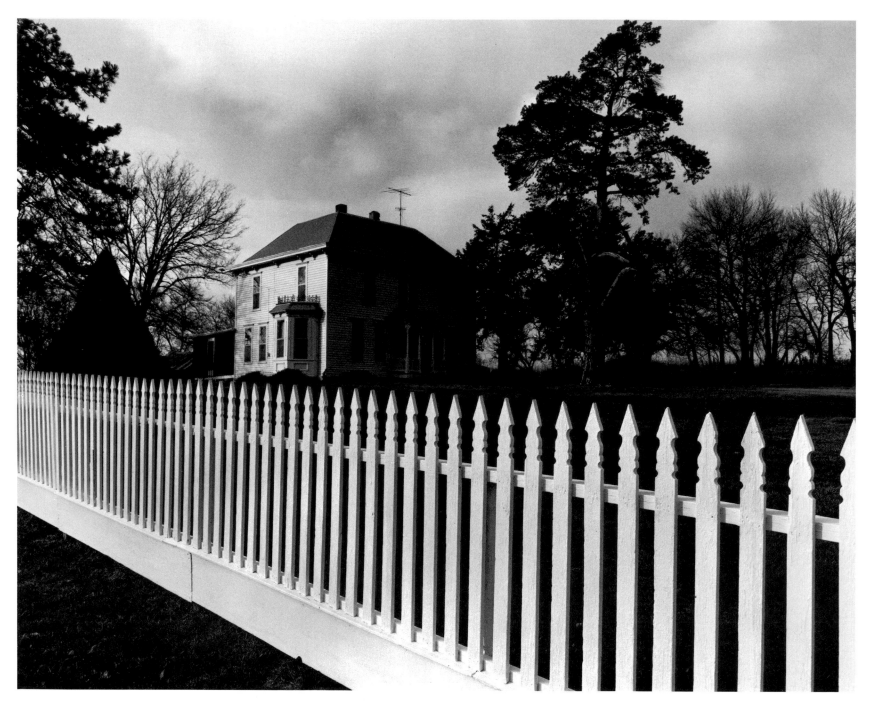

Plate 24—Lynn Dance, catalog no. 243

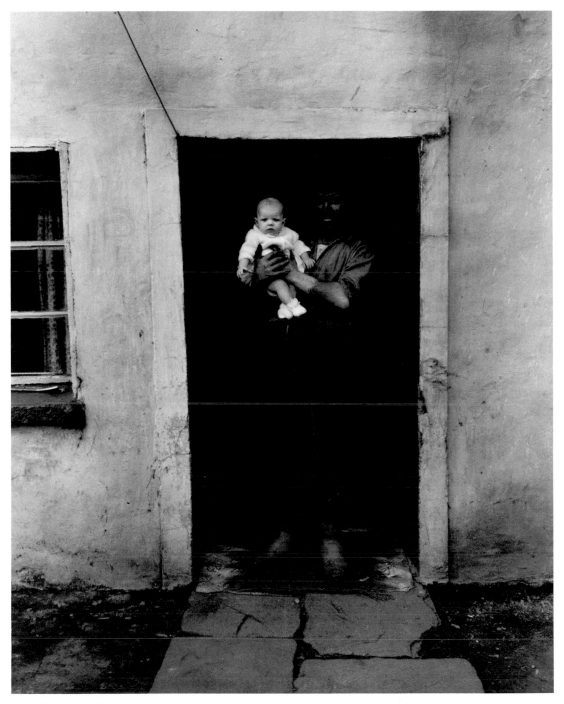

Plate 25 — Bruce Davidson, catalog no. 246

38

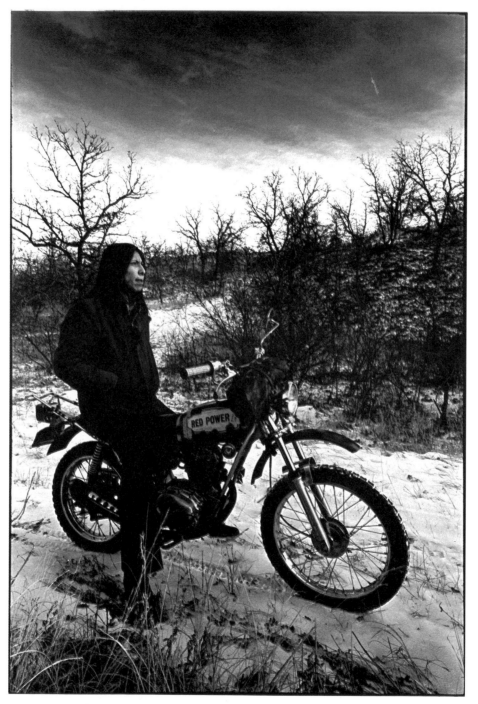

Plate 26—Don Doll, S. J., catalog no. 256

Plate 27 — Frederick Henry Evans, catalog no. 270

40

Plate 28 — Walker Evans, catalog no. 273

Plate 29—Lee Friedlander, catalog no. 284

42

Plate 30—Francis Frith, catalog no. 288

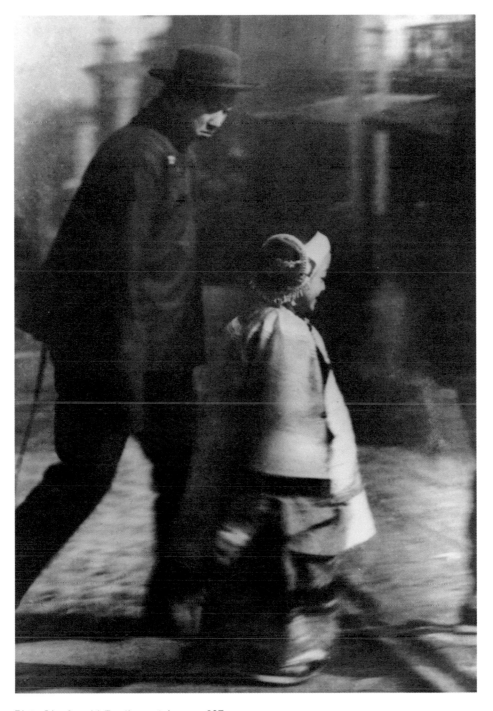

43

Plate 31—Arnold Genthe, catalog no. 297

44

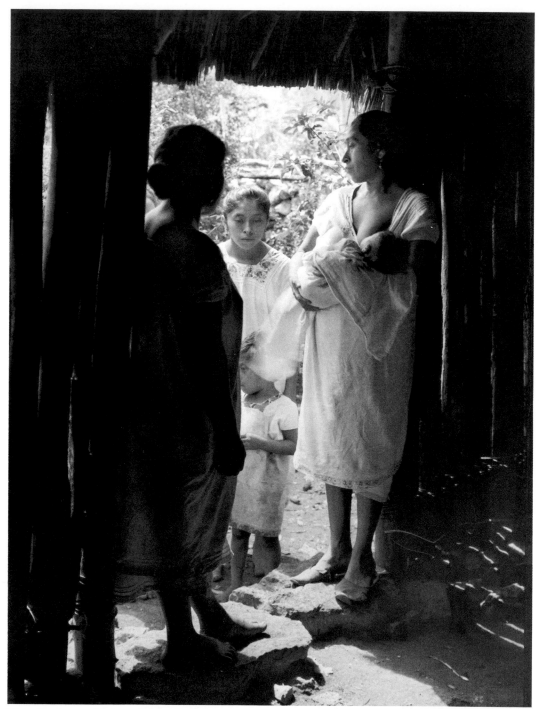

Plate 32—Laura Gilpin, catalog no. 305

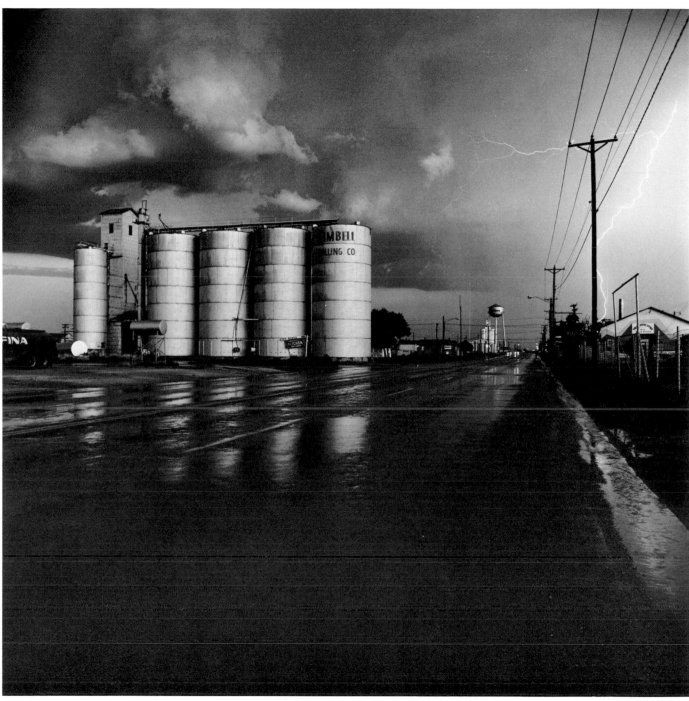

Plate 33—Frank Gohlke, catalog no. 310

46

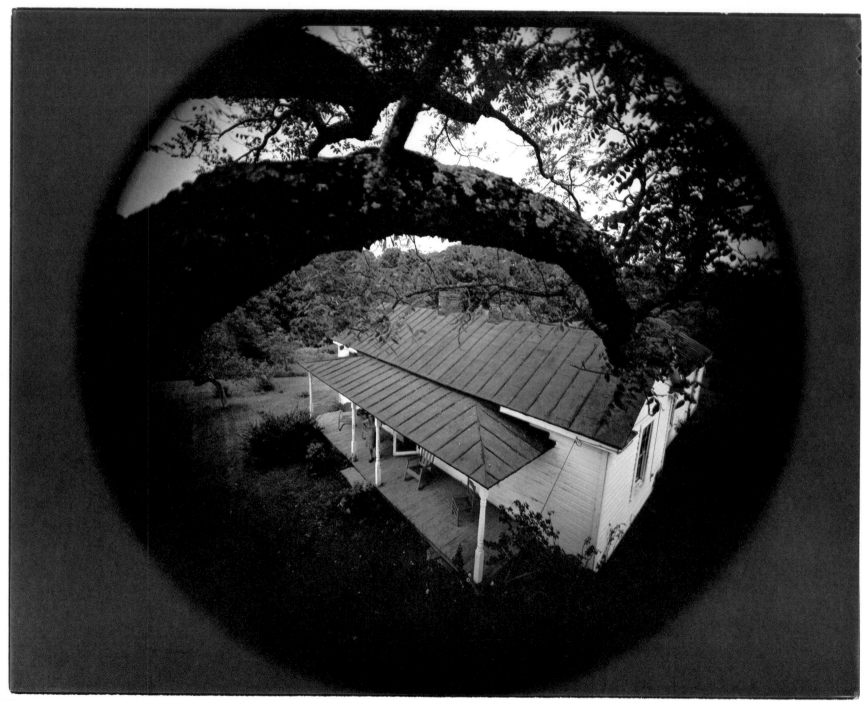

Plate 34—Emmet Gowin, catalog no. 311

Plate 35—Betty Hahn, catalog no. 326

48

Plate 36—Charles Harbutt, catalog no. 329

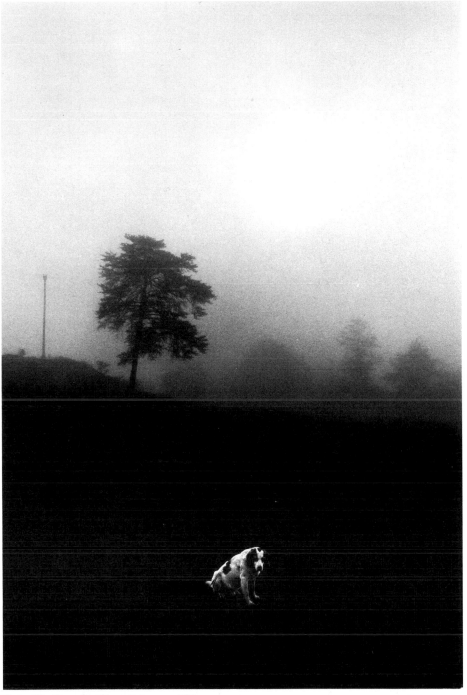

Plate 37—Dave Heath, catalog no. 330

50

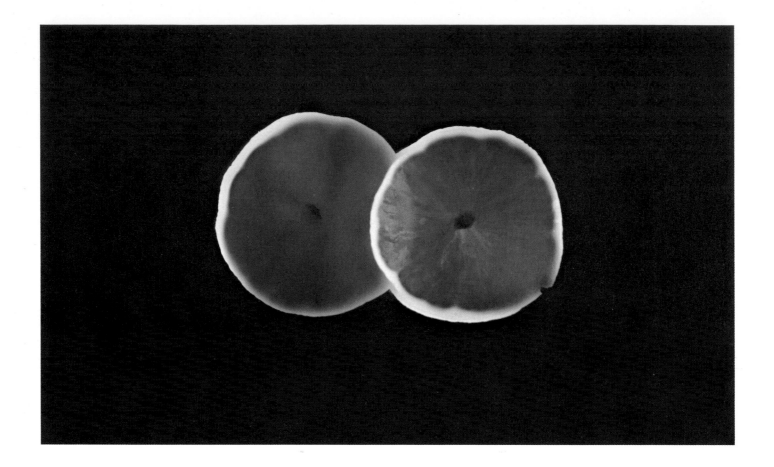

Plate 38—Robert Heinecken, catalog no. 334

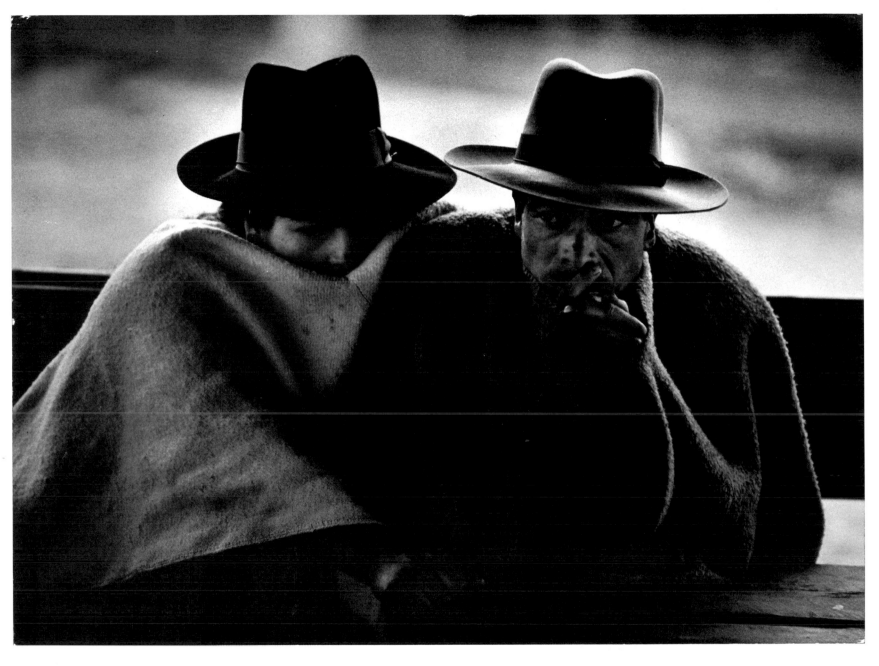

Plate 39—Ken Heyman, catalog no. 345

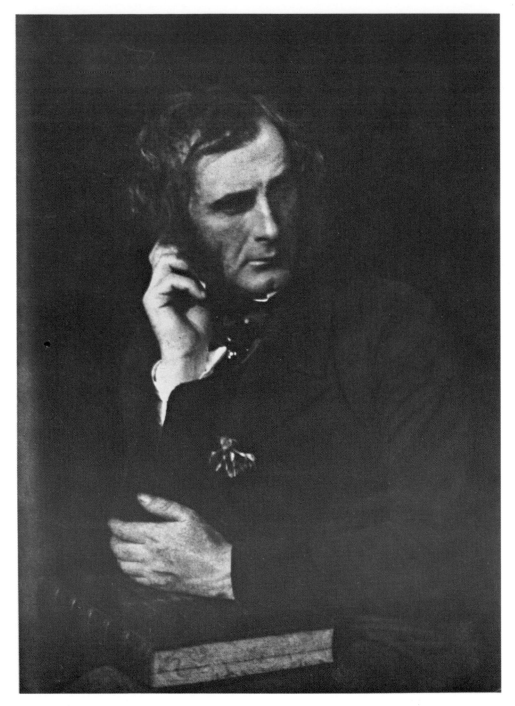

Plate 40—David Octavius Hill, catalog no. 346

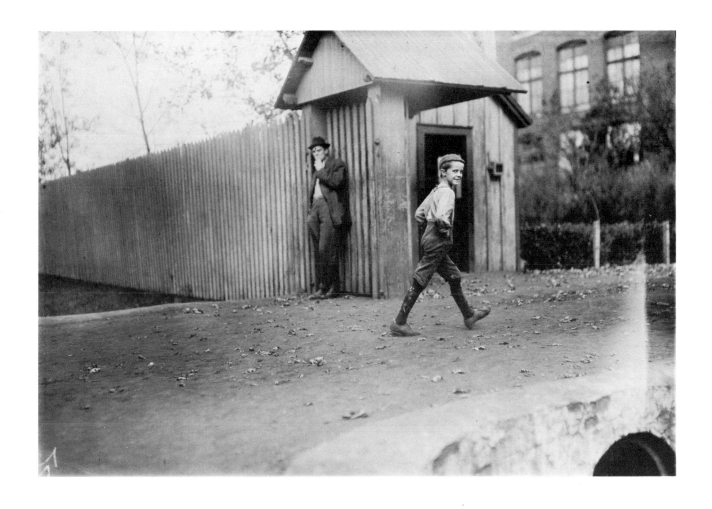

53

Plate 41 — Lewis W. Hine, catalog no. 349

54

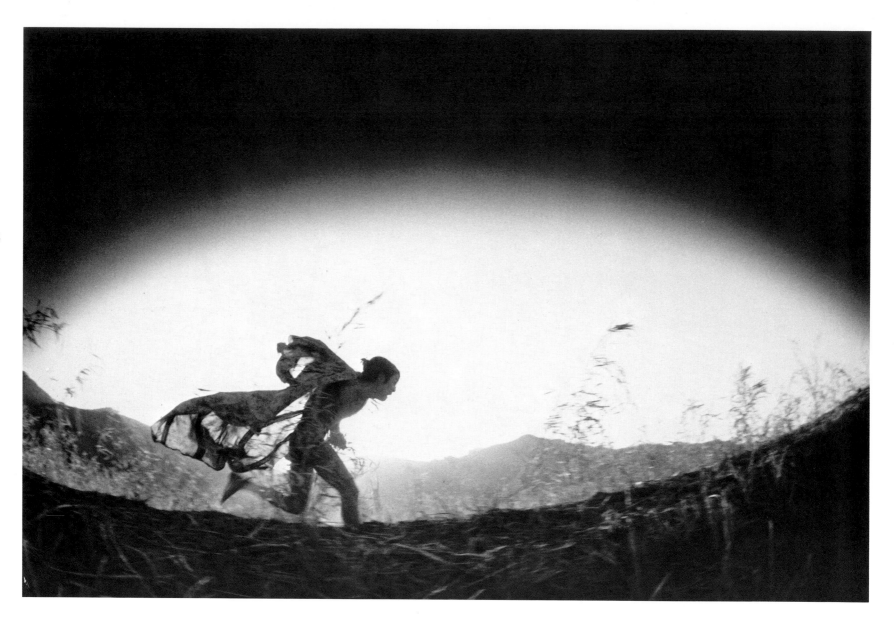

Plate 42—Eikoh Hosoe, catalog no. 357

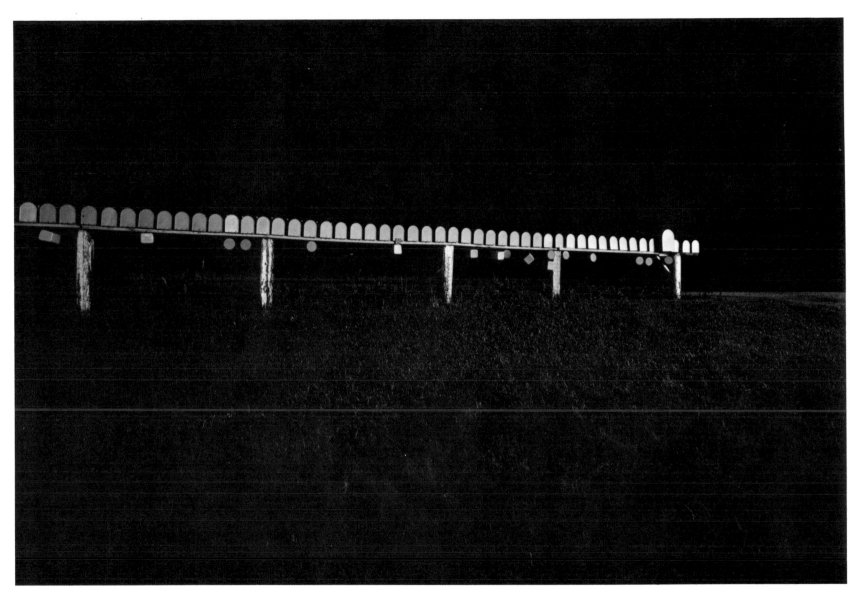

Plate 43—Joseph Jachna, catalog no. 369

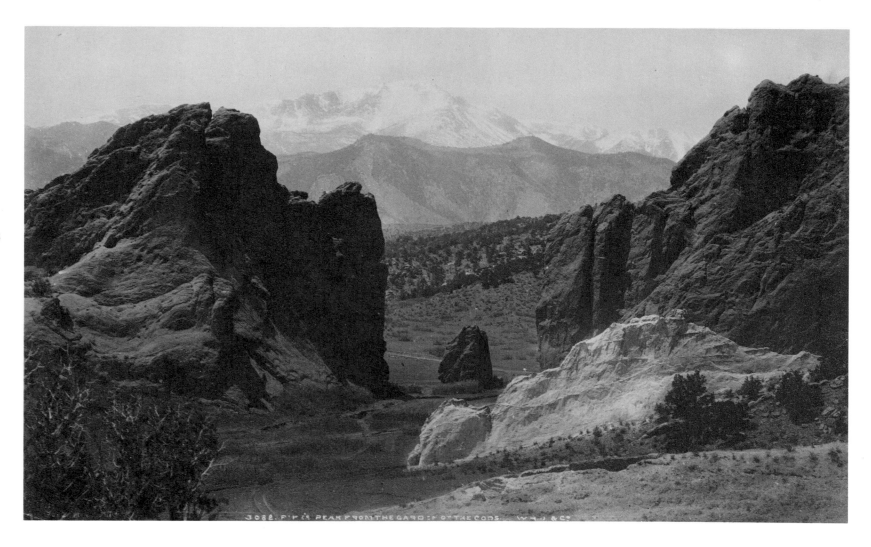

Plate 44—William Henry Jackson, catalog no. 370

Plate 45—Keith Jacobshagen, catalog no. 373

58

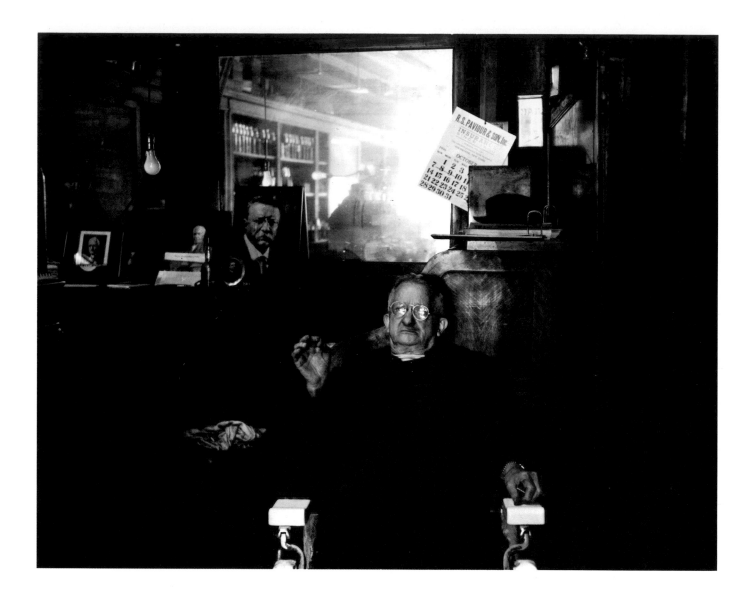

Plate 46—Kenneth Josephson, catalog no. 380

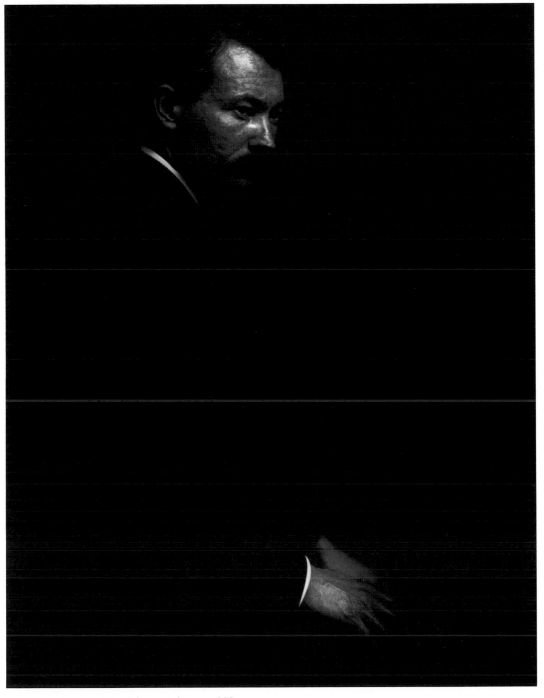

Plate 47—Gertrude Kasebier, catalog no. 386

60

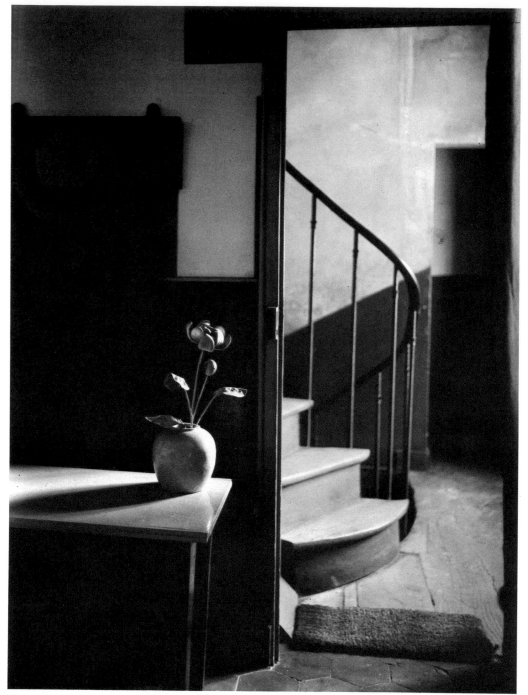

Plate 48—Andre Kertesz, catalog no. 390

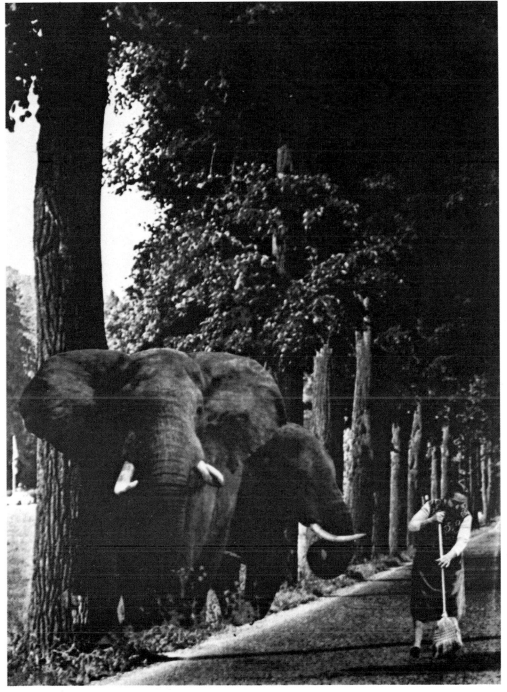

Plate 49—Ellen Land-Weber, catalog no. 399

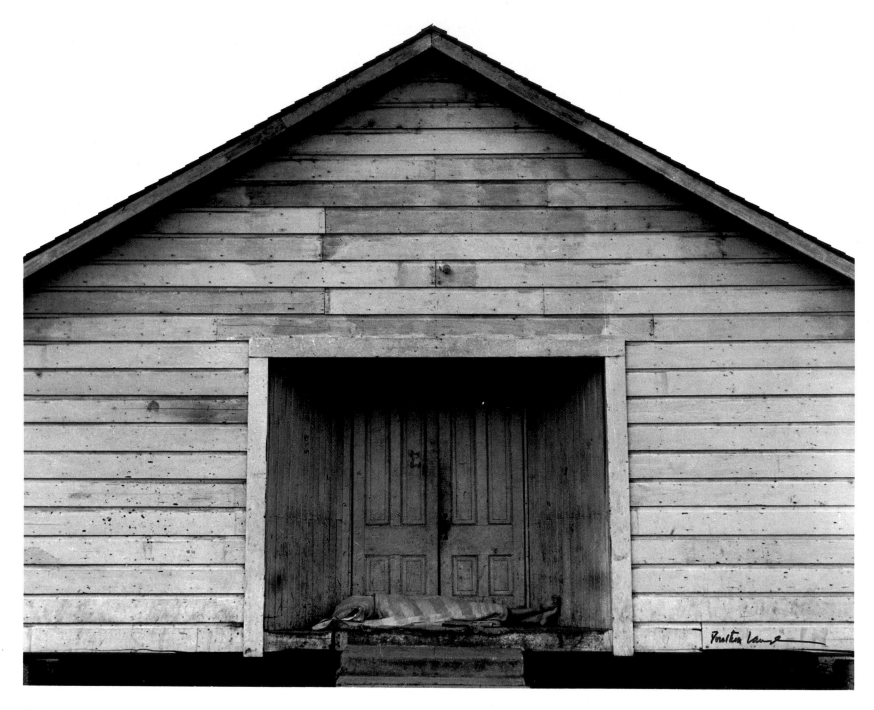

Plate 50—Dorothea Lange, catalog no. 412

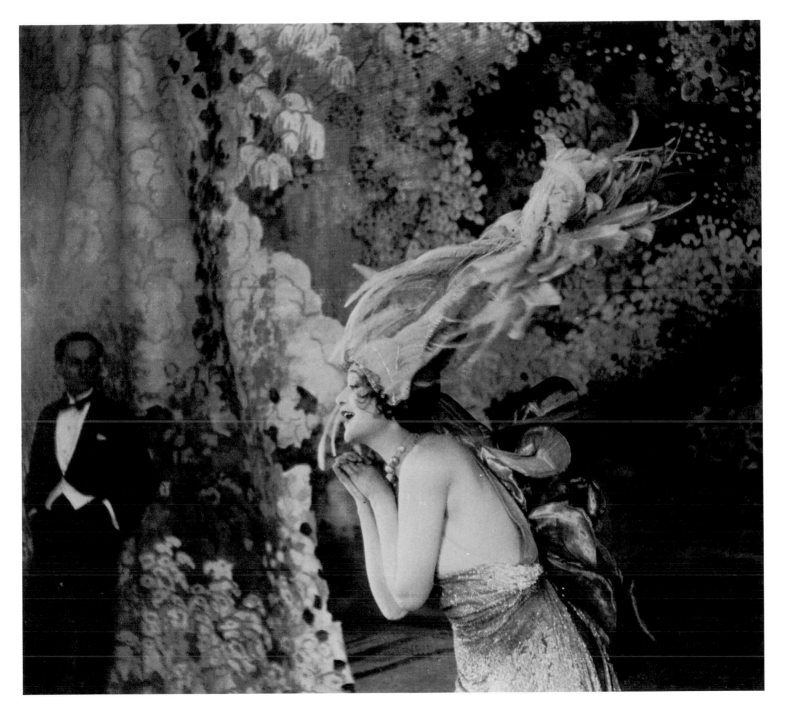

Plate 51—Jacques Henri Lartigue, catalog no. 418

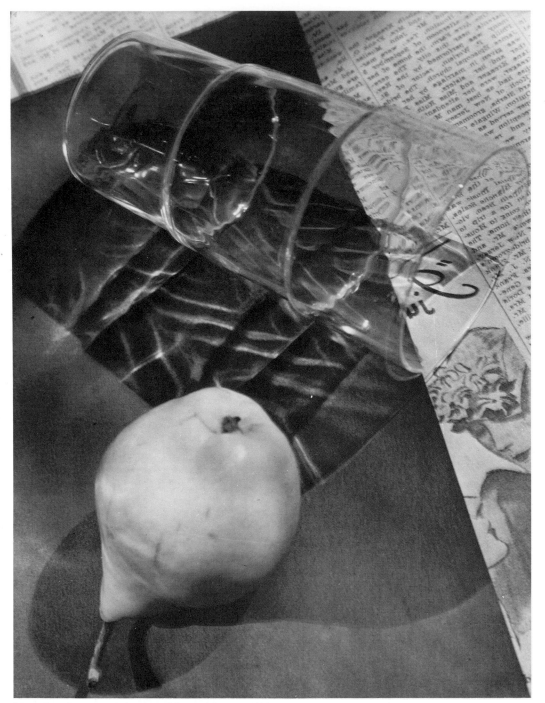

Plate 52—Clarence John Laughlin, catalog no. 423

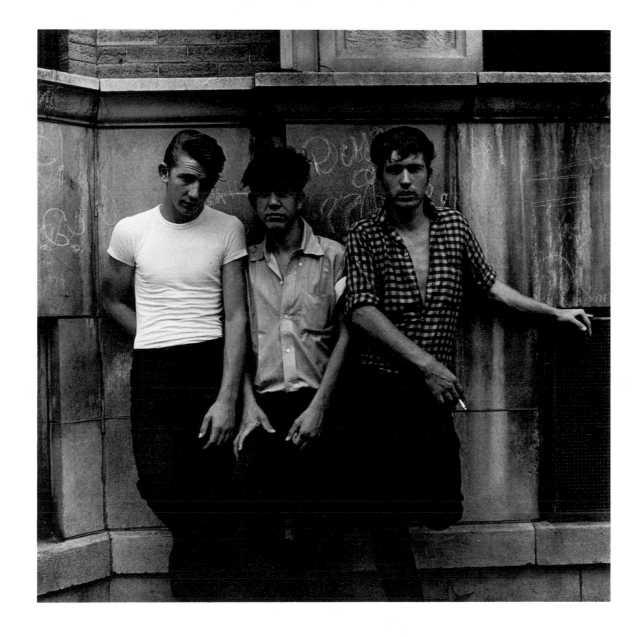

Plate 53—Danny Lyon, catalog no. 439

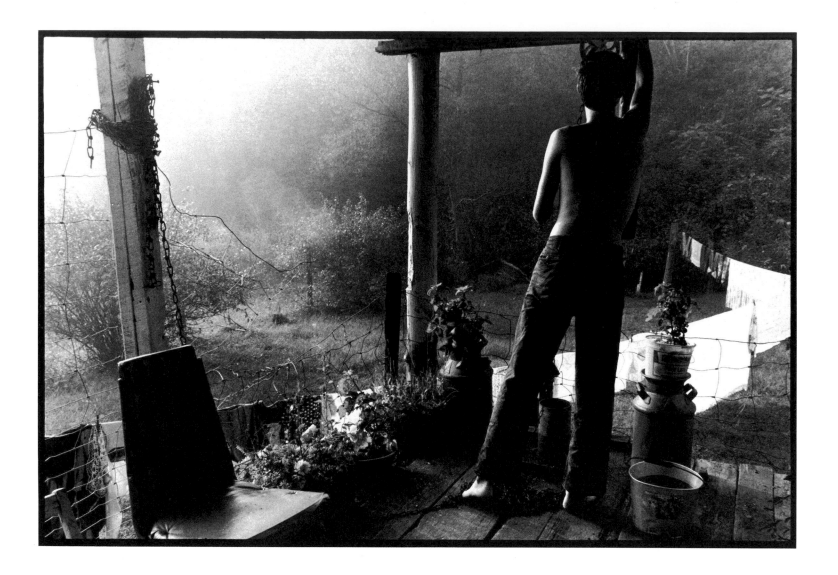

Plate 54—Margaret A. MacKichan, catalog no. 454

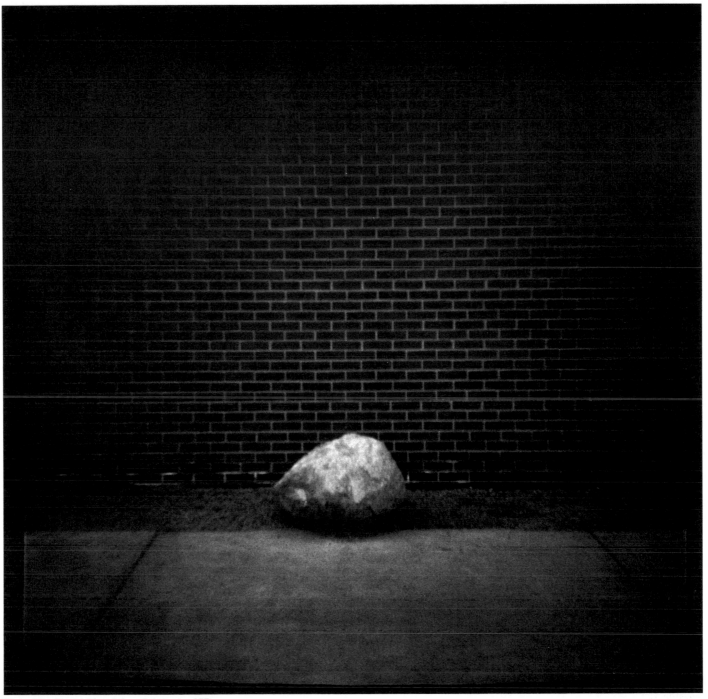

Plate 55—David Mandel, catalog no. 457

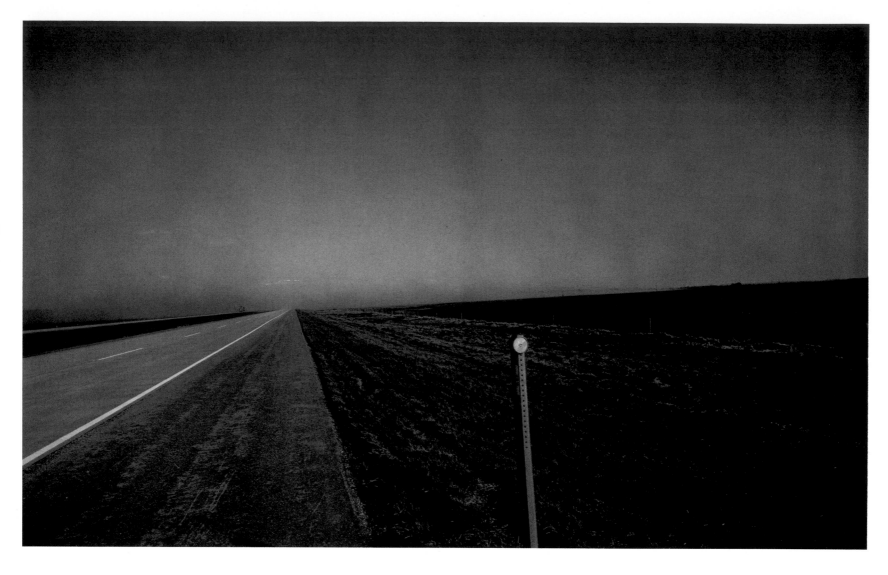

Plate 56—Lawrence McFarland, catalog no. 461

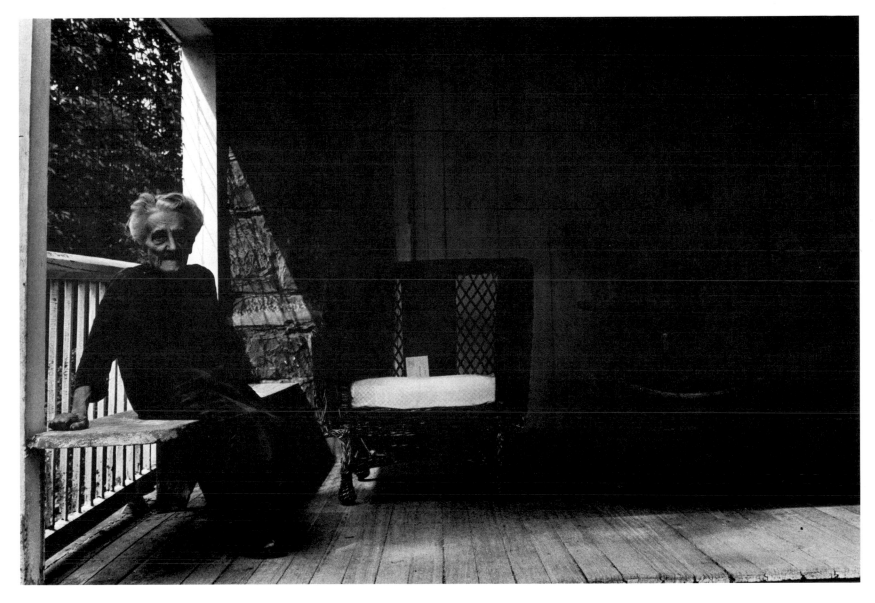

Plate 57—Michael McLoughlin, catalog no. 466

70

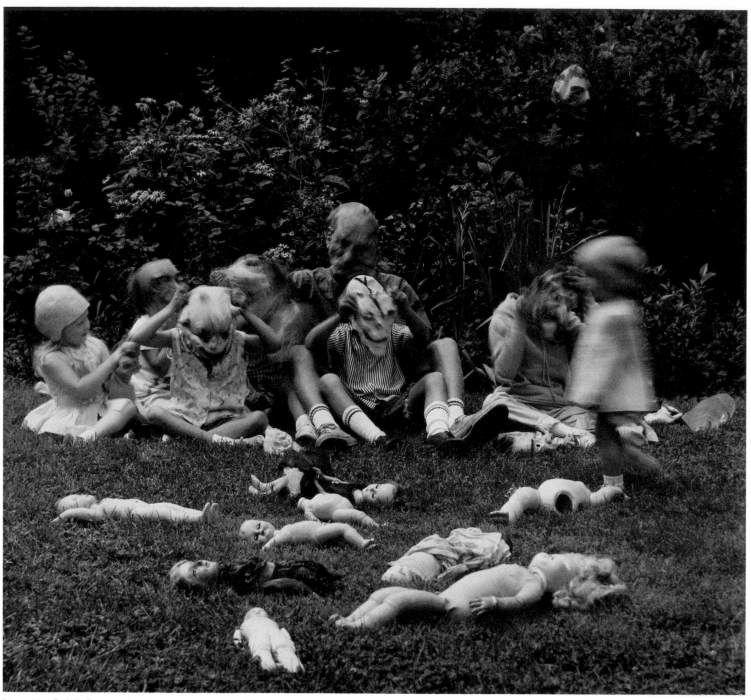

Plate 58—Ralph Eugene Meatyard, catalog no. 472

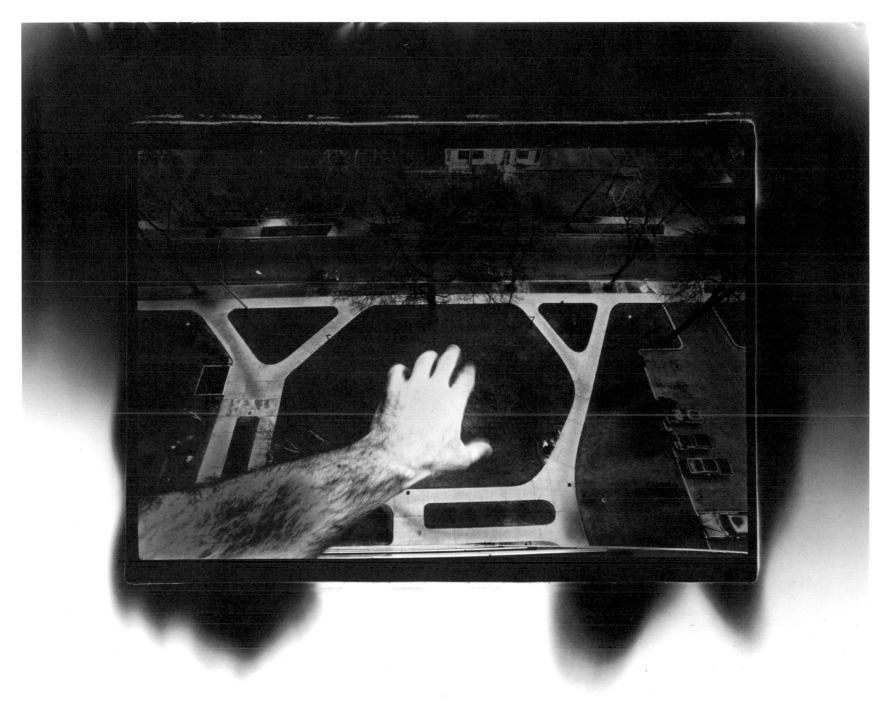

Plate 59—Roger Mertin, catalog no. 479

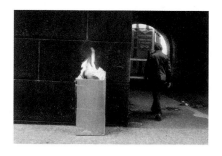

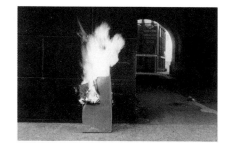

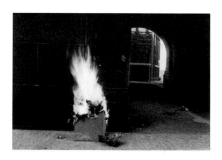

Plate 60—Duane Michals, catalog nos. 485-490

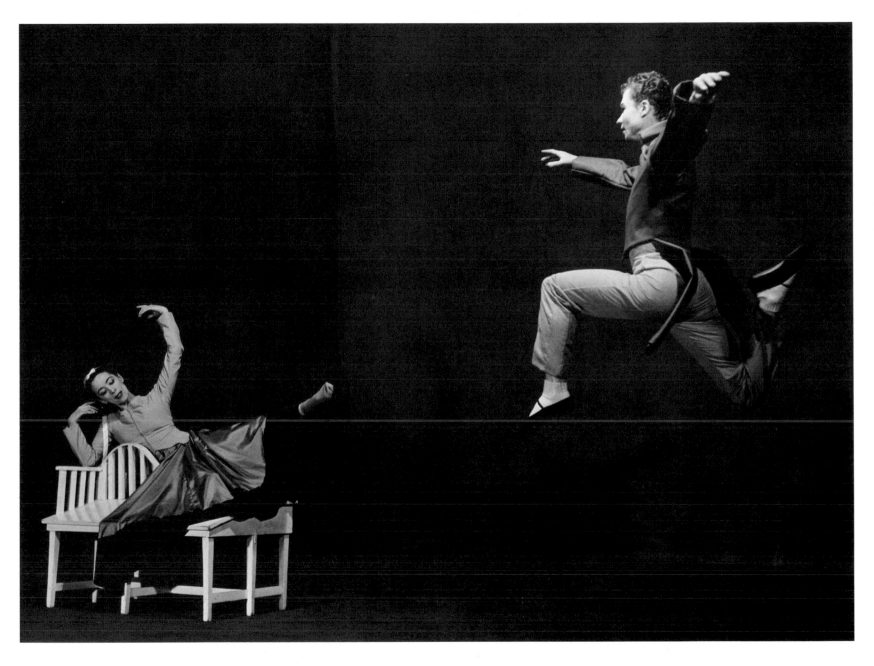

Plate 61 — Barbara Morgan, catalog no. 496

Plate 62—Wright Morris, catalog no. 500

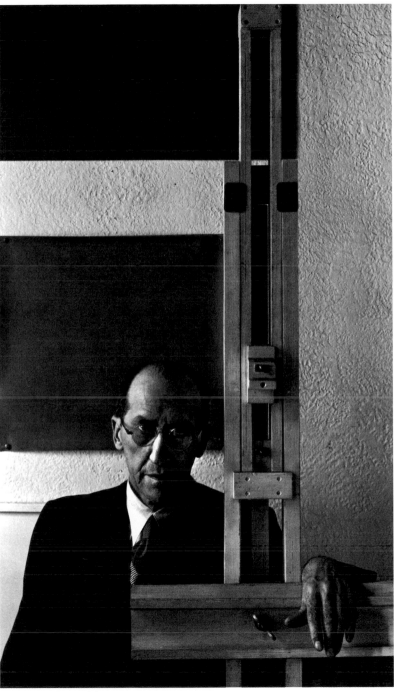

Plate 63—Arnold Newman, catalog no. 517

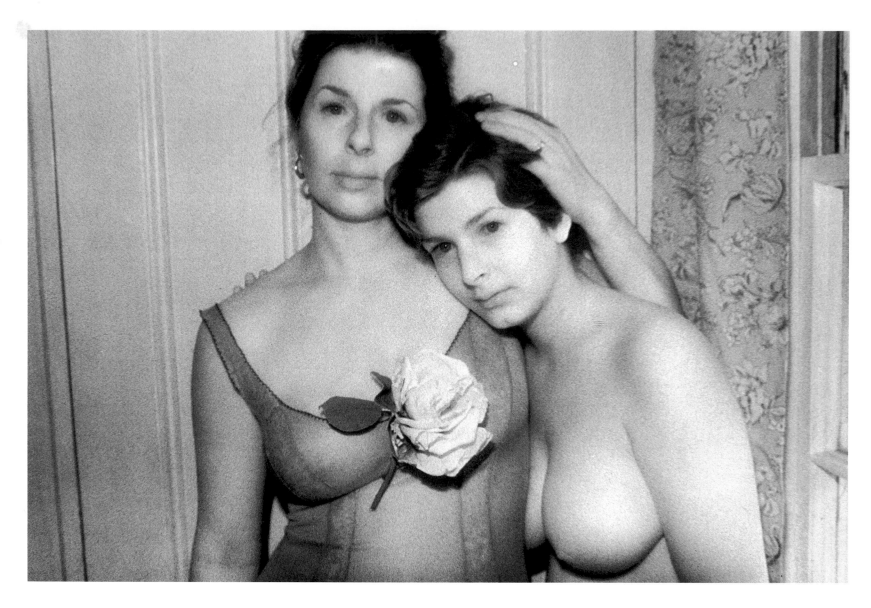

Plate 64—Starr Ockenga, catalog no. 529

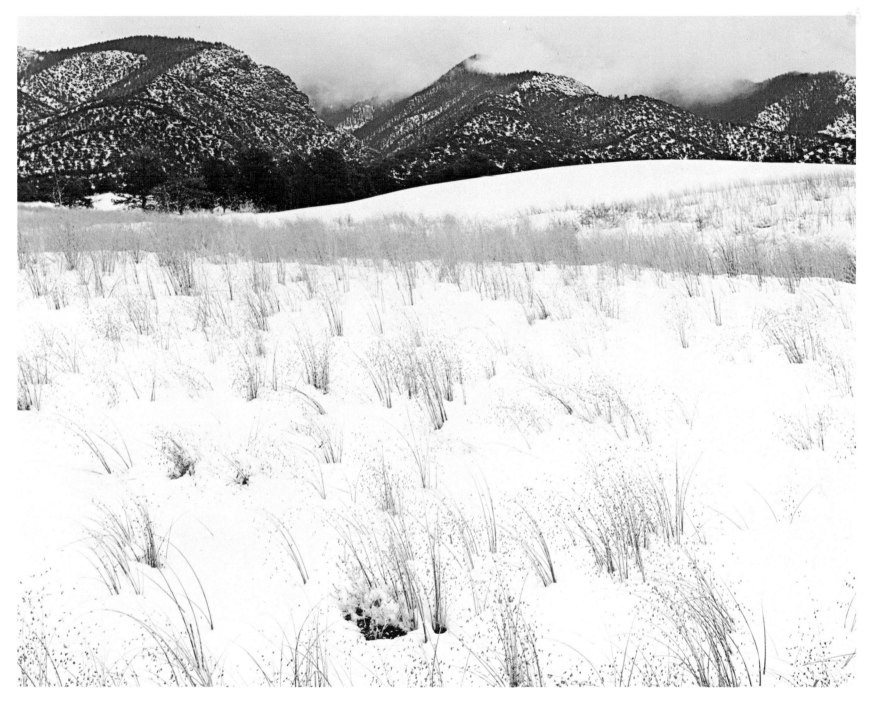

Plate 65—Eliot F. Porter, catalog no. 543

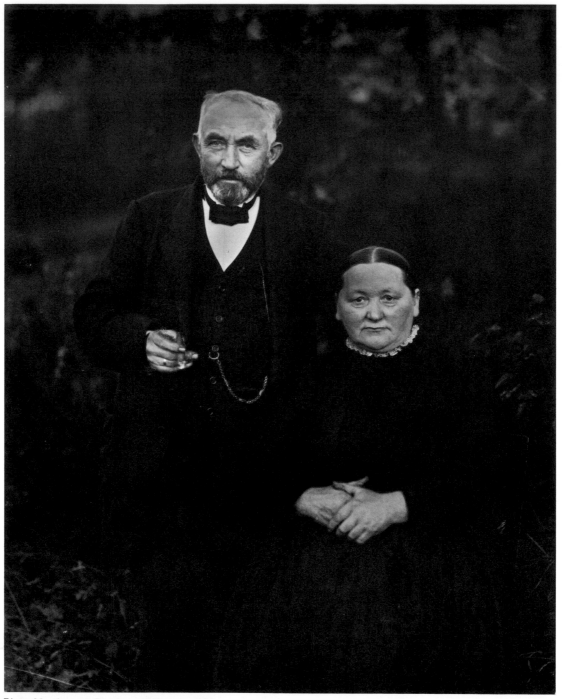

Plate 66—August Sander, catalog no. 564

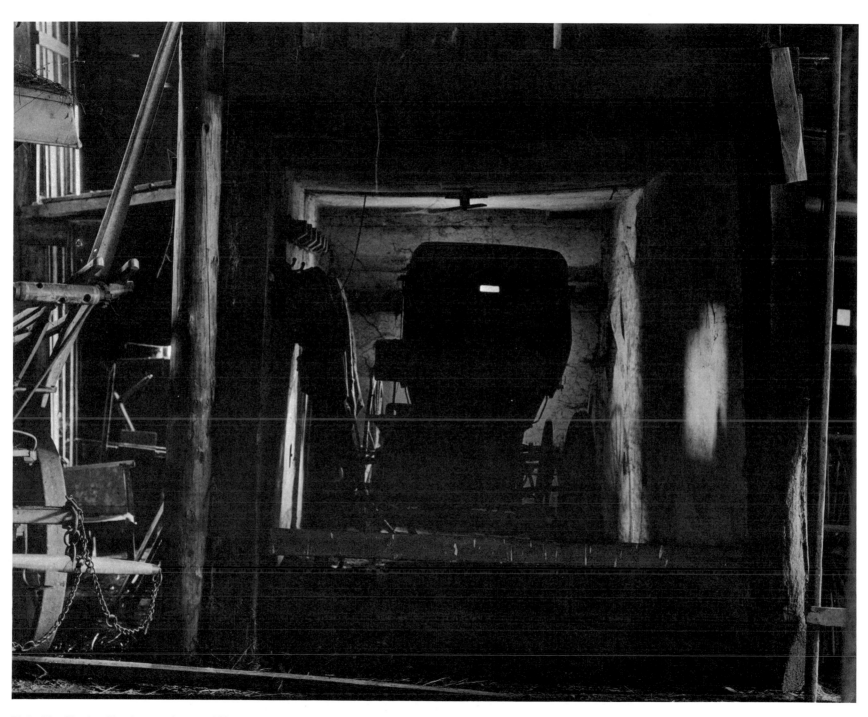

Plate 67—Charles Sheeler, catalog no. 602

80

Plate 68—Stephen Shore, catalog no. 603

81

Plate 69—Art Sinsabaugh, catalog no. 613

82

Plate 70—Aaron Siskind, catalog no. 620

83

Plate 71—Neal Slavin, catalog no. 623

Plate 72—Henry Holmes Smith, catalog no. 629

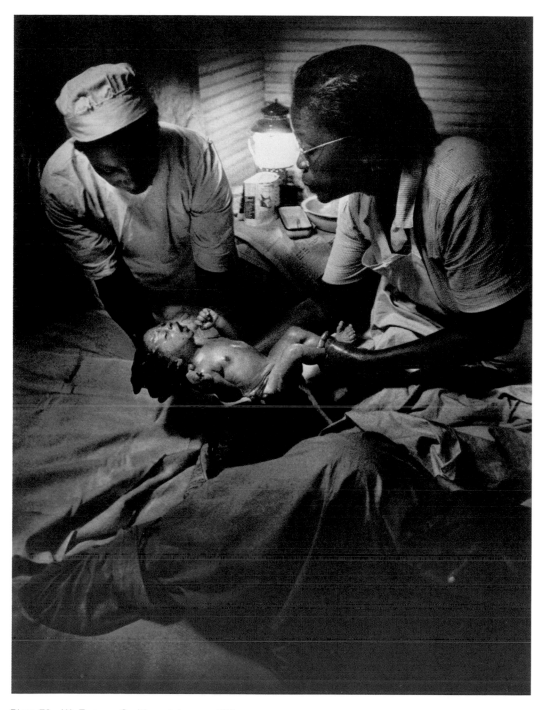

Plate 73—W. Eugene Smith, catalog no. 632

Plate 74—Frederick Sommer, catalog no. 644

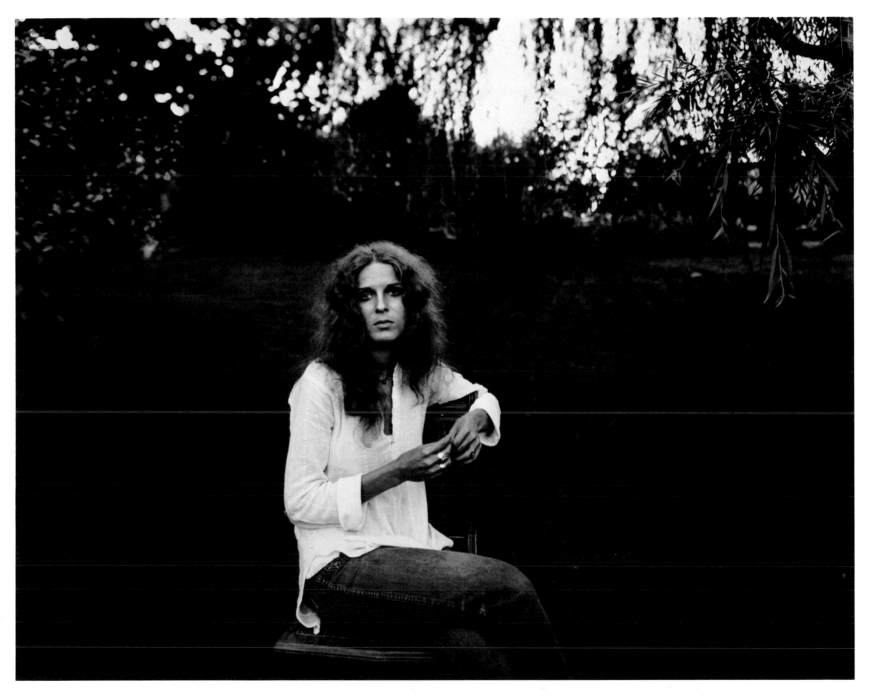

Plate 75—John Spence, catalog no. 647

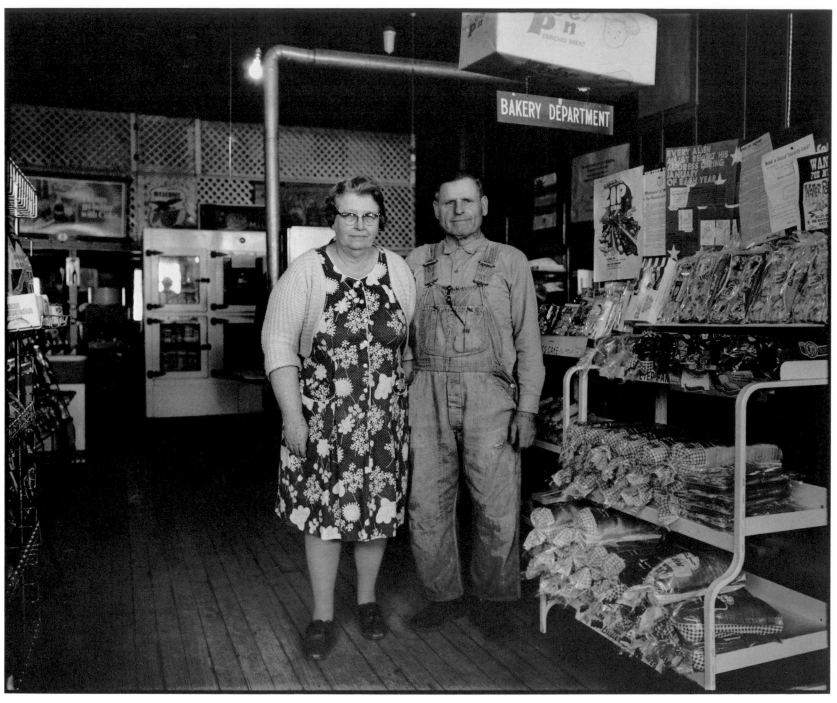

88

Plate 76—Robert Starck, catalog no. 651

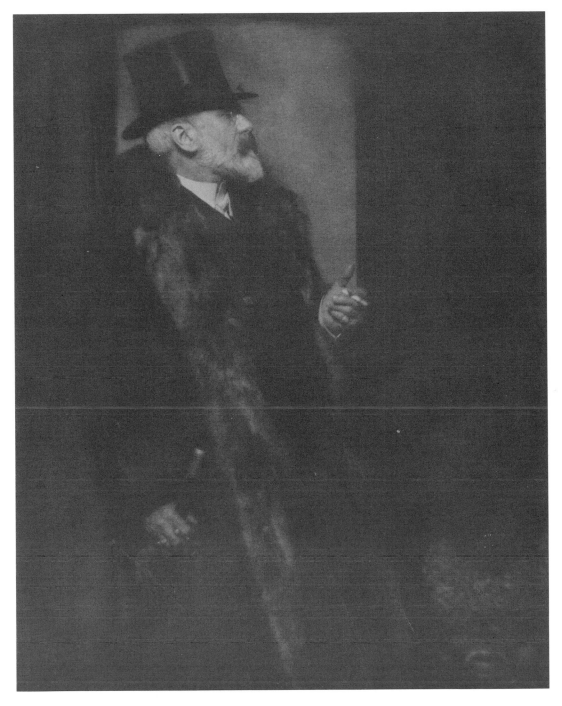

89

Plate 77—Edward Steichen, catalog no. 704

90

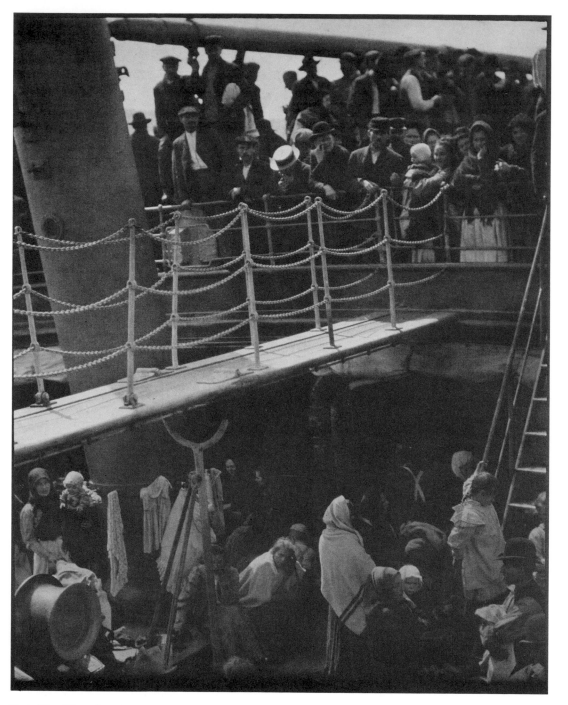

Plate 78—Alfred Stieglitz, catalog no. 709

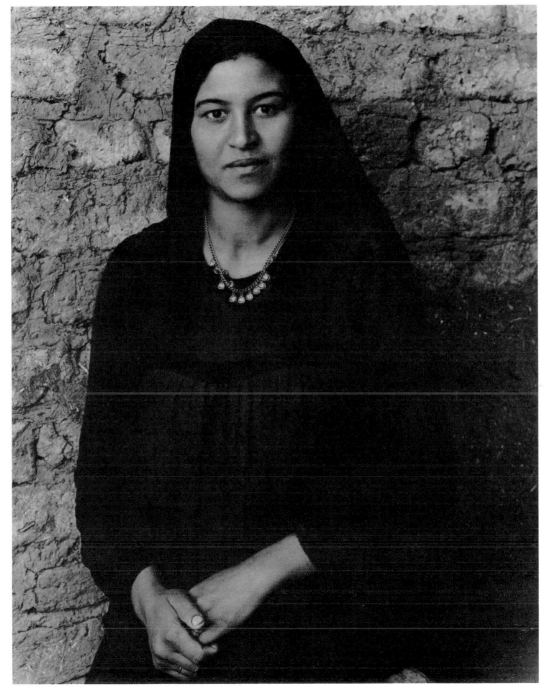

Plate 79—Paul Strand, catalog no. 732

Plate 80—Josef Sudek, catalog no. 741

Plate 81—William Henry Fox Talbot, catalog no. 762

94

Plate 82—Edmund Teske, catalog no. 765

Plate 83—George Tice, catalog no. 770

96

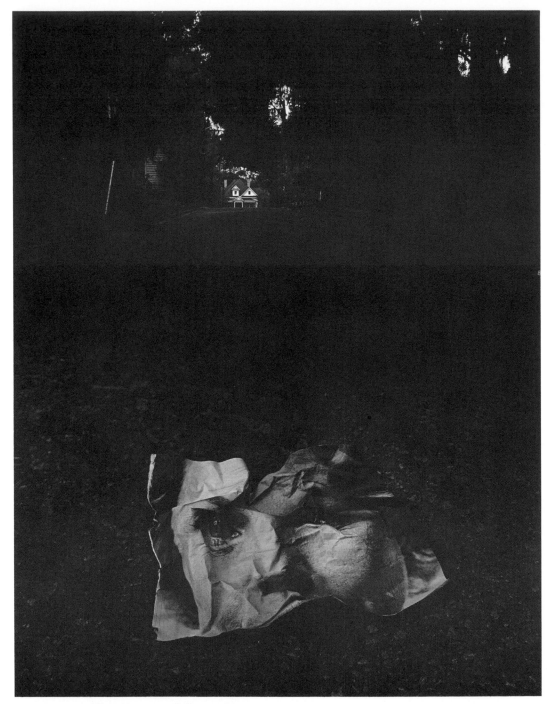

Plate 84—Jerry N. Uelsmann, catalog no. 771

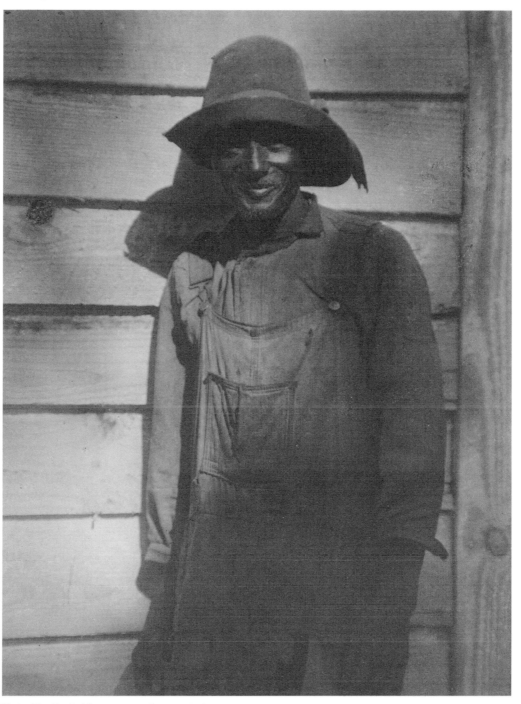

Plate 85—Doris Ulmann, catalog no. 776

98

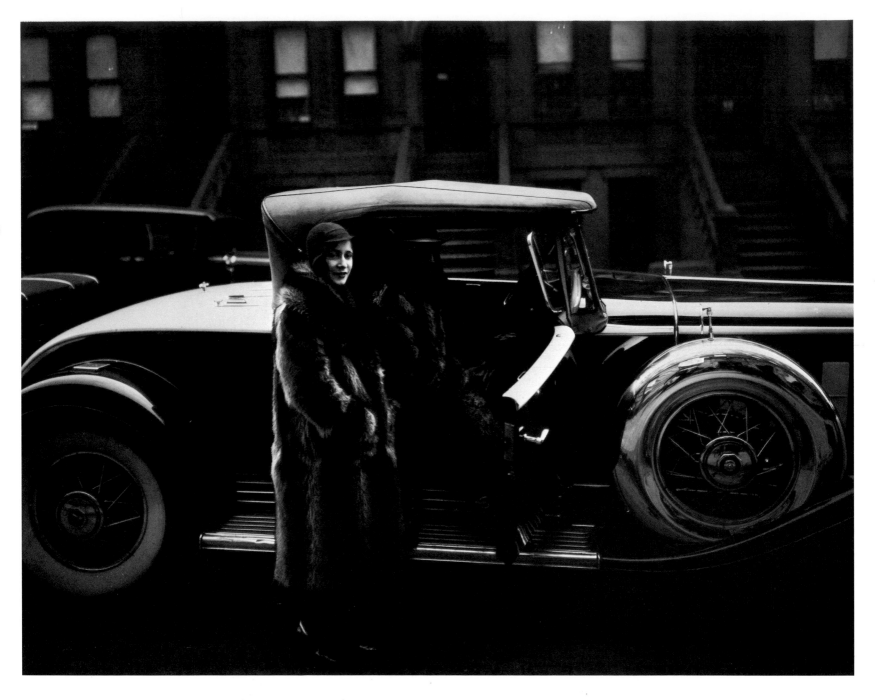

Plate 86—James Van Derzee, catalog no. 778

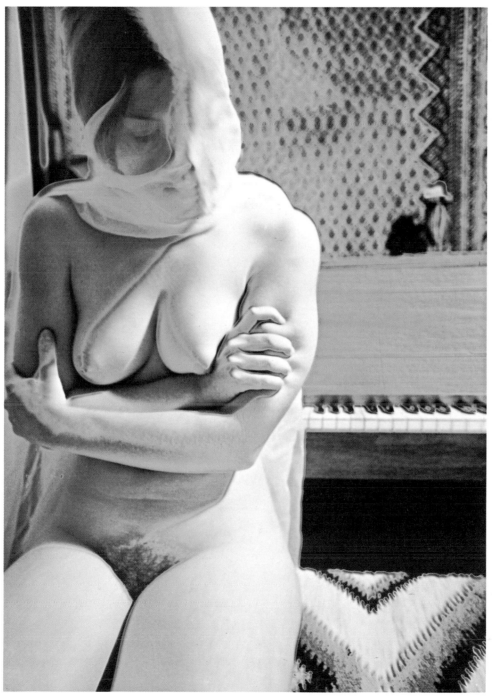

Plate 87—Todd Walker, catalog no. 796

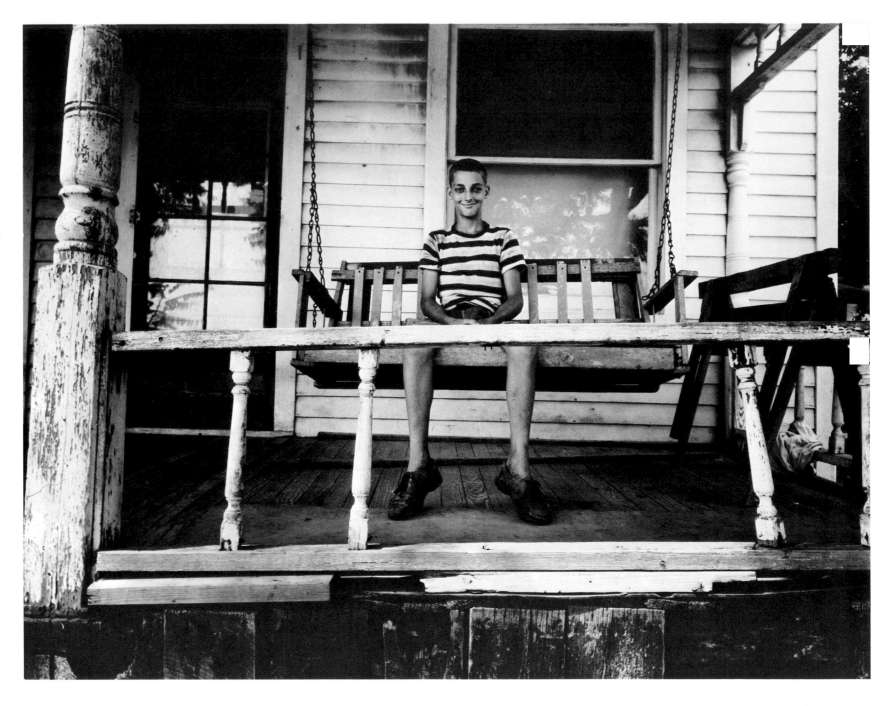

Plate 88—Jack Welpott, catalog no. 801

101

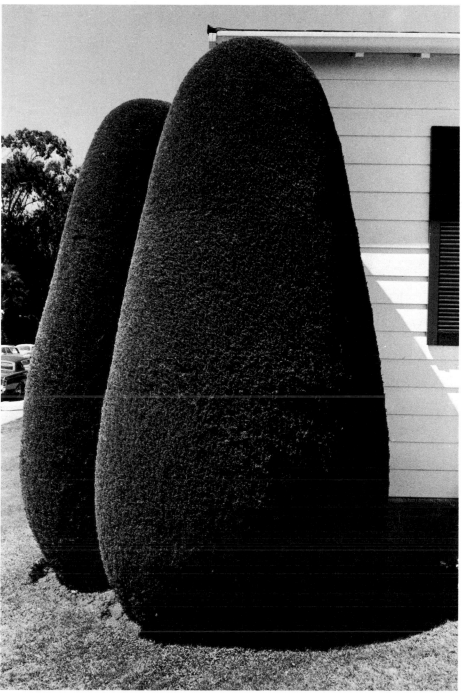

Plate 89—Henry Wessel, Jr., catalog no. 803

102

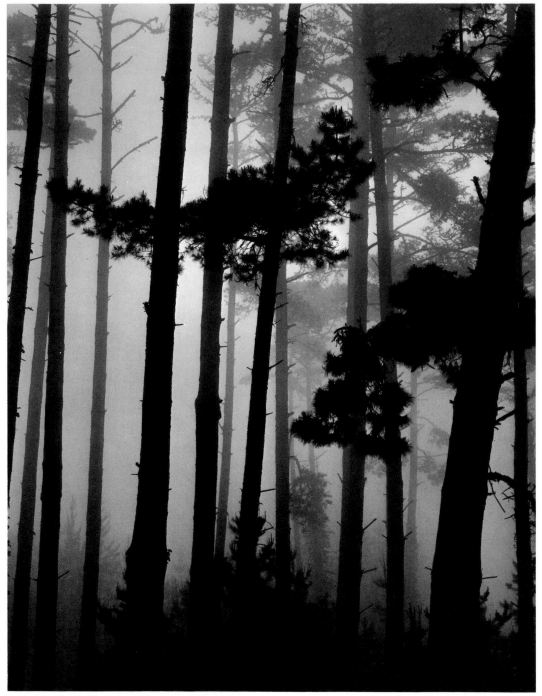

Plate 90—Brett Weston, catalog no. 818

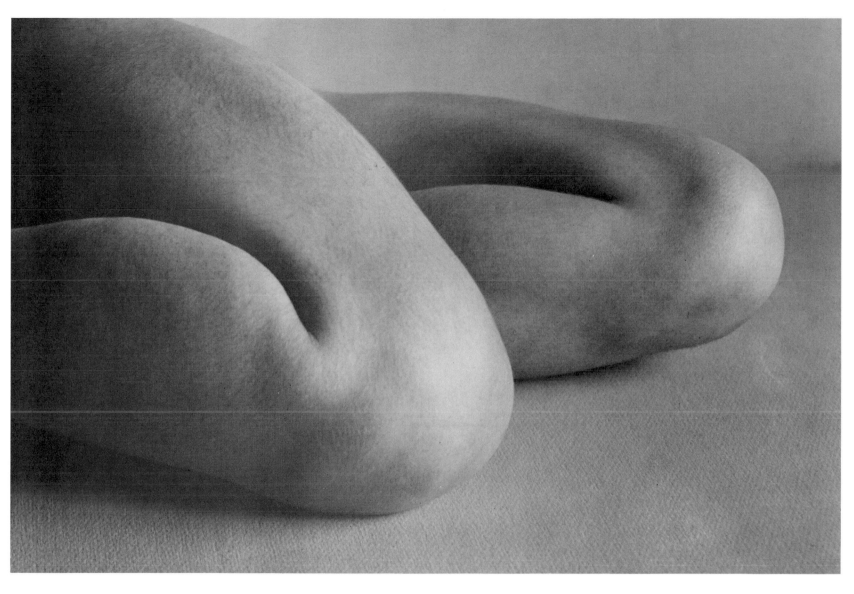

103

Plate 91—Edward Weston, catalog no. 827

104

Plate 92—Clarence White, catalog no. 843

Plate 93—Minor White, catalog no. 860

106

Plate 94—Garry Winogrand, catalog no. 867

Plate 95—John Wood, catalog no. 873

108

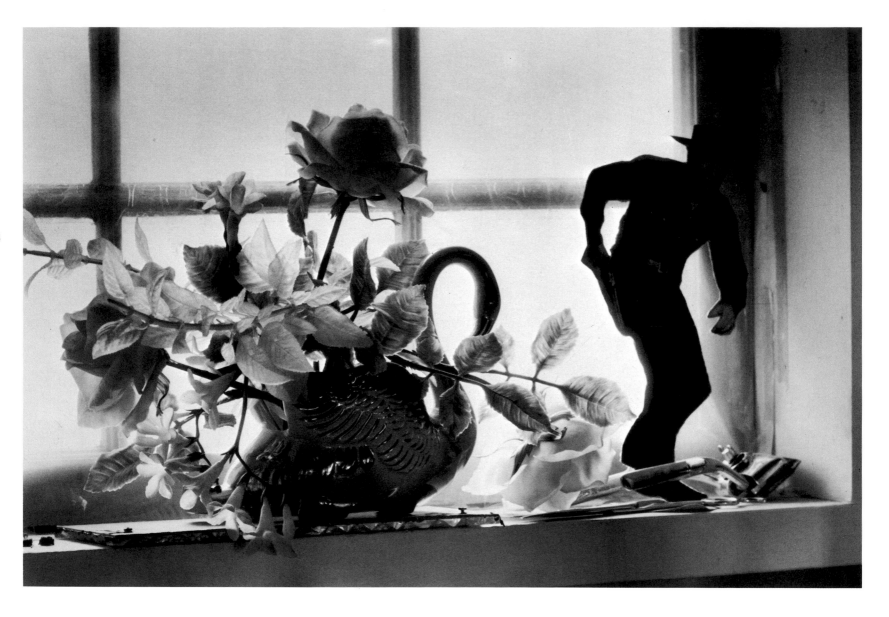

Plate 96 — Myron Wood, catalog no. 875

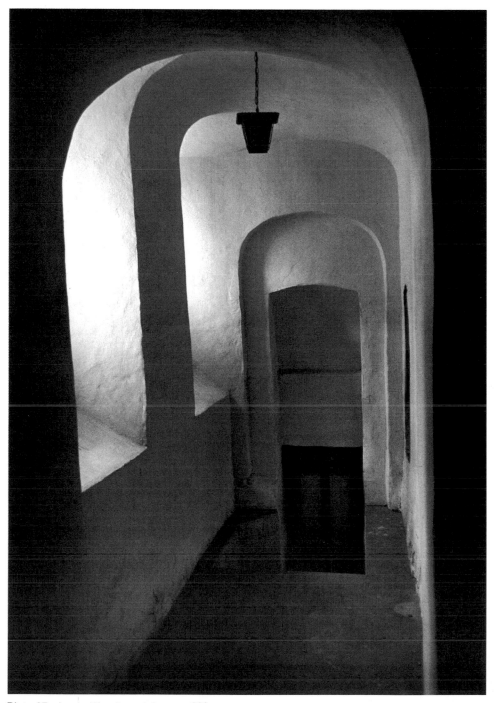

Plate 97—Lucia Woods, catalog no. 880

110

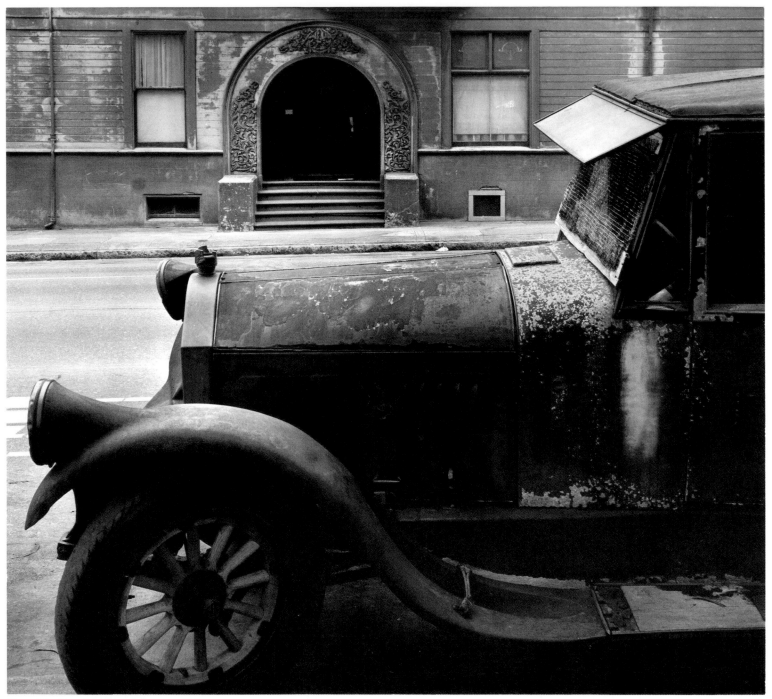

Plate 98—Don Worth, catalog no. 884

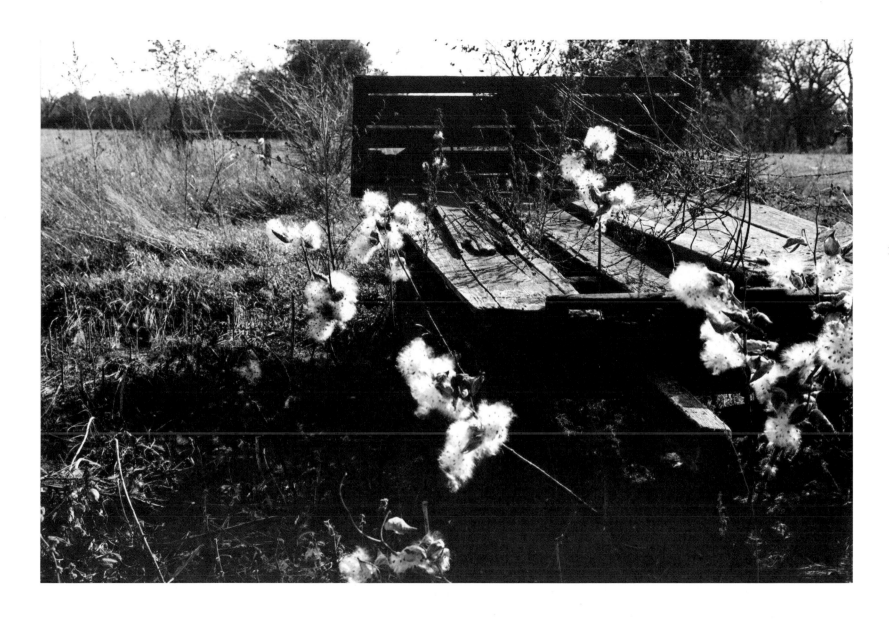

111

Plate 99—Peter J. Worth, catalog no. 887

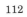

112

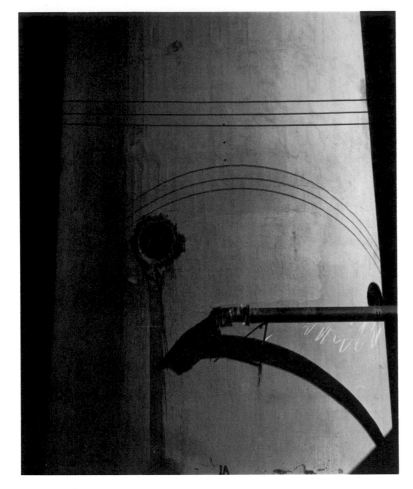

Plate 100—Steve Yates, catalog no. 891

113

The following catalog has been designed to provide a detailed list of the photographs in the Gallery's permanent collection together with selected facts pertaining to the photographers. No attempt has been made to include information of a biographical nature beyond an indication of education, awards, solo exhibitions and inclusion in public collections. Readily available sources of information have been consulted, including the photographers themselves, but the information provided is, in all probability, not exhaustive.

TITLES

A notable variation occurs in the titles given to individual prints. The artists or a standard publication have been used as the authority where necessary. Alternative titles, and translations from foreign languages are provided in parentheses. The contemporary preference for "UNTITLED" — or a coded negative number, has been respected but a description of subject matter has also been given in parentheses to afford positive identification.

DATES

The dating of photographs is complicated in many ways. The dates given by the artist or, at second best, provided by a standard monograph have been given priority, recognizing the possibility of error in both instances. Where the information has been available, the date of taking and the date of printing have both been given, separated by a slash mark. Modern prints from old negatives and prints made by photographers other than the creators have been so indicated.

SOLO EXHIBITIONS

Exception has been made of exhibitions of two or three artists. References have been abbreviated when they occur more than once. It should be understood that in some instances the galleries or institutions indicated no longer exist.

PUBLIC COLLECTIONS

Those collections known to contain more than fifty prints by a given artist have been listed first and are separated from other collections by a double slash mark.

MEASUREMENTS

Height precedes width in all measurements.

REPRODUCTIONS AND BIBLIOGRAPHY

The references to reproductions are arranged in a chronological order, with references to photographic annuals, periodicals and newspapers, complete as given, following those to books. The bibliography appended at the end of the catalog contains only those publications which contain reproductions of photographs in the collection.

In the interests of conciseness, a system of abbreviations has been used throughout the catalog, the key to which is given below.

Aardvark — Aardvark Gallery, San Francisco, CA

"A" Camera — "A" Camera, Chicago, IL

Achenbach — Achenbach Foundation for Graphic Art, California Palace of the Legion of Honor, San Francisco, CA

Addison — Addison Gallery of American Art, Andover, MA

Akron — Akron Art Institute, Akron, OH

Alabama — Art Gallery of University of Alabama, Tuscaloosa, AL

Alfred — Alfred University, Alfred, NY

Amon Carter — Amon Carter Museum of Western Art, Fort Worth, TX

An American Place — An American Place, NYC

A Photographers Gallery — A Photographers Gallery, NYC

AIC — Art Institute of Chicago, IL

AIC-School — School of the Art Institute of Chicago, IL

Baltimore — Baltimore Museum of Art, Baltimore, MD

Bathhouse — Bathhouse Gallery, Milwaukee, WI

Beloit — Beloit College, Beloit, WI

Bennington — Bennington College, Bennington, VT

Berkeley — University of California, Berkeley, CA

Berkshire—Berkshire Museum, Pittsfield, MA
Black Mountain—Black Mountain College,
 Black Mountain, NC
Blanden—Blanden Art Gallery, Fort Dodge, IA
BN—Bibliotheque Nationale, Paris, France
BPL—Boston Public Library, Boston, MA
Boston—Boston University, Boston, MA
Boulder—University of Colorado, Boulder, CO
Bowdoin—Bowdoin College Museum of Art,
 Brunswick, ME
Brooklyn—Brooklyn Museum, Brooklyn, NY
Brucke—Galerie de Brucke, Vienna, Austria
Burpee—Burpee Art Museum, Rockford, IL
Camera Work-Costa Mesa—Camera Work Gallery,
 Costa Mesa, CA
Camera Work-Newport—Camera Work Gallery,
 Newport Beach, CA
Cameraworks—Cameraworks Gallery,
 Los Angeles, CA
Caravan—Caravan Gallery, NYC
Carbondale—University Museum & Art Gallery,
 Southern Illinois University, Carbondale, IL
Carpenter—Carpenter Center, Harvard University,
 Cambridge, MA
Castelli—Castelli Graphics, NYC
Ceejee—Ceejee Gallery, Los Angeles, CA
Center of the Eye—Center of the Eye Gallery,
 Aspen, CO/Santa Fe, NM
CPS—Center for Photographic Studies,
 Louisville, KY
CMB—Chase Manhattan Bank, NYC
Cincinnati—Cincinnati Art Museum,
 Cincinnati, OH
Cleveland—Cleveland Museum of Art,
 Cleveland, OH
CSFAC—Colorado Springs Fine Art Center,
 Colorado Springs, CO
CSM—Colorado State Museum, Denver, CO
Columbia—Columbia College, Chicago, IL
Concordia—Concordia College, Seward, NE
Corcoran—Corcoran Gallery of Art, Washington, DC
Cornell—Herbert F. Johnson Museum of Art,
 Cornell University, Ithaca, NY
CAPS—Creative Artists Public Service Award
Creative Eye—Creative Eye, Sonoma, CA

Creighton—The Creighton University, Omaha, NE
Cronin—Cronin Gallery, Houston, TX
Currier—Currier Gallery of Art, Manchester, NH
Dallas—Texas Center for Photographic Studies,
 Dallas, TX
Dartmouth—Dartmouth College Museum &
 Galleries, Dartmouth, NH
Davison—Davison Art Center, Wesleyan University,
 Middletown, CT
Dayton—Dayton Art Institute, Dayton, OH
De Cordova—De Cordova Museum, Lincoln, MA
Delphic—Delphic Studios, NYC
Denver—Denver Art Museum, Denver, CO
Detroit—Detroit Institute of Arts, Detroit, MI
East Street—East Street Gallery, Grinnell, IA
Edison Street—Edison Street Gallery,
 Salt Lake City, UT
Egan—Egan Gallery, NYC
Everson—Everson Museum of Art, Syracuse, NY
ENB—Exchange National Bank, Chicago, IL
Focus—Focus Gallery, San Francisco, CA
Fogg—Fogg Art Museum, Harvard University,
 Cambridge, MA
FOP—Friends of Photography, Carmel, CA
Gainesville—University Gallery, University of
 Florida, Gainesville, FL
Gallery f/22—Gallery f/22, Santa Fe, NM
Garrett—Garrett-Evangelical Theological
 Seminary, Evanston, IL
Galveston—Galveston Art Center, Galveston, TX
GI—Lunn Gallery/Graphics International Ltd.,
 Washington, DC
Guggenheim—John Simon Guggenheim Memorial
 Foundation, NYC
Hallmark—Hallmark Gallery, NYC
Halsted—Halsted 831 Gallery, Birmingham, MI
Hawkins—G. Ray Hawkins Gallery, Los Angeles, CA
Hayward—Hayward Gallery, London, England
Helios—Helios Gallery, NYC
Henry—Henry Gallery, University of Washington,
 Seattle, WA
High—High Museum of Art, Atlanta, GA
ISU—Illinois State University, Normal, IL
Image—Image Gallery, NYC
Impressions—Impressions Gallery, York, England

Indiana—Indiana University Art Museum,
 Bloomington, IN
Indianapolis—Indianapolis Museum of Art,
 Indianapolis, IN
ICP—International Center of Photography, NYC
IMP—International Museum of Photography at
 The George Eastman House, Rochester, NY
ICA—Institute of Contemporary Art, Boston, MA
ID—Institute of Design, Illinois Institute of
 Technology, Chicago, IL
Iowa—The University of Iowa Museum of Art,
 Iowa City, IA
Jacksonville—Jacksonville Art Museum,
 Jacksonville, FL
Joslyn—Joslyn Art Museum, Omaha, NE
Julien Levy—Julien Levy Gallery, NYC
Kalamazoo—Kalamazoo Institute of Arts,
 Kalamazoo, MI
Kansas—University of Kansas Museum of Art,
 Lawrence, KS
KCAI—Kansas City Art Institute, Kansas City, MO
Krannert—Krannert Art Museum, University of
 Illinois, Urbana, IL
Lane Foundation—William H. Lane Foundation,
 Leominster, MA
LC—Library of Congress, Washington, DC
Light—Light Gallery, NYC
Light Impressions—Light Impressions Gallery,
 Rochester, NY
Limelight—Limelight Gallery, NYC
Lincoln First—Lincoln First Bank of Rochester, NY
Logan—David & Reva Logan Foundation,
 Chicago, IL
LACMA—Los Angeles County Museum of Art,
 Los Angeles, CA
Louisville—Photographic Archives, University of
 Louisville, Louisville, KY
Madison—Madison Art Center, Madison, WI
Maine—University of Maine, Orono, ME
Marlborough-NYC-London—Marlborough
 Gallery, New York, NY or London, England
MIT—Massachusetts Institute of Technology,
 Cambridge, MA
Menil—Menil Foundation, Houston, TX
MMA—Metropolitan Museum of Art, NYC

Michigan—Museum of Art, University of Michigan,
 Ann Arbor, MI
Mills—Mills College, Oakland, CA
MPM—Milwaukee Public Museum, Milwaukee, WI
MIA—Minneapolis Institute of Arts,
 Minneapolis, MN
Minnesota—University Gallery, University of
 Minnesota, Minneapolis
Mirvish—David Mirvish, Toronto, Canada
MHdY—M. H. de Young Memorial Museum,
 San Francisco, CA
MWP—Munson-Williams-Procter Institute, Utica, NY
MCNY—Museum of the City of New York, NY
MCA—Museum Contemporary Art, Chicago, IL
MFA—Museum of Fine Arts, Boston, MA
MFAH—Museum of Fine Arts, Houston, TX
MOMA—Museum of Modern Art, NYC
MNM—Museum of New Mexico, Santa Fe, NM
Murfreesboro—Middle Tennessee State University,
 Murfreesboro, TN
NBC-Lincoln—National Bank of Commerce-
 Lincoln, Lincoln, NE
NCFA—National Collection of Fine Arts,
 Washington, DC
NEA—National Endowment for the Arts,
 Washington, DC
NGC—National Gallery of Canada, Ottawa, Canada
NPG-London—National Portrait Gallery,
 London, England
NPG-Washington—National Portrait Gallery,
 Washington, DC
Nebraska—Sheldon Memorial Art Gallery,
 University of Nebraska-Lincoln, Lincoln, NE
Nebraska Union—Nebraska Union, University of
 Nebraska-Lincoln, Lincoln, NE
Neikrug—Marjorie Neikrug Gallery, NYC
Nelson—William Rockhill Nelson Gallery and
 Atkins Museum of Fine Arts, Kansas City, MO
Newark—Newark Museum, Newark, NJ
New England—New England School of
 Photography, Boston, MA
NOMA—New Orleans Museum of Art,
 New Orleans, LA
Newport Beach—Newport Beach Art Museum,
 Newport Beach, CA

New School — New School for Social Research, NYC
NYPL — New York Public Library, NYC
Nexus — Nexus Gallery, Atlanta, GA
Nikon — Nikon Salon, Tokyo, Japan
Northeastern — Northeastern Illinois University, Chicago, IL
Northwestern — Northwestern University, Evanston, IL
Oakland — Oakland Museum, Oakland, CA
Oberlin — Allen Memorial Art Museum, Oberlin, OH
Ohio Silver — Ohio Silver Gallery, Los Angeles, CA
Oklahoma — Museum of Art, University of Oklahoma, Norman, OK
Oregon — Museum of Art, University of Oregon Eugene, OR
Panopticon — Panopticon Gallery, Boston, MA
Pasadena — Norton Simon Museum of Art at Pasadena, CA
PCA — Philadelphia College of Art, Philadelphia, PA
PMA — Philadelphia Museum of Art, Philadelphia, PA
PPC — Philadelphia Print Club, Philadelphia, PA
Phoenix — Phoenix Art Museum, Phoenix, AZ
Phoenix College — Phoenix College, Phoenix, AZ
PG-London — Photographers Gallery, London, England
PSA — Photographic Society of America
Photography Place — Photography Place, Berwyn, PA
Photo League — Photo League Gallery, NYC
Polaroid — Polaroid Corporation, Cambridge, MA
Pomona — Pomona College, Claremont, CA
Portland — Portland Art Museum, Portland, OR
Prakapas — Prakapas Gallery, NYC
Pratt — Pratt Institute, Brooklyn, NY
Princeton — The Art Museum, Princeton University, Princeton, NJ
Princeton Library — Princeton University Library, Princeton, NJ
Quivira — Quivira Gallery, Albuquerque, NM
Reed — Reed College, Portland, OR
RISD — Rhode Island School of Design, Providence, RI
Rice — Rice University, Houston, TX

Ringling — John & Mable Ringling Museum of Art, Sarasota, FL
Roswell — Roswell Museum & Art Center, Roswell, NM
RPS — Royal Photographic Society, London, England
Ryerson — Ryerson Polytechnic Institute, Toronto, Canada
St. John's College — St. John's College, Santa Fe, NM
SFAI — San Francisco Art Institute, San Francisco, CA
SFMMA — San Francisco Museum of Modern Art, San Francisco, CA
SFSU — San Francisco State University, San Francisco, CA
Santa Barbara — Santa Barbara Museum of Art, Santa Barbara, CA
Schoelkopf — Robert Schoelkopf Gallery, NYC
Seagram — Joseph E. Seagram & Sons Inc., NYC
Seattle — Seattle Art Museum, Seattle, WA
Schuman — Schuman Gallery, Rochester, NY
Shado — Shado Gallery, Oregon City, OR
Siembab — Carl Siembab Gallery, Boston, MA
Silver Image-Ohio — Silver Image, Ohio State University, Columbus, OH
Silver Image-Tacoma — Silver Image Gallery, Tacoma, WA
Sioux City — Sioux City Arts Center, Sioux City, IA
Skidmore — Skidmore College Art Gallery, Saratoga Springs, NY
Smith — Smith College Museum of Art, Northampton, MA
Smithsonian — Museum of History and Technology, Smithsonian Institution, Washington, DC
Soho — Soho Photo, NYC
SPE — Society for Photographic Education
Spiritus — Susan Spiritus Gallery, Newport Beach, CA
Springfield — Springfield Museum of Fine Arts, Springfield, MA
Stanford — Stanford University Museum and Art Gallery, Stanford University, Stanford, CA
St. Louis — St. Louis Art Museum, St. Louis, MO
St. Petersburg — Museum of Fine Arts of St. Petersburg, FL

Stedlijk — Stedlijk Museum, Amsterdam, Netherlands

Sun Valley — Sun Valley Center for the Arts & Humanities, Sun Valley, ID

SUNY-Buffalo — State University of New York, Buffalo, NY

SUNY-Geneseo — State University of New York, Geneseo, NY

Tampa — Florida Center for the Arts, University of South Florida, Tampa, FL

Tempe — University Art Collections, Arizona State University, Tempe, AR

Texas — Humanities Research Center, University of Texas, Austin, TX

Thackrey & Robertson — Thackrey & Robertson, San Francisco, CA

Topeka — Mulvane Art Center, Washburn University, Topeka, KS

Toronto — Art Museum of Ontario, Toronto, Canada

TGP — Toronto Gallery of Photography, Toronto, Canada

Toren — Toren Gallery, San Francisco, CA

Tucson — Center for Creative Photography, University of Arizona, Tucson, AZ

Tulane — Tulane University, New Orleans, LA

Tyler — Tyler School of Art, Temple University, Philadelphia, PA

Underground — Underground Gallery, NYC

UC-Davis — Memorial Union Art Gallery, University of California, Davis, CA

UCLA — Frederick S. Wight Art Gallery, University of California, Los Angeles, CA

UC-Santa Clara — de Saisset Art Gallery & Museum, University of California, Santa Clara, CA

UNC — University of North Carolina, Chapel Hill, NC

UNI — University of Northern Iowa, Cedar Falls, IA

UNM — University Art Museum, University of New Mexico, Albuquerque, NM

USU — Utah State University, Logan, UT

UU-Salt Lake City — University of Utah, Salt Lake City, UT

Vassar — Vassar College Art Gallery, Poughkeepsie, NY

V&A — Victoria & Albert Museum, London, England

VMFA — Virginia Museum of Fine Arts, Richmond, VA

Vision — Vision Gallery, Boston, MA

VSW — Visual Studies Workshop, Rochester, NY

Vreeland — Francis W. Vreeland Awards, University of Nebraska-Lincoln, Lincoln, NE

Wadsworth — Wadsworth Atheneum, Hartford, CT

WAC — Walker Art Center, Minneapolis, MN

Washington — Washington Gallery of Photography, Washington, DC

Wellesley — Wellesley Free Library, Wellesley, MA

Whitney — Whitney Museum of American Art, NYC

Wichita — Edwin A. Ulrich Museum of Art, Wichita State University, Wichita, KS

Williams — Williams College Museum of Art, Williamstown, MA

Witkin — Witkin Gallery, NYC

Woods — Woods Fellowship, University of Nebraska-Lincoln, Lincoln, NE

Worcester — Worcester Art Museum, Worcester, MA

Yale — Yale University Art Gallery, Yale University, New Haven, CT

YMHA — Young Men's Hebrew Association

119

WILLIAM H. ABBENSETH
b. New York, New York, 1892
Education: Worked under WPA, 1935-39
Public Collections: Minnesota; Nebraska; Oakland
 1. ARCHITECTURAL DETAIL
 silver print
 6⅝″ x 4½″ / 16.8cm. x 11.4cm.
 University Collection, allocated by the Work
 Projects Administration, 1943
 Acc. No. U-1988

BERENICE ABBOTT
b. Springfield, Ohio, 1898
Education: Ohio State University, 1918-21; studied sculpture under Bourdelle and Brancusi; assistant to Man Ray, 1923-29
Solo Exhibitions: 1926—Au Sacre du Printemps, Paris; 1930—Contemporary Art Club, Harvard University, Cambridge; 1932—Julien Levy; 1934—New School; Oakland; Yale; 1934-35—MCNY; 1935—Jerome Stavola Gallery, Hartford, CT; Springfield; Fine Arts Guild, Cambridge, MA; Dartmouth; Princeton; 1937—MCNY; 1938—Hudson D. Walker Gallery, NYC; 1941—MIT; 1947—Galerie de l'Epoque, Paris; 1950—Akron; 1951—AIC; 1953—SFMMA; Caravan; 1955—Currier; 1956—Toronto; 1959—New School; 1960—Siembab; Currier; Smithsonian; Kalamazoo; 1969—Smithsonian; 1970—MOMA; 1976—Marlborough, NYC; GI; Frumkin, Chicago; 1977—Vision (with Brandt and Brassai)
Public Collections: Newark// AIC; CMB; Detroit; Fogg; High; Indiana; IMP; Kalamazoo; Krannert; LC; Menil; MMA; Michigan; Milwaukee Art Center; Milwaukee, WI; MIA; Minnesota; MCNY; MFA; MFAH; MOMA; NCFA; NGC; NPG-Washington; Nebraska; NOMA; Oberlin; Oklahoma; PMA; Princeton; RISD; SFMMA; Seagram; Smith; Smithsonian; St. Petersburg; UNM; VMFA; Worcester; Yale
 2. MURRAY HILL HOTEL, PARK AVENUE AT 41ST
 STREET, November 19, 1935
 silver print
 9⅜″ x 7⅜″ / 23.8cm. x 18.7cm.
 Reproduced: *Changing New York,* no. 63
 University Collection
 Acc. No. U-1854

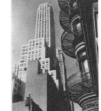

 3. HENRY STREET, LOOKING WEST FROM
 MARKET STREET, MANHATTAN, November
 29, 1935
 silver print
 7¼″ x 9½″ / 18.4cm. x 24.1cm.
 Reproduced: *Changing New York,* no. 18
 University Collection
 Acc. No. U-1855

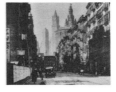

*4. CLIFF AND HENRY STREETS, November 29, 1935
 silver print
 8⅝″ x 3⅜″ / 21.9cm. x 8.6cm.
 University Collection
 Acc. No. U-1856

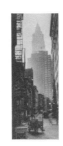

5. TRAVELING TIN SHOP, BROOKLYN, May 22,
 1936
 silver print
 7⅝″ x 9⅝″ / 19.4cm. x 24.5cm.
 Reproduced: *Changing New York,* no. 91
 University Collection
 Acc. No. U-1857

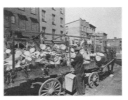

6. ST. MARKS CHURCH WITH SKYWRITING, March
 23, 1937
 silver print
 9½″ x 7⅝″ / 24.1cm. x 19.4cm.
 Reproduced: *Changing New York,* no. 35
 University Collection
 Acc. No. U-1858

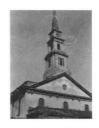

7. QUEENSBORO BRIDGE, LOOKING S.W. FROM
 PIER AT 41ST ROAD, LONG ISLAND CITY,
 QUEENS, May 25, 1937
 silver print
 7⅝″ x 9⅝″ / 19.4cm. x 24.5cm.
 Reproduced: *Changing New York,* no. 70
 University Collection
 Acc. No. U-1859

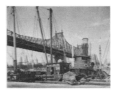

8. STATUE OF GARIBALDI, WASHINGTON
 SQUARE, December 29, 1937
 silver print
 9¼″ x 7⅜″ / 23.5cm. x 18.7cm.
 University Collection
 Acc. No. U-1860

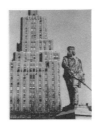

9. MULLIGAN PLACE, 453 6TH AVENUE
 silver print
 9⅝" x 7½" / 24.5cm. x 19cm.
 University Collection
 Acc. No. U-1861

10. JEFFERSON MARKET COURT, 9TH ST. & 6TH
 AVENUE
 silver print
 8½" x 7⅛" / 21.6cm. x 18.1cm.
 University Collection
 Acc. No. U-1862

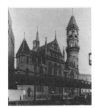

11. WATERFRONT, SOUTH STREET
 silver print
 7⅜" x 9⅜" / 18.7cm. x 23.8cm.
 University Collection
 Acc. No. U-1863

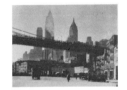

12. THE EL, 2ND & 3RD AVE. LINE, HANOVER
 SQUARE & PEARL ST.
 silver print
 9½" x 7⅜" / 24.1cm. x 18.7cm.
 University Collection
 Acc. No. U-1864

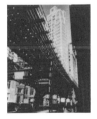

13. MAC DOUGAL ALLEY, 9TH STREET AND
 WASHINGTON PLACE
 silver print
 9⅜" x 7½" / 23.8cm. x 19cm.
 University Collection
 Acc. No. U-1865

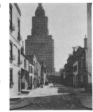

Note: Numbers 2 through 13 above, allocated by the Work Projects Administration, 1943.

ANSEL EASTON ADAMS
b. San Francisco, 1902
Education: Private study of music, first instruction in photography with Frank Dittman; met Paul Strand in 1930, became a full time photographer thereafter
Awards: 1946, 1948, 1959—Guggenheim; 1961—University of California, DFA (honorary); 1968—Department of the Interior; 1969—PSA

Solo Exhibitions: 1931—Smithsonian; 1932—MHdY; 1936—An American Place; 1939—SFMMA; 1944—MOMA; 1951—AIC; 1952—IMP; 1963—MHdY; 1972—PPC; Stanford; 1972-73—SFMMA; 1976—V&A; Columbia Gallery of Photography, Columbia, MS; Cronin; Tucson
Public Collections: PMA; SFMMA; Tucson// Achenbach; Addison; Alabama; Amon Carter; AIC; Berkeley; BN; BPL; Bowdoin; Burpee; CMB; Cincinnati; Cleveland; CSFAC; Corcoran; Cornell; Dayton; Denver; Detroit; ENB; Everson; Fogg; FOP; High; Indiana; IMP; Indianapolis; Kalamazoo; LC; Louisville; MIT; Menil; Michigan; MIA; Minnesota; MWP; MFA; MFAH; MOMA; NGC; Nebraska; Nelson; NOMA; Oakland; Oberlin; Oklahoma; Pasadena; Polaroid; Princeton; RISD; Ringling; RIT; RPS; Seagram; Smith; Smithsonian; St. Petersburg; Tempe; Texas; UCLA; UNM; VMFA; Worcester; Yale

14. LEAVES, MILLS COLLEGE, CALIFORNIA,
 c. 1930
 silver print
 7¼" x 8⅞" / 18.4cm. x 22.5cm.
 Signed, Ansel Adams, lower right
 Reproduced: *Ansel Adams: Photographs 1923-1963,* p. 123
 F. M. Hall Collection, 1958
 Acc. No. H-510

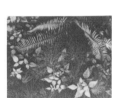

15. ROOF AND TOWER: INDUSTRIAL BUILDING,
 1931
 silver print
 7⅛" x 9⁵/₁₆" / 18.1cm. x 23.7cm.
 Signed, Ansel E. Adams 1931, lower right
 F. M. Hall Collection, 1958
 Acc. No. H-508

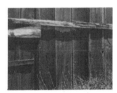

16. FENCE: BOARD WALL WITH GRASSES, 1932
 silver print
 6⅞" x 8⅞" / 17.5cm. x 22.5cm.
 Signed, Ansel E. Adams 1932, lower right & Ansel
 Adams, verso
 F. M. Hall Collection, 1958
 Acc. No. H-506

17. OLD HOUSE, REDWOOD CITY, CALIFORNIA,
 1934
 silver print
 9⅛" x 6⅛" / 23.2cm. x 15.6cm.
 Signed, Ansel Adams, lower right & Ansel Adams/
 1934, verso
 F. M. Hall Collection, 1958
 Acc. No. H-511

18. BARN, CAPE COD, MASSACHUSETTS, c. 1937
 silver print
 9¹/₁₆″ x 12⅞″ / 23cm. x 32.7cm.
 Signed, Ansel Adams, lower right & Cape Cod
 Barn by Ansel Adams, verso
 Reproduced: *A Selection of Works,* pl. 1; *Ansel*
 Adams; Images 1923-1974, p. 97; *NAA Quar-*
 terly, Spring 1972, p. 4
 F. M. Hall Collection, 1958
 Acc. No. H-507

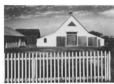

19. THE TETONS AND THE SNAKE RIVER, GRAND
 TETON NATIONAL PARK, WYOMING, 1942
 silver print
 15⁷/₁₆″ x 19⁹/₁₆″ / 39.2cm. x 49.7cm.
 Signed, Ansel Adams, lower right
 Reproduced: *This is the American Earth,* p. 15;
 These We Inherit, pl. 15; *The Photographer*
 and the American Landascape, n.p.; *The Te-*
 tons and the Yellowstone, p. 18; *LLP-Great*
 Photographers, p. 215; *Ansel Adams,* p. 69;
 Photography Year 1975, p. 222
 Nebraska Art Association, gift of Lawrence Reger
 Acc. No. N-227

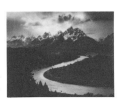

20. ZABRISKIE POINT, DEATH VALLEY NATIONAL
 MONUMENT, CALIFORNIA, c. 1942
 silver print
 9⁵/₁₆″ x 7½″ / 23.7cm. x 19cm.
 Signed, Ansel Adams, lower right
 Reproduced: *These We Inherit,* pl. 10; *Ansel*
 Adams, p. 63
 F. M. Hall Collection, 1958
 Acc. No. H-509

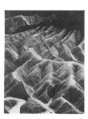

21. OAK TREE, RAIN, SONOMA COUNTY HILLS,
 CALIFORNIA, 1960
 silver print
 15½″ x 19⅛″ / 39.4cm. x 48.6cm.
 Signed, Ansel Adams, lower right
 Reproduced: *Ansel Adams,* p. 83
 F. M. Hall Collection, purchased from the artist,
 1966
 Acc. No. H-1140

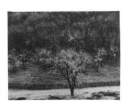

22. HOUSE NEAR CARSON CITY, NEVADA
 silver print, enlarged from a Polaroid Land Type
 55/PN Negative
 17⁹/₁₆″ x 13³/₁₆″ / 44.6cm. x 33.5cm.
 Signed, Ansel Adams, lower right
 Reproduced: *American Photography: The*
 Sixties, p. 10
 F. M. Hall Collection, purchased from the artist,
 1966

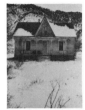

122

Acc. No. H-1138
*23. STUMP FERNS: NORTHERN CALIFORNIA
 REDWOODS
 silver print
 14⅞″ x 19³/₁₆″ / 37.8cm. x 48.7cm.
 Signed, Ansel Adams, lower right
 F. M. Hall Collection, purchased from the artist,
 1966
 Acc. No. H-1139

ROBERT ADAMS
b. Orange, New Jersey, 1937
Education: University of Redlands, Redlands, CA, BA
(English), 1959; USC, PhD (English), 1965
Awards: 1973—NEA; Guggenheim; 1975—American
Association of State & Local History
Solo Exhibitions: 1971—CSFAC; 1972—CSM; 1976—
St. John's College, Rice; Castelli; 1977— Nebraska
Public Collections: CMB; CSFAC, CSM; IMP; MMA;
MFAH; MOMA; Nebraska; Polaroid; Princeton;
Wheaton College, Wheaton, IL

24. PIKES PEAK, 1970/1974
 silver print
 5¹¹/₁₆″ x 6″ / 14.4cm. x 15.2cm.
 Reproduced: *The New West,* p. 105
 Nebraska Art Association, purchased with the
 aid of funds from the National Endowment for
 the Arts, 1976
 Acc. No. N-387

*25. COLORADO SPRINGS, 1970/1974
 silver print
 6″ x 6″ / 15.2cm. x 15.2cm.
 Reproduced: *The New West,* p. 41
 Nebraska Art Association, purchased with the
 aid of funds from the National Endowment
 for the Arts, 1976
 Acc. No. N-388

ROBERT ADAMSON, Scottish
b. St. Andrews, Scotland, 1821
d. St. Andrews, Scotland, 1848
Note: See David Octavius Hill

MURRAY ALCOSSER
b. New York, New York, 1937
Education: Self taught in photography
Solo Exhibitions: 1970—Photographer's Gallery, NYC;
1971—Brooklyn Museum; 1972—Hudson Park Branch
Library, NYC; New School; 1973—Witkin; 1975—Hun-
dred Acres Gallery, NYC; 1976—Louis K. Meisel Gal-
lery, NYC; Morgan Gallery, Shawnee Mission, KS;
Galerie le Portail, Heidelberg, West Germany
Public Collections: Kansas, MOMA; Nebraska; NOMA;
New School

26. STICK OF GUM, 1974
 type C color
 19⅜" x 13" / 49.2cm. x 33cm.
 Nebraska Art Association, purchased with the
 aid of funds from the National Endowment for
 the Arts, 1976
 Acc. No. N-433

LEOPOLDO ALINARI, Italian, (1832-1865)
GIUSEPPE ALINARI, Italian, (1836-1890)
Note: Founders, in 1854, of a firm specializing in pub-
lications in the field of art and in photographs of works
of art. Their catalog contained more than a hundred
thousand negatives.
Public Collections: BPL; Nebraska; UNM

27. PANORAMIC VIEW OF SIENA, SEEN FROM
 S. DOMENICO
 albumen print
 7⁷/₁₆" x 9¹³/₁₆" / 18.9cm. x 24.9cm.
 University Collection
 Acc. No. U-2210

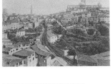

28. PALAZZO COMUNALE, SIENA
 albumen print
 9¾" x 7½" / 24.8cm. x 19.1cm.
 University Collection
 Acc. No. U-2211

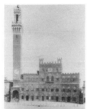

29. INTERIOR OF THE CATHEDRAL OF SIENA,
 SEEN FROM THE BAPTISTRY
 albumen print
 7½" x 9¹³/₁₆" / 19.1cm. x 24.9cm.
 University Collection
 Acc. No. U-2212

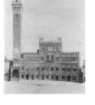

30. CATHEDRAL OF SIENA, FACADE OF THE
 PICCOLOMINI LIBRARY
 albumen print
 7⅜" x 9⅞" / 18.7cm. x 25.1cm.
 University Collection
 Acc. No. U-2213

Note: Nos. 27 through 30, gift of Jon Nelson. This gift
includes additional prints of subjects in England,
Greece, France, Switzerland, Germany and Egypt, all
by unidentified photographers.

JAMES ALINDER
b. Glendale, California, 1941
Education: Macalester College, St. Paul, MN, BA, 1962;
Minnesota, 1962-64; UNM, MFA, 1968
Awards: 1972—Woods; 1973—NEA; 1974—Woods
Solo Exhibitions: 1968—Maine; 1969—Nebraska; 1970
—Blanden; Focus; 1971—Madison; Halsted; 1972—
Center of the Eye; Alfred; 1973—Nebraska; East Street;
1974—The Once Gallery, NYC; Oregon; Gallery f/22;
Northeast College, Norfolk, NE; Elkhorn Depot Gal-
lery, Sun Valley, ID; University of South Dakota, Ver-
million; 1976—Boulder; 1977—St. Michael's College
Gallery, Winooski, VT
Public Collections: AIC; Blanden; BN; IMP; Kansas;
LC; Lincoln Rochester Bank, Rochester, NY; MIT;
MFAH; MNM; MOMA; NBC-Lincoln; NGC; Nebraska;
Oklahoma; Rice; Smithsonian; St. Petersburg; UNM;
VMFA; VSW

31. THE FLY, 1967
 silver print
 5¼" x 9½" / 13.3cm. x 24.1cm.
 Signed, James Alinder, 1967, lower right
 Reproduced: *Vision and Expression,* p. 145;
 Fotografie 70, Prague, Czechoslovakia, March,
 1970, p. 75
 University Collection, gift of the artist, 1976
 Acc. No. U-1883

32. FROM FORM FLOW SERIES, 1967
 silver print
 5⅝" x 7⅛" / 14.3cm. x 18.1cm.
 Signed, James Alinder, 1967, lower right
 University Collection, gift of the artist, 1976
 Acc. No. U-1884

33. TOTAL, 1968
 silver print
 5¾" x 13¼" / 14.6cm. x 33.7cm.
 Reproduced: *Creative Camera,* July 1970, pp.
 214-215
 University Collection, gift of the artist, 1976
 Acc. No. U-1888

34. FOOTSTEPS, YPSILANTI, MICHIGAN, 1969
 silver print
 5⁹/₁₆" x 12¹/₁₆" / 14.2cm. x 30.7cm.
 Signed, James Alinder, lower right, date, lower
 left
 University Collection, gift of the artist, 1976
 Acc. No. U-1887

35. MONA LISA, RIALTO, CALIFORNIA, 1970
 silver print
 5⅝" x 12¼" / 14.3cm. x 31.1cm.
 Signed, James Alinder, lower right, date, lower
 left
 University Collection, gift of the artist, 1976
 Acc. No. U-1885

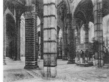

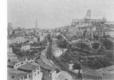

36. AT BREAKFAST, FRESNO, CALIFORNIA, 1970
 silver print
 5⅝″ x 12³/₁₆″ / 14.3cm. x 31cm.
 Signed, James Alinder, lower right, dated
 lower left
 University Collection, gift of the artist, 1976
 Acc. No. U-1886

37. STONE CHILDREN, FOREST LAWN, 1970
 silver print
 7⅝″ x 16½″ / 19.4cm. x 41.9cm.
 Signed, Jim Alinder, lower right, dated
 lower left
 University Collection, gift of the artist, 1976
 Acc. No. U-1890

38. GRAIN ELEVATOR, PALMYRA, NEBRASKA, 1971
 silver print
 16¾″ x 7⅝″ / 42.6cm. x 19.4cm.
 Signed, Jim Alinder, lower right
 Reproduced: *Jim Alinder,* n.p.
 University Collection, gift of the artist, 1976
 Acc. No. U-670

39. FIRST WHITE CHILD, 1972
 silver print
 8⅜″ x 18″ / 21.3cm. x 45.7cm.
 F. M. Hall Collection, purchased from the artist,
 1974
 Acc. No. H-1979

*40. MT. RUSHMORE, BLACK HILLS, S.D., 1972
 silver print
 8³/₁₆″ x 17⅞″ / 20.8cm. x 45.4cm.
 Reproduced: *Consequences,* n.p.; *Jim Alinder,*
 n.p.
 F. M. Hall Collection, purchased from the artist,
 1974
 Acc. No. H-1980

41. BILLBOARD, OMAHA, 1972
 silver print
 7⅝″ x 16¹¹/₁₆″ / 19.4cm. x 42.4cm.
 Signed, Jim Alinder, lower right, dated
 lower left
 University Collection, gift of the artist, 1976
 Acc. No. U-1889

42. NEIL ARMSTRONG SPACE CENTER, 1973
 silver print
 8⁵/₁₆″ x 17¹⁵/₁₆″ / 21.1cm. x 45.6cm.
 Reproduced: *Consequences,* n.p.
 F. M. Hall Collection, purchased from the artist,
 1974
 Acc. No. H-1982

124

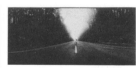

43. HIGHWAY, HAWAII, 1973
 silver print
 8⁵/₁₆″ x 17¹³/₁₆″ / 21.1cm. x 45.2cm.
 Reproduced: *Jim Alinder,* n.p.; *Consequences,*
 n.p.
 F. M. Hall Collection, purchased from the artist,
 1974
 Acc. No. H-1981

ALEXANDER ALLAND
b. Sebastopol, Crimea, 1902
Education: Worked as a photographer's assistant in
Constantinople
Awards: 50th Anniversary Medal, MCNY
Solo Exhibitions: 1939—New School; 1943, 1945,
1946, 1947—MCNY; 1977—Prakapas
Public Collections: MCNY; MOMA; Nebraska; Newark;
NOMA; New York Historical Society; NYPL

44. FACTORY DESIGN, 1936
 silver print
 10⅛″ x 10⅛″ / 25.7cm. x 25.7cm.
 University Collection, allocated by the Work
 Projects Administration, 1943
Note: This print is one of a series taken in preparation
for a photo mural at the Newark Museum.
Acc. No. U-1893

MANUEL ALVAREZ-BRAVO, Mexican
b. Mexico City, 1902
Education: Self taught in photography
Solo Exhibitions: 1932—Galeria Posada, Mexico City;
1935—Palacio de Bellas Artes, Mexico City (with
Cartier-Bresson); Julien Levy (with Walker Evans &
Cartier Bresson); 1936—Hull House Art School, Chi-
cago; Almer Coe Optical Co., Chicago; 1939—Uni-
versidad Nacional de Mexico, Mexico City; 1942—
Photo League; 1944—AIC; 1945—Sociedad de Arte
Moderno, Mexico City; 1954—Centro de Relaciones
Culturales Anglo-Mexicano, Mexico City; 1956—
MOMA (with Paul Strand, August Sander and Walker
Evans); 1957—Salon de la Plastica Mexicana, Instituto
National de Bellas Artes, Mexico City; 1966 Galeria de
Arte Mexicano (Galeria de Ines Amor), Mexico City;
1968—Palacio de Bellas Artes, Mexico City (for the
XIX Olympiad); 1971—Pasadena; MOMA; IMP; 1974—
AIC; 1976—Musée Nicephore Niépce, Chalon sur-
Sâone; France; Galerie du Chateau d'Eau, Toulouse,
France
Public Collections: National Institute of Fine Arts of
Mexico; Pasadena// BN; Corcoran; Detroit; ENB;
Everson; Fogg; IMP; MOMA; Museum of Modern Art,
Moscow, USSR; NGC; Nebraska; NOMA; PMA; St.
Petersburg; Tucson; UNM

*45. LOS AGACHADOS (The Crouched Ones), 1934
silver print
7⅜" x 9⅝" / 18.7cm. x 24.4cm.
Signed, M. Alvarez-Bravo/Mexico, lower right
Reproduced: **The Photographer's Eye,** p. 151;
Manuel Alvarez-Bravo, p. 30; **Camera,** January, 1972, p. 41; **Museum News,** Jan-Feb, 1976, p. 22; **Photography Year 1977,** p. 19
F. M. Hall Collection, 1975
Acc. No. H-2018

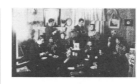

46. LA PENA NEGRA (The Black Grief), 1939
silver print
8³/₁₆" x 10⅜" / 20.8cm. x 26.4cm.
Signed, M. Alvarez-Bravo/Mexico, lower right
Reproduced: **Manuel Alvarez-Bravo,** p. 33
F. M. Hall Collection, 1975
Acc. No. H-2019

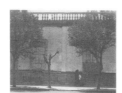

AMERICAN, 19TH CENTURY, PHOTOGRAPHER UNKNOWN

Note: The following group of prints was made by Roger Williams from glass negatives found in a garage in Afton, NY in 1972. Precise dating being difficult if not impossible, the date, "circa 1890" is offered for the group. The titles are ours. The prints have been shown publicly only once, at the Sheldon Gallery in April, 1976.

47. GROUP PORTRAIT WITH COUPLE PLAYING PATTY CAKE
silver print
5" x 7¹⁵/₁₆" / 12.7cm. x 20.2cm.
F. M. Hall Collection, 1973
Acc. No. H-1927

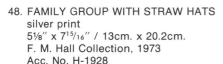

48. FAMILY GROUP WITH STRAW HATS
silver print
5⅛" x 7¹⁵/₁₆" / 13cm. x 20.2cm.
F. M. Hall Collection, 1973
Acc. No. H-1928

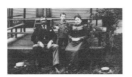

49. TWO MEN ON A ROCK
silver print
5" x 7¹⁵/₁₆" / 12.7cm. x 20.2cm.
F. M. Hall Collection, 1973
Acc. No. H-1929

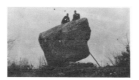

50. GROUP PORTRAIT: MEN DRESSED AS WOMEN, WOMEN DRESSED AS MEN
silver print
4¹⁵/₁₆" x 7⅞" / 12.5cm. x 20cm.
F. M. Hall Collection, 1973
Acc. No. H-1930

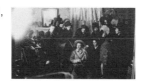

51. APPLE AND POPCORN PARTY
silver print
5" x 8" / 12.7cm. x 20.3cm.
F. M. Hall Collection, 1973
Acc. No. H-1931

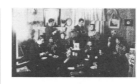

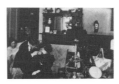

52. INTERRUPTED PROPOSAL
silver print
5" x 6¹⁵/₁₆" / 12.7cm. x 17.6cm.
F. M. Hall Collection, 1973
Acc. No. H-1932

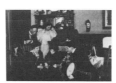

53. EVENING PARTY, LOOKING AT AN AUTOGRAPH BOOK
silver print
5" x 6¹⁵/₁₆" / 12.7cm. x 17.6cm.
F. M. Hall Collection, 1973
Acc. No. H-1933

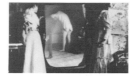

54. PAIR OF FEMALE PEEPING TOMS
silver print
5" x 7¹⁵/₁₆" / 12.7cm. x 20.2cm.
F. M. Hall Collection, 1973
Acc. No. H-1934

55. PAIR OF BACHELORS MENDING CLOTHES
silver print
5" x 7¹⁵/₁₆" / 12.7cm. x 20.2cm.
F. M. Hall Collection, 1973
Acc. No. H-1935

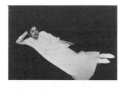

56. LADY WITH BOOK ON SOFA
silver print
5" x 7" / 12.7cm. x 17.8cm.
F. M. Hall Collection, 1973
Acc. No. H-1936

57. GIRL SEATED ON A RAILING
silver print
5" x 7¹⁵/₁₆" / 12.7cm. x 20.2cm.
F. M. Hall Collection, 1973
Acc. No. H-1937

EMILIO AMERO, Mexican
b. Ixtlahuaca, Mexico, 1901
Education: Academy of San Carlos, Mexico, DF
Public Collections: Nebraska; Oklahoma
Note: Amero is better known as a painter and litho-
grapher and is chiefly responsible, with Jean Charlot,
for the revival of printmaking in Mexico. He has, how-
ever, also produced abstract films and direct chem-
ical photographs without negatives.

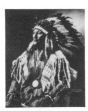

58.-87. AMERO PICTURE BOOK, 30 ORIGINAL
PHOTOGRAPHS OF MEXICO, Introduction by
Alexander King, Published by E. Weyhe, New
York, 1940
silver prints, copy 9 of 100
all prints, 13⅜″ x 10½″ / 40cm. x 26.7cm.
University Collection, 1971
Acc. Nos. U-1713.1 through U-1713.30

126

JOHN A. ANDERSON
b. Stockholm, Sweden, 1869
d. Atascadero, California, 1948
Education: Self taught as a photographer
Solo Exhibition: 1977—Nebraska (with Buechel & Doll)
Public Collections: Amon Carter; Nebraska; Nebraska
State Historical Society, Lincoln; Seattle

88. THE WHITE BUFFALO CEREMONY, 1892
silver print
4¼″ x 7¹/₁₆″ / 10.8cm. x 17.9cm.
Acc. No. U-1954

89. JORDAN'S TRADING POST, 1893
silver print
7½″ x 9⅛″ / 19.1cm. x 23.2cm.
Acc. No. U-1953

90. CHIEF TWO STRIKE, 1896
silver print
8⁹/₁₆″ x 6⁹/₁₆″ / 21.7cm. x 16.7cm.
Acc. No. U-1952

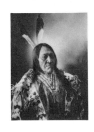

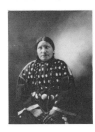

91. CHIEF IRON SHELL, 1900
silver print
8⅝″ x 7⅛″ / 21.9cm. x 18cm.
Acc. No. U-1958

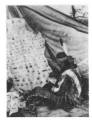

92. SARAH BLUE EYES, c. 1900
silver print
8⁹/₁₆″ x 6⁹/₁₆″ / 21.7cm. x 16.7cm.
Acc. No. U-1962

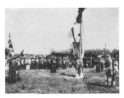

93. SUN DANCE, 1910
silver print
7¹/₁₆″ x 9⅛″ / 17.9cm. x 23.2cm.
Acc. No. U-1957

*94. KILLS TWO, A BRULE MEDICINE MAN DOING
THE "BIG MISSOURI WINTER COUNT,"
1796-1926
silver print
8⅞″ x 6¹³/₁₆″ / 22.5cm. x 17.3cm.
Acc. No. U-1963

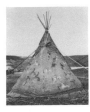

95. A CEREMONIAL TEPEE
silver print
7¹³/₁₆″ x 6⅞″ / 19.8cm. x 17.5cm.
Acc. No. U-1955

96. YELLOW HAIR AND HIS WIFE, PLENTY HORSE
 silver print
 8⁹⁄₁₆" x 6⁷⁄₈" / 21.7cm. x 17.5cm.
 Acc. No. U-1960

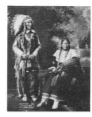

97. ONE STAR (Resting)
 silver print
 8⁹⁄₁₆" x 6⁷⁄₈" / 21.7cm. x 17.5cm.
 Acc. No. U-1961

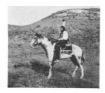

98. FOOL BULL, A MEDICINE MAN
 silver print
 8⁷⁄₈" x 6¹³⁄₁₆" / 22.5cm. x 17.3cm.
 Acc. No. U-1956

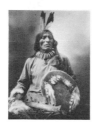

99. ROSEBUD HOME
 silver print
 4¹⁄₁₆" x 7¹⁄₈" / 10.3cm. x 19.4cm.
 Acc. No. U-1959

Note: Nos. 88 through 99 above are part of the University Collection, gift of the Mid-America Arts Alliance, 1976. All prints, made from the original negatives by Jim Alinder, are reproduced in **Crying for a Vision.**

SYBIL ANIKEYEV
b. 1896
Education: Self taught in photography
Solo Exhibitions: 1936—Mills
Public Collections: Berkeley; Minnesota; MOMA; Nebraska

100. PUMPKINS, c. 1936
 silver print
 7¾" x 9¾" / 19.7cm. x 24.8cm.
 University Collection
 Acc. No. U-1880

101. NET, c. 1936
 silver print
 9½" x 7½" / 24.1cm. x 19cm.
 University Collection
 Acc. No. U-1881

102. BIG SUR BARN, c. 1936
 silver print
 7⅝" x 9⅝" / 19.4cm. x 24.4cm.
 University Collection
 Acc. No. U-1882

Note: Nos. 100 through 102 above, allocated by the Work Projects Administration, 1943

127

DIANE ARBUS
b. New York, New York, 1923
d. New York, New York, 1971
Education: Studied photography with Lisette Model, 1959
Awards: 1963, 1966—Guggenheim
Solo Exhibitions: 1965—MOMA; 1967—MOMA; Fogg; 1972—MOMA; MCA; Baltimore; WAC; NGC; Venice Biennale; 1972-73—Hayward; 1977—Helios; GI
Public Collections: Denver; ENB; Fogg; High; IMP; Kalamazoo; Kansas; LC; MIA; MFA; MFAH; MOMA; NGC; Nebraska; NOMA; Oberlin; Pasadena; PMA; Princeton; Smith; Smithsonian; Tucson; VMFA; Worcester; Yale

103. CHILD WITH A TOY HAND GRENADE IN
 CENTRAL PARK, NYC, 1962
 silver print made from original negative by Neil Selkirk
 14¾" x 14¾" / 37.5cm. x 37.5cm.
 Reproduced: **Diane Arbus,** n.p.; **Language of Light,** pl. 8; **American Photography: Past into Present,** p. 134
 F. M. Hall Collection, 1977
 Acc. No. H-2155

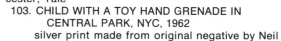

*104. LADY AT A MASKED BALL WITH TWO ROSES
 ON HER DRESS, 1967
 silver print made from original negative by Neil Selkirk
 14½" x 14½" / 36.8cm. x 36.8cm.
 Reproduced: **Diane Arbus,** n.p.
 F. M. Hall Collection, 1977
 Acc. No. H-2156

EUGENE ATGET, French
b. Libourne, France, 1856/1857
d. Paris, France, 1927
Education: Seaman and actor; self taught in photography
Solo Exhibitions: 1960—Cincinnati; 1967—Texas; 1969—Schoelkopf; SFMMA; Photography Place (with Lee Friedlander); MOMA; 1976—Marlborough, NYC
Public Collections: MOMA; NGC; Smithsonian// AIC; Baltimore; Cornell; Dayton; ENB; Fogg; High; IMP; Indiana; LC; Menil; Michigan; Minnesota; MFAH; Nebraska; NOMA; Oberlin; Oklahoma; Pasadena; PMA; Princeton; RISD; SFMMA; Seattle; Texas; Tucson; UNM; VMFA; Worcester; Yale

 105.-124. 20 PHOTOGRAPHS BY EUGENE ATGET
 silver prints, gold toned, copy 47 of 100, printed from original glass plates by Berenice Abbott, 1956
 F. M. Hall Collection, 1963
 Acc. Nos. H-837.1 through H-837.20

LEWIS BALTZ
b. Newport Beach, California, 1945
Education: San Francisco Art Institute, BFA, 1969; Claremont Graduate School, MFA, 1971
Awards: 1973—NEA; 1976—Guggenheim; NEA
Solo Exhibitions: 1970—Pomona; 1971—Castelli; 1972—IMP; 1973—Castelli; 1974—Corcoran; Jefferson Place Gallery, Washington, DC; 1975—Castelli; PCA; UNM; Jack Glenn Gallery, Newport Beach, CA; 1976—Galerie December, Dusseldorf, Germany; Vision; GI; MFAH; La Jolla Museum of Contemporary Art, La Jolla, CA; Corcoran; Baltimore; Seattle
Public Collections: Addison; AIC; Baltimore; BN; Columbia College, Chicago; Corcoran; IMP; LC; Lincoln First; Miami-Dade Community College, Coral Gables, FL; MFA; MFAH; MOMA; NCFA; Nebraska; Oakland; Pasadena; Pomona; Princeton; Seagram; Seattle; UC-Davis; UCLA; UC-San Diego; UNM

*125. CORONA DEL MAR, 1971 (A)
 silver print
 6¹/₁₆″ x 8⅞″ / 15.4cm. x 22.5cm.
 F. M. Hall Collection, purchased from the artist, 1972
 Acc. No. H-1581

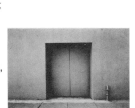

126. CORONA DEL MAR, 1971 (B)
 silver print
 5⅞″ x 8⅞″ / 14.9cm. x 22.5cm.
 Reproduced: *Contemporary Photography,* ,n.p.
 F. M. Hall Collection, purchased from the artist, 1972
 Acc. No. H-1580

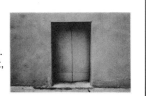

THOMAS F. BARROW
b. Kansas City, Missouri, 1938
Education: Kansas City Art Institute, BFA, 1963; Institute of Design, Illinois Institute of Technology, MS, 1967
Awards: 1973—NEA
Solo Exhibitions: 1969—UC-Davis; 1972, 1974—Light; 1975—Deja Vu Gallery, Toronto, Canada; 1976—Light
Public Collections: Detroit; Fogg; IMP; Kansas; Lincoln Rochester Trust Co., Rochester, NY; Logan; MIT; MOMA; Nebraska; NGC; Oklahoma; Pasadena; PMA; Princeton Library; Ryerson; St. Petersburg; Sun Valley; Tampa; Tucson; UNM; VMFA; VSW

127. PINK STUFF (Interstate Span), 1971/76
 chemically toned, chlorobromide print
 4³/₁₆″ x 13½″ / 10.6cm. x 34.3cm.
 Signed, Thomas F. Barrow, lower right
 Nebraska Art Association, purchased with the aid of funds from the National Endowment for the Arts, 1976
 Acc. No. N-396

FELICE BEATO, Italian-English, active 1854-1885
Note: See James Robertson

CECIL BEATON, English
b. London, England, 1904
Education: Harrow; Cambridge; self taught in photography
Solo Exhibitions: 1930—Cooling Gallery, London; 1968—NPG-London; 1973—Sonnabend Gallery, NYC; 1974—Kodak House, London
Public Collections: BPL; Indianapolis; Nebraska; NOMA; RISD; Texas; UNM; Yale

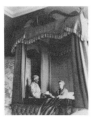

128. EDITH SITWELL, RENISHAW HALL, 1927
 silver print
 17⅞″ x 14⅛″ / 45.4cm. x 35.9cm.
 Signed, Beaton, lower right
 Reproduced: *The Best of Beaton,* p. 166
 F. M. Hall Collection, 1976
 Acc. No. H-2148

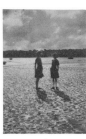

129. NANCY & BABA
 silver print
 17⅝″ x 12¼″ / 44.8cm. x 31.1cm.
 Signed, Beaton, lower right
 F. M. Hall Collection, 1976
 Acc. No. H-2149

FRANCIS BEDFORD, English, (1816-1894)
Education: Trained as a lithographer; self taught in photography, Bedford was one of the best known landscape and architectural photographers of the nineteenth century in England
Public Collections: NGC; Texas// AIC; Burpee; ENB; Indiana; Iowa; LC; Michigan; Nebraska; NOMA; RISD; UNM; Worcester

130. LUDLOW CASTLE FROM THE RIVER
albumen print
7¾" x 11¼" / 19.7cm. x 28.6cm.
F. M. Hall Collection, 1972
Acc. No. H-2810

131. LLANGOLLEN, THE CANAL
albumen print
4⅛" x 6" / 10.5cm. x 15.2cm.
F. M. Hall Collection, 1972
Acc. No. H-2811

132. SNOWDON FROM PORTMADOC EMBANKMENT
albumen print
4¹⁵/₁₆" x 7¾" / 12.5cm. x 19.7cm.
F. M. Hall Collection, 1972
Acc. No. H-2812

133. WORCESTER, EDGAR TOWER
albumen print
6⅜" x 8⅜" / 16.2cm. x 21.3cm.
F. M. Hall Collection, 1972
Acc. No. H-2813

134. WREXHAM, ERBISTOCK FERRY
albumen print
5" x 7¾" / 12.7cm. x 19.7cm.
F. M. Hall Collection, 1972
Acc. No. H-2814

E. J. BELLOCQ
Note: There is little or no biography for Bellocq. The publication listed below suggests the period 1895-1940 as that of his principal activity.
Public Collections: Everson; MIA; MOMA; NGC; Nebraska; NOMA; SFMMA; Tulane; VSW; Yale

*135. SEATED GIRL, c. 1911-13
gold chloride print, printed by Lee Friedlander
9¹⁵/₁₆" x 7¹⁵/₁₆" / 25.2cm. x 20.2cm.
Reproduced: *E. J. Bellocq: Storyville Portraits,* pl. 7
F. M. Hall Collection, 1975
Acc. No. H-2062

STEVEN L. BERENS
b. Fort Collins, Colorado, 1952
Education: University of Nebraska, BFA, 1974; Florida State University, Tallahassee, FL, MFA, 1977
Solo Exhibitions: 1976—Gragg Gallery, Southwestern Regional Library, Bainbridge, GA
Public Collections: Florida State University, Tallahassee; Nebraska

136. UNTITLED, (Trees), 9/76
silver print
11" x 14" / 27.9cm. x 35.6cm.
Signed, Steven L. Berens, lower right
Nebraska Art Association, gift of the artist, 1977
Acc. No. N-437

137. UNTITLED, (Air), 12/76
silver print
11" x 14" / 27.9cm. x 35.6cm.
Signed, Steven L. Berens, lower right
Nebraska Art Association, gift of the artist, 1977
Acc. No. N-438

RUTH BERNHARD
b. Berlin, Germany, 1905
Education: Berlin Academy of Art; apprenticeship in commercial photography studio, NYC
Awards: 1976—"Dorothea Lange Award," Oakland Museum
Solo Exhibitions: 1936—Pacific Institute of Music & Art, Los Angeles; Jake Zeitlin Gallery, Los Angeles; 1938—P.M. Gallery, NYC; 1939—Tokyo, Japan; 1941— Little Gallery, San Francisco; 1956—Gump's Gallery, San Francisco; Paris, France; Oakland; 1959—City College, San Francisco; Contemporary Gallery, San Francisco; 1962—San Francisco Public Library; 1963 —Portland State College, OR; Siembab; 1965—Toren; 1966—Oregon; Aardvark; Jacksonville; 1967—Focus; 1968—Oregon; Light; MIT; 1969—Aardvark; Pasadena; 1970—MIT; 1971—Neikrug; 1972—USU-Logan; 1973—Columbia; 1974—Palo Alto Cultural Center, Palo Alto, CA; UC-Humboldt; 1975—Shado; Neikrug;

Silver Image, Tacoma; Malden Gallery, Fullerton, CA; Mills; 1976—Fullerton State College Gallery, Fullerton, CA; Edison Street; Secret City Gallery, San Francisco; Creative Eye; Columbia; 1977—Hunt Gallery, Minneapolis; Witkin
Public Collections: Detroit; IMP; Indiana; Krannert; MOMA; Nebraska; NGC; Oakland; Pasadena; SFMMA; St. Petersburg; Tucson; UNM

138. TREE TRUNK, 1937
 silver print
 9½″ x 7½″ / 24.1cm. x 19cm.
 University Collection, allocated by the Work Projects Administration, 1943
 Acc. No. U-1949

139. TWO LEAVES, #7 from "The Gift of the Commonplace", 1953 mmon-
 silver print
 9¾″ x 7⁷/₁₆″ / 24.8cm. x 18.9cm.
 Signed, Ruth Bernhard, lower right
 Reproduced: *U. S. Camera,* 1956, p. 130
 Nebraska Art Association, purchased with the aid of funds from the National Endowment for the Arts, 1977
 Acc. No. N-390

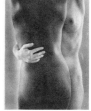

*140. TWO FORMS, #10 from "The Eternal Body", 1965
 silver print
 Signed, Ruth Bernhard, lower right
 Nebraska Art Association, purchased with the aid of funds from the National Endowment for the Arts, 1977
 Acc. No. N-389

MARGARET BOURKE-WHITE
b. New York, New York, 1904
d. Darien, Connecticut, 1971
Education: Clarence White School of Photography; Columbia University; Cornell University
Solo Exhibitions: 1956—AIC; 1971—Siembab; 1972—Cornell; MWP; 1974—UC-Santa Clara; 1976—Neikrug (with Milton Novotny)
Public Collections: Cornell// Addison; AIC; Baltimore; Brooklyn; Cleveland; High; IMP; Kansas; LC; Louisville; Milwaukee; MFA; MFAH; MOMA; NGC; Nebraska; NOMA; PMA; RISD; RPS; Smithsonian; St. Petersburg; Tampa; Tempe; UNM; VMFA; Worcester

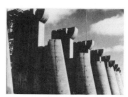

141. DAM, FORT PECK, MONTANA
 silver print from original negative by *Time/Life*
 10½″ x 13⅞″ / 26.7cm. x 35.2cm.
 Reproduced: *LLP: Photojournalism,* p. 63; *Margaret Bourke-White, Photojournalist,* pp. 56, 57; *The Photographs of Margaret Bourke-White,* pp. 107, 108; *U. S. Camera,* 1960, p. 228
 F. M. Hall Collection, 1976
 Note: Cropped version used for cover of first issue of *Life* Magazine, November 23, 1936.
 Acc. No. H-2151

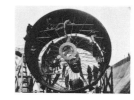

*142. STEEL LINES, FORT PECK, MONTANA
 silver print from original negative by *Time/Life*
 10¹⁵/₁₆″ x 14″ / 27.8cm. x 35.6cm.
 Reproduced: *Margaret Bourke-White Photojournalist,* p. 61; *The Photographs of Margaret Bourke-White,* pp. 114, 115; *Life* Magazine, Nov. 23, 1936
 F. M. Hall Collection, 1976
 Acc. No. H-2152

CONSTANTIN BRANCUSI, French
b. Targu Jiu, Romania, 1876
d. Paris, France, 1957
Note: Brancusi, known as one of the major sculptors of the twentieth century, was also an avid photographer of his own work. Several hundred prints are in the collection of the Musee Nationale d'Art Moderne, Paris.

143. SELF-PORTRAIT OF THE ARTIST IN HIS STUDIO, 1922
 silver print
 15¾″ x 11¾″ / 40cm. x 29.8cm.
 Inscribed, "a H. P. Roche/ami tres (illegible)/ C. Brancusi," lower right; also dry stamp CB, bottom right
 University Collection, gift of Mrs. Olga Sheldon
 Acc. No. U-1950

BILL BRANDT, English
b. London, England, 1905
Education: Germany; Switzerland; Paris; worked as an assistant to Man Ray
Solo Exhibitions: 1938—Musée des Arts et Metiers Graphiques, Paris; 1969—MOMA; 1970—Hayward; 1975-76—V&A; 1976—Arts Council of Great Britain; Marlborough-New York & London; Cronin; 1977—Vision (with Abbott and Brassai)
Public Collections: AIC; BN; CMB; Detroit; ENB; High; IMP; Milwaukee; MIA; MOMA; MFA; NGC; Nebraska; NOMA; PMA; Princeton; SFMMA; Smithsonian; Texas; UNM; V&A; VMFA; Worcester

*144. NUDE WITH MIRROR, 1952-56
 silver print
 13¼″ x 11¼″ / 33.7cm. x 28.6cm.
 Signed, Bill Brandt, lower right
 Reproduced: *Perspective of Nudes,* p. 26; *Shadow of Light,* p. 77; *U. S. Camera,* 1962, p. 149
 F. M. Hall Collection, 1975
 Acc. No. H-2063

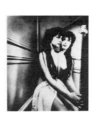

BRASSAI, (Gyula Hàlasz), French
b. Brassov, Romania, 1899
Education: Ecole des Beaux Arts, Budapest; Art Academy, Berlin; became a photographer upon the urging of Andre Kertesz, c. 1929
Solo Exhibitions: 1954—AIC; 1956—MOMA; 1965—BN; 1968—MOMA; 1971—Schoelkopf; 1976—Mirvish (with Abbott and Brandt); Marlborough-NYC; 1977—Vision (with Abbott and Brandt)
Public Collections: Albright-Knox; AIC; Baltimore; Cleveland; Detroit; ENB; High; IMP; Indiana; IMP; LC; Menil; Michigan; MFA; MOMA; Nebraska; NOMA; Oberlin; Oklahoma; RISD; SFMMA; Texas; Tucson; UNM; VMFA; Worcester; Yale
 145. STREETWALKER (Grosse Poule de Face, La belle de Nuit, 1932
 silver print, 13/30
 14⅛″ x 10¹/₁₆″ / 35.9cm. x 25.6cm.
 Signed, Brassai, lower right
 Reproduced: *Brassai,* p. 37; *Beaton/Buckland,* p. 149; *Secret Paris of the 30's,* n.p.
 F. M. Hall Collection, 1970
 Acc. No. H-1415

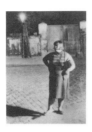

 146. AVENUE DE L'OBSERVATOIRE, 1934
 silver print, 17/30
 10¹/₁₆″ x 14⁷/₁₆″ / 25.6cm. x 36.7cm.
 Signed, Brassai, lower right
 Reproduced: *Brassai,* p. 42
 F. M. Hall Collection, 1970
 Acc. No. H-1416

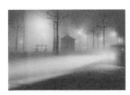

*147. ROME-NAPLES EXPRESS (Le Dormeur), 1955
 silver print, 2/30
 14⅛″ x 10⅜″ / 35.9cm. x 26.4cm.
 Signed, Brassai, lower right
 Reproduced: *Brassai,* p. 63
 F. M. Hall Collection, 1970
 Acc. No. H-1414

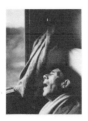

NACHO BRAVO
Note: Nacho Bravo is one of seven photographers whose work was allocated by the Work Projects Administration to the University of Nebraska Art Galleries in 1943. Extensive enquiry made in the interests of the

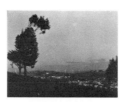

present publication has failed to produce information regarding place and date of birth, education and subsequent activity.
 148. THE BRIDGE
 silver print
 7¾″ x 9⅝″ / 19.7cm. x 24.4cm.
 University Collection
 Acc. No. U-1870

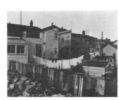

 149. SHACK
 silver print
 4⅝″ x 6⅝″ / 11.7cm. x 16.8cm.
 University Collection
 Acc. No. U-1871

 150. LITTLE WASH
 silver print
 7½″ x 9¼″ / 19cm. x 23.5cm.
 University Collection
 Acc. No. U-1872

JOHN BROOK
b. Woonsocket, Rhode Island, 1924
Education: Harvard University, BS, 1946; self taught in photography
Awards: 1960—Gold Medal, Terza Biennale, Milan, Italy
Solo Exhibitions: 1947—Boston; 1952—Boston; Turin, Milan, Italy; 1955—Boston; Kanegis; 1957—Kanegis; 1958—De Cordova Museum, Lincoln, MA; 1959—Kanegis; 1960—Symphony Hall, Boston; 1961—IMP; 1962—Siembab; 1965—New York; 1967—Siembab; 1968—FOP; 1969—Addison; Lamont Library, Harvard University, Cambridge, MA; 1970—Siembab; 1971—Focus; 1974—Siembab
Public Collections: Addison; AIC; IMP; MMA; MOMA; Nebraska; Polaroid; Smith; Smithsonian; Tucson; VMFA; Worcester
 151. UNTITLED (Nude Couple; Woman's Face and Breast Dominant)
 silver print
 9⅝″ x 7⅝″ / 24.4cm. x 19.4cm.
 Signed, John Brook/166 Newbury/Boston, verso
 Reproduced: *A Long the Riverrun,* n.p., *PFA-III 1961,* p. 34; *Aperture,* 12:3, n.p.
 F. M. Hall Collection, purchased from the artist, 1966
 Acc. No. H-1112

131

*152. UNTITLED (Lovers in Woods)
 silver print
 14″ x 10¹⁵/₁₆″ / 35.6cm. x 27.8cm.
 Signed, John Brook/166 Newbury/Boston 02116,
 verso
 Reproduced: **American Photography: The
 Sixties,** p. 11; **A Long the Riverrun,** n.p.
 F. M. Hall Collection, purchased from the artist,
 1966
 Acc. No. H-1113

153. UNTITLED (Nursing Child)
 silver print
 9¾″ x 8½″ / 24.8cm. x 21.6cm.
 Signed, John Brook/166 Newbury/Boston 02116,
 verso
 Reproduced: **A Long the Riverrun,** n.p.
 F. M. Hall Collection, purchased from the artist,
 1966
 Acc. No. H-1116

EUGENE J. BUECHEL, S.J.
b. Schleida, Germany, 1874
d. St. Francis, South Dakota, 1954
Education: Self taught in photography
Solo Exhibitions: 1977 — Nebraska (with Anderson &
Doll)
Public Collections: Buechel Memorial Lakota Museum,
St. Francis, SD; Nebraska

154. ARTHUR WHITE FEATHER & HIS WIFE NELLIE
 RUNNING ON THEIR WEDDING DAY, 1929
 silver print
 10¹/₁₆″ x 7″ / 25.6cm. x 17.8cm.
 Acc. No. U-1967

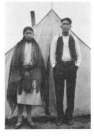

155. MRS. FRANK FOUR HORSES WITH QUILT
 silver print
 10¹/₁₆″ x 7″ / 25.6cm. x 17.8cm.
 Acc. No. U-1975

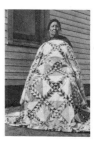

156. THEODORE BALD EAGLE & WIFE LUELLA
 WILLIAMS, 1945
 silver print
 10¹/₁₆″ x 6¹/₁₆″ / 25.6cm. x 15.4cm.
 Acc. No. U-1972

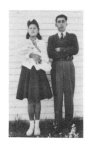

157. JOE UNDERSTANDING CROW AND MELISSA
 HOLY EAGLE ON DAY OF MARRIAGE
 silver print
 10¹/₁₆″ x 6¹/₁₆″ / 25.6cm. x 15.4cm.
 Acc. No. U-1968

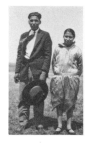

158. JOSEPHINE JUMPING EAGLE IN AIRPLANE,
 1928
 silver print
 6⁹/₁₆″ x 10¹/₁₆″ / 16.7cm. x 25.6cm.
 Reproduced: **Rosebud and Pine Ridge Photo-
 graphs,** n.p.
 Acc. No. U-1966

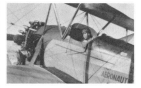

159. SUN DANCE AT ROSEBUD, 1928
 silver print
 6⁹/₁₆″ x 10¹/₁₆″ / 16.7cm. x 25.6cm.
 Acc. No. U-1965

160. MOTHER GENERAL ALOYSIA & INDIANS, 1931
 silver print
 6¹/₁₆″ x 10¹/₁₆″ / 15.4cm. x 25.6cm.
 Acc. No. U-1969

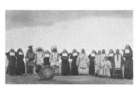

161. SPRING CREEK CHURCH AND CAMPERS ON
 MEMORIAL DAY, 1937
 silver print
 6⁵/₁₆″ x 10¹/₁₆″ / 16cm. x 25.6cm.
 Acc. No. U-1974

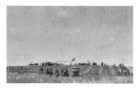

132

162. BADLANDS NORTH OF CHARLES ROOKS
silver print
10¹/₁₆" x 6¹/₁₆" / 25.6cm. x 15.4cm.
Acc. No. U-1973

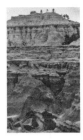

163. THE WHOLE NIGHT CHASE FAMILY, 1931
silver print
5¹³/₁₆" x 10¹/₁₆" / 14.8cm. x 25.6cm.
Acc. No. U-1970

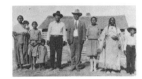

164. RAY WHIPPLE PULLING FATHER BUECHEL'S
CAR, 1933
silver print
6½" x 10¹/₁₆" / 16.5cm. x 25.6cm.
Acc. No. U-1971

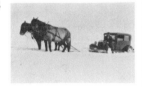

165. GROUP OF SIX GIRLS
silver print
6¹/₁₆" x 10¹/₁₆" / 15.4cm. x 25.6cm.
Reproduced: *Rosebud and Pine Ridge Photographs,* n.p.
Acc. No. U-1964

Note: Nos. 154 through 165 above are part of the University Collection, gift of the Mid-America Arts Alliance, 1976. All prints, made from the original negatives by Jim Alinder, are reproduced in *Crying for a Vision.*

WYNN BULLOCK

b. Chicago, Illinois, 1902
d. Monterey, California, 1975
Education: Trained as a musician; self taught in photography; Art Center School, Los Angeles, 1938; studied with Edward Kaminski
Solo Exhibitions: 1941—LACMA; 1947—Santa Barbara; 1954—UCLA; 1955—Limelight; 1956—Cherry Foundation Art Gallery, Carmel, CA; MHdY; 1957—Bulawayo, Southern Rhodesia; Capetown, South Africa; Durban, South Africa; East London, Cape Province, South Africa; Johannesburg Photographic & Cine Society; Photographia de Assoucao dos Velhos, Pietermaritzburg and Lourenco Marques, Portuguese East Africa; Port Elizabeth, Cape Province, South Africa; IMP; 1958—Federation of Arts, Prague, Czechoslovakia; 1959—Gull Pacific Arts Gallery, Richmond, CA;

1960—Princeton; Monterey Peninsula College, Monterey, CA; 1961—Fine Arts Gallerie Pierre Vanderburght, Brussels; Icon Gallery, Venice, CA; 1962—Siembab; Chauncey Cowles Memorial Art Gallery, Spokane, WA; 1963—Toren; 1964—Gainesville; 1966—Foothill College, Los Altos, CA; IMP; 1967—Jacksonville; 1968—Camera Work-Newport; RISD; University of St. Thomas Media Center, Houston; 1969—ID; Phoenix College; Reed; SFMMA; Skidmore; Iowa; UNC; University of The South, Sewanee, TN; Henry; Witkin; 1970—Amon Carter; SFMMA; CSFAC; MIA; Rice; Santa Barbara; Temple University, Philadelphia; 1971—Bathhouse; Columbia; Halsted; FOP; Maryland Institute of Art, Baltimore; MNM; University of Georgia, Athens; 1972—Limited Edition Gallery, Chicago; Shado; USIA (Rekjavik, London, Paris, Bonn, Ankara, Jidda & Tunis); UC-Santa Clara; 1973—Light; Pasadena; Ohio University, Athens

Public Collections: SFMMA; Tucson// Addison; Amon Carter; Burpee; Detroit; Everson; ENB; FOP; Gainesville; Indiana; IMP; Lane Foundation; Lincoln First; Kalamazoo; Krannert; MMA; Michigan; Mills; MIA; MFA; MFAH; MNM; MOMA; Museum of Photography, Paris; NCA; NGC; Nebraska; NOMA; Norfolk Museum of Art, Norfolk, VA; Oakland; Oregon; Pasadena; Phoenix College; PMA; Princeton; Rhodes NGA, Rhodes, South Africa; RISD; Ringling; Smith; Smithsonian; St. Petersburg; Texas; UCLA; UC-Santa Cruz; UNM; VMFA; VSW; Yale

*166. LET THERE BE LIGHT, 1951
silver print
7¼" x 9½" / 18.4cm. x 24.1cm.
Signed, Wynn Bullock '51, lower right
Reproduced: *Photography in America,* p. 177
F. M. Hall Collection, purchased from the artist, 1965
Acc. No. H-1037

167. CHILD IN FOREST, 1951
silver print
7½" x 9⅝" / 19cm. x 24.4cm.
Signed, Wynn Bullock '51, lower right
Reproduced: *The Family of Man,* n.p.; *Photography in the Twentieth Century,* p. 76; *Photographs from the Coke Collection,* n.p., *LLP: The Great Themes,* p. 149; *Bullock Photographer,* n.p.; *Aperture,* 2:3, p. 26; *Camera,* January, 1972, p. 27
F. M. Hall Collection, purchased from the artist, 1965
Acc. No. H-1035

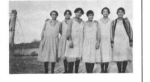

168. NAVIGATION WITHOUT NUMBERS, 1957
 silver print
 6¹⁵/₁₆″ x 8¹³/₁₆″ / 17.6cm. x 22.4cm.
 Signed, Wynn Bullock '57, lower right
 Reproduced: *Photography 64,* p. 15; *Bullock Photographer,* n.p.; *Bullock A Way of Life,* p. 87; *Maddow (Faces),* p. 461; *U. S. Camera,* 1959, p. 152; *Art in America,* December, 1964, p. 93; *Camera,* January, 1972, p. 30
 F. M. Hall Collection, purchased from the artist, 1965
 Acc. No. H-1036

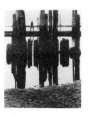

169. BOY FISHING, 1959
 silver print
 9⁷/₁₆″ x 7⁹/₁₆″ / 24cm. x 19.2cm.
 Signed, Wynn Bullock '59, lower right
 Reproduced: *Bullock A Way of Life,* p. 95; *PFA-IV,* 1966, n.p.
 F. M. Hall Collection, purchased from the artist, 1965
 Acc. No. H-1038

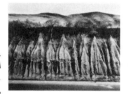

170. EROSION, 1959
 silver print
 7¼″ x 9¼″ / 18.4cm. x 23.5cm.
 Signed, Wynn Bullock '59, lower right
 Reproduced: *Photography at Mid-Century,* p. 16; *Bullock Photographer,* n.p.; *Bullock A Way of Life,* p. 99; *Aperture,* 9:3, p. 14; *U. S. Camera,* 1961, p. 262; *Camera,* January, 1972, p. 32
 F. M. Hall Collection, purchased from the artist, 1965
 Acc. No. H-1039

ABRAHAM M. BYERS

Note: Biographical data pertaining to Abraham Byers has not been established. It is known that he took over a photographer's studio in lieu of payment for a loan, taught himself the rudiments of the art and carried on the business only until it could be sold. He is known to have been a personal acquaintance of Lincoln.

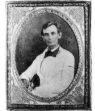

ABRAHAM LINCOLN, May 7, 1858
 ambrotype (oval)
 3⁷/₁₆″ x 2⅝″ / 8.8cm. x 6.6cm.
 Reproduced: *Meserve,* no. 7; *Ostendorf & Hamilton,* p. 15; *Lorant,* p. 71; *Boorstin,* p. 15; San Diego Tribune, Feb. 12, 1937; *Lorant (Life),* Feb. 9, 1948, p. 111
 Love Memorial Library, University of Nebraska, Lincoln, gift of Mrs. Abraham Byers, 1943

HARRY M. CALLAHAN
b. Detroit, Michigan, 1912
Education: Self taught in photography; influenced by Ansel Adams, Alfred Stieglitz; association with Todd

Webb, Edward Steichen, Aaron Siskind
Awards: 1956—Graham Foundation; 1965—White House Festival of the Arts; 1972—Guggenheim
Solo Exhibitions: 1951—AIC; Black Mountain; 1951-58—MOMA (traveling exhibition); 1956—KCAI; 1957—American Cultural Center, Paris (with Aaron Siskind); 1958—IMP; 1961—Superior Street Gallery, Chicago; 1962—MOMA (with Robert Frank); University of Warsaw, Poland; 1963—Galeria Krysztofory, Cracow, Poland; Siembab; Galeria Towarzystwo, Warsaw; 1964—Heliography Gallery, NYC; Hallmark; 1965—SFSU; 1966—Reed; 1970—Siembab; 1976—Galerie Lichttropfen, Aachen, West Germany; MOMA; 1977—Mirvish
Public Collections: Tucson//Addison; AIC; Bowdoin; Carpenter; Cornell; Dayton; Detroit; ENB; Fogg; Gainesville; High; IMP; Kalamazoo; Kansas; Krannert; LC; Louisville; Menil; Milwaukee; MIA; MFA; MFAH; MOMA; NGC; Nebraska; NOMA; Pasadena; PMA; Princeton; RISD; SFMMA; Seagram; Smithsonian; St. Petersburg; UCLA; UNM; VMFA; Worcester; Yale

171. GRASSES IN SNOW, DETROIT, 1943
 silver print
 7⅛″ x 9¹¹/₁₆″ / 18cm. x 24.6cm.
 Signed, Harry Callahan, lower right
 Reproduced: *Photographs/Harry Callahan,* pl. 95; *Harry Callahan,* p. 60; *Masters of the Camera,* pp. 204-5; *U.S. Camera,* 1949, p. 15
 F. M. Hall Collection, purchased from the artist, 1965
 Acc. No. H-1053

172. WEED AGAINST SKY, DETROIT, 1948
 silver print
 7⅝″ x 7⁷/₁₆″ / 19.4cm. x 18.9cm.
 Signed, Harry Callahan, lower right
 Reproduced: *Photographs/Harry Callahan,* pl. 97; *Pollack,* p. 531; *Swedlund,* p. 39; *Creative Camera,* 1977, p. 77
 F. M. Hall Collection, purchased from the artist, 1965
 Acc. No. H-1054

173. ELEANOR, 1948
 silver print
 6½″ x 8¹³/₁₆″ / 16.5cm. x 22.4cm.
 Signed, Harry Callahan, lower right
 Reproduced: *Photography at Mid-Century,* p. 30; *Photographs/Harry Callahan,* pl. 23; *A Concise History of Photography,* pl. 233; *Harry Callahan,* p. 15; *Masters of the Camera,* p. 207; *Swedlund,* p. 112; *Aperture,* 14:2; *Camera,* Nov. 1975, p. 25
 F. M. Hall Collection, purchased from the artist, 1965
 Acc. No. H-1046

*174. CHICAGO, 1949
 silver print
 10½″ x 13⅜″ / 26.7cm. x 34cm.
 Signed, Harry Callahan, lower right
 Reproduced: *Photographs/Harry Callahan,*
 pl. 39; *Harry Callahan,* p. 36
 F. M. Hall Collection, purchased from the artist,
 1965
 Acc. No. H-1048

175. WELLS STREET, CHICAGO, 1949
 silver print
 6½″ x 7″ / 16.5cm. x 17.8cm.
 Signed, Harry Callahan, lower right
 Reproduced: *Photographs/Harry Callahan,*
 pl. 38; *Creative Camera,* 1977, p. 82; *U. S.
 Camera,* 1949, p. 15; *Saturday Review,* Sept.
 26, 1964, p. 38; *Camera,* July, 1975, p. 32
 F. M. Hall Collection, purchased from the artist,
 1965
 Acc. No. H-1047

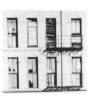

176. ELEANOR, CHICAGO, 1949
 silver print
 9⅝″ x 9½″ / 24.4cm. x 24.1cm.
 Signed, Harry Callahan, lower right
 Reproduced: *Photographs/Harry Callahan,*
 pl. 2; *Harry Callahan,* p. 18; *Creative Camera,*
 1977, p. 87; *Maddow (Faces),* p. 463; *Time,*
 December 20, 1976, p. 70
 F. M. Hall Collection, purchased from the artist,
 1965
 Acc. No. H-1044

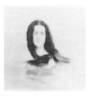

177. CHICAGO, 1950
 silver print
 7⅝″ x 9½″ / 19.4cm. x 24.1cm.
 Signed, Harry Callahan, lower right
 Reproduced: *Photographs/Harry Callahan,*
 pl. 104
 F. M. Hall Collection, purchased from the artist,
 1965
 Acc. No. H-1057

178. CHICAGO, c. 1950
 silver print
 7½″ x 9½″ / 19.1cm. x 24.1cm.
 Signed, Harry Callahan, lower right
 Reproduced: *Photographs/Harry Callahan,*
 pl. 101; *Harry Callahan,* p. 65; *LLP-Great Pho-
 tographers,* p. 221; *Langauge of Light,* pl. 40;
 Time, December 20, 1976, p. 70
 F. M. Hall Collection, purchased from the artist,
 1965
 Acc. No. H-1055

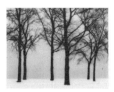

179. ELEANOR, 1951
 silver print
 3¾″ x 4¹¹/₁₆″ / 9.5cm. x 11.9cm.
 Signed, Harry Callahan, lower right
 Reproduced: *Photographs/Harry Callahan,*
 pl. 19; *Photography in the Twentieth Century,*
 p. 72; *Creative Camera,* 1977, p. 83; *Swed-
 lund,* p. 47; *U. S. Camera,* 1957, p. 145; *Aper-
 ture,* 4:1, p. 22
 F. M. Hall Collection, purchased from the artist,
 1965
 Acc. No. H-1045

180. CHICAGO, 1954
 silver print
 8¹³/₁₆″ x 13⅜″ / 22.4cm. x 34cm.
 Signed, Harry Callahan, lower right
 Reproduced: *Photographs/Harry Callahan,*
 pl. 79
 F. M. Hall Collection, purchased from the artist,
 1965
 Acc. No. H-1050

181. CHICAGO, c. 1955
 silver print
 9¾″ x 9⅝″ / 24.8cm x 24.4cm.
 Signed, Harry Callahan, lower right
 Reproduced: *Photographs/Harry Callahan,*
 pl. 81; *Harry Callahan,* p. 35
 F. M. Hall Collection, purchased from the artist,
 1965
 Acc. No. H-1051

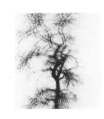

182. MULTIPLE EXPOSURE TREE, CHICAGO, 1956
 silver print
 7¹¹/₁₆″ x 7½″ / 19.5cm. x 19.1cm.
 Signed, Harry Callahan, lower right
 Reproduced: *Photographs/Harry Callahan,*
 pl. 102; *Newhall,* p. 201; *Photography/64,*
 p. 16; *Pollack,* p. 536; *Harry Callahan,* p. 66;
 Photography in America, p. 184; *Creative
 Camera,* 1977, p. 108; *Saturday Review,* Sep-
 tember 26, 1964, p. 38
 F. M. Hall Collection, purchased from the artist,
 1965
 Acc. No. H-1056

183. AIX-EN-PROVENCE, FRANCE, 1957
 silver print
 10½″ x 13⅜″ / 26.7cm. x 34cm.
 Signed, Harry Callahan, lower right
 Reproduced: *Harry Callahan,* p. 67
 F. M. Hall Collection, purchased from the artist,
 1965
 Acc. No. H-1058

184. GRASSES, WISCONSIN, 1959
 silver print
 6¼" x 9⁹/₁₆" / 15.9cm. x 24.3cm.
 Signed, Harry Callahan, lower right
 Reproduced: **Photographs/Harry Callahan,**
 pl. 92; **Harry Callahan,** p. 69; **Creative Camera,**
 1977, p. 80
 F. M. Hall Collection, purchased from the artist,
 1965
 Acc. No. H-1052

185. WABASH AVENUE, CHICAGO, 1959
 silver print
 9" x 13⅜" / 22.9cm. x 34cm.
 Signed, Harry Callahan, lower right
 Reproduced: **Photographs/Harry Callahan,**
 pl. 46
 F. M. Hall Collection, purchased from the artist,
 1965
 Acc. No. H-1049

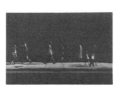

186. NEW HAMPSHIRE, 1961
 silver print
 5¹¹/₁₆" x 9⁹/₁₆" / 14.4cm. x 24.3cm.
 Signed, Harry Callahan, lower right
 Reproduced: **Photographs/Harry Callahan,**
 pl. 122; **Harry Callahan,** p. 70
 F. M. Hall Collection, purchased from the artist,
 1965
 Acc. No. H-1059

JO ANN CALLIS
b. Cincinnati, Ohio, 1940
Education: Ohio State University, 1958-60; California
State University, Long Beach, 1962-65; UCLA, BA, 1974
Solo Exhibitions: 1974 — Grandview Gallery, Los
Angeles; 1975 — Tyler School of Art; Orange Coast Col-
lege, Costa Mesa, CA
Public Collections: BN; ISU; Nebraska; UNM

187. UNTITLED (Star), 1974
 silver print
 8⁵/₁₆" x 5⁹/₁₆" / 21.1cm. x 14.1cm.
 Signed, Jo Ann Callis, verso
 F. M. Hall Collection, purchased from the artist,
 1975
 Acc. No. H-2020

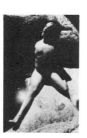

JULIA MARGARET CAMERON, English
b. Garden Reach, Calcutta, India, 1815
d. Glencairn Estate, DiKoya Valley, Ceylon, 1879
Education: Self taught in photography, began to work
in December, 1863
Solo Exhibitions: 1865 — Colnaghi, London; 1866 —
The French Gallery, London; 1868 — The German Gal-
lery, London; 1889 — The Camera Gallery, London;
1904 — Serendipity Gallery, London; 1927 — RPS;
1971 — Leighton House, London; 1974 — Stanford Uni-
versity, Palo Alto, CA; 1975-76 — NPG-London

Public Collections: NPG-London; RPS; Texas; V&A//
AIC; Cleveland; Detroit; ENB; High; IMP; Indiana; LC;
Louisville; Michigan; MFA; MOMA; NGC; Nebraska;
NOMA; PMA; Princeton; RISD; Seattle; Smithsonian;
Tucson; UNM; Yale

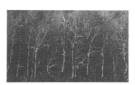

188. MOUNTAIN NYMPH, 1866
 albumen print
 11⁹/₁₆" x 9¼" / 29.4cm. x 23.5cm.
 Signed, Julia Margaret Cameron, lower right;
 inscribed: "From Life," lower left & "No. 3,"
 bottom left; dry stamp, bottom center: etc. etc.
 F. M. Hall Collection, 1968
 Note: Colin Ford has identified the sitter as Lady
 Clara Vere de Vere.
 Acc. No. H-1289

189. CHARLES HAY CAMERON, 1869
 albumen print
 12⅜" x 9⅝" / 31.4cm. x 24.4cm.
 Signed, autotype, drystamp, lower right corner;
 C. H. Cameron, lower center
 Reproduced: **Powell,** pl. 19; **Gernsheim** (Came-
 ron), p. 154
 F. M. Hall Collection, 1968
 Acc. No. H-1287

190. ALATHEA, STUDY OF ALICE LIDDELL, 1872
 albumen print
 12¾" x 9⅛" / 32.4cm. x 23.2cm.
 Inscribed, "Alathea" bottom center & "Study of
 Alice Liddell," lower right
 Reproduced: **Ovenden,** p. 75; **Beaton/Buckland,**
 p. 67; **Gernsheim,** p. 160
 F. M. Hall Collection, 1968
 Acc. No. H-1288

*191. GYPSY CHILDREN
 albumen print
 9½" x 8" / 24.1cm. x 20.3cm.
 Unsigned, dry stamp, bottom center margin;
 Registered photography sold by Messrs. Col-
 naghi 14 Pall Mall, East London
 University Collection, gift of Robert Schoelkopf,
 1968
 Acc. No. U-586

PAUL CAPONIGRO
b. Boston, Massachusetts, 1932
Education: Boston University (Music); self taught in
photography; studied with Benjamin Chin, Minor
White and Alfred W. Richter
Awards: 1961 — Tenth Boston Arts Festival; 1966 —
Guggenheim; 1972 — NEA; 1974 — NY Art Directors
Club; 1975 — Guggenheim; NEA
Solo Exhibitions: 1958 — IMP; 1960 — Siembab; Boston

University; 1962—Wellesley Free Library, Wellesley, MA; UNH; 1963—A Photographers Place, Philadelphia; Slembab; 1965—Gallery 216, NYC; 1968—Louisville; MOMA; 1969—FOP; 1970—Princeton; SFMMA; Bathhouse; 1972—AIC; 1973—University of Maryland, Baltimore; 1974—Springfield; Lakeview Center for the Arts & Science, Peoria, IL; 1975—V&A; FOP; 1976—Cronin; G. Hawkins Gallery, Los Angeles, CA; Albright-Knox; MNM; Columbia; 1976-77—Silver Image-Tacoma (with Eliot Porter); Siembab; 1977—Mirvish

Public Collections: Polaroid; Tucson//AIC; BN; Boston Athenaeum, Boston, MA; BPL; Cornell; Detroit; ENB; Fogg; High; IMP; Kalamazoo; Katonah Gallery, Katonah; NY; Krannert; LC; Louisville; Menil; MOMA; MMA; MFAH; NGC; Nebraska; NOMA; Oregon; Pasadena; PMA; RISD; Seattle; Smith; Smithsonian; St. Petersburg; Tampa; UCLA; UNM; V&A; VMFA; VSW; Yale

192. BREWSTER, N.Y., 1963
negative print
7⁵/₁₆″ x 9⁵/₁₆″ / 18.6cm. x 25.2cm.
Signed, Paul Caponigro, lower right; Numbered '63, lower left
Reproduced: *Paul Caponigro,* p. 48; *Swedlund,* p. 40
F. M. Hall Collection, purchased from the artist, 1966
Acc. No. H-1127

*193. TIDE POOL, NAHANT, MASSACHUSETTS, 1965
silver print
9⅜″ x 7⅜″ / 23.8cm. x 18.7cm.
Signed, Paul Caponigro, lower right
Reproduced: *American Photography: The Sixties,* p. 13; *Paul Caponigro,* p. 36
F. M. Hall Collection, purchased from the artist, 1966
Acc. No. H-1126

WALTER CHAPPELL
b. Portland, Oregon, 1925
Education: Benson Polytechnical School; Ellison-White Conservatory of Music; University of Portland School of Music; studied Architecture under Frank Lloyd Wright
Solo Exhibitions: 1956—MMA; Denver; National Jewish Hospital & Research Center, Denver; 1957—MOMA; IMP; George Wittenborn Gallery, NYC; 1959—Smithsonian; Boston; Rabin Studio, NYC; 1960—Siembab; 1961—Polaroid; 1963—Gallery Archive of Heliography, NYC; VII Photographers Gallery, Provincetown, MA; 1964—SFSU; El Mochuelo Gallery, Santa Barbara, CA; 1965—Hip Pocket Book Gallery, Santa Cruz, NM; 1966—Craft House, Taos, NM; Quivira; Levin Gallery, Santa Fe, NM; 1967—MNM; 1968—Nirvana, Santa Fe, NM; 1970—Coast Gallery, Big Sur, CA; 1976—Creative Eye

Public Collections: ENB; Indiana; IMP; MIT; MMA; MFAH; MOMA; MNM; Nebraska; Pasadena; Polaroid; RISD; Roswell; SFSU; Smithsonian; UCLA; VSW; Whitney Museum of American Art, NYC

194. UNTITLED (Mother and Child), 1962
silver print
9⁷/₁₆″ x 7⁷/₁₆″ / 24cm. x 18.9cm.
Signed, Walter Chappell 62, lower right
Nebraska Art Association, purchased with the aid of funds from the National Endowment for the Arts, 1976
Acc. No. N-355

*195. UNTITLED (Abstract Nudes), 1967
silver print
7½″ x 9½″ / 19.1cm. x 24.1cm.
Signed, Walter Chappell 1963, lower right
Nebraska Art Association, purchased with the aid of funds from the National Endowment for the Arts, 1976
Acc. No. N-374

137

THOMAS CLYDE
b. Potsdam, German, 1916
Education: Princeton University
Solo Exhibitions: 1963—Parrish Art Museum, Southampton, NY; 1964—Berkshire; Tanglewood Gatehouse, MA; Keene Art Gallery, Southampton, NY; 1971—Southampton College, Southampton, NY; 1975—Nebraska
Public Collections: Berkshire; MOMA; Nebraska

196. LAMASTRE I
silver print
10¾″ x 13¹⁵/₁₆″ / 27.3cm. x 35.4cm.
Reproduced: *Time Preserved,* n.p.; *Artists of Suffolk County, Part VIII,* p. 6
F. M. Hall Collection, purchased from the artist, 1976
Acc. No. H-2139

197. UNTITLED (Laughing Foot)
silver print
13⅞″ x 11″ / 35.2cm. x 27.9cm.
F. M. Hall Collection, purchased from the artist, 1970
Acc. No. H-2140

198. UNTITLED (Window Blinds)
silver print
10¹⁵/₁₆″ x 13¹³/₁₆″ / 27.8cm. x 35.1cm.
F. M. Hall Collection, purchased from the artist, 1976
Acc. No. H-2141

VAN DEREN COKE

b. Lexington, Kentucky, 1921
Education: University of Kentucky, BA, 1956; Indiana University, MFA, 1958
Awards: 1974—Guggenheim
Solo Exhibitions: 1940—University of Kentucky; 1955—Caravan; Louisville; Texas; 1956—IMP; 1958—Gainesville; 1959—Davison; Tulane; 1961—IMP; 1962—Tempe; Siembab; 1963—Phoenix; Florida State University, Tallahassee; 1967—UNH; Oregon; 1968—Quivira; 1972—Focus; Madison; 1973—Witkin; 1976—Brucke; A. Nagel Galerie, Berlin; Spiritus; Schoelkopf
Public Collections: Addison; BN; IMP; Louisville; MIA; MOMA; NGC; Nebraska; Oklahoma; SFMMA; Smithsonian; Tempe

199. THE WITNESSES, 1960/62
 silver print
 7½" x 8¼" / 19.1cm. x 21cm.
 F. M. Hall Collection, purchased from the artist, 1966
 Acc. No. H-962

200. CHEMICALLY POLLUTED SWAMP, 1961
 silver print
 7$^7/_{16}$" x 9⅝" / 18.9cm. x 24.4cm.
 Signed, V.C. '61, lower right
 Reproduced: **Memento Mori,** n.p.
 F. M. Hall Collection, purchased from the artist, 1966
 Acc. No. H-961

201. WICKER CHAIR AND MOVING MOSS, 1961
 silver print
 8$^1/_{16}$" x 6⅝" / 20.5cm. x 16.8cm.
 Signed, V.C. '61, lower right
 Reproduced: **Memento Mori,** n.p.
 F. M. Hall Collection, purchased from the artist, 1966
 Acc. No. H-960

202. ROADSIDE CROSSES, 1962
 silver print
 9¼" x 7½" / 23.5cm. x 19.1cm.
 Signed, V.C. '62, lower right
 University Collection, gift of the artist, 1966
 Acc. No. U-489

203. CACTUS IN ARIZONA, 1962
 silver print
 9$^9/_{16}$" x 7$^{11}/_{16}$" / 24.3cm. x 19.5cm.
 Signed, V.C. '62, lower right
 Reproduced: **Van Deren Coke,** n.p.
 F. M. Hall Collection, purchased from the artist, 1966
 Acc. No. H-963

JEAN BAPTISTE CAMILLE COROT, French

b. Paris, France, 1796
d. Ville d'Avray, France, 1875

204. SOUVENIR D'OSTIE, 1855
 cliche verre, Delteil 157, second state
 10¾" x 13½" / 27.3cm. x 34.3cm.
 Signed, Corot, lower right
 F. M. Hall Collection, 1970
 Acc. No. H-1495

MARIE COSINDAS

b. Boston, Massachusetts, 1925
Education: Modern School of Fashion Design; Boston Museum School; studied with Paul Caponigro, 1961; Ansel Adams, 1962; Minor White, 1963 and 1964
Awards: 1967—Guggenheim
Solo Exhibitions: 1962—UNH; 1963—Arlington Street Church, Boston; Harvard University, Cambridge, MA; 1966—MOMA; PCA; MFA; 1967—AIC; 1970—Brockton Art Center, Brockton, MA; 1976—ICA; Dartmouth
Public Collections: Addison; AIC; ENB; IMP; MOMA; NGC; Nebraska; Polaroid; VSW

*205. DOLLS, 1965
 polacolor
 4$^5/_{16}$" x 3$^5/_{16}$" / 11cm. x 8.4cm.
 Signed, Marie Cosindas/281 Dartmouth Street/ Boston, Mass., verso
 Reproduced: **Marie Cosindas,** n.p.
 F. M. Hall Collection, purchased from the artist, 1966
 Acc. No. H-1114

206. TED NEWMAN, 1965
 polacolor
 3$^5/_{16}$" x 4$^5/_{16}$" / 8.4cm x 11cm.
 Signed, Marie Cosindas/281 Dartmouth Street/ Boston, Mass., verso
 Reproduced: **Marie Cosindas,** n.p.
 F. M. Hall Collection, purchased from the artist, 1966
 Acc. No. H-1115

KONRAD CRAMER

b. Munich, Germany, 1888
d. Woodstock, New York, 1965
Education: Self taught in photography; encouraged by Alfred Stieglitz
Solo Exhibitions: 1964—RIT; 1977—Prakapas
Public Collections: IMP// Nebraska; PMA

207. PORTRAIT OF KARL FORTESS
 silver print
 9¹⁵/₁₆″ x 7⅞″ / 25.2cm. x 20cm.
 Signed, Konrad Cramer/Woodstock, lower right
 F. M. Hall Collection, 1976
 Acc. No. H-2153

RALSTON CRAWFORD

b. St. Catherines, Ontario, 1906
Education: Otis Art Institute, Los Angeles; Pennsylvania Academy of the Fine Arts, Philadelphia; Barnes Foundation, Merion, PA; Columbia University, NYC; Academies Colarossi & Scandinave, Paris; self taught in photography
Awards: 1932—Tiffany Fellowship
Solo Exhibitions: 1947—Honolulu Academy of Arts; 1949—Louisiana State University, Baton Rouge, LA; Minnesota; 1950—Downtown Gallery, NYC; 1974—Nebraska; Montgomery Museum of Fine Arts; MWP
Note: Ralston Crawford's photographs have been seen most frequently as part of exhibitions of his paintings and graphic art.
Public Collections: Tulane// MWP; Nebraska; SFMMA

208. SAINT LOUIS CEMETERY (With Large Shadow), 1958
 silver print
 13⅜″ x 10¹¹/₁₆″ / 34cm. x 27.1cm.
 F. M. Hall Collection, purchased from the artist, 1965
 Acc. No. H-1043

209. SAINT LOUIS CEMETERY, No. 1, 1958
 silver print
 13⅜″ x 10¹¹/₁₆″ / 34 cm. x 27.1cm.
 F. M. Hall Collection, purchased from the artist, 1965
 Acc. No. H-1042

210. BULLFIGHT, SPAIN, 1959
 silver print
 7½″ x 11¾″ / 19.1cm. x 29.8cm.
 Reproduced: *The Photography of Ralston Crawford,* p. 20
 F. M. Hall Collection, purchased from the artist, 1965
 Acc. No. H-1040

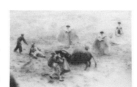

211. BURGUNDY STREET BARBER SHOP, 1960
 silver print
 13½″ x 10⅝″ / 34.3cm. x 27cm.
 F. M. Hall Collection, purchased from the artist, 1965
 Acc. No. H-1041

*212. BROKEN LOCOMOTIVE WHEELS, 1961
 silver print
 13¾″ x 16⅝″ / 34.9cm. x 42.2cm.
 University Collection, gift of the artist, 1965
 Acc. No. U-540

213. BUDDY ICARD
 silver print
 10½″ x 13½″ / 26.7cm. x 34.3cm.
 University Collection, gift of the artist, 1965
 Acc. No. U-539

IMOGEN CUNNINGHAM

b. Portland, Oregon, 1883
d. San Francisco, California, 1976
Education: University of Washington, Seattle (chemistry); Technische Hochschule, Dresden, 1909; influenced by Gertrude Kasebier, Edward S. Curtis & Edward Weston
Awards: 1970—Guggenheim
Solo Exhibitions: 1912—Brooklyn Institute of Arts & Sciences; 1932—LACMA; MHdY, 1935—Dallas Art Museum, Dallas, TX; 1936—E. B. Crocker Art Gallery, Sacramento, CA; 1951—SFMMA; 1953—Mills; 1956—Cincinnati; Limelight; 1957—Oakland; 1959—Oakland; 1961—IMP; 1964—SFMMA; AIC; 1965—Henry; 1967—Stanford; 1968—California College of Arts & Crafts, Oakland; Focus; 1968-69—Smithsonian; 1969—Siembab; Phoenix; College Library Gallery; 1970—MHdY; 1971—Seattle; FOP; Bathhouse; SFAI; 1972—Mt. Angel Abbey, Mt. Angel, OR; Ohio Silver Gallery, Los Angeles; 1973—Witkin; MMA; 1974—Henry
Public Collections: LC; Oakland; Tucson// AIC; Baltimore; Berkeley; Cornell; Dayton; Denver; Detroit; ENB; Fogg; High; IMP; Kalamazoo; Krannert; Michigan; MIA; MWP; MFA; MFAH; MOMA; NGC; NPG-Washington; Nebraska; NOMA; Oberlin; Oklahoma; Oregon; Pasadena; Princeton; RISD; SFMMA; Seagram; Seattle; Smith; Smithsonian; St. Petersburg; UCLA; UNM; VMFA; Worcester; Yale

214. CLAIRE (The Dream), 1910/1912
platinum print
9¼" x 6½" / 23.5cm. x 16.5cm.
Reproduced: **IMOGEN!,** p. 22; **Camera,** no. 10
p. 9
F. M. Hall Collection, purchased from the artist,
1966
Acc. No. H-1164

215. TRAFALGAR SQUARE, 1910
platinum print, printed from negative enlarged
from kodak 2¼" x 3¼", one half of negative
8¼" x 7⅜" / 21cm. x 18.7cm.
Signed, Imogen/Cunningham, lower right; Imo-
gen Cunningham Partridge, verso
Reproduced: **Imogen Cunningham: Photo-
graphs,** pl. 2
F. M. Hall Collection, purchased from the artist,
1966
Acc. No. H-1169

216. ADAM AND EVE (The Supplicant), 1912
platinum print
9⅝" x 7⅛" / 24.4cm. x 18.1cm.
Reproduced: **Imogen,** p. 27; **Camera,** no. 10, p. 10
F. M. Hall Collection, purchased from the artist,
1966
Acc. No. H-1168

217. WOOD BEYOND THE WORLD, c. 1912
platinum print, enlarged from 5" x 7" negative
9½" x 6⅞" / 24.1cm. x 17.5cm.
Reproduced: **Imogen Cunningham: Photo-
graphs,** pl. 6
F. M. Hall Collection, purchased from the artist,
1966
Note: Title suggested by Wm. Morris story of
that name.
Acc. No. H-1170

*218. ON THE MOUNTAIN (On Mt. Rainier), 1915
platinum print, enlarged from 4" x 5" negative
9⅛" x 7⁵/₁₆" / 23.2cm. x 18.6cm.
Signed, Imogen Cunningham, lower right
Reproduced: **Aperture,** 11:14, n.p.
F. M. Hall Collection, purchased from the artist,
1966
Acc. No. H-1171

219. SNAKE, 1921
negative print
12⅛" x 9¹¹/₁₆" / 30.8cm. x 24.6cm.
Signed, Imogen Cunningham 1921, lower right
Reproduced: **Imogen Cunningham: Photo-
graphs,** pl. 17; **Album 5,** 1970, p. 23; **Aperture,**
11:14, p. 140
F. M. Hall Collection, purchased from the artist,
1966
Note: The Washington Press monograph dates
this print in 1929.
Acc. No. H-1162

220. FIGURES, 1923
silver print
6¹³/₁₆" x 9⅝" / 17.3cm. x 24.4cm.
Signed, Imogen Cunningham 1923, lower right
Reproduced: **Imogen Cunningham: Photo-
graphs,** pl. 9; **Aperture,** 11:14, p. 141; **Aperture,**
15:3, n.p.
F. M. Hall Collection, purchased from the artist,
1966
Note: In the University of Washington Press
monograph this print is entitled "Nude." Our
title is that provided by the photographer.
Acc. No. H-1160

221. MAGNOLIA BLOSSOM, 1925
silver print
9½" x 12⅜" / 24.1cm. x 31.4cm.
Signed, Imogen Cunningham 1925, lower right
Reproduced: **Imogen Cunningham: Photo-
graphs,** pl. 11; **Women of Photography,** n.p.;
Photography Year 1975, p. 37; **Masters of the
Camera,** p. 84; **Aperture,** 11:14, p. 143
F. M. Hall Collection, purchased from the artist,
1966
Acc. No. H-2001

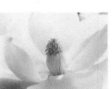

222. TWO CALLAS, c. 1929
silver print
11½" x 9¹/₁₆" / 29.2cm. x 23cm.
Signed, Imogen Cummingham, lower right
Reproduced: **Imogen Cunningham: Photo-
graphs,** pl. 13; **Album 5,** 1970, p. 25; **Camera,**
no. 10, p. 21; **Aperture,** 11:14, p. 145; **Aperture,**
14:2, n.p.
F. M. Hall Collection, purchased from the artist,
1966
Acc. No. H-1163

223. RUBBER PLANT, c. 1929
silver print
13³/₁₆" x 10⅛" / 33.5cm. x 25.7cm.
Signed, Imogen Cunningham, lower right
Reproduced: **Imogen Cunningham: Photo-
graphs,** pl. 14; **Camera,** October, 1975 (cover)
F. M. Hall Collection, purchased from the artist,
1966
Acc. No. H-1156

224. ALFRED STIEGLITZ, PHOTOGRAPHER, 1934
silver print
9¹¹/₁₆″ x 7⁵/₁₆″ / 24.6cm. x 18.6cm.
Signed, Imogen Cunningham 1934, lower right
Reproduced: *Imogen Cunningham* (Stanford),
pl. 6; *Imogen Cunningham: Photographs,* pl.
26; *Danziger and Conrad,* n.p.; *Camera,* no.
10, p. 30; *Aperture,* 11:14, p. 150
F. M. Hall Collection, purchased from the artist,
1966
Acc. No. H-1161

225. GERTRUDE STEIN AT THE MARK HOPKINS,
1937
silver print
7¹⁵/₁₆″ x 7″ / 20.2cm. x 17.8cm.
Signed, Imogen Cunningham 1937, lower right
Reproduced: *Imogen Cunningham: Photo-
graphs,* pl. 36; *Aperture,* 11:14, p. 148
F. M. Hall Collection, purchased from the artist,
1966
Acc. No. H-1167

226. MORRIS GRAVES, PAINTER, 1950
silver print
9¹¹/₁₆″ x 12″ / 24.6cm. x 30.5cm.
Signed, Imogen Cunningham 1950, lower right
Reproduced: *Imogen Cunningham: Photo-
graphs,* pl. 44; *Maddow,* p. 414; *PFA-V,* 1967,
p. 26; *Aperture,* 3:4 (cover); *Aperture,* 5:2, p.
66; *Aperture,* 11:14, p. 155; *Camera,* no. 10,
p. 34; *Aperture,* 14:2, n.p.
F. M. Hall Collection, purchased from the artist,
1966
Acc. No. H-1155

227. MAN RAY, PHOTOGRAPHER, PARIS, 1960
silver print
8″ x 7⅛″ / 20.3cm. x 18.1cm.
Signed, Imogen Cunningham 1961, lower right
Reproduced: *Aperture,* 11:14, p. 168
F. M. Hall Collection, purchased from the artist
Acc. No. H-1165

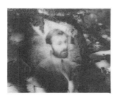

228. CEMETERY IN FRANCE, 1960
silver print
10³/₁₆″ x 10⅜″ / 25.9cm. x 26.4cm.
Signed, Imogen Cunningham 1960, lower right
Reproduced: *Imogen Cunningham: Photo-
graphs,* pl. 73; *Album 5,* 1970, p. 34
F. M. Hall Collection, purchased from the artist,
1966
Acc. No. H-1159

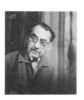

229. PEOPLE ON THE ROAD, GERMANY (In the
Manner of August Sander), 1960
silver print
12⅝″ x 10⅜″ / 32.1cm. x 26.4cm.
Signed, Imogen Cunningham 1960, lower right
Reproduced: *Imogen Cunningham* (Stanford),
pl. 16; *Imogen Cunningham: Photographs,*
pl. 68; *Album 5,* 1970, p. 33; *Aperture,* 11:14,
p. 166
F. M. Hall Collection, purchased from the artist,
1966
Acc. No. H-1158

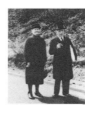

141

230. RESTAURANT IN CHARTRES (Leni at Chartres),
1961
silver print
7¼″ x 7⅝″ / 18.4cm. x 19.4cm.
Signed, Imogen Cunningham 1961, lower right
Reproduced: *Imogen Cunningham* (Stanford),
(cover); *Imogen Cunningham: Photographs,*
pl. 75; *Aperture,* 11:14, p. 167
F. M. Hall Collection, purchased from the artist,
1966
Acc. No. H-1166

231. JAMES BROUGHTON, 1963
silver print
10″ x 10⅛″ / 25.4cm. x 25.7cm.
Signed, Imogen Cunningham 1963, lower right
Reproduced: *American Photography: The
Sixties,* p. 15
F. M. Hall Collection, purchased from the artist,
1966
Acc. No. H-1157

232. FOUR HANDS AND THREE HEADS, 1964
silver print
7¹¹/₁₆″ x 9⁹/₁₆″ / 19.5cm. x 24.3cm.
Signed, Imogen Cunningham 1964, lower right
Reproduced: *Imogen Cunningham: Photo-
graphs,* pl. 83; *Aperture,* 11:14, p. 173
F. M. Hall Collection, purchased from the artist,
1966
Acc. No. H-1154

WILLIAM R. CURRENT
b. Pasadena, California, 1922
Education: Art Center School, Los Angeles
Awards: 1964—Guggenheim; 1965—White House
Festival of the Arts
Solo Exhibitions: 1963—IMP; MNM; 1965—AIC
Public Collections: Amon Carter// AIC; Burpee; IMP;
MOMA; Nebraska; Oakland; Pasadena; Smithsonian

233. UNTITLED (Pueblo Wall), 1964
 silver print
 10½″ x 10½″ / 26.7cm. x 26.7cm.
 Signed, Wm. R. Current '64, verso
 Reproduced: *American Photography: The Sixties,* p. 15
 F. M. Hall Collection, purchased from the artist, 1966
 Acc. No. H-1110

234. UNTITLED (Tree & Shadow), 1964
 silver print
 10½″ x 10½″ / 26.7cm. x 26.7cm.
 Signed, Wm. R. Current '64, verso
 F. M. Hall Collection, purchased from the artist, 1966
 Acc. No. H-1109

235. THE WHITE HOUSE, CANYON DE CHELLY, 1964
 silver print
 10½″ x 10½″ / 26.7cm. x 26.7cm.
 Signed, William R. Current '64, verso
 Reproduced: *Pueblo Architecture of the Southwest,* p. 88
 F. M. Hall Collection, purchased from the artist, 1966
 Acc. No. H-1134

236. UNTITLED (Log Shelter), 1964
 silver print
 10½″ x 10½″ / 26.7cm. x 26.7cm.
 Signed, William R. Current '64, verso
 F. M. Hall Collection, purchased from the artist, 1966
 Acc. No. H-1111

237. UNTITLED (Dead Bird), 1965
 silver print
 10½″ x 10½″ / 26.7cm. x 26.7cm.
 Signed, William R. Current '65, verso
 F. M. Hall Collection, purchased from the artist, 1966
 Acc. No. H-1135

EDWARD S. CURTIS

b. Whitewater, Wisconsin, 1868
d. Los Angeles, California, 1952
Education: Self taught in photography, Curtis undertook the compilation of a pictorial record of the North American Indian. This project, begun in 1896, was completed in 1930 and is contained in the two publications listed below.
Solo Exhibitions: 1904-06—Seattle; Washington, DC; New York; Boston; Pittsburgh; 1971—Pierpont Morgan Library, NYC; 1972—PMA; Halsted; Columbia; 1973—Thackrey & Robertson; 1975—Nebraska; 1976—Nebraska; Carl Solway Gallery, Cincinnati
Public Collections: Amon Carter; LC; PMA// Balti-

more; Berkeley; CMB; Cincinnati; CSFAC; Detroit; ENB; Gainesville; High; IMP; Louisville; Menil; MIA; Minnesota; MFAH; MOMA; NGC; Nebraska; NOMA; Oakland; Oklahoma; RISD; SFMMA; Seattle; Smith; Texas; Tucson; UNM; VMFA; VSW; Worcester; Yale
Note: In addition to the museum collections listed above, Curtis' *The North American Indian* is available in the ethnology collections of many university, college and public libraries.

THE NORTH AMERICAN INDIAN
 limited edition, 124/500, twenty volumes, twenty portfolios, 1907-30
 Love Memorial Library, University of Nebraska, Lincoln

238. FOOTPATH ALONG INDIAN RIVER, SITKA
 gravure
 4⅞″ x 7½″ / 12.4cm. x 19.1cm.
 Published: *Harriman Alaska Expedition,* Vol. I, p. 48
 Acc. No. U-1899

239. PART OF COLUMBIA GLACIER, PRINCE WILLIAM SOUND
 gravure
 4½″ x 6⅞″ / 11.4cm. x 17.5cm.
 Published: *Harriman Alaska Expedition,* Vol. I, p. 68
 Acc. No. U-1900

240. BEAVER TOTEM, DESERTED VILLAGE
 gravure
 16¹³⁄₁₆″ x 4⁵⁄₁₆″ / 42.7cm. x 11cm.
 Published: *Harriman Alaska Expedition,* Vol. I, p. 146
 Acc. No. U-1901

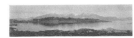

241. SITKA HARBOR
 gravure
 2″ x 7⅛″ / 5cm. x 18.1cm.
 Published: *Harriman Alaska Expedition,* Vol. II, p. 200
 Acc. No. U-1902.1

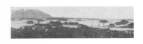

242. FORT WRANGELL
 gravure
 2″ x 7⅛″ / 5cm. x 18.1cm.
 Published: *Harriman Alaska Expedition,* Vol. II, p. 200
 Acc. No. U-1902.2

Note: Nos. 238 through 242 are part of the University Collection, gift of Albert Mikuta.

LYNN DANCE
b. Los Angeles, California, 1949
Education: Nebraska, BFA, 1972
Awards: 1975-76—Nebraska Bicentennial Commission; Nebraska Arts Council
Solo Exhibitions: 1973—Nebraska Union; 1977—Nebraska (with Robert Starck)
Public Collections: Nebraska// NBC-Lincoln

*243. THE FRERICHS' FARMSTEAD NEAR TALMAGE, 1975
 silver print
 8¹/₁₆″ x 9¹³/₁₆″ / 20.5cm. x 24.9cm.
 Reproduced: *Images of Nebraska,* p. 1
 University Collection, 1976
 Acc. No. U-1849

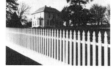

Note: Additional prints by Lynn Dance, (U-2005 through U-2103), all part of the Nebraska Photographic Documentary Project, are the gift of the artist to the University Collection. Fifty-five of these prints are reproduced in *Images of Nebraska.*

CHARLES FRANCOIS DAUBIGNY, French
b. Paris, France, 1817
d. Paris, France, 1878

244. LES CERFS, 1862
 cliche verre, Delteil 134
 6½″ x 7¹³/₁₆″ / 16.5cm. x 19.8cm.
 Signed, Daubigny, lower right in reverse
 F. M. Hall Collection, 1967
 Acc. No. H-1203

BRUCE DAVIDSON
b. Oak Park, Illinois, 1933
Education: Self taught in photography; RIT, 1953-56
Awards: 1959, 1961—Guggenheim; 1969—NEA
Solo Exhibitions: 1964-65—AIC; 1966—MOMA; Moderna Museet, Stockholm; 1970—MOMA; 1971—SFMMA; 1976—Addison (with Jerry Uelsmann)
Public Collections: Addison; AIC; Carpenter; ENB; Fogg; IMP; MOMA; Nebraska; Pasadena; VSW; Yale

245. WALES, BOY WITH CARRIAGE, 1965
 silver print
 6⁹/₁₆″ x 9¹⁵/₁₆″ / 16.7cm. x 25.2cm.
 F. M. Hall Collection, purchased from the artist, 1966
 Acc. No. H-1118

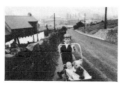

*246. WALES, FATHER WITH CHILD, 1965
 silver print
 9½″ x 7⁹/₁₆″ / 24.1cm. x 19.2cm.
 Reproduced: *American Photography: The Sixties,* p. 16
 F. M. Hall Collection, purchased from the artist, 1966
 Acc. No. H-1119

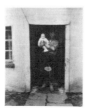

247. WALES (Pony), 1965
 silver print
 6½″ x 9¾″ / 16.5cm. x 24.8cm.
 Reproduced: *Language of Light,* pl. 37
 F. M. Hall Collection, purchased from the artist, 1966
 Acc. No. H-1117

ROY DE CARAVA
b. New York City, 1919
Education: Cooper Union; Harlem Art Center; George Washington Carver Art School
Awards: 1952—Guggenheim; 1969—Mt. Morris United Presbyterian Church & Community Life Center; 1972—Benin; 1975—Honorary Citizen, Houston, TX
Solo Exhibitions: 1950—Forty-Fourth Street Gallery, NYC; 1951, 1954—NYPL; 1955—A Photographers Gallery; 1956—Camera Club of NYC; 1967—NYPL; 1969—Studio Museum in Harlem; 1970—Nebraska; 1974—University of Massachusetts, Amherst; 1975—MFAH; 1976—Corcoran; Benin Gallery, NYC; 1977—Witkin
Public Collections: Addison, AIC; Atlanta University, GA; CMB; Corcoran; IMP; Menil; MMA; MFAH; MOMA; Nebraska; NOMA; Pasadena; Seagram; UNM; VMFA

248. GRADUATION DAY, 1952
 silver print
 9⅜″ x 13⁷/₁₆″ / 23.8cm. x 34.1cm.
 Reproduced: *The Sweet Flypaper of Life,* p. 69; *Roy de Carava Photographer,* n.p.
 University Collection, purchased from the artist, Catherine M. Johnson Fund, 1970
 Acc. No. U-2214

249. COAT HANGER IN RESTAURANT, 1961
 silver print
 9¼″ x 12⅞″ / 23.5cm. x 32.7cm.
 University Collection, purchased from the artist, Catherine M. Johnson Fund, 1970
 Acc. No. U-2215

250. HEADLESS BOY (Boy with arms folded), 1961
 silver print
 12¹³/₁₆″ x 9¹³/₁₆″ / 32.5cm. x 24.9cm.
 Reproduced: *Roy de Carava: Photographs,* p. 35
 University Collection, purchased from the artist, Catherine M. Johnson Fund, 1970
 Acc. No. U-2216

251. BIRD ON A SPIKE, 1962
 silver print
 13³/₁₆" x 8⅛" / 33.5cm. x 20.6cm.
 University Collection, purchased from the artist,
 Catherine M. Johnson Fund, 1970
 Acc. No. U-2217

252. FASHION CENTER, 1962
 silver print
 9⅜" x 13⁷/₁₆" / 23.8cm. x 34.1cm.
 University Collection, purchased from the artist,
 Catherine M. Johnson Fund, 1970
 Acc. No. U-2218

253. TWO MEN, TWO BENCHES, 1969
 silver print
 10⅝" x 13⁷/₁₆" / 27cm. x 34.1cm.
 University Collection, purchased from the artist,
 Catherine M. Johnson Fund, 1970
 Acc. No. U-2219

DON DOLL, S.J.

b. Milwaukee, Wisconsin, 1937
Education: St. Louis University (philosophy); Marquette University, Milwaukee, WI (photography), 1964
Awards: Special recognition in World Understanding category for photographs of the Brule Sioux, Spring Creek, SD, in the "Pictures of the Year," competition sponsored by the University of Missouri School of Journalism, Nikon and the National Press Photographers Association
Solo Exhibitions: 1967, 1975 — Creighton; 1977 — Nebraska (with Anderson and Buechel)
Public Collections: Nebraska

254. SEWEL MAKES ROOM FOR THEM, 1975
 silver print
 12" x 8" / 30.5cm. x 20.3cm.
 Signed, Don Doll, S.J., lower right
 Acc. No. U-1976

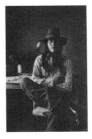

255. ANNA ROSE WHITE HAT, WITH TYRONE,
 CAMILLE, MARLON AND J.J., 1975
 silver print
 12" x 8" / 30.5cm. x 20.3cm.
 Signed, Don Doll, S.J., lower right
 Acc. N. U-1977

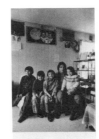

*256. GORDON SWIFT HAWK, 1975
 silver print
 12" x 8" / 30.5cm. x 20.3cm.
 Signed, Don Doll, S.J., lower right
 Acc. No. U-1978

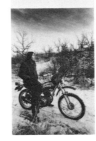

257. VICTOR MAKES ROOM FOR THEM HUNTING
 DEER ALONG LITTLE WHITE RIVER, 1975
 silver print
 8¹/₁₆" x 12" / 20.5cm. x 30.5cm.
 Signed, Don Doll, S.J., lower right
 Acc. No. U-1980

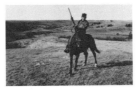

258. ORVILLE AND OPHELIA KILLS IN SIGHT, WITH
 JUNIOR, 1974
 silver print
 8⅛" x 12" / 20.6cm. x 30.5cm.
 Signed, Don Doll, S.J., lower right
 Acc. No. U-1979

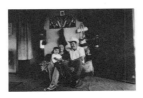

259. MORRIS KILLS IN SIGHT, GLENFORD WALKING
 EAGLE, AMBROSE, SYLVAN AND DANIEL
 WHITE HAT, 1975
 silver print
 8" x 12" / 20.3cm. x 30.5cm.
 Signed, Don Doll, S.J., lower right
 Acc. No. U-1981

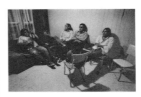

260. MRS. CORRINE CLOUDMAN'S
 "TRANSITIONAL" HOUSE, 1974
 silver print
 8" x 12" / 20.3cm. x 30.5cm.
 Signed, Don Doll, S.J., lower right
 Acc. No. U-1982

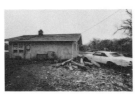

261. PETER SWIFT HAWK'S HOUSE, 1975
silver print
8" x 12" / 20.3cm. x 30.5cm.
Signed, Don Doll, S.J., lower right
Acc. No. U-1983

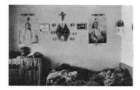

262. GRADUATION 1975 AT ST. FRANCIS HIGH
SCHOOL, 1975
silver print
8" x 12" / 20.3cm. x 30.5cm.
Signed, Don Doll, S.J., lower right
Acc. No. U-1984

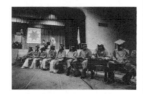

263. MEMORIAL DAY, 1974
silver print
8" x 12" / 20.3cm. x 30.5cm.
Signed, Don Doll, S.J., lower right
Acc. No. U-1985

264. FREDDY WALKING EAGLE WITH HARVEY'S
BRONZE STAR, 1975
silver print
8" x 12" / 20.3cm. x 30.5cm.
Signed, Don Doll, S.J., lower right
Acc. No. U-1986

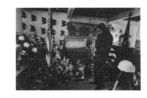

265. TEAM AND WAGON LEADING PROCESSION IN
HARVEY WALKING EAGLE'S FUNERAL, 1975
silver print
8⅛" x 12" / 20.6cm. x 30.5cm.
Signed, Don Doll, S.J., lower right
Acc. No. U-1987

Note: Nos. 254 through 265 above are a part of the
University Collection, a gift of the Mid-America Arts
Alliance, 1976. All prints are reproduced in ***Crying for
a Vision.***

AARON EGEL

Note: Aaron Egel is one of seven photographers whose
work was allocated by the Work Projects Administra-
tion to the University of Nebraska Art Galleries in 1943.
Extensive enquiry made in the interests of the present
publication has failed to produce information regard-
ing place and date of birth, education and subsequent
activity.

266. SABBATH STUDIES, 1937
silver print
13¼" x 10⅜" / 33.7cm. x 26.4cm.
University Collection
Acc. No. U-1918

267. SABBATH STUDIES, 1937
silver print
13¼" x 10½" / 33.7cm. x 26.7cm.
University Collection
Acc. No. U-1919

JAMES L. ENYEART

b. Auburn, Washington, 1943
Education: KCAI, BFA, 1965; University of Kansas,
MFA, 1972
Awards: 1966-67—OAS Fellowship; 1975—NEA
Solo Exhibitions: 1965—Nelson; 1966—North Ameri-
can Cultural Institute, Santiago, Chile; 1967—Uni-
tarian Gallery, Kansas City, MO; Halls Gallery, Kansas
City, MO; 1967-68—Missouri State Council on the Arts
(traveling exhibition); 1969—Museum of Natural His-
tory, University of Kansas, Lawrence, KS; 1971—
Kansas; Gallery Modernage, NYC; 1972—Albrecht
Gallery, St. Joseph, MO; 7 East 7th Street Gallery,
Lawrence, KS; 1975—University of Exeter, England;
1976—PG-London
Public Collections: Albrecht Gallery, St. Joseph, MO;
BN; IMP; Kansas; Nebraska

268. LINWOOD POST OFFICE, 1975
silver print
11" x 14" / 27.9cm. x 35.6cm.
Signed, Jim Enyeart, lower right
Reproduced: ***No Mountains in the Way,*** pl. 1
Nebraska Art Association, purchased with the
aid of funds from the National Endowment for
the Arts, 1976
Acc. No. N-425

269. FORD, 1975
silver print
11″ x 14″ / 27.9cm. x 35.6cm.
Signed, Jim Enyeart, lower right
Reproduced: *No Mountains in the Way,* pl. 35
Nebraska Art Association, purchased with the
 aid of funds from the National Endowment for
 the Arts, 1976
Acc. No. N-426

FREDERICK HENRY EVANS, English
b. England, 1855
d. London, England, 1943
Education: Self taught in photography
Awards: 1928 — Honorary Fellow, RPS
Solo Exhibitions: 1897 — Architectural Club of Boston;
1900 — RPS; 1906 — Photo-Secession; 1922, 1944 —
RPS; 1964 — IMP; 1972 — RPS
Public Collections: PMA// AIC; Baltimore; Carpenter;
Cleveland; Dayton; Detroit; ENB; High; IMP; LC; Menil;
Michigan; MIA; MFA; MOMA; NGC; Nebraska; NOMA;
Oberlin; Oklahoma; Princeton; RPS; SFMMA; Seattle;
Smith; Smithsonian; Texas; UNM; VMFA; Worcester

*270. MAWSON AND HERBERT FRAUL

platinum prints
a. 4⅝″ x 2⅜″ / 11.7cm. x 6cm.
b. 4⅝″ x 2¹¹/₁₆″ / 11.7cm x 6.8cm.
Signed, Monogram stamp, FHE, lower right
F. M. Hall Collection, 1975
Acc. Nos. H-2021.1, H-2021.2

271. NORTH CHOIR AMBULATORY, LOOKING WEST,
 GLOUCESTER CATHEDRAL
platinum print
5¹¹/₁₆″ x 4⁷/₁₆″ / 14.4cm. x 11.3cm.
Signed, Monogram dry stamp, FHE, lower right
 and lower left
F. M. Hall Collection, 1975
Acc. No. H-2022

WALKER EVANS
b. St. Louis, Missouri, 1903
d. New Haven, Connecticut, 1975
Education: Phillips Academy, Andover, MA; Williams
College, Williamstown, MA, 1922-23; Sorbonne, Paris,
1926
Awards: 1940, 1941, 1959 — Guggenheim; 1962 — Car-
negie Corporation; 1968 — Honorary Litt. D., Williams
College; Fellow, American Academy of Arts and
Sciences
Solo Exhibitions: 1932 — Julien Levy (with George Platt
Lynes); 1933 — MOMA; 1938 — MOMA; 1948 — AIC; 1962
— MOMA; 1963-65 — circulated by MOMA; 1964 — AIC;
1966 — MOMA; Schoelkopf; circulated by NGC; 1970 —
The Century Association, NYC; 1971 — Schoelkopf;
1972 — Yale; Dartmouth; 1973, 1974 — Schoelkopf; 1976

— Bibliotheque Royale, Brussels, Belgium; 1977 —
Cronin; Schoelkopf
Public Collections: LC; NGC// Alabama; AIC; Balti-
more; Burpee; Carpenter; Cleveland; Corcoran; Cor-
nell; Dartmouth; Dayton; Detroit; ENB; Everson; Fogg;
High; IMP; Kalamazoo; Louisville; Menil; Michigan;
Milwaukee; MIA; Minnesota; MFA; MFAH; MOMA;
NPG-Washington; Nelson; NOMA; Oberlin; Oklahoma;
PMA; Princeton; RISD; SFMMA; Seagram; Smith;
Smithsonian; St. Petersburg; Texas; Tucson; UCLA;
UNM; VMFA; Wadsworth; Worcester; Yale

272. PHOTOGRAPHER'S WINDOW DISPLAY,
 BIRMINGHAM, ALA., March, 1936
silver print
8¾″ x 7⅛″ / 22.2cm. x 18.1cm.
Signed, Walker Evans, lower right; titled, dated
 and signed, verso
Reproduced: *Looking at Photographs,* p. 117;
 Masters of Photography, p. 152; *Newhall,* pl.
 62; *Walker Evans* (FSA), no. 229; *Photography
 in America,* p. 135; *American Photographs,* p.
 2; *Aperture,* 14:2, n.p.
F. M. Hall Collection, 1975
Note: The subject of this print, which has usually
 been located in Savannah, Georgia, has been
 identified as being in Birmingham, Alabama, in
 accordance with an FSA record at the Library of
 Congress.
Acc. No. H-2024

*273. TEAGUE HARDWARE CO.

silver print
7⅝″ x 9⅝″ / 19.4cm. x 24.4cm.
Signed, Walker Evans, lower right
F. M. Hall Collection, 1975
Acc. No. H-2023

RICHARD FALLER
b. Boston, Massachusetts, 1941
Education: Boston; PCA; studied with Minor White,
1963-64
Solo Exhibitions: 1964 — Kenmore Galleries, Philadel-
phia; 1968 — Siembab; 1969 — Addison; 1970 — MIT;
UNH; 1971 — Siembab; Roswell; 1972 — Roswell; 1973
— Siembab; Quivira; 1975 — Nebraska
Public Collections: AIC; MOMA; MNM; Nebraska;
PMA; Polaroid; Roswell

274. NAVE, SAN BONAVENTURA MISSION, GRAN
 QUIVIRA NATIONAL MONUMENT, 1969

silver print
9¹⁵/₁₆″ x 13⁵/₁₆″ / 25.2cm. x 33.8cm.
Signed, Richard Faller 1969, lower right
F. M. Hall Collection, purchased from the artist,
 1976
Acc. No. H-2025

275. DETAIL, SAN MIGUEL MISSION, SANTA FE,
 N.M., 1970
 silver print
 5¹³/₁₆″ x 6¹/₁₆″ / 14.8cm. x 15.4cm.
 Signed, Richard Faller 1970, lower right
 F. M. Hall Collection, purchased from the artist,
 1976
 Acc. No. H-2027

276. COPRINUS, 1971
 silver print
 5″ x 6⅜″ / 12.7cm. x 16.2cm.
 Signed, Richard Faller 1971, lower right
 F. M. Hall Collection, purchased from the artist,
 1976
 Acc. No. H-2028

277. SANTUARIO DE CHIMAYO, 1972
 silver print
 7¾″ x 6⁵/₁₆″ / 19.7cm. x 16cm.
 Signed, Richard Faller 1972, lower right
 F. M. Hall Collection, purchased from the artist,
 1976
 Acc. No. H-2026

DANIEL FARBER
b. Worcester, Massachusetts, 1906
Education: Self taught in photography
Solo Exhibitions: Addison; Kalamazoo; Maine; UNM;
VMFA; Worcester; Dartmouth; MFA; Illinois, Urbana;
Nebraska
Public Collections: Addison; AIC; Akron; BPL; Cleve-
land; CSFAC; Dayton; Denver; High; Kalamazoo; LC;
Maine; MMA; Milwaukee; Minnesota; MWP; MFA;
MOMA; Nebraska; Oberlin; Oregon; RISD; Ringling;
Rosewell; Santa Barbara; Smith; Smithsonian; Tampa;
VMFA; Worcester; Yale

278. JENNIE'S KITCHEN, 1956
 dye transfer
 12¹⁵/₁₆″ x 19⅛″ / 32.9cm. x 48.6cm.
 Signed, Daniel Farber 1956, verso
 University Collection, gift of the artist, 1973
 Acc. No. U-1906

279. UNDER THE PIER, 1962
 dye transfer
 20″ x 13³/₁₆″ / 50.8cm. x 33.5cm.
 Signed, Daniel Farber 1962, verso
 University Collection, gift of the artist, 1973
 Acc. No. U-1730

280. FROSTED BERRY LEAVES, 1965
 dye transfer
 13⁵/₁₆″ x 19⁹/₁₆″ / 33.8cm. x 49.7cm.
 Signed, Daniel Farber 1965, verso
 University Collection, gift of the artist, 1973
 Acc. No. U-1729

281. LEDGE AND GRASS, 1972
 dye transfer
 13⅛″ x 19³/₁₆″ / 33.3cm. x 48.7cm.
 Signed, Daniel Farber 1972, verso
 University Collection, gift of the artist, 1973
 Acc. No. U-1905

STEVEN R. FITCH
b. Tucson, Arizona, 1949
Education: University of California, Berkeley, BA, 1971
Awards: 1973, 1975—NEA
Solo Exhibitions: 1973—Studio Gallery, Bolinas, CA;
1975—Darkroom Workshop Gallery, Berkeley; Berke-
ley; Shado; 1976—Orange Coast College, Costa
Mesa, CA
Public Collections: Kalamazoo; Lincoln First; MFA;
MOMA; Nebraska; Oakland; UNM

282. TRUCKSTOP SIGN, HIGHWAY 86, BENSON,
 ARIZONA, 1972
 sepia toned silver print
 9⅜″ x 12⅛″ / 23.8cm. x 30.8cm.
 Signed, Steve Fitch 1972, lower right
 Reproduced: *Light & Substance,* p. 32; **Diesels
 and Dinosaurs,** n.p.; **Afterimage,** May-June,
 1975, p. 15
 Nebraska Art Association, purchased with the
 aid of funds from the National Endowment for
 the Arts, 1976
 Acc. No. N-427

283. UNTITLED (Elko, Nevada), 1974
 flashed and selenium toned silver print
 12″ x 12″ / 30.5cm. x 30.5cm.
 Signed, Steve Fitch 1974, verso
 Nebraska Art Association, purchased with the
 aid of funds from the National Endowment for
 the Arts, 1976
 Acc. No. N-428

LEE FRIEDLANDER
b. Aberdeen, Washington, 1934
Education: Art Center College of Design, Los Angeles;
studied with Edward Kaminski
Awards: 1960, 1962—Guggenheim; 1972—NEA
Solo Exhibitions: 1963—IMP; 1968—UCLA; 1971—
Focus; 1972—Focus; MOMA; 1973—Witkin; 1975—
MOMA; Broxton Gallery, Los Angeles; 1976—MIA;
Dallas; Corcoran; GI; Yajima Gallery, Montreal; Photo-
galerie Kunsthaus, Zurich

Public Collections: Baltimore; BN; Corcoran; Detroit; Fogg; IMP; Kansas; LC; MIA; MFA; MFAH; MOMA; Nebraska; NGC; NOMA; Princeton; RISD; SFMMA; Seagram; Smithsonian; Stedlijk; St. Petersburg; Tampa; Tucson; UCLA; UNM; V&A; VMFA; VSW; Yale

*284. HOTEL ROOM, PORTLAND, MAINE, 1962
silver print
6¹³/₁₆″ x 10¹/₁₆″ / 17.3cm. x 25.6cm.
Signed, Lee Friedlander, verso
Reproduced: **LLP: The Camera,** p. 25
Nebraska Art Association, purchased with the aid of funds from the National Endowment for the Arts, 1976
Acc. No. N-372

285. UNTITLED (Firemen in Front of Burning House), 1966
silver print
6″ x 9¼″ / 15.2cm. x 23.5cm.
Signed, Lee Friedlander, verso
Reproduced: **Work from the Same House,** n.p.
Nebraska Art Association, purchased with the aid of funds from the National Endowment for the Arts, 1976
Acc. No. N-373

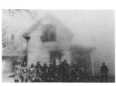

FRANCIS FRITH, English
b. Chesterfield, Derbyshire, 1822
d. Cannes, France, 1898
Education: Self taught in photography; retired from a successful business at an early age, Frith converted a love of travel into a second business, one of the most successful of the period, devoted to recording the scenery and monuments of England, Egypt and Palestine. Frith's pictures are of prime documentary importance in addition to their quality as photographs.
Public Collections: British Museum; BPL; NGC; PMA; RPS; Texas; VSW// AIC; Burpee; Detroit; ENB; Indiana; IMP; Iowa; LC; Louisville; Michigan; MIA; MOMA; Nebraska; NOMA; Princeton; RISD; Smithsonian; Tucson; UNM; VMFA; Worcester; Yale
Note: The large collection of glass plates, prints and postal cards remaining at the dissolution of Frith's Company at Reigate is now owned by Rothmans, Pall Mall, London.

286. OTTERY ST. MARY, ALFINGTON VILLAGE, DEVON
albumen print
5⅝″ x 8⅛″ / 14.3cm. x 20.6cm.
Stamped, "Copyright F. Frith & Co. Ltd. Reigate," numbered 56678, verso
F. M. Hall Collection, 1976
Acc. No. H-2145

287. GEORGE MEREDITH'S HOUSE AT BOXHILL, SURREY
albumen print
5⅝″ x 8⅛″ / 14.3cm. x 20.6cm.
Stamped, "F. Frith & Co. Ltd., Raglan Road, Reigate," numbered 50960a, verso
F. M. Hall Collection, 1976
Acc. No. H-2146

*288. CHAMONIX, GLACIER DES BOSSONS
albumen print
7¾″ x 6³/₁₆″ / 19.7cm. x 15.7cm.
Titled & numbered 17665, verso
F. M. Hall Collection, 1976
Acc. No. H-2144

289. WOODED GORGE
albumen print
10¹/₁₆″ x 7″ / 25.5cm. x 17.8cm.
Numbered, 1278, verso
F. M. Hall Collection, 1976
Acc. No. H-2147

ALBERT EUGENE GALLATIN
b. Villanova, Pennsylvania, 1882
d. New York, New York, 1952
Education: Cutler School, Vermont; New York Law School; self taught in photography
Note: Eugene Gallatin is best know as a painter and collector of abstract art. His collection is now housed at the Philadelphia Museum of Art. His portraits are the result of his close association with many of the artists belonging to the School of Paris.
Public Collections: Nebraska; PMA

290. PORTRAIT OF PABLO PICASSO, 1933
silver print
10″ x 7¾″ / 25.4cm. x 19.7cm.
Signed, A. E. Gallatin/Paris 1933, lower left
F. M. Hall Collection, 1976
Acc. No. H-2154

148

RON GEIBERT

b. Jamestown, North Dakota, 1952
Education: Creighton, BFA, 1974
Solo Exhibitions: 1974—Creighton; 1975—Concordia; 1976—East Street; Chadron State College, NE; Sioux City; Nebraska
Public Collections: Nebraska

291. GAS STATION, STUART, NEBRASKA, 1974
agfacolor print
7⁹/₁₆″ x 9⅝″ / 19.2cm. x 24.4cm.
Signed, R. Geibert, '74, lower right
Nebraska Art Association, purchased from the artist, with the aid of funds from the National Endowment for the Arts, 1976
Acc. No. N-450

292. DOUBLE DOORS, 1974
agfacolor print
9⁹/₁₆″ x 7½″ / 24.3cm. x 19.1cm.
Signed, R. Geibert, '74, lower right
Nebraska Art Association, purchased from the artist, with the aid of funds from the National Endowment for the Arts, 1976
Acc. No. N-451

293. SILO SHAPES, 1974
agfacolor print
7⁹/₁₆″ x 9½″ / 19.2cm. x 24.1cm.
Signed, R.G., lower right
Nebraska Art Association, purchased from the artist, with the aid of funds from the National Endowment for the Arts, 1976
Acc. No. N-452

DAVID W. GENGLER

b. Norwalk, Connecticut, 1946
Education: Colorado College, Colorado Springs, CO, BA (geology), 1970; self taught in photography
Solo Exhibitions: 1972—CSFAC; 1976—Stills, Ithaca, NY; Popular Photography Gallery, NYC
Public Collections: Cornell; Nebraska

294. BUOY #2, 1975
silver print
4⅜″ x 6⅝″ / 11.1cm. x 16.8cm.
Signed, David W. Gengler 1975, lower right
Nebraska Art Association, purchased with the aid of funds from the National Endowment for the Arts, 1976
Acc. No. N-368

295. THE WHITE MOUSE, SOUTHPORT, CT, 1976
silver print
4⅜″ x 6⅝″ / 11.1cm. x 16.8cm.
Signed, David W. Gengler 1976, lower right
Nebraska Art Association, purchased with the aid of funds from the National Endowment for the Arts, 1976
Acc. No. N-377

ARNOLD GENTHE

b. Berlin, Germany, 1869
d. Connecticut, 1942
Education: University of Berlin; University of Jena, Ph D, 1894 (philology); self taught in photography
Solo Exhibitions: 1975—Staten Island Museum, Staten Island, NY
Public Collections: Achenbach; LC// AIC; Berkeley; FOP: High; IMP; MOMA; NGC; NPG-Washington; Nebraska; NOMA; Oakland; Princeton; RISD; Smithsonian; Texas; Tucson; UNM

296. PORTRAIT OF HORACE TRAUBEL
silver print
9½″ x 7½″ / 24.1cm. x 19.1cm.
Signed, Arnold Genthe/NY, lower right
University Collection, gift of Virginia Zabriskie, 1976
Note: Print in the Library of Congress, presumably from the same sitting, dated April 18, 1917.
Acc. No. U-1892

*297. MAN & GIRL IN CHINATOWN
silver print
13½″ x 9³/₁₆″ / 34.3cm. x 23.3cm.
F. M. Hall Collection, 1976
Acc. No. H-2029

298. CHINATOWN ALLEY AT NIGHT
silver print
9⅞″ x 12½″ / 25.1cm. x 31.8cm.
Signed, Arnold Genthe/NY, lower left
F. M. Hall Collection, 1976
Acc. No. H-2030

MONTE H. GERLACH

b. Hastings, Nebraska, 1950

Education: University of Nebraska, BA, 1972; Institute Design, Illinois Institute of Technology, MS, 1974

Awards: 1972—Nebraska Press Association; Mademoiselle National Photography Competition; 1975—Southland Photography Exhibition, Southland, CA; Nikon Student Photography Competition

Solo Exhibitions: 1975—Colorado College, Colorado Springs; "A" Camera, Chicago; 1976—Mark Four Gallery, Lincoln, NE

Public Collections: Nebraska

299. BODY FORM, 1974
 silver print
 8¼" x 11½" / 21cm. x 19.2cm.
 Signed, M. H. Gerlach 74, lower right
 Nebraska Art Association, purchased from the artist, with the aid of funds from the National Endowment for the Arts, 1976
 Acc. No. N-391

300. RISING FORM, 1974
 silver print
 11½" x 7¹/₁₆" / 29.2cm. x 17.9cm.
 Signed, M. H. Gerlach 75, lower right
 Nebraska Art Association, gift of the artist, 1976
 Acc. No. N-393

301. KAREN, 1975
 silver print
 5¾" x 11½" / 14.6cm. x 29.2cm.
 Signed, M. H. Gerlach 8/75, lower right
 Nebraska Art Association, gift of the artist, 1976
 Acc. No. N-392

LAURA GILPIN

b. Colorado Springs, Colorado, 1891

Education: Self taught in photography; attended Clarence White School of Photography; also studied with Anton Bruehl and Bernard Horn

Awards: 1970—DHL (honorary) UNM; 1972—Brotherhood Award, National Conference of Christians & Jews; 1974—Governor's Award, New Mexico; 1975—Guggenheim

Solo Exhibitions: 1918—Clarence H. White School, NYC; Camera Club Galleries, NYC; 1920—Pictorial Photographers of America; London Salon of Photography; 1924—Pictorial Photographers of America, NYC; Baltimore Photographic Club; 1933—Denver; Century of Progress Worlds Fair, Chicago; 1934—LC; CSFAC; American Museum of Natural History, NYC; 1935—International Salon, Madrid, Spain; Beacon

School, Wellesley, MA; 1956—American Museum of Natural History, NYC; 1957—Laboratory of Anthropology, Santa Fe; IMP; Stillwater, OK; 1966—St. John's College, Santa Fe; 1968—Museum of Albuquerque; Amon Carter; 1969—West Texas Museum, Lubbock; 1970—Institute of American Indian Arts, Santa Fe; Oklahoma Art Center, Oklahoma City; 1971—St. John's College, Santa Fe; 1973—Witkin; 1974—MNM (and national tour sponsored by Western Association of Art Museums)

Public Collections: Amon Carter; CSFAC; Dayton; IMP; Kalamazoo; LC; MFAH; MOMA; NGC; Nebraska; Nelson; NOMA; Princeton; Roswell; Smithsonian; St. Petersburg; Tucson; UNM; Yale

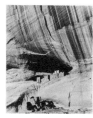

302. PORTRAIT OF GLADYS FOWLER, 1910
 autochrome
 9⅝" x 5⁵/₁₆" / 24.4cm. x 13.5cm.
 Signed, Laura Gilpin/1910, lower right (mat)
 Nebraska Art Association, purchased with the aid of funds from the National Endowment for the Arts, 1977
 Acc. No. N-464

303. SUNRISE AT GRAND CANYON, 1930
 platinum print
 9½" x 7¾" / 24.1cm. x 19.7cm.
 Signed, Laura Gilpin/1930, lower right (mat)
 Nebraska Art Association, purchased with the aid of funds from the National Endowment for the Arts, 1977
 Acc. No. N-465

304. THE WHITE HOUSE, CANYON DE CHELLY, 1930
 silver print
 14¹/₁₆" x 11⅛" / 35.7cm. x 28.4cm.
 Signed, Laura Gilpin/1930, lower right
 Reproduced: *The Pueblos,* p. 69
 Nebraska Art Association, purchased with the aid of funds from the National Endowment for the Arts, 1977
 Acc. No. N-472

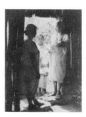

*305. MAYAN WOMEN, 1932
 silver print
 9¾" x 7⁷/₁₆" / 24.8cm. x 18.9cm.
 Signed, Laura Gilpin/1932, lower right (mat)
 Nebraska Art Association, purchased with the aid of funds from the National Endowment for the Arts, 1977
 Acc. No. N-466

306. THE CLIFF PALACE FROM SUN POINT, 1941
 silver print
 19¹/₁₆" x 14¹⁵/₁₆" / 48.4cm. x 37.7cm.
 Signed, Laura Gilpin/1941, lower right
 Reproduced: *The Pueblos,* p. 35
 Nebraska Art Association, purchased with the
 aid of funds from the National Endowment for
 the Arts, 1977
 Acc. No. N-467

307. SUMMER HOGAN OF OLD LADY LONG SALT,
 1953
 silver print
 11" x 13¹⁵/₁₆" / 27.9cm. x 35.4cm.
 Signed, Laura Gilpin/1953, lower right (mat)
 Reproduced: *The Enduring Navajo,* p. 70-71
 Nebraska Art Association, purchased with the
 aid of funds from the National Endowment for
 the Arts, 1977
 Acc. No. N-468

308. BALLOONS AT WINDOW ROCK, 1964
 type C color print
 7¹⁵/₁₆" x 9¹⁵/₁₆ / 20.2cm. x 25.2cm.
 Signed, Laura Gilpin/1964, lower right
 Nebraska Art Association, purchased with the
 aid of funds from the National Endowment for
 the Arts, 1977
 Acc. No. N-469

FRANK GOHLKE
b. Wichita Falls, Texas, 1942
Education: University of Texas, Austin, BA (English),
1964; Yale University, New Haven, CT, MA (English),
1967; studied with Paul Caponigro, 1967-68
Awards: 1973—Minnesota State Arts Council, Visual
Arts Fellowship; 1975—Guggenheim; 1976-77—NEA
Solo Exhibitions: 1969—Middlebury College, Middle-
bury, VT; University of Ohio, Zanesville; 1970—Ben-
nington; 1971—Underground; 1974—IMP; Halsted;
AIC; 1975—Light; Amon Carter
Public Collections: Amon Carter; AIC; ENB; IMP;
Kalamazoo; Kansas; Logan; NGC; Middlebury College,
VT; MIA; Nebraska; Polaroid; Seagram; UNM

309. GRAIN ELEVATORS, MINNEAPOLIS, SERIES 1,
 19, 1976
 silver print
 8⁵/₁₆" x 8¼" / 21.1cm. x 21cm.
 Signed, Frank Gohlke 1974, verso
 Nebraska Art Assocation, purchased with the
 aid of funds from the National Endowment for
 the Arts, 1976
 Acc. No. N-371

*310. LANDSCAPE—GRAIN ELEVATOR AND
 LIGHTNING FLASH, LAMESA, TEXAS, 1976
 silver print
 13¾" x 13¾" / 34.9cm. x 34.9cm.
 Signed, Frank W. Gohlke 1976, verso
 Nebraska Art Association, purchased with the
 aid of funds from the National Endowment for
 the Arts, 1976
 Acc. No. N-418

EMMET GOWIN
b. Danville, Virginia, 1941
Education: Richmond Professional Institute, Rich-
mond, VA, BFA, 1965; RISD, MFA, 1967; studied with
Harry Callahan
Awards: 1974—Guggenheim; 1977—NEA
Solo Exhibitions: 1968—Dayton; 1971—MIT; PG-Lon-
don; 1972—Light; 1973—FOP; Light; 1974—Fotogal-
erie Lichtropfen, Aachen, West Germany; 1976—Light;
1977—Spiritus
Public Collections: AIC; Arizona; CPS; Cincinnati;
Corcoran; Dayton; Detroit; Fogg; IMP; Kansas; LC;
Louisville; NGC; MIA; MFA; MFAH; MOMA; Nebraska;
NOMA; Polaroid; Princeton; RISD; Smithsonian; St.
Petersburg; Tucson; UCLA; UNM; VMFA; Worcester;
Yale

*311. VIEW OF RENNIE BOOHER'S HOUSE,
 DANVILLE, VIRGINIA (Gertrude Mitchell), 1973
 silver print
 8" x 9¹⁵/₁₆" / 20.3cm. x 25.2cm.
 Signed, Emmet Gowin, verso
 Reproduced: *Emmet Gowin Photographs,* n.p.
 Nebraska Art Association, purchased with the
 aid of funds from the National Endowment for
 the Arts, 1976
 Acc. No. N-397

ROBERT GRIER
b. Alliance, Nebraska, 1946
Education: North Platte Junior College, North
Platte, NE
Solo Exhibitions: 1973—Kansas; 1975—Nebraska
Public Collections: Kansas; Nebraska

312. ICE BREAK UP AT MC CONAUGHY, 1972
 silver print
 9⅜" x 7⁷/₁₆" / 23.8cm. x 18.9cm.
 Signed, R. D. Grier, verso
 Nebraska Art Association, purchased from the
 artist, gift of Lawrence Reger
 Acc. No. N-434

152

313. STORM CLOUDS AT BRANCHED OAK, 1972
silver print
8½" x 6⁵/₁₆" / 21.6cm. x 16cm.
Signed, R. D. Grier, verso
Reproduced: **NAA Quarterly,** Winter, 1974, p. 6
Nebraska Art Association, purchased from the
artist, gift of Lawrence Reger
Acc. No. N-435

314. TOADSTOOL PARK #1, 1972
silver print
7¼" x 8¾" / 18.4cm. x 22.2cm.
Signed, R. D. Grier, verso
Nebraska Art Association, purchased from the
artist, gift of Lawrence Reger
Acc. No. N-436

HENRY D. GUILBERT, Honduran
Note: These photographs were presented by a nephew
of the artist during his residency at the University. Ex-
tensive enquiry made in the interests of the present
publication has failed to produce information regard-
ing place and date of birth, education and subsequent
activity.

315. PACIFIC COAST—SAN LORENZO—BOATS
silver print
10½" x 12⅞" / 26.7cm. x 32.7cm.
Signed, Guilbert, lower left
Acc. No. U-292

316. PACIFIC COAST—SAN LORENZO—PALM
silver print
13⅜" x 10½" / 34cm. x 26.7cm.
Signed, Guilbert, lower center
Acc. No. U-293

317. COUNTRY GIRL
silver print
13⅜" x 10½" / 34cm. x 26.7cm.
Signed, Guilbert, lower right
Acc. No. U-294

318. MAN WITH CHICKENS
silver print
10⅜" x 12⅜" /26.4cm. x 31.4cm.
Signed, Guilbert, lower right
Acc. No. U-295

319. HOUSE—NEAR YOJOA LAKE
silver print
13⅜" x 10½" / 34cm. x 26.7cm.
Signed, Guilbert, lower left
Acc. No. U-296
Note: Nos. 315 through 319 are part of the University
Collection, gift of Fernando Lardizabal, 1955.

ARA GULER, Turkish
b. Istanbul, Turkey, 1928
Education: Istanbul University (Economics & Jour-
nalism)
Awards: 1962—Master of Leica
Solo Exhibitions: 1967—Nebraska; 1972—BN
Public Collections: Nebraska

320. UNTITLED (Turkish Wall Sign)
silver print
11⅝" x 9¹³/₁₆" / 29.5cm. x 24.9cm.
Stamped, Photographed by Ara Guler, verso
Reproduced: **Camera,** Feb., 1962, p. 3
University Collection, purchased from the artist,
1967
Acc. No. U-554

321. UNTITLED (Gasoline Cans)
silver print
16⅞" x 11¼" / 42.9cm. x 28.6cm.
Stamped, Photographed by Ara Guler, verso
University Collection, purchased from the artist,
1967
Acc. No. U-555

322. UNTITLED (Two Turkish Women With Children)
silver print
17" x 11⁷/₁₆" / 43.2cm. x 29.1cm.
Stamped, Photographed by Ara Guler, verso
University Collection, purchased from the artist,
1967
Acc. No. U-556

323. UNTITLED (Turkish Boy)
 silver print
 11⅜" x 16¹⁵/₁₆" / 28.9cm. x 43cm.
 Stamped, Photographed by Ara Guler, verso
 Reproduced: *Camera,* Feb., 1977, p. 17
 University Collection, purchased from the artist,
 1967
 Acc. No. U-557

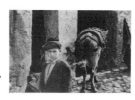

324. UNTITLED (Courtyard of a Turkish House)
 silver print
 17⁷/₁₆" x 11¾" / 44.3cm. x 29.8cm.
 Stamped, Photographed by Ara Guler, verso
 Unlversity Collection, purchased from the artist,
 1967
 Acc. No. U-558

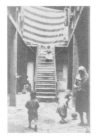

325. UNTITLED (Turkish Cemetery)
 silver print
 11⅝" x 7¾" /29.5cm. x 19.7cm.
 Stamped, Photographed by Ara Guler, verso
 University Collection, purchased from the artist,
 1967
 Acc. No. U-559

BETTY HAHN
b. Chicago, Illinois, 1940
Education: Indiana University, BA, 1963; MFA, 1966;
worked with Henry Holmes Smith and Nathan Lyons,
1967-68
Awards: 1971—Pratt Graphics Center; 1976—New
York State Council on the Arts
Solo Exhibitions: 1968—Cabrillo College, Aptos, CA
(with Gayle Smalley); 1969—Smithsonian (with Gayle
Smalley); 1971—CPS; 1972—Riverside Gallery,
Rochester, NY; 1973—Witkin; 1974—Focus; 1976—
Nexus; New England
Public Collections: AIC; Akron; BN; Boulder; CPS;
CMB; Colorado; ENB; IMP; Kansas; MOMA; NGC; Ne-
braska; Oklahoma; Oakland; Pasadena; SFMMA; San
Jose State College; San Jose, CA; Smithsonian; Tuc-
son; UCLA; UNM; VMFA; VSW
*326. ROAD AND RAINBOW, 1971
 gum bichromate on cotton with colored thread
 stitching
 10⅝" x 14¾" / 27cm. x 37.5cm.
 Signed, 1971 Betty Hahn, verso
 Reproduced: *Women of Photography,* n.p.
 F. M. Hall Collection, purchased from the artist,
 1972
 Acc. No. H-1586

CHARLES HARBUTT
b. Camden, New Jersey, 1935
Education: Marquette University, BS (Journalism),
1956
Awards: 1972—CAPS
Solo Exhibitions: 1960—Image Gallery, NYC; MMA;
1963—IMP; 1965—MOMA; 1966—IMP; 1967—AIC;
Smithsonian; 1969—Jewish Museum, NYC; Brooklyn;
1970—MIT; Sao Paulo Biennial; 1971—Imagework,
Boston; MOMA; 1974—Photogalerie, Paris; 11 Dia-
framma, Milan, Italy; Photography Place; Soho; Mid-
town YMHA; Jewish Museum, NYC; Whitney; 1975 —
Peter's Valley Craftsmen, Layton, NY; Community Dark
Room, Syracuse, NY; Photopia, Philadelphia, PA; PG-
London; Syracuse University, Syracuse, NY; 1975-76—
Musee Reattu, Arles, France; 1976 — Kenan Center,
Lockport, NY; Garrett; Vassar; Bennington; 1977
—Kalamazoo; Panopticon; Infinite Eye, Milwaukee;
Dayton
Public Collections: Smithsonian//AIC; BN; ENB; IMP;
Iowa; LC; MMA; MOMA; Nebraska; NOMA; Princeton;
RISD; SFMMA; Stedelijk

327. BLIND CHILD GRASPING FOR LIGHT, 1961
 silver print
 6½" x 10" / 16.5cm. x 25.4cm.
 Reproduced: *LLP: Light & Film,* p. 27; *Photo-
 graphy in America,* p. 231; *Photography in the
 Twentieth Century,* p. 105; *Aperture,* 12:3,
 n.p.; *Aperture,* 14:2, n.p.
 F. M. Hall Collection, 1966
 Acc. No. H-1018

328. UNTITLED (Back Seat), 1963
 silver print
 6½" x 10" / 16.5cm. x 25.4cm.
 F. M. Hall Collection, 1966
 Acc. No. H-1017

*329. EMPTY BILLBOARDS, AVENUE OF THE
 AMERICAS, NEW YORK, 1965
 silver print
 6½" x 10" / 16.5cm. x 25.4cm.
 Reproduced: *Travelog,* p. 9
 F. M. Hall Collection, 1966
 Acc. No. H-1019

DAVE HEATH
b. Philadelphia, Pennsylvania, 1931
Education: Philadelphia Museum College of Art, 1957
Awards: 1963,1964 — Guggenheim
Solo Exhibitions: 1958 — 7 Arts Gallery, NYC; 1961 —
Image Gallery, NYC; 1963 — AIC; 1964 — IMP; 1965 —
Minnesota
Public Collections: NGC// AIC; IMP; Minnesota;
MOMA; Nebraska; PMA; Tampa; UCLA; VSW; Yeshiva
University, NYC

*330. DOG IN LANDSCAPE, 1963
 silver print
 9¾″ x 6½″ / 24.8cm. x 16.5cm.
 Signed, Dave Heath, lower right
 F. M. Hall Collection, purchased from the artist,
 1966
 Acc. No. H-1025

331. PORTRAIT OF GIRL IN CAR: MARGARITA
 PEREZ, 1964
 silver print
 8¹³⁄₁₆″ x 9⅜″ / 22.4cm. x 23.8cm.
 Signed, Dave Heath, lower right
 F. M. Hall Collection, purchased from the artist,
 1966
 Acc. No. H-1024

332. ANGRY BOY BEING RESTRAINED, 1964
 silver print
 10¾″ x 7⅜″ / 27.6cm. x 18.7cm.
 Signed, Dave Heath, lower right
 Reproduced: *American Photography: The
 Sixties,* p. 20
 F. M. Hall Collection, purchased from the artist,
 1966
 Acc. No. H-1026

ROBERT HEINECKEN
b. Denver, Colorado, 1931
Education: UCLA, BA, 1959; MFA, 1960
Awards: 1975 — Guggenheim; 1977 — NEA
Solo Exhibitions: 1964 — Mount St. Mary's Fine Arts
Gallery, Los Angeles; 1965 — Long Beach Museum of
Art, CA; 1966 — California State College, Los Angeles;
Mills; 1967 — IMP; 1968 — Focus; 1969 — Occidental Col-
lege, Los Angeles; 1970 — Witkin; Phoenix College;
1971 — Boulder; 1972 — Pasadena; 1973 — California
State College, San Bernardino, CA; FOP; Light; 1974 —
Madison; 1976 — Dallas; Light; IMP
Public Collections: Alabama; Claremont College,
Claremont, CA; FOGG; IMP; Kansas; LC; Louisville;
MIA; Mills; MFAH; MOMA; NGC; Nebraska; Newport

Beach; Northeastern; Oakland; Pasadena; Santa
Monica College, Santa Monica, CA; SFMMA; St. Peters-
burg; Tucson; UNM; VSW; Worcester

333. FOUR FIGURES #2, 1970
 photogram, bleached, stained, redeveloped,
 solarized
 9⅞″ x 7¾″ / 25.1cm. x 19.7cm.
 Signed, Heinecken May 70, lower right
 Nebraska Art Association, purchased with the
 aid of funds from the National Endowment for
 the Arts, 1976
 Acc. No. N-416

*334. L IS FOR LEMON SLICES — 4, 1971
 hand colored photogram (chalk)
 4¹³⁄₁₆″ x 7⅞″ / 12.2cm. x 20cm.
 Signed, Heinecken 1971, lower right
 Nebraska Art Association, purchased with the
 aid of funds from the National Endowment for
 the Arts, 1976
 Acc. No. N-417

GEORGE HERLICK
Note: George Herlick is one of seven photographers
whose work was allocated by the Work Projects Ad-
ministration to the University of Nebraska Art Galleries
in 1943. Extensive enquiry made in the interests of the
present publication has failed to produce information
regarding place and date of birth, education and sub-
sequent activity.

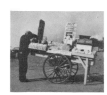

335. HOT PEANUTS
 silver print
 9⅞″ x 11¼″ / 25.1cm. x 28.6cm.
 University Collection
 Acc. No. U-1989

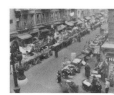

336. ORCHARD STREET
 silver print
 10⅝″ x 13¼″ / 27cm. x 33.7cm.
 University Collection
 Acc. No. U-1990

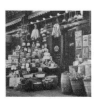

337. GROCERIES
 silver print
 11¼″ x 10½″ / 28.6cm. x 26.7cm.
 University Collection
 Acc. No. U-1991

338. BASS VIOL
 silver print
 9⅛" x 8⅛" / 23.2cm. x 20.6cm.
 University Collection
 Acc. No. U-1992

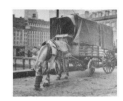

339. TIME OUT FOR LUNCH
 silver print
 8⅝" x 10¼" / 21.9cm. x 26cm.
 University Collection
 Acc. No. U-1993

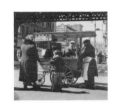

340. LIGHT REFRESHMENTS ON 8TH AVENUE
 silver print
 9¼" x 9⅛" / 23.5cm. x 23.2cm.
 University Collection
 Acc. No. U-1994

341. LOAD OF HAY
 silver print
 9⅛" x 10½" / 23.2cm. x 26.7cm.
 University Collection
 Acc. No. U-1995

342. HORSES AND DRAY
 silver print
 5⅜" x 9½" / 13.7cm. x 24.1cm.
 University Collection
 Acc. No. U-1996

ANDREW HERMAN
Note: Andrew Herman is one of seven photographers whose work was allocated by the Work Projects Administration to the University of Nebraska Art Galleries in 1943. Extensive enquiry made in the interests of the present publication has failed to produce information regarding place and date of birth, education and subsequent activity.

343. SEWING PROJECT
 silver print
 10¼" x 10½" / 26cm. x 26.7cm.
 University Collection
 Acc. No. U-1895

KEN HEYMAN
b. New York, New York, 1930
Education: Self taught in photography
Awards: 1976—World Understanding
Solo Exhibitions: 1963—MOMA; 1965—Hallmark; Smithsonian; 1976—ICP
Public Collections: Smithsonian// Nebraska; PMA

344. WOMAN WITH BIRD, PERU, 1963
 silver print
 16½" x 13¼" / 41.9cm. x 33.7cm.
 Stamped, Ken Heyman, verso
 F. M. Hall Collection, purchased from the artist, 1966
 Acc. No. H-1120

*345. TWO MEN, COLOMBIA, 1963
 silver print
 12⅛" x 16⁵/₁₆" / 30.8cm. x 41.4cm.
 Stamped, Ken Heyman, verso
 F. M. Hall Collection, purchased from the artist, 1966
 Acc. No. H-1121

DAVID OCTAVIUS HILL, Scottish
b. Perth, Scotland, 1802
d. Edinburgh, Scotland, 1870
Solo Exhibitions: 1970—Davison; 1977—Thackrey & Robertson
Public Collections: Edinburgh Public Libraries; NGC; National Library of Scotland, Edinburgh; NPG-London; Royal Scottish Academy, Edinburgh; Scottish National Portrait Gallery, Edinburgh; Texas// Albright-Knox; AIC; Cincinnati; Cornell; Detroit; ENB; Fogg; High; IMP; Indiana; LC; Michigan; MOMA; MFA; Nebraska; NOMA; Oklahoma; PMA; Princeton; RISD; SFMMA; Seattle; Smith; Smithsonian; Tampa; Tucson; UNM; VMFA; Worcester

*346. PORTRAIT OF SIR FRANCIS GRANT, P.R.S.A., Sept., 1845
 carbon print from the original calotype negative made by Jessie Bertram, 1916
 7¹³/₁₆" x 5⅝" / 19.8cm. x 14.3cm.
 Reproduced: *Schwarz,* pl. 44; *Nickel,* pl. 65; *An Early Victorian Album,* p. 134
 F. M. Hall Collection, 1975
 Acc. No. H-2031

LEWIS W. HINE
b. Oshkosh, Wisconsin, 1874
d. Hastings-on-Hudson, New York, 1940
Education: University of Chicago; Ethical Culture School, NYC; Columbia University, Pd M, 1905; self taught in photography
Solo Exhibitions: 1920—Civic Art Club, NYC; National Arts Club, NYC; Woman's Club, Hastings-on-Hudson; 1931—Yonkers Museum, Yonkers, NY; 1939—Photo League; Riverside Museum, NYC; Des Moines Fine

Arts Association, IA; NY State Museum, Albany; 1970-71—Witkin; 1971— Halsted; Focus; 1973— Paine Art Center, Oshkosh, WI; Vassar; 1974—Topeka; 1975—GI; 1977—Brooklyn; Berkeley; Denver; Chicago Historical Society; Carnegie Institute, Pittsburgh, PA; Yale; Topeka

Public Collections: LC; Louisville// Addison; AIC; BPL; Carpenter; Cincinnati; Cornell; Detroit; ENB; Fogg; High; IMP; Menil; Michigan; Milwaukee; MIA; Minnesota; MFA; MFAH; MOMA; NCFA; NGC; Nebraska; NOMA; Oklahoma; Pasadena; Princeton; RISD; SFMMA; Seagram; Smithsonian; Tampa; Texas; UNM; VMFA; Worcester; Yale

Note: For a list of archival collections of Hine's photographs, see Gutman, *Lewis Hine & the American Social Conscience,* pp. 52-53

347. SULLIVAN'S DELIVERY BOY, SO. CAROLINA, 1908
silver print
4¾" x 6¾" / 12.1cm. x 17.1cm.
F. M. Hall Collection, 1974
Acc. No. H-2035

348. TWO SMILING BOYS, INDIANA, 1908
silver print
4⅞" x 6¾" / 12.4cm. x 17.1cm.
F. M. Hall Collection, 1974
Acc. No. H-2033

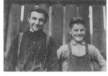

*349. BOY GOING TO WORK, MERRIMAC MILLS, HUNTSVILLE, ALABAMA, NOON, November, 1910
silver print
4¹¹/₁₆" x 6¹¹/₁₆" / 11.9cm. x 17cm.
Reproduced: *Gutman,* p. 103
F. M. Hall Collection, 1974
Acc. No. H-2143

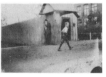

350. OYSTER SHUCKER, MISSISSIPPI, 1911
silver print
4¾" x 6¾" / 12.1cm. x 17.1cm.
F. M. Hall Collection, 1974
Acc. No. H-2034

351. DRESSMAKER, BOSTON, MASS., c. 1916
silver print
4⅝" x 6¾" / 11.7cm. x 17.1cm.
F. M. Hall Collection, 1974
Acc. No. H-2032

HY HIRSH

Note: Hy Hirsh is one of seven photographers whose work was allocated by the Work Projects Administration to the University of Nebraska Art Galleries in 1943. Extensive enquiry made in the interests of the present publication has failed to produce information regarding place and date of birth, education and subsequent activity.

Public Collections: Minnesota; Nebraska; Oregon

352. SAN FRANCISCO, March 8th, 1936
silver print
7¼" x 9¼" / 18.4cm. x 23.5cm.
University Collection
Acc. No. U-1894

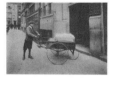

SOL HORN

See Hirsh—**Note Above**

353. YORK AVENUE, 1937
silver print
9⅜" x 12⅜" / 23.8cm. x 31.4cm.
University Collection
Acc. No. U-1850

BRUCE HOROWITZ

b. Philadelphia, Pennsylvania, 1949
Education: Pennsylvania State University, BA, 1970; SUNY-Buffalo; VSW, MFA, 1974
Awards: 1975—NEA; 1976, 1977—CAPS
Solo Exhibitions: 1974—Pennsylvania State University; Michigan; 1975—IMP
Public Collections: IMP; MOMA; Nebraska; VSW

354. UNTITLED (Portrait of a Girl), 1974
silver print
10½" x 10⁹/₁₆" / 26.7cm. x 26.8cm.
Nebraska Art Association, purchased with the aid of funds from the National Endowment for the Arts, 1976
Acc. No. N-431

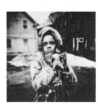

355. UNTITLED (Girl with Doll), 1974
silver print
10½" x 10⅝" / 26.7cm. x 27cm.
Nebraska Art Association, purchased with the aid of funds from the National Endowment for the Arts, 1976
Acc. No. N-432

GEORGE HORVATH

Note: George Horvath is one of seven photographers whose work was allocated by the Work Projects Administration to the University of Nebraska Art Galleries in 1943. Extensive enquiry made in the interests of the present publication has failed to produce information regarding place and date of birth, education and subsequent activity.

356. PIGEON (Sculpture by Reuben Nakian)
 silver print
 6½" x 9⅛" / 16.5cm. x 23.2cm.
 University Collection
 Acc. No. U-1873

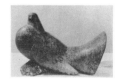

EIKOH HOSOE, Japanese
b. Tokyo, Japan, 1933
Education: Tokyo College of Photography, 1954
Awards: 1964—*Best Photographer of the Year* by
Society of Photographic Critics (Japan)
Solo Exhibitions: 1956, 1960—Japan; 1970—
Smithsonian; Focus; 1973—Light; 1974—International
Culture Center, Antwerp, Belgium; 1975—FOP; Spec-
trum Gallery, Barcelona; Light
Public Collections: Addison; BN; IMP; LC; MOMA;
Museum of Modern Art, Tokyo; NGC; Nebraska; Smith-
sonian; Tokyo College of Art, Nikon University; VSW;
Yale

*357. UNTITLED (#20), from "An Extravagantly Tragic
 Comedy," 1968
 silver print
 7¹³/₁₆" x 11⅝" / 19.8cm. x 29.5cm.
 Signed, Eikoh Hosoe/1970, verso
 F. M. Hall Collection, purchased from the artist,
 1970
 Acc. No. H-1417

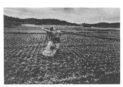

358. UNTITLED (#8), from "An Extravagantly Tragic
 Comedy," 1968
 silver print
 11⁵/₁₆" x 7⅝" / 28.7cm. x 19.4cm.
 Signed, Eikoh Hosoe/1970, verso
 F. M. Hall Collection, purchased from the artist,
 1970
 Acc. No. H-1418

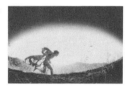

359. UNTITLED (#17), from "An Extravagantly Tragic
 Comedy," 1968
 silver print
 7⅞" x 11⅝" / 20cm. x 29.5cm.
 Signed, Eikoh Hosoe/1970, verso
 Reproduced: *Five Photographers,* n.p.
 F. M. Hall Collection, purchased from the artist,
 1970
 Acc. No. H-1419

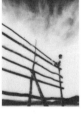

360. UNTITLED (#19), from "An Extravagantly Tragic
 Comedy," 1968
 silver print
 7¹¹/₁₆" x 11⁷/₁₆" / 19.5cm. x 29.1cm.
 Signed, Eikoh Hosoe/1970, verso
 F. M. Hall Collection, purchased from the artist,
 1970
 Acc. No. H-1420

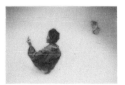

361. UNTITLED (#22), from "An Extravagantly Tragic
 Comedy," 1968
 silver print
 11⁷/₁₆" x 7⅞" / 29.1cm. x 20cm.
 Signed, Eikoh Hosoe/1970, verso
 Reproduced: *Five Photographers,* n.p.
 F. M. Hall Collection, purchased from the artist,
 1970
 Acc. No. H-1421

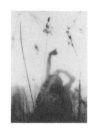

362. UNTITLED (#25), from "An Extravagantly Tragic
 Comedy," 1968
 silver print
 7⅞" x 11¾" / 20cm. x 29.8cm.
 Signed, Eikoh Hosoe/1970, verso
 Reproduced: *Five Photographers,* n.p.
 F. M. Hall Collection, purchased from the artist,
 1970
 Acc. No. H-1422

363. UNTITLED (#7), from "An Extravagantly Tragic
 Comedy," 1968
 silver print
 11½" x 7⅝" / 29.2cm. x 19.3cm.
 Signed, Eikoh Hosoe/1970, verso
 F. M. Hall Collection, purchased from the artist,
 1970
 Acc. No. H-1561

Note: The collection also includes, "Killed by Roses,"
photography Eikoh Hosoe, model and introduction by
Yukio Mishima, 1963 (Spanish translation).

EARL IVERSEN
b. Chicago, 1943
Education: University of Illinois at Chicago Circle, BA,
1970; Rhode Island School of Design, (photography),
MFA, 1973
Awards: 1970—Graham Foundation; 1976—Kansas
Arts Commission
Solo Exhibitions: 1975—Photographic Gallery, Kansas
City, MO
Public Collections: MOMA; Nebraska

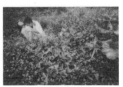

364. PARKING LOT, DISNEY WORLD, FLORIDA, 1972
 silver print
 6⅛" x 9³/₁₆" / 15.6cm. x 23.3cm.
 Signed, Earl Iversen, lower right
 Nebraska Art Association, purchased with the
 aid of funds from the National Endowment for
 the Arts, 1976
 Acc. No. N-353

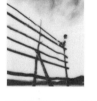

365. FORTRESS, QUEBEC PROVINCE, CANADA, 1972
 silver print
 6¹/₁₆″ x 9⅛″ / 15.4cm. x 23.2cm.
 Signed, Earl Iversen, lower right
 Nebraska Art Association, purchased with the
 aid of funds from the National Endowment for
 the Arts, 1976
 Acc. No. N-354

366. AT THE ARCH, ST. LOUIS, MISSOURI, 1974
 silver print
 6¹/₁₆″ x 9⅛″ / 15.4cm. x 23.2cm.
 Signed, Earl Iversen, lower right
 Nebraska Art Association, purchased with the
 aid of funds from the National Endowment for
 the Arts, 1976
 Acc. No. N-352

158

JOSEPH JACHNA
b. Chicago, Illinois, 1935
Education: Institute of Design, Illinois Institute of
Technology, Chicago, BS, 1968; MS, 1961; studied with
Aaron Siskind and Harry Callahan
Awards: 1973—Ferguson; FOP; 1976—NEA
Solo Exhibitions: 1960—Photo Independent Gallery,
Chicago; 1961—Photo Independent Gallery; McKerr
Observatory Gallery, Chicago; AIC; 1963—St. Mary's
College, Notre Dame; 1964—Highland Park High
School, Chicago; 1965—University of Illinois, Chicago;
1969—Oregon; 1970—Lightfall Gallery, Evanston, IL;
University of Wisconsin, Milwaukee; Maine; 1971—
Louisville; 1972—AIC; Lightfall Gallery; Shado; 1974—
CPS; FOP; Dayton; Tyler; Nikon; 1975—University of
Notre Dame, IN; Oakton Community College, Oakton,
IL; Afterimage Gallery, Dallas, TX; 1976—Silver Image-
Ohio
Public Collections: AIC; Burpee; CPS; ENB; FOP; ID;
IMP; Kalamazoo; Kansas; Logan; Louisville; MIT;
Milwaukee, MIA; MFAH; Nebraska; Purdue University,
Lafayette, IN; Ryerson; Shado

367. DOOR COUNTY, WISCONSIN, 1970
 silver print
 6¹³/₁₆″ x 10⅛″ / 17.3cm. x 25.7cm.
 Signed, Joseph Jachna, verso
 Nebraska Art Association, purchased from the
 artist, with the aid of funds from the National
 Endowment for the Arts, 1976
 Acc. No. N-367

368. COLORADO, 1974
 silver print
 9″ x 13½″ / 22.9cm. x 34.3cm.
 Signed, Joseph Jachna, verso
 Nebraska Art Association, purchased from the
 artist, with the aid of funds from the National
 Endowment for the Arts, 1976
 Acc. No. N-407

*369. NEAR GRAND ISLAND, NEBRASKA, 1975
 silver print
 8³/₁₆″ x 12″ / 20.8cm. x 30.5cm.
 Signed, Joseph Jachna, verso
 Nebraska Art Association, purchased from the
 artist, with the aid of funds from the National
 Endowment for the Arts, 1976
 Acc. No. N-408

WILLIAM HENRY JACKSON
b. Keesville, New York, 1843
d. New York, New York, 1942
Note: Between 1870-79 Jackson worked as a pho-
tographer for eight U. S. Government geological sur-
veys of the American West. His work was instrumental
in the establishment of the Yosemite National Park in
1872. Self taught in photography.
Awards: 1937—Recognition medal, University of Colo-
rado; 1938—Honorary Fellow, RPS; 1941—Honorary
Doctor of Law, University of Wyoming
Public Collections: Amon Carter; BPL; Colorado His-
torical Society, Denver, CO; Denver Public Library; LC//
Addison; AIC; Berkeley; Carpenter; Detroit; ENB;
Fogg; High; IMP; MOMA; NCFA; NGC; Nebraska;
NOMA; Oakland; RISD; Smithsonian; Texas; Tucson;
UNM; Yale

*370. GATEWAY AT THE GARDEN OF THE GODS,
 NEAR MANITOU
 albumen print
 5¹⁵/₁₆″ x 9¹³/₁₆″ / 15.1cm. x 24.9cm.
 Numbered and titled in the negative, No. 3082,
 Pikes Peak from the Garden of the Gods WBJ
 & Co.
 F. M. Hall Collection, 1976
 Acc. No. H-2036

371. BALANCED ROCK, GARDEN OF THE GODS
 albumen print
 7¹/₁₆″ x 4⁷/₁₆″ / 17.9cm. x 11.3cm.
 Numbered and titled in the negative, No. 602
 Balanced Rock Garden of the Gods WHJ
 & Co.
 F. M. Hall Collection, 1976
 Acc. No. H-2037

KEITH JACOBSHAGEN

b. Wichita, Kansas, 1941
Education: Kansas City Art Institute, BFA, 1965; Kansas, MFA, 1968
Awards: 1970—Tulsa Art Directors Club; 1975—Woods
Solo Exhibitions: 1969—Nebraska; 1972—Alfred University, Alfred, NY; 1974—Nebraska
Public Collections: Kansas; NBC-Lincoln; Nebraska; Oakland; Oklahoma; Pasadena

372. SALT LAKE CITY, 1972
silver print
6⁵/₁₆″ x 9¹/₁₆″ / 16cm. x 23cm.
Signed, K. Jacobshagen, lower left
F. M. Hall Collection, purchased from the artist, 1974
Acc. No. H-2068

*373. LINCOLN, NEBRASKA, 1973
silver print
9¹/₈″ x 13³/₈″ / 23.2cm. x 34cm.
Signed, K. Jacobshagen, lower right
F. M. Hall Collection, purchased from the artist, 1974
Acc. No. H-2072

374. RUTHERFORD, CALIFORNIA, 1973
silver print
6¹/₄″ x 9¹/₈″ / 15.9cm. x 23.2cm.
Signed, K. Jacobshagen, lower left
F. M. Hall Collection, purchased from the artist, 1974
Acc. No. H-2069

375. RUTHERFORD, CALIFORNIA, 1974
silver print
9¹/₈″ x 13¹/₁₆″ / 23.2cm. x 33.2cm.
Signed, K. Jacobshagen, lower left
F. M. Hall Collection, purchased from the artist, 1974
Acc. No. H-2070

376. LINCOLN, NEBRASKA, 1974
silver print
9″ x 13¹/₁₆″ / 22.9cm. x 33.2cm.
Signed, K. Jacobshagen, lower left
F. M. Hall Collection, purchased from the artist, 1974
Acc. No. H-2071

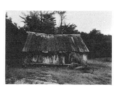

377. NAPA, CALIFORNIA, 1974
silver print
9″ x 13¹/₈″ / 22.9cm. x 33.3cm.
Signed, K. Jacobshagen, lower right
F. M. Hall Collection, purchased from the artist, 1974
Acc. No. H-2073

CHRISTOPHER JAMES

b. Boston, Massachusetts, 1947
Education: Cummington Community of the Arts, Cummington, MA, 1968; Massachusetts College of Art, Boston, BFA, 1969; RISD, MAT, 1971
Solo Exhibitions: 1969—Boston Art Director's Club; 1973—Eastman Kodak, Rochester, NY; 1974—Springfield; Archetype Gallery, New Haven, CT; 1975—Shado; Siembab; Connecticut College Museum, New London, CT; 1976—Siembab; 1977—Panopticon; Nebraska; Amherst College, Amherst, MA; MIA; Archetype Gallery
Public Collections: Amherst College; BN; Logan; MIA; Musee Francais de la Photographie, Bievre, France; Nebraska; Worcester

378. SIDEWALK SUPPER, 1974
silver print
8³/₄″ x 11¹³/₁₆″ / 22.2cm. x 30cm.
Signed, Christopher P. James/1974, verso
F. M. Hall Collection, purchased from the artist, 1975
Acc. No. H-2038

379. COMMENCMENT TENT NO. 7, 1976
silver print with applied enamel
5″ x 7¹/₈″ / 12.7cm. x 18.1cm.
Signed, Christopher James 1976, verso
Nebraska Art Association, purchased from the artist, with the aid of funds from the National Endowment for the Arts, 1977
Acc. No. N-445

KENNETH JOSEPHSON

b. Detroit, Michigan, 1932
Education: Rochester Institute of Technology, BFA, 1951-53, 1955-58; Institute of Design, Illinois Institute of Technology, MA, 1959-60
Awards: 1972—Guggenheim; 1975—NEA
Solo Exhibitions: 1966—Konspackskolan, Stockholm, Sweden; 1971—VSW; AIC; 1973—SUNY-Buffalo; University of Rochester, Rochester, NY; Nova Scotia College of Design, Halifax, NS; 1974—291 Gallery, Milan, Italy; Iowa; College of Marin, Kentfield, CA; 1976—Cameraworks Gallery, Los Angeles; Brucke
Public Collections: AIC; BN; Burpee; CPS; ENB; Fogg; Gainesville; IMP; Iowa; Louisville; MIA; MFAH; MOMA; NGC; Nebraska; Pasadena; Princeton; SFMMA; Seagram; St. Petersburg; Tampa; UCLA; UNM; VMFA; VSW

*380. MR. ADAMS, ROCHESTER, NEW YORK, 1956
 silver print
 5⅝" x 7½" / 14.3cm. x 19.1cm.
 F. M. Hall Collection, purchased from the artist,
 1965
 Acc. No. H-1032

381. CHICAGO, 1961
 silver print
 5¹⁵/₁₆" x 8¹⁵/₁₆" / 15.1cm. x 22.7cm.
 Reproduced: *Photography in the Twentieth*
 Century, p. 127; *LLP: Light & Film,* p. 40
 F. M. Hall Collection, purchased from the artist,
 1965
 Acc. No. H-1033

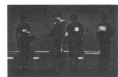

382. CHICAGO, 1961
 silver print
 5¹³/₁₆" x 9¹/₁₆" / 14.8cm. x 23cm.
 F. M. Hall Collection, purchased from the artist,
 1965
 Acc. No. H-1034

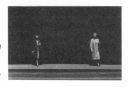

YOUSEF KARSH, Canadian
b. Mardin, Armenia (Turkey), 1908
Education: Studied under John H. Garo, Boston
Awards: 1960—Doctor of Laws, Carleton University,
Ottawa, Ontario; Doctor of Laws, Queen's University,
Kingston, Ontario; 1961—Doctor of Humane Letters,
Dartmouth College; 1968—Medal of Service of the
Order of Canada; 1970—Honorary Fellow, RPS
Solo Exhibitions: 1959—NGC
Public Collections: AIC; IMP; Kansas; MMA; MOMA:
Museum of Modern Art, Tokyo; NGC; Nebraska; RPS;
St. Louis; UNM

383. SIR WINSTON CHURCHILL, 1941
 silver print
 19⅜" x 15⁹/₁₆" / 49.2cm. x 39.5cm.
 Signed, © Karsh/Ottawa, lower right
 Reproduced: *Life,* Dec. 1941 (cover); *Faces of*
 Destiny, p. 41; *A Concise History of Photo-*
 graphy, p. 208; *Portraits of Greatness,* p. 45;
 Karsh Portfolio, p. 35; *Faces of our Time,* p. 39;
 Karsh Portraits, p. 47
 Nebraska Art Association, gift of the Lincoln
 Camera Club, in memory of Sten T. Anderson,
 FPSA, 1977
 Acc. No. N-473

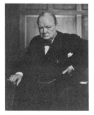

GERTRUDE KASEBIER
b. Des Moines, Iowa, 1852
d. New York, New York, 1934
Education: Studied painting/photography at Pratt In-
stitute, 1888; studied photography in Paris, 1893
Solo Exhibitions: 1906—Little Galleries of the Photo-
Secession, NYC; 1926—Brooklyn Institute of Arts &
Sciences

Public Collections: Albright-Knox; AIC; Baltimore;
Cornell; Detroit; ENB; Fogg; IMP; LC; Louisville; MIA;
MFA; MOMA; NGC; Nebraska; Oakland; PMA; Prince-
ton; RISD; SFMMA; Smithsonian; St. Petersburg;
Texas; Tucson; UNM; VMFA; Worcester; Yale

384. EVELYN NESBITT, c. 1903
 silver print toned and coated to simulate gum
 print
 13⁷/₁₆" x 10⁹/₁₆" /34.1cm. x 26.8cm.
 Reproduced: *LLP: The Camera,* p. 35; *Photo-*
 graphy in America, p. 79
 F. M. Hall Collection, 1968
 Acc. No. H-1294

385. ARTHUR B. DAVIES
 silver print toned and coated to simulate gum
 print
 13½" x 10⁹/₁₆" /34.3cm x 26.8cm.
 F. M. Hall Collection, 1968
 Acc. No. H-1293

*386. ROBERT HENRI
 silver print toned and coated to simulate gum
 print
 13⁷/₁₆" x 10⁷/₁₆" / 34.1cm. x 26.5cm.
 F. M. Hall Collection, 1968
 Acc. No. H-1296

387. CLARENCE WHITE FAMILY
 silver print toned and coated to simulate gum
 print
 13⁷/₁₆" x 10½" / 34.1cm. x 26.7cm.
 F. M. Hall Collection, 1968
 Acc. No. H-1295
Note: Nos. 384 through 387 printed from original neg-
atives at the Library of Congress.

ANDRE KERTESZ
b. Budapest, Hungary, 1894
Education: Academy of Commerce, Budapest; self
taught in photography
Awards: 1930—Silver medal, "Exposition Colonial,"
Paris; 1963—Gold medal, IV Mostra Biennale Inter-
nazionale della Fotografia, Venice; 1965—Honorary
Member, A.S.M.P.; 1974—Guggenheim; 1976—Com-
mander of the Order of Arts and Letters, French Gov-
ernment
Solo Exhibitions: 1927—Au Sacre du Printemps Gal-
lery, Paris; 1946—AIC; 1962—Long Island University,

160

NY; 1963—BN; Modernage Studio, NYC; IV Mostra Biennale Internazionale della Fotografia, Venice; 1965—MOMA; 1971—Moderna Museet, Stockholm; Magyar Nemzeti Galeria, Budapest; 1972—Valokuva-museon, Helsinki; 1973—Hallmark; Light; 1976—French Cultural Embassy, NYC; Silver Image-Ohio; 1977—Mirvish

Public Collections: AIC; CMB; Cleveland; Detroit; ENB; Everson; High; Indiana; IMP; Koenig-Albert Museum, (Zwickau; Krannert; Menil; Michigan; MFA; MFAH; MOMA; NGC; Nebraska; NOMA; Pasadena; Princeton; RISD; SFMMA; Smith; Smithsonian; Staatliche Museum Kunstbibliothek, Berlin; St. Petersburg; Tucson; UNM; Vassar, VMFA; Worcester; Yale

388. THE SWING, ESZTERGOM, HUNGARY,
 September 26, 1917
 silver print
 9¾″ x 7¾″ / 24.8cm. x 19.7cm.
 Signed, A. Kertesz, verso
 Reproduced: *Andre Kertesz—Sixty Years of Photography,* p. 25
 F. M. Hall Collection, 1970
 Acc. No. H-1424

389. BLIND MUSICIAN, ABONY, HUNGARY
 (Wandering Violinist), July 19, 1921
 silver print
 13¹⁵/₁₆″ x 11¹/₁₆″ / 35.4cm. x 28.1cm.
 Signed, A. Kertesz, verso
 Reproduced: *Newhall,* p. 156; *Andre Kertesz Photographer,* p. 11; *Andre Kertesz, Paragraphic,* p. 5; *Concerned Photographer,* n.p.; *Andre Kertesz—Sixty Years of Photography,* p. 23; *Maddow (Faces),* p. 491; *Camera,* April, 1963, p. 13
 F. M. Hall Collection, 1970
 Acc. No. H-1423

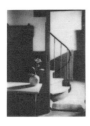

*390. CHEZ MONDRIAN, PARIS, 1926
 silver print
 13⁷/₁₆″ x 10″ / 34.1cm. x 25.4cm.
 Signed, Andre Kertesz, verso
 Reproduced: *Andre Kertesz, Paragraphic,* p. 43; *PFA-V,* 1967, p. 31; *Concerned Photographer,* n.p.; *Pollack,* p. 256; *Andre Kertesz—Sixty Years of Photography,* p. 119; *Camera,* April, 1963, p. 23; *Aperture,* 14:2, n.p.
 University Collection, gift of Lawrence Reger, 1968
 Acc. No. U-571

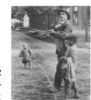
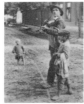

391. SATIRIC DANCER, PARIS, 1926
 silver print
 9¾″ x 7¹³/₁₆″ / 24.8cm. x 19.8cm.
 Signed, A. Kertesz/Paris 1926, verso
 Reproduced: *Andre Kertesz, Paragraphic,* p. 18; *Andre Kertesz, Photographer,* p. 22; *Concerned Photographer,* n.p.; *Pollack,* p. 256; *Andre Kertesz—Sixty Years of Photography,* p. 20; *Beaton/Buckland,* p. 146; *Maddow (Faces),* p. 451
 F. M. Hall Collection, 1970
 Acc. No. H-1426

392. MONTPARNASSE, SQUARE JOLIVET, PARIS, 1927
 silver print
 9¹³/₁₆″ x 7⅜″ / 24.9cm. x 18.7cm.
 Signed, A. Kertesz, verso
 Reproduced: *Andre Kertesz—Sixty Years of Photography,* p. 139
 F. M. Hall Collection, 1970
 Acc. No. H-1425

393. LANDING PIGEON, NEW YORK, March 2, 1960
 silver print
 13¹³/₁₆″ x 10¹⁵/₁₆″ / 35.1cm. x 27.8cm.
 Stamped verso, Photo by Andre Kertesz
 Reproduced: *Andre Kertesz, Paragraphic,* p. 51; *Concerned Photographer,* n.p.; *Pollack,* p. 257; *Andre Kertesz—Sixty Years of Photography,* p. 207; *Camera,* April, 1963, p. 29
 F. M. Hall Collection, 1966
 Acc. No. H-1123

394. RAIN, NEW YORK, 8/10/65
 silver print
 13⅝″ x 9⁹/₁₆″ / 34.6cm. x 24.3cm.
 Stamped verso, Photo by Andre Kertesz
 F. M. Hall Collection, 1966
 Acc. No. H-1122

LESLIE KRIMS

b. Brooklyn, New York, 1943

Education: Cooper Union, BFA, 1964; Pratt Institute, MFA, 1967

Awards: 1969—Artistic Decorators Inc.; 1970-71—Research Foundation at SUNY; 1971—NY State Council on the Arts; CAPS; National Education Association Fellowship; NEA; 1972—National Education Association Fellowship; 1973, 1975—CAPS

Solo Exhibitions: 1966—Pratt; 1969—IMP; Focus; Witkin; Akron; 1970—Il Diaframma, Milan, Italy; Galerie Prisma IV, Lund, Sweden; 1971—IMP; Moore College, Philadelphia; Boulder; Silver Image-Ohio; Toronto Gallery of Photography, Toronto; 1972—Witkin; International Culture Center, Antwerp, Belgium; Album Fotogalerie, Cologne, West Germany; 1973—Fotogal-

erie Wilde, Cologne, West Germany; Boston University; 1974—MFA; Galerie Delpire, Paris; Galeria Documenta, Torino, Italy; Light Impressions; 1975—Light; Yajima Gallerie, Montreal; Brucke; Shadai Gallery, Tokyo; VSW; 1976—Colgate University, Hamilton, NY; Ohio Wesleyan University, Delaware, OH; Colorado; Galerie A. Nagel, Berlin; 1977—Light

Public Collections: Addison; Charles Rand Penny Foundation, NYC; Colgate University, Hamilton, NY; Cornell; IMP; Kansas; Kalamazoo; LC; MIA; MFA; MFAH; MOMA; NGC; Nebraska; NOMA; Ohio Wesleyan University, Delaware, OH; Oklahoma; RISD; St. Petersburg; SUNY-Geneseo; Tokyo College of Photography, Japan; Tucson; UCLA; UNM; Vassar; VMFA; VSW

395. UNTITLED, from "Little People of America," 1971
kodalith
7¼" x 4¹⁵/₁₆" / 18.4cm. x 12.5cm.
Signed, Krims, lower right
Reproduced: **Little People of America,** n.p.;
Bulletin, UNM, p. 27
Nebraska Art Association, purchased with the aid of funds from the National Endowment for the Arts, 1976
Acc. No. N-394

396. UNTITLED, from "The Deerslayers," 1972
kodalith
4½" x 7" / 11.4cm. x 17.8cm.
Signed, Krims, lower right
Reproduced: **The Deerslayers,** n.p.
Nebraska Art Association, purchased with the aid of funds from the National Endowment for the Arts, 1976
Acc. No. N-395

KIPTON KUMLER
b. Cleveland, Ohio, 1940
Education: Cornell, BE, 1963; ME, 1966; Harvard, MBA, 1969; studied with Minor White and Paul Caponigro
Awards: 1976—NEA
Solo Exhibitions: 1972—Polaroid; 1974—MIT; Siembab; Addison; 1975—Schoelkopf; 1976—Douglas Kenyon Gallery, Chicago; 1977—Hawkins; Cronin
Public Collections: Addison; BN; Cornell; IMP; MMA; MFA; Nebraska; Worcester

397. UNTITLED (Plant Form), 1971
silver print
19¹/₁₆" x 15⁹/₁₆" / 48.4cm. x 39.5cm.
Signed, Kumler, lower right
Reproduced: **Kipton Kumler,** p. 49; **Afterimage,**
Dec. 1975, p. 15
Nebraska Art Association, purchased with the aid of funds from the National Endowment for the Arts, 1976
Acc. No. N-383

KARL E. KURTZ
b. Milwaukee, Wisconsin, 1942
Education: Columbus College of Art & Design, Columbus, OH; Kansas City Art Institute, BFA, 1965; Indiana University, MFA, 1969
Solo Exhibitions: 1975—The Gallery, Bloomington, IN; Concordia
Public Collections: Nebraska; Wellesley College Museum, Wellesley, MA

398. JOHN HENRY
dye transfer print
6¼" x 9½" / 15.9cm. x 24.1cm.
Signed, Carl Kurtz, lower left
University Collection, gift of the Nebraska Union, 1975
Acc. No. U-1716

ELLEN LAND-WEBER
b. Rochester, New York, 1943
Education: Brown University, Providence, RI, 1961-63; University of Michigan, Ann Arbor, 1964; Iowa, 1964-65, MFA, 1968
Solo Exhibitions: 1967—Gallery for Advancement of Photography, Iowa City; 1974—Nebraska; Focus; 1977—Spiritus; Spectrum Gallery, Tucson
Public Collections: AIC; IMP; NGC; Nebraska; NOMA; Pasadena; UNM

*399. ELEPHANT SWEEP, 1973
3M color print
10¹¹/₁₆" x 7¾" / 27.2cm. x 19.7cm.
Signed, E. Land-Weber 1973, lower right
F. M. Hall Collection, purchased from the artist, 1975
Acc. No. H-2040

400. WOMAN RIDING STORK, 1973
3M color print
10⁹/₁₆" x 8⁷/₁₆" / 26.8cm. x 21.4cm.
Signed, Ellen Land-Weber 1973, lower right
F. M. Hall Collection, purchased from the artist, 1975
Acc. No. H-2041

401. DEER FEAST, 1975
office copier print
8⁵/₁₆" x 11" / 21.1cm. x 27.9cm.
Signed, Ellen Land-Weber 1975, verso
F. M. Hall Collection, purchased from the artist, 1975
Acc. No. H-2039

162

DOROTHEA LANGE

b. Hoboken, New Jersey, 1895
d. Marin County, California, 1965
Education: Worked with Arnold Genthe, 1915; Columbia University; studied with Clarence White, 1917-18
Awards: 1941—Guggenheim
Solo Exhibitions: 1966—MOMA; Worcester; LACMA; Oakland; 1967-68—Amon Carter; 1971—Oakland
Public Collections: Oakland// Alabama; Amon Carter; AIC; Berkeley; Cleveland; Detroit; ENB; Fogg; IMP; LC; Louisville; Minnesota; MFA; MFAH; MOMA; Nebraska; NOMA; PMA; SFMMA; Smith; Smithsonian; Texas; Tucson; UNM; Worcester

402. THIRTEEN YEARS OLD, SAN FRANCISCO, 1923
silver print
12½″ x 10″ / 31.8cm. x 25.4cm.
Signed, Dorothea Lange, lower right
Reproduced: *Dorothea Lange,* p. 18
F. M. Hall Collection, purchased from the artist, 1965
Acc. No. H-1069

403. STREET DEMONSTRATION, SAN FRANCISCO, 1933
silver print
13¼″ x 10⅜″ / 33.7cm. x 26.4cm.
Signed, Dorothea Lange, upper right
Reproduced: *Photography 64,* p. 23; *Dorothea Lange,* p. 22; *The Woman's Eye,* p. 67; *U. S. Camera,* 1937, p. 31; *U. S. Camera,* 1941, Vol. I, p. 109
F. M. Hall Collection, purchased from the artist, 1965
Acc. No. H-1067

404. WHITE ANGEL BREAD-LINE, WATERFRONT, SAN FRANCISCO, 1933
silver print
13⅜″ x 10⁵/₁₆″ / 34cm. x 26.2cm.
Signed, Dorothea Lange, upper right
Reproduced: *Masters of Modern Art,* p. 195; *Family of Man,* p. 151; *Masters of Photography,* p. 141; *Dorothea Lange,* p. 20; *U. S. Camera,* 1935, p. 156; *U. S. Camera,* 1941, Vol. I, p. 116; *Camera,* Feb., 1973, p. 18
F. M. Hall Collection, purchased from the artist, 1965
Acc. No. H-1066

405. ANDREW FURUSETH, SAN FRANCISCO, CALIFORNIA, from ''The Human Face,'' 1934
silver print
8⅛″ x 7¾″ / 20.6cm. x 19.7cm.
Signed, D. L., lower left
F. M. Hall Collection, purchased from the artist, 1965
Acc. No. H-1075

406. MIGRANT MOTHER, NIPOMO, CALIFORNIA, 1936
silver print
13¼″ x 10½″ / 33.7cm. x 26.7cm.
Signed, Dorothea Lange, 1936, upper right
Reproduced: *Family of Man,* p. 151; *Masters of Photography,* p. 143; *Newhall,* p. 143; *Dorothea Lange,* p. 25; *In This Proud Land,* p. 18; *Photography in America,* p. 143; *Swedlund,* p. 26; *Maddow (Faces),* p. 320; *Masters of the Camera,* p. 130; *U. S. Camera,* 1936, p. 133; *Camera,* Oct., 1962, p. 39; *Portrait of a Decade,* p. 71
F. M. Hall Collection, purchased from the artist, 1965
Acc. No. H-1061

407. MIGRATORY COTTON PICKER, ELOY, PINAL COUNTY, ARIZONA (Man with Hand Raised), 1936
silver print
10³/₁₆″ x 13¹/₁₆″ / 25.9cm. x 33.2cm.
Signed, Dorothea Lange, upper right
Reproduced: *Dorothea Lange,* p. 18 (dated 1940); *Photographers on Photography,* pl. 28
F. M. Hall Collection, purchased from the artist, 1965
Acc. No. H-1062

408. MIGRATORY COTTON PICKER, ELOY, PINAL COUNTY, ARIZONA, 1936 (a)
silver print
7⅜″ x 9⁹/₁₆″ / 18.7cm. x 24.3cm.
Signed, D. L., upper left
F. M. Hall Collection, purchased from the artist, 1965
Acc. No. H-1064

409. MIGRATORY COTTON PICKER, ELOY, PINAL COUNTY, ARIZONA, 1936 (b)
silver print
7¼″ x 9⅝″ / 18.4cm. x 24.5cm.
Signed, D. L., upper left
F. M. Hall Collection, purchased from the artist, 1965
Acc. No. H-1063

410. MIGRATORY COTTON PICKER, ELOY, PINAL COUNTY, ARIZONA, 1936 (c)
silver print
7½″ x 9⅝″ / 19.1cm. x 24.5cm.
Signed, D. L., upper left
F. M. Hall Collection, purchased from the artist, 1965
Acc. No. H-1065

411. STOOP LABOR, SALINAS VALLEY, CALIFORNIA,
 1936
 silver print
 10⅜" x 13³/₁₆" / 26.4cm. x 33.5cm.
 Signed, Dorothea Lange, upper right
 Reproduced: **Family of Man,** p. 53; **In This Proud
 Land,** p. 101
 F. M. Hall Collection, purchased from the artist,
 1965
 Acc. No. H-1068

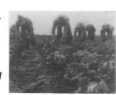

*412. GRAYSON, SAN JOAQUIN VALLEY, CALIFORNIA
 (Doorstep Document), from "Last Ditch," 1938
 silver print
 10¼" x 13" / 26cm. x 33cm.
 Signed, Dorothea Lange, lower right
 Reproduced: **Dorothea Lange,** p. 41; **U. S.
 Camera,** 1940, p. 169 (cropped)
 F. M. Hall Collection, purchased from the artist,
 1965
 Acc. No. H-1072

413. THE DEFENDANT, ALAMEDA COUNTY COURT
 HOUSE, OAKLAND, CALIFORNIA, 1956
 silver print
 13³/₁₆" x 10¼" / 33.5cm. x 26cm.
 Signed, Dorothea Lange, lower left
 Reproduced: **Masters of Photography,** p. 146;
 Dorothea Lange, p. 78 (dated c. 1955-57)
 F. M. Hall Collection, purchased from the artist,
 1965
 Acc. No. H-1074

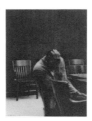

414. PATHAN WARRIOR TRIBESMAN,
 KHYBER PASS, from "Remembrance of
 Asia," 1958
 12⅞" x 10⁷/₁₆" / 32.7cm. x 26.5cm.
 Signed, Dorothea Lange, upper right
 Reproduced: **Dorothea Lange,** p. 89
 F. M. Hall Collection, purchased from the artist,
 1965
 Acc. No. H-1073

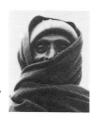

415. SONS OF ASIA #1, KOREAN CHILD, from
 "Remembrance of Asia," 1958
 silver print
 6³/₁₆" x 4¾" / 15.7cm. x 12.1cm.
 Signed, D. L., lower right
 Reproduced: **Dorothea Lange,** p. 94
 F. M. Hall Collection, purchased from the artist,
 1965
 Acc. No. H-1060

164

416. SONS OF ASIA: PAKISTANI YOUTH, KARACHI,
 from "Remembrance of Asia," 1958
 silver print
 9¹³/₁₆" x 11³/₁₆" / 24.9cm. x 28.4cm.
 Signed, Dorothea Lange, upper left
 Reproduced: **Dorothea Lange,** p. 90
 F. M. Hall Collection, purchased from the artist,
 1965
 Acc. No. H-1070

417. THREE O'CLOCK IN THE AFTERNOON,
 GOVERNMENT HOSPITAL, VENEZUELA, from
 "Women," 1960
 silver print
 10⅜" x 13⁵/₁₆" / 26.4cm. x 33.8cm.
 Signed, Dorothea Lange, lower right
 F. M. Hall Collection, purchased from the artist,
 1965
 Acc. No. H-1071

JACQUES HENRI LARTIGUE, French
b. Courbevoie, France, 1894
Education: Academie Julien, Paris; self taught in
photography
Awards: Legion d'Honneur; Medaille d'argent de la
Ville de Paris
Solo Exhibitions: 1963 — MOMA; 1966 — Photokina,
Cologne; 1970-71 — PG-London (Marseilles, Le Havre,
Hamburg); 1972 — Neikrug; Witkin; 1974 — Bibliotheque
Nationale, Montreal; 1975 — Musee des Arts Decoratifs,
Paris; 1976 — Seibu Art Museum, Tokyo
Public Collections: AIC; CMB; Detroit; ENB; Indiana;
IMP; Iowa; MIA; MOMA; Nebraska; Oberlin; SFMMA;
Tucson; VMFA

*418. GABY DESLYS AT THE CASINO DE PARIS, 1918
 silver print
 10⁵/₁₆" x 11¹/₁₆" / 26.2cm. x 28.1cm.
 Signed, J. H. Lartigue, lower right
 Reproduced: **Diary of a Century,** n.p.
 F. M. Hall Collection, 1976
 Acc. No. H-2150

WILLIAM LA RUE
b. New York, New York, 1928
Education: University of Hawaii, Honolulu, BA, 1952;
San Francisco State College, MA, 1956
Solo Exhibitions: 1959—Oakland; City Lights Book-
store, San Francisco; 1963—Contra Costa Junior Col-
lege, CA; 1965—Orange Coast College, Costa Mesa,
CA; 1967—Barry Evans Studio Gallery, San Francisco;
SFMMA, ID
Public Collections: IMP; Nebraska; Oakland; SFMMA

419. NEGRO BOY, 1956
silver print
6⅜" x 13⁵/₁₆" / 16.2cm. x 33.8cm.
Signed, William La Rue, lower right
F. M. Hall Collection, purchased from the artist,
1966
Acc. No. H-1008

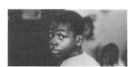

420. RANCHOS OF TAOS, 1964
silver print
7¾" x 9¹¹/₁₆" / 19.7cm. x 24.6cm.
Signed, William La Rue, lower right
F. M. Hall Collection, purchased from the artist,
1966
Acc. No. H-1007

421. NUDE BOY, 1965
silver print
9¹¹/₁₆" x 6¹¹/₁₆" / 24.6cm. x 17cm.
Signed, William La Rue, lower right
F. M. Hall Collection, purchased from the artist,
1966
Acc. No. H-1009

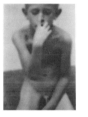

422. DOLL, 1966
silver print
7¹¹/₁₆" x 9⅝" / 19.5cm. x 24.5cm.
Signed, William La Rue, lower right
F. M. Hall Collection, purchased from the artist,
1966
Acc. No. H-1031

CLARENCE JOHN LAUGHLIN
b. Lake Charles, Louisana, 1905
Education: Self taught in photography
Solo Exhibitions: 1936—Isaac Delgado Museum, New
Orleans; 1939—Princeton; 1940—Julien Levy (with
Atget); 1942—New School; 1946-47—WAC; 1948—
SFMMA; Seattle; Phillips Gallery, Washington, DC;
1949—Northwestern; 1950—MIT; 1951—Stanford;
1952—AIC; 1954—Cleveland; 1956—Wadsworth;
1957—LACMA; Detroit; 1962—Smithsonian; 1965—
MPM; 1967—Carson-Pirie-Scott, Chicago; 1973-74—
PMA; NOMA; 1976—NOMA; MCA; Columbia
Public Collections: Louisville// AIC; BN; ENB; Fogg;

IMP; MMA; MOMA; Nebraska; NOMA; PMA; Phillips
Gallery, Washington, DC; Smithsonian

*423. SOLIDITY AND TRANSLUCENCY, 1936
silver print
10⅛" x 13⅝" / 25.7cm. x 34.6cm.
Signed, Clarence John Laughlin, lower right;
artist's stamp, verso
Nebraska Art Association, purchased with the
aid of funds from the National Endowment for
the Arts, 1977
Acc. No. N-461

424. FROM A SAGGING HOUSE, 1953
silver print
11" x 13¾" / 27.9cm. x 34.9cm.
Signed, Clarence John Laughlin, lower right;
artist's stamp, verso
Nebraska Art Association, purchased with the
aid of funds from the National Endowment for
the Arts, 1977
Acc. No. N-462

RICHARD LEBOWITZ
b. Pittsburgh, Pennsylvania, 1937
Education: Harvard College, Cambridge, MA, BA
Awards: 1963-64—Merrill Foundation
Public Collections: IMP; MOMA; Nebraska; NOMA;
RISD

425. CHILDREN'S MENTAL HOSPITAL, 1962
silver print
6⅜" x 9⁹/₁₆" / 16.2cm. x 24.3cm.
F. M. Hall Collection, purchased from the artist,
1966
Acc. No. H-1136

426. EDITH, 1965
silver print
6⁹/₁₆" x 6⁹/₁₆" / 16.7cm. x 16.7cm.
F. M. Hall Collection, purchased from the artist,
1966
Acc. No. H-1137

JEROME LIEBLING
b. New York, New York, 1924
Education: Brooklyn College, 1942, 1946-48; New
School for Social Research, NYC, 1948-49; studied
with Walter Rosenblum
Awards: 1976—Guggenheim
Solo Exhibitions: 1950—WAC; 1951—Portland; 1957—
IMP; 1958—MIA; 1963—WAC
Public Collections: Fogg; IMP; MIA; Minnesota; MFA;
MOMA; Nebraska; Tucson; UCLA; Yale

427. MANNEQUIN WITH PLASTIC BAG, 1963
 silver print
 19⁵/₁₆" x 14¹⁵/₁₆" / 49.1cm. x 37.9cm.
 Signed, Jerome Liebling, verso
 Reproduced: **American Photography: The
 Sixtics,** p. 25
 F. M. Hall Collection, purchased from the artist,
 1966
 Acc. No. H-1141

428. BLIND WOMAN AT REST, 1963
 silver print
 18¹³/₁₆" x 23³/₈" / 47.8cm. x 59.4cm.
 Signed, Jerome Liebling, verso
 F. M. Hall Collection, purchased from the artist,
 1966
 Acc. No. H-1142

166 **LYNN LOWN**
 b. Iowa Falls, Iowa, 1947
 Education: University of Paris, 1966; Ellsworth Col-
 lege, Iowa Falls, 1966-68; University of Iowa, BFA,
 1971; University of Oregon, MFA, 1973
 Solo Exhibitions: 1969—University of Iowa Student
 Union, Iowa City; 1970—Iowa; Parsons College, Fair-
 field, IA; 1971—East Street; Wayne State College,
 Wayne, NE; 1973—Significant Directions Photo Gal-
 lery, Davis, CA; 1974—Shado; East Street; 1975—Iowa;
 Gallery f/22
 Public Collections: Iowa; Nebraska
 429. UNTITLED (Aspens A), 1975
 silver print
 12³/₈" x 9½" / 31.4cm. x 24.1cm.
 Signed, Lynn Lown 1975, lower right
 Nebraska Art Association, purchased from the
 artist, with the aid of funds from the National
 Endowment for the Arts, 1976
 Acc. No. N-384

 430. UNTITLED (Aspens B), 1975
 silver print
 12½" x 9⅞" / 31.8cm. x 25.1cm.
 Signed, Lynn Lown 1975, lower right
 Nebraska Art Association, purchased from the
 artist, with the aid of funds from the National
 Endowment for the Arts, 1976
 Acc. No. N-385

431. UNTITLED (Sand & Grasses)
 silver print
 12³/₈" x 8⅛" / 31.4cm. x 20.6cm.
 Signed, Lynn Lown 1973, lower right
 Nebraska Art Association, gift of the artist, 1976
 Acc. No. N-386

CHARLES FLETCHER LUMMIS
b. Lynn, Massachusetts, 1859
d. Pasadena, California, 1928
Note: C. F. Lummis was an explorer and student of the
Indian, Spanish and Anglo cultures of the American
Southwest. He was the founder of the Southwest Mu-
seum, Highland Park, Los Angeles.
Public Collections: UNM// LC; Nebraska
432. PUEBLO SANTO DOMINGO, CORN DANCE, 1888
 cyanotype
 4³/₈" x 7³/₈" / 11.1cm. x 18.8cm.
 F. M. Hall Collection, 1976
 Acc. No. H-2056

433. PUEBLO OF TAOS, OLD CHURCH AND NORTH
 HOUSE, 1889
 cyanotype
 4³/₈" x 6⅞" / 11.1cm. x 17.4cm.
 F. M. Hall Collection, 1976
 Acc. No. H-2060

434. RITO DE LOS FRIGOLES, 1890
 cyanotype
 4⁷/₁₆" x 6⅞" / 11.3cm. x 17.5cm.
 F. M. Hall Collection, 1976
 Acc. No. H-2059

435. PUEBLO INDIAN HUNTER, 1890
 cyanotype
 6¾" x 4³/₈" / 17.2cm. x 11.1cm.
 F. M. Hall Collection, 1976
 Acc. No. H-2058

436. PUEBLO OF ACOMA, NORTH END OF THE
 MESA, 1891
 cyanotype
 4½" x 6¹⁵/₁₆" / 11.4cm. x 17.6cm.
 F. M. Hall Collection, 1976
 Acc. No. H-2061

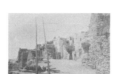

437. HUALPI DANCE COURT AND KIVAS, 1891
 cyanotype
 4⅜" x 6⅛" / 11.1cm. x 17.5cm.
 F. M. Hall Collection, 1976
 Acc. No. H-2057

Note: Dating of the prints listed above was provided
by Jim Hajicek whose Masters dissertation is devoted
to the photography of C. F. Lummis

DANNY LYON

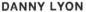

b. Brooklyn, New York, 1942
Education: University of Chicago, BA, 1963
Awards: 1969—Guggenheim
Solo Exhibitions: 1966—AIC; 1968—South Street Museum, NYC; 1969—AIC; 1970—SFAI; Rice; Fogg; 1971—University of Chicago; 1972—Nebraska Union
Public Collections: UNM// Addison; AIC; Detroit; Everson; ENB; Fogg; IMP; MFA; MFAH; MOMA; Nebraska; NOMA; Princeton; RISD; Smithsonian; UCLA

438. ILLIANA SPEEDWAY, INDIANA, from ''The Bike
 Riders,'' 1965
 silver print
 5⁷/₁₆" x 8" / 13.8cm. x 20.3cm.
 Signed, Danny Lyon, verso
 Reproduced: *Toward a Social Landscape,* p. 43;
 Photography in the Twentieth Century, p. 141
 F. M. Hall Collection, purchased from the artist,
 1966
 Acc. No. H-1015

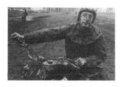

*439. UPTOWN CHICAGO, JULY, 1965
 silver print
 6" x 6" / 15.2cm. x 15.2cm.
 Signed, Danny Lyon, verso
 Reproduced: *American Photography: The
 Sixties,* p. 26; *12 Photographers of the Ameri-
 can Social Landscape,* n.p.
 F. M. Hall Collection, purchased from the artist,
 1966
 Acc. No. H-1016

JOAN LYONS

b. New York, New York, 1937
Education: Alfred University, BFA, 1957; SUNY-Buffalo, MFA, 1975
Awards: 1975—CAPS
Solo Exhibitions: 1968, 1969, 1970—Schuman Gallery, Rochester, NY; 1974—Sun Valley; 1975—Moncton Art Center, Moncton, New Brunswick; 1976—Vision; 1977

—Pensacola Junior College, Pensacola, FL
Public Collections: ENB; IMP; MFAH; MOMA; NGC; Nebraska; Pasadena; Rochester; Seagram; Sun Valley; Tucson; VSW

440.-451. A FAMILY ALBUM, 1969
 photo-silkscreen prints (12), copy 11 of 18
 F. M. Hall Collection, purchased from the artist,
 1969
 Note: Four of the above prints are reproduced in
 Into the 70's, pp. 52 & 53
 Acc. Nos. H-1476.1 through H-1476.12

MARGARET A. MAC KICHAN

b. Charleston, West Virginia, 1948
Education: University of Nebraska, Lincoln, BFA, 1970; University of New Mexico, MA, 1974; MFA, 1977
Awards: 1970—Vreeland
Solo Exhibitions: 1975—Nebraska; 1976—Galveston
Public Collections: Nebraska; UNM

452. MA LETTERMAN'S PORCH, 1969
 silver print
 6⁷/₁₆" x 9¼" / 16.4cm. x 23.5cm.
 F. M. Hall Collection, purchased from the artist,
 1976
 Acc. No. H-2066

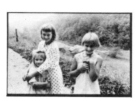

453. VIRGIL'S YOUNG'UNS, 1973
 silver print
 6½" x 9⅜" / 16.5cm. x 23.8cm.
 F. M. Hall Collection, purchased from the artist,
 1976
 Acc. No. H-2065

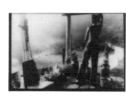

*454. BOBBY AT THE WELL, 1973
 silver print
 5⅝" x 8³/₁₆" / 14.3cm. x 20.8cm.
 F. M. Hall Collection, purchased from the artist,
 1976
 Acc. No. H-2067

PATRICIA MAC LAUGHLIN
b. New Haven, Connecticut, 1944
Education: Southern Connecticut State College, New Haven, BS, 1966; UCLA, MA, 1969; MFA, 1971
Solo Exhibitions: 1973—Gallery of Photography, Vancouver, B.C.
Public Collections: Nebraska

455. SELF PORTRAIT, 1974
tone-line process, printed on Agfa Portriga Rapid 118, hand colored
5⅜″ x 6⅝″ / 13.7cm. x 16.8cm.
Signed, Patricia A. MacLaughlin, verso
University Collection, gift of the Nebraska Union, 1975
Acc. No. U-1715

DAVID MANDEL
b. Port Arthur, Texas, 1947
Education: Brandeis University, BA (Psychology), 1969; University of Nebraska, MFA, 1976
Solo Exhibitions: 1976—Nebraska
Public Collections: Nebraska; SUNY-Geneseo

456. UNIDENTIFIED WALL #5, 1976
silver print
8¹⁵/₁₆″ x 13¼″ / 22.7cm. x 33.7cm.
Nebraska Art Association, purchased from the artist, with the aid of funds from the National Endowment for the Arts, 1976
Acc. N-414

*457. PHILOSOPHER'S STONE, 1976
sepia toned print
10⁹/₁₆″ x 10¹¹/₁₆″ / 26.8cm. x 27.1cm.
Nebraska Art Association, gift of the artist, 1976
Acc. No. N-415

SIMON MARSDEN, English
b. Lincoln, Lincolnshire, 1948
Education: Sorbonne, University of Paris, 1965-67; New York School of Photography
Public Collections: BN; Indiana; MOMA; Nebraska; Pasadena; V&A

458. NORBER ROCKS, YORKSHIRE, 1972
silver print
6¹⁵/₁₆″ x 10¼″ / 17.6cm. x 26cm.
Signed, S.N.L. Marsden, lower right
Reproduced: *Young British Photographers,* p. 40
F. M. Hall Collection, 1977
Acc. No. H-2160

459. UNTITLED (Landscape with Bridge)
silver print, toned
7″ x 10⅜″ / 17.8cm. x 26.4cm.
Signed, S.N.L. Marsden, lower right
F. M. Hall Collection, 1977
Acc. No. H-2161

LAWRENCE MC FARLAND
b. Wichita, Kansas, 1942
Education: Kansas City Art Institute, BFA, 1970-73; Nebraska, MFA, 1973-76
Awards: 1974-75—Woods; 1976—Vreeland
Solo Exhibitions: Boulder
Public Collections: IMP; LC; MIA; NBC-Lincoln; Nebraska; SUNY-Geneseo

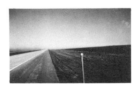

460. APACHE SACRED PLACE, 1975
silver print
7″ x 12″ / 17.8cm. x 30.5cm.
Nebraska Art Association, gift of the artist, 1976
Acc. No. N-375

*461. DUST STORM I-29, 1976
silver print
7½″ x 12″ / 19.1cm. x 30.5cm.
Nebraska Art Association, purchased from the artist, with the aid of funds from the National Endowment for the Arts, 1976
Acc. No. N-376

462. WHEAT FIELD, 1976
silver print
7¹/₁₆″ x 12″ / 18cm. x 30.5cm.
Signed, Lawrence McFarland, lower right
Reproduced: *Kansas Album,* p. 35
University Collection, gift of the artist, 1977
Acc. No. U-1903

MICHAEL MC LOUGHLIN
b. Peoria, Illinois, 1936
Education: Pratt Institute, BFA, 1963; studied with Alexey Brodovitch and Nathan Lyons
Solo Exhibitions: 1966—Doane College, Crete, NE; 1967—Nebraska; 1968—Oregon; 1969—Focus; 1971—University of Wisconsin, Eau Claire
Public Collections: IMP; MOMA; Nebraska; Oklahoma; UNM; UU-Salt Lake City; VSW

463. NEGRO YOUTH, BROOKLYN, 1963/1967
silver print
7⅞″ x 5⅜″ / 20cm. x 13.7cm.
Signed, Michael McLoughlin 67, verso
F. M. Hall Collection, purchased from the artist, 1968
Acc. No. H-1307

464. BOWERY, NEW YORK CITY, 1964/65
silver print
10½″ x 7″ / 26.7cm. x 17.8cm.
Signed, Michael McLoughlin, verso
F. M. Hall Collection, purchased from the artist,
1968
Acc. No. H-1312

465. SLAUGHTER HOUSE, YORK, NEBRASKA, 1965
silver print
10⁷/₁₆″ x 7⅛″ / 26.5cm. x 18.1cm.
Signed, Michael McLoughlin, verso
University Collection, gift of the artist, 1968
Acc. No. U-611

*466. OLD WOMAN, NEW YORK, 1965
silver print
7″ x 10⅜″ / 17.8cm. x 26.4cm.
Signed, Michael D. McLoughlin 65, verso
F. M. Hall Collection, purchased from the artist,
1968
Acc. No. H-1306

467. MIGRANT LABOR CAMP, PRINCEVILLE,
ILLINOIS, 1966
silver print
10½″ x 7″ / 26.7cm. x 17.8cm.
Signed, Michael McLoughlin, verso
F. M. Hall Collection, purchased from the artist,
1968
Acc. No. H-1310

468. FAIRVIEW, KANSAS, 1966
silver print
7⁷/₁₆″ x 7¼″ / 18.9cm. x 18.4cm.
Signed, Michael McLoughlin, verso
F. M. Hall Collection, purchased from the artist,
1968
Acc. No. H-1311

469. KARATE, ROCHESTER, N.Y., 1967
silver print
7¹/₁₆″ x 7″ / 17.9cm. x 17.8cm.
Signed, Michael McLoughlin 67, verso
F. M. Hall Collection, purchased from the artist,
1968
Acc. No. H-1308

470. CHURCH DOORS, SILVER PLUME, COLO., 1967
silver print
5¼″ x 7¹³/₁₆″ / 13.3cm. x 19.8cm.
Signed, Michael McLoughlin 67, verso
F. M. Hall Collection, purchased from the artist,
1968
Acc. No. H-1309

JOHN MC WILLIAMS
b. Pittsfield, Massachusetts, 1941
Education: RISD, BFA, 1965, MFA, 1967, studied with
Harry Callahan
Awards: 1975—NEA; 1976—Guggenheim
Solo Exhibitions: 1973, 1974—Nexus; 1975—Gallery
218, Memphis, TN; 1976—Light
Public Collections: Delaware; High; Jacksonville;
MOMA; Nebraska

471. ALABAMA, 1/18/75
silver print
14¾″ x 18⅜″ / 37.5cm. x 46.7cm.
Signed, Alabama 1/18/75 John McWilliams, verso
Nebraska Art Association, purchased with the
aid of funds from the National Endowment for
the Arts, 1976
Acc. No. N-449

RALPH EUGENE MEATYARD
b. Normal, Illinois, 1925
d. Lexington, Kentucky, 1972
Education: Trained as an optician; studied photogra-
phy with Van Deren Coke, Henry Holmes Smith and
Minor White
Solo Exhibitions: 1957—A Photographers Gallery,
NYC (with Van Deren Coke); 1959—Tulane; 1961—
Morehead State College, Morehead, KY; Gainesville;
1962—Siembab; Gainesville; 1963—Tempe; Gaines-
ville; 1965—UNM; 1966—Tempe; 1967—J. B. Speed
Museum, Louisville, KY; Bellarmine College, Louis-
ville, KY; UNM; 1970—Doctor's Park, Lexington, KY;
CPS; Ohio University, Athens; University of Kentucky,
Louisville; 1971—AIC; IMP; J. B. Speed Museum; Jef-
ferson Community College, Watertown, KY; MIT; Col-
gate; Steinrock Gallery, Lexington, KY; 1972—Charles
W. Bowers Memorial Museum, Santa Ana, CA; Co-
lumbia; Cortland Free Library, Cortland, NY; Doctor's
Park; Focus; Light Impressions; Logan Helm Wood-
ford County Library, Versailles, KY; Matrix, Hartford,
CT; Northeast Louisiana State College, Monroe, LA;
Watson Gallery, Elmira College, Elmira, NY; 1973—

Cincinnati Art Academy, Cincinnati, OH; University of Delaware, Newark, DE; Witkin; 1974—CSFAC; Oakton College, Morton Grove, IL; 1976—ISU; Leigh Yawkey Woodson Art Museum, Wausau, WI; 1977—UC-Santa Barbara; Williams

Public Collections: Louisville// Addison; Alabama; AIC; CPS; Cincinnati; IMP; LC; MIT; MMA; MFA; MFAH; MOMA; NGC; Nebraska; NOMA; Oklahoma; Pasadena; PMA; Smithsonian; Tampa; Thomas Merton Studies Center, Louisville; UCLA; UNM; VMFA; VSW

*472. CAROLING, CAROLING, 1963
 silver print
 7¼" x 7⅞" / 18.4cm. x 20cm.
 Stamped, Ralph Eugene Meatyard, verso
 Reproduced: *American Photography: The Sixties,* p. 28
 F. M. Hall Collection, purchased from the artist, 1966
 Acc. No. H-1129

473. DINNER WITH DICKCISSEL, 1964
 silver print
 6⁹⁄₁₆" x 6¹⁵⁄₁₆" / 16.7cm. x 17.6cm.
 Stamped, Ralph Eugene Meatyard, verso
 F. M. Hall Collection, purchased from the artist, 1966
 Acc. No. H-1128

474. SIGHT/SOUND, NO. 1, 1968
 silver print
 7¼" x 7¼" / 18.4cm. x 18.4cm.
 Stamped, Ralph Eugene Meatyard, Lexington, Kentucky, verso
 Reproduced: *Five Photographers,* n.p.
 F. M. Hall Collection, purchased from the artist, 1970
 Acc. No. H-1429

*475. LAUGHTER, NO. 8, 1968
 silver print
 7" x 7½" / 17.8cm. x 19.1cm.
 F. M. Hall Collection, purchased from the artist, 1970
 Acc. No. H-1428

476. LAUGHTER, NO. 4, 1968
 silver print
 7" x 7⁷⁄₁₆" / 17.8cm. x 18.9cm.
 Signed, Ralph Eugene Meatyard, verso
 Reproduced: *Five Photographers,* n.p.
 F. M. Hall Collection, purchased from the artist, 1970
 Acc. No. H-1427

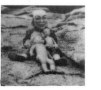

170

DAVID MELBY
b. Wichita, Kansas, 1942
Education: Kansas City Art Institute; Wichita State University, BFA, 1967; University of Nebraska, MFA, 1970
Awards: 1975-76—NEA; Iowa State University
Solo Exhibitions: 1976—Iowa State University, Ames; 1977—Nebraska
Public Collections: Mutual Benefit Life, Kansas City, MO; Nebraska

477. ALTAR, CYPRUS, 1974
 silver print
 6¹⁄₁₆" x 9" / 15.4cm x 22.9cm.
 Signed, David Melby, verso
 Nebraska Art Association, purchased from the artist, with the aid of funds from the National Endowment for the Arts, 1976
 Acc. No. N-369

478. KOLOKHORIO, CYPRUS, 1974
 silver print
 5½" x 8³⁄₁₆" / 14cm. x 20.8cm.
 Signed, David Melby, verso
 Nebraska Art Association, gift of the artist, 1976
 Acc. No. N-370

ROGER MERTIN
b. Bridgeport, Connecticut, 1942
Education: Rochester Institute of Technology, BFA, 1965; SUNY-Buffalo—VSW, MFA, 1972; worked with Minor White and Nathan Lyons
Awards: 1974—CAPS; 1974—Guggenheim; 1976—NEA
Solo Exhibitions: 1965—RIT; 1966—IMP; 1969—UC-Davis; Moore College of Art, Philadelphia; 1970—Haystack School of Crafts, Deer Isle, ME; 1971—Center of the Eye; 1972—TCP; Riverside Studio 2, Rochester, NY; 1973, 1975—Light; 1976—The Afterimage Photograph Gallery, Dallas, TX
Public Collections: AIC; Baltimore; Center of the Eye; Fogg; IMP; Kalamazoo; Lincoln First; MIA; MIT; MOMA; NGC; Nebraska; Pasadena; Princeton; Ryerson; Seagram; St. Petersburg; Tampa; UNM; VSW

*479. UNTITLED (Hand over Aerial View), 1971
 silver print, sabattier effect
 7¹⁵⁄₁₆" x 9¹⁵⁄₁₆" / 20.2cm. x 25.2cm.
 Signed, Roger Mertin '71, lower right
 F. M. Hall Collection, purchased from the artist, 1972
 Acc. No. H-1582

480. CENTRAL PARK, N.Y., 1975
 silver print
 8⁹/₁₆" x 13¹³/₁₆" / 21.8cm. x 35.1cm.
 Signed, Roger Mertin, verso
 Nebraska Art Association, purchased with the
 aid of funds from the National Endowment for
 the Arts, 1976
 Acc. No. N-401

481. ROCHESTER, N.Y., 1975
 silver print
 8⅝" x 13" /21.9cm. x 33cm.
 Signed, Roger Mertin, verso
 Nebraska Art Association, purchased with the
 aid of funds from the National Endowment for
 the Arts, 1976
 Acc. No. N-402

RAY K. METZKER
b. Milwaukee, Wisconsin, 1931
Education: Beloit College, Beloit, WI, BA, 1949-53;
Institute of Design, Illinois Institute of Technology,
Chicago, MS, 1956-59
Awards: 1966—Guggenheim; 1974—NEA
Solo Exhibitions: 1959—AIC; 1967—MOMA; 1971—
UNM; 1974—PPC; 1976—The Picture Gallery, Zurich,
Switzerland
Public Collections: AIC; BN; ENB; IMP; Krannert;
MMA; Milwaukee; MFA; MFAH; MOMA; NGC; Nebraska; PMA; RISD; Seagram; Smithsonian; St. Petersburg; UCLA; UNM; VMFA

482. 62 CZ—13 hb (Children Walking), 1962
 silver print
 6" x 8¹³/₁₆" / 15.2cm. x 22.4cm.
 F. M. Hall Collection, purchased from the artist,
 1966
 Acc. No. H-1011

483. 63 GI-36he (In), 1963
 silver print
 8⅞" x 5¹⁵/₁₆" / 22.5cm. x 15.1cm.
 F. M. Hall Collection, purchased from the artist,
 1966
 Acc. No. H-1010

484. 63 AJ-31he (Parking), 1963
 silver print
 6⅛" x 8¹⁵/₁₆" / 15.6cm. x 22.7cm.
 F. M. Hall Collection, purchased from the artist,
 1966
 Acc. No. H-1012

DUANE MICHALS
b. McKeesport, Pennsylvania, 1932
Education: University of Denver, BA; self taught in
photography
Awards: 1975—CAPS
Solo Exhibitions: 1963, 1965—Underground; 1968—
AIC; 1970—MOMA; 1971—IMP; 1972—SFAI; 1973—
Kunstverein, Cologne; Delpire, Paris; 1974—Light;
1976—Brucke
Public Collections: Addison, AIC; BN; CPS; IMP; LC;
MIA; MFA; MOMA; NGC; Nebraska; NOMA; Pasadena;
RISD; Smithsonian; Tampa; UCLA; UNM; Worcester

*485.—490. SEQUENCE: THE SENSELESS ACT, 1968
 silver prints (6)
 3⁹/₁₆" x 5⅛" / 9.1cm. x 13cm.
 Signed, Duane Michals, Print 1, lower right
 Reproduced: *Sequences,* n.p.
 Nebraska Art Association, purchased with the
 aid of funds from the National Endowment for
 the Arts, 1976
 Acc. Nos. N-424.1 through N-424.6

171

LAURANCE W. MILLER
b. Port Chester, New York, 1942
Education: University of South Florida, Tampa, MFA
Public Collections: Nebraska

491. ROBINSON'S HOUSE, 1971
 silver print, contact print of whole roll of film
 7³/₁₆" x 9¹¹/₁₆" / 18.3cm. x 24.6cm.
 F. M. Hall Collection, purchased from the artist,
 1972
 Acc. No. H-1583

PETER DAVID TYLER MONSON
b. Lincoln, Nebraska, 1945
Education: Rochester Institute of Technology, NY,
1963-64; University of Nebraska, Lincoln, BFA, 1976;
self taught in photography
Solo Exhibitions: 1969—University of Wisconsin, Milwaukee; 1973—Nebraska
Public Collections: Nebraska

492. COKE BOTTLES
 silver print
 8¹/₁₆" x 10⅜" / 20.5cm. x 26.4cm.
 University Collection, gift of Mr. and Mrs. Norman A. Geske
 Acc. No. U-1898

RAYMOND MOORE, English
b. Wallasey, Cheshire, 1920
Education: Wallasey School of Art, 1937-40; Royal
College of Art, London, 1947-50; MIT, with Minor White
Solo Exhibitions: 1959—London; 1962—London;
1966—University College, Aberystwyth, Wales; RWS
Galleries, London; 1970—IMP; 1971—Siembab; AIC;
1973—PG-London; 1975—Thackrey and Robertson
Public Collections: AIC; IMP; MOMA; Nebraska; Tex-
as; V&A

493. UNTITLED (Landscape), 1963
 silver print
 8¾" x 8¾" /22.2cm. x 22.2cm.
 Signed, Raymond Moore, verso
 Reproduced: **Creative Camera International
 Yearbook,** 1977, p. 16
 F. M. Hall Collection, 1977
 Acc. No. H-2163

494. UNTITLED (Landscape with Stormy Sky)
 silver print
 7⁹/₁₆" x 11⅜" / 19.3cm. x 39.4cm.
 Signed, Raymond Moore, verso
 F. M. Hall Collection, 1977
 Acc. No. H-2162

BARBARA MORGAN
b. Buffalo, Kansas, 1900
Education: UCLA, 1919-23
Solo Exhibitions: 1938—Bennington College; YMHA,
NYC; 1939—Columbia University, NYC; Minnesota;
Duke University, Durham, NC; Kamin Dance Gallery,
NYC; Wheaton College, MA; 1939-40—LACMA; 1940—
Photo League; Black Mountain; Dock Street Theater,
Charleston, SC; Greenwich Library, Greenwich, CT;
Pratt; Minnesota; 1941—Davison; Baltimore; 1943—
Black Mountain; YW-YMHA, NYC; Kaufmann Gallery,
NYC; Carleton College, Northfield, MN; 1944—Black
Mountain; The Woman's College of the University of
North Carolina, Greensboro, NC; 1945—MOMA; Jew-
ish Community Center, Detroit, MI; 1946—University
of Redlands, Redlands, CA; Minnesota; University of
Wisconsin, Madison, WI; 1947—World Youth Festival,
Prague, Czechoslovakia; 1952—NYPL; Hudson Park
Branch Library, NYC; Banker's Federal Savings and
Loan Gallery, NYC; 1955—IMP; 1956—Kodak Mez-
zanine Gallery, Grand Central Station, NYC; 1957—
Parent's Magazine Gallery, NYC; 1959—Connecticut
College, New London, CT; 1962—Tempe; UCLA;
1964—Societé Francaise de Photographie, Paris;
1964-65—IMP; 1965—Carnegie Institute, Pittsburgh;
Ceejee; Louisville; 1969—Long Island University,
Brooklyn; 1970—Smithsonian; FOP; 1971—Halsted;
Montclair Art Museum, Montclair, NJ; Phoenix College;
USU-Logan; 1972—MOMA; Amon Carter; Focus;
Ohio Silver Gallery, Los Angeles; 1973—King Pitcher
Gallery, Pittsburgh, PA; Scarsdale National Bank, NY;

Pasadena; 1974—American Indian Art Institute, Santa
Fe, NM; 1975—Lincoln Savings Bank, NYC; 1976—
Halsted; Hawkins; Washington
Public Collections: Amon Carter; AIC; Boulder; De-
troit; ENB; IMP; Kansas; LC; Lincoln First; Louisville;
MIT; MMA; Montclair Art Museum, Montclair, NJ;
MFAH; MOMA; NGC; NPG-Washington; Nebraska;
NOMA; Pasadena; PMA; Princeton Library; Seagram;
Smithsonian; St. Petersburg; SUNY- Purchase; UCLA;
UNM; Yale

495. MARTHA GRAHAM—LETTER TO THE WORLD,
 1940
 silver print
 18⅛" x 15⁷/₁₆" / 46cm. x 39.2cm.
 Signed, Barbara Morgan 1940, lower right
 F. M. Hall Collection, 1975
 Acc. No. H-2043

*496. MARTHA GRAHAM—LETTER TO THE WORLD—
 "DEAR MARCH, COME IN," 1940
 silver print
 14⅝" x 19⅜" / 37.2cm. x 49.2cm.
 Signed, Barbara Morgan 1940, lower right
 Reproduced: **Barbara Morgan,** p. 24
 F. M. Hall Collection, 1975
 Acc. No. H-2042

WRIGHT MORRIS
b. Central City, Nebraska, 1910
Education: Pomona College, Claremont, CA, 1930-
33; self taught in photography
Awards: 1942, 1946, 1954—Guggenheim
Solo Exhibitions: 1940—New School; 1948—Nebras-
ka; 1975—Nebraska; 1975-76—Stuhr Museum, Grand
Island, NE; 1976—Sioux City; Anderson Art Center,
Anderson, IN; Henry; Iowa; 1977—Eastern Illinois Uni-
versity, Charleston, IL; Hermitage Foundation Mu-
seum, Norfolk, VA; SFMMA; Prakapas; Cronin
Public Collections: MFAH; MOMA; Nebraska; Prince-
ton

497. STRAIGHT BACKED CHAIR BY DOOR, 1947
 silver print
 9⁹/₁₆" x 7½" / 24.3cm. x 19.1cm.
 Signed, Wright Morris, verso
 Reproduced: **God's Country and My People,**
 n.p.; **The Home Place,** p. 40; **Quality,** p. 180;
 Wright Morris, p. 57
 Nebraska Art Association, purchased from the
 artist, with the aid of funds from the National
 Endowment for the Arts, 1977
 Acc. No. N-453

498. UNCLE HARRY, ENTERING BARN, 1947
 silver print
 9⁹/₁₆″ x 7½″ / 24.3cm. x 19.1cm.
 Signed, Wright Morris, verso
 Reproduced: **The Home Place,** p. 177; **Wright
 Morris,** p. 59; **U. S. Camera,** 1949, p. 30
 Nebraska Art Association, purchased from the
 artist, with the aid of funds from the National
 Endowment for the Arts, 1977
 Acc. No. N-454

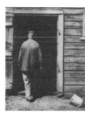

499. MODEL T IN SHED, NEBRASKA, 1947
 silver print
 9⁵/₁₆″ x 7½″ / 23.7cm. x 19.1cm.
 Signed, Wright Morris, verso
 Reproduced: **God's Country and My People,**
 n.p.; **The Photographer's Eye,** p. 17; **Wright
 Morris,** p. 75; **U.S. Camera,** 1949, p. 31
 Nebraska Art Association, purchased from the
 artist, with the aid of funds from the National
 Endowment for the Arts, 1977
 Acc. No. N-455

*500. DRESSER DRAWER, 1947
 silver print
 7½″ x 9½″ / 19.1cm. x 24.1cm.
 Signed, Wright Morris, verso
 Reproduced: **God's Country and My People,**
 n.p.; **The Home Place,** p. 140; **Wright Morris,**
 p. 69
 Nebraska Art Association, purchased from the
 artist, with the aid of funds from the National
 Endowment for the Arts, 1977
 Acc. No. N-456

JONATHAN MORSE
b. New York, New York, 1948
Education: Phillips Academy, Andover, MA, 1966;
Yale, BA, 1970; Visual Studies Workshop, MFA, 1976
Solo Exhibitions: 1975 — Prospect Street Gallery, Cam-
bridge, MA
Public Collections: Addison; IMP; MOMA; Nebraska;
NOMA; VSW

501.-507. ∮ 7 EXTRA LARGE, 1975-76
 color offset lithographs, (7), copy 9 of 30, pub-
 lished at Pentacle Press, Carlisle, MA, 1976
 all prints 16″ x 20″ / 40.6cm. x 50.8cm.
 Signed, J. Morse 1975, all prints, lower right
 Nebraska Art Association, purchased from the
 artist, with the aid of funds from the National
 Endowment for the Arts, 1976
 Acc. Nos. N-400.1 through N-400.7

EADWEARD MUYBRIDGE, English
b. Kingston-on-Thames, England, 1830
d. Kingston-on-Thames, England, 1904
Note: Self taught in photography, Muybridge's pri-
mary contribution to the history of photography is con-
tained in his eleven volume work, **Animal Locomotion,**
published under the auspices of the University of
Pennsylvania in 1887. He also produced extraordinary
landscapes of the Yosemite Valley and, with his inven-
tion of the 200 praxiscope, contributed significantly
to the development of the motion picture.
Public Collections: Addison; Amon Carter; AIC; Berke-
ley; BPL; Burpee; Carpenter; CMB; Cleveland; Cor-
coran; Cornell; Dayton; Detroit; Fogg; High; IMP; LC;
Louisville; Menil; MFAH; MOMA; NGC; Nebraska;
NOMA; Oakland; Oklahoma; PMA; Princeton; RISD;
SFMMA; Smith; Smithsonian; Texas; Tucson; UNM;
VSW; Worcester; Yale

508. WOMAN RISING FROM A RECLINING POSITION
 collotype, Plate 271 from Vol. 6 of
 Animal Locomotion
 7¼″ x 16¹³/₁₆″ / 18.4cm. x 42.7cm.
 F. M. Hall Collection, 1975
 Acc. No. H-2044

509. WOMAN PLAYING TENNIS
 collotype, Plate 298 from Vol. 7 of
 Animal Locomotion
 10″ x 12⅜″ / 25.4cm. x 31.4cm.
 F. M. Hall Collection, 1975
 Acc. No. H-2045

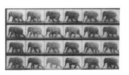

510. ELEPHANT WALKING
 collotype, Plate 733 from Vol. 11 of
 Animal Locomotion
 8⅛″ x 14⅞″ / 20.6cm. x 37.8cm.
 F. M. Hall Collection, 1975
 Acc. No. H-2046

MARK NADIR
Note: Mark Nadir is one of seven photographers
whose work was allocated by the Work Projects Ad-
ministration to the University of Nebraska Art Galleries
in 1943. Extensive enquiry made in the interests of the
present publication has failed to produce information
regarding place and date of birth, education and sub-
sequent activity.

511. FRONT STREET
 silver print
 13¾″ x 10½″ / 34.9cm. x 26.7cm.
 Signed, Nadir, lower left
 University Collection
 Acc. No. U-1851

JOYCE NEIMANAS

b. Chicago, Illinois, 1944
Education: School of the Art Institute of Chicago,BAE, 1966; MFA, 1969
Solo Exhibitions: 1969—2nd Unitarian Church of Chicago; 1st Unitarian Church of Chicago; 1973—University of Rhode Island, Kingston, RI
Public Collections: AIC; IMP; Iowa; Nebraska; Princeton; SFMMA

512. A ONE POSE PHOTOGRAPH OF FRANCOIS, 1970
silver print, hand colored
3¹³/₁₆" x 5⅞" / 9.7cm. x 14.9cm.
Signed, Joyce Neimanas, lower right
F. M. Hall Collection, purchased from the artist, 1972
Acc. No. H-1584

ED NELLIS

b. Lincoln, Nebraska, 1948
Education: University of Nebraska, BFA, 1971; University of Iowa, MA, 1973; MFA, 1975
Public Collections: Kalamazoo; Nebraska

513. 329, 1972
silver print
5³/₁₆" x 7¾" / 13.2cm. x 19.7cm.
Reproduced: *Photographers / Midwest Invitational,* n.p.
Nebraska Art Association, gift of the artist, 1976
Acc. No. N-366

514. LET'S, 1974
silver print
4⅝" x 7" / 11.8cm. x 17.8cm.
Reproduced: *Exposure,* 13:1, p. 22
Nebraska Art Association, purchased with the aid of funds from the National Endowment for the Arts, 1976
Acc. No. N-365

ARNOLD NEWMAN

b. New York, New York, 1918
Education: University of Miami, 1937-38
Awards: 1951—Photokina Award, Cologne, Germany; 1961—Citation, Philadelphia Museum College of Art; Newhouse Citation, Syracuse University; 1963—Gold Medal, the Fourth Biennale Internazionale Della Fotografia, Venice; 1975—Life Achievement in Photography Award, ASMP
Solo Exhibitions: 1941—A.D. Gallery, NYC (with Ben Rose); 1941-42—Brooklyn; 1945-46—PMA; 1951—Camera Club, NYC; Milwaukee; 1953—AIC; 1955—Portland; 1956—UC-Santa Barbara; 1957—University of Virginia Museum of Art, Charlottesville, VA; 1958—Cincinnati; 1961—Phoenix; 1963—Fourth Biennale Internazionale Della Fotografia, Venice; 1972—Light;

IMP; 1974—Light; 1976—Galerie Fiolet, Amsterdam, Holland; 1977—Light
Public Collections: Addison; AIC; Cincinnati; Cleveland; Dayton; Detroit; ENB; Fogg; High; Indiana; IMP; Kansas; Louisville; Menil; MIA; MMA; MWP; MFAH; MOMA; NGC; NPG-London; Nebraska; NOMA; Oklahoma; Pasadena; PMA; Portland; RISD; SFMMA; Smithsonian; St. Petersburg; Texas; Tucson; UNM; Worcester; Yale

*515.—524. PORTRAITS/ARNOLD NEWMAN, 1942-1967
silver prints (10), copy 7 of 25
F. M. Hall Collection, 1975
Acc. Nos. H-1993.1 through H-1993.10

SONYA NOSKOWIAK

b. Leipzig, Germany, 1900
d. Greenbrae, California, 1975
Education: Self taught in photography; studied with Edward Weston
Public Collections: Tucson//Berkeley; Minnesota; Nebraska; Oakland

525. WHARF AT RICHMOND (Port Richard), 1931
silver print
7⅛" x 9¼" / 18.1cm. x 23.5cm.
Reproduced: *Camera,* Feb., 1973, p. 21
University Collection
Acc. No. U-1869

526. TRACK AND BARN
silver print
9½" x 7½" / 24.1cm. x 19.1cm.
University Collection
Acc. No. U-1866

527. WINDOW
silver print
9¼" x 7½" / 23.5cm. x 19.1cm.
University Collection
Acc. No. U-1867

528. SHACKS
 silver print
 7½" x 9½" / 19.1cm. x 24.1cm.
 University Collection
 Acc. No. U-1868
Note: Nos. 525 through 528 above, allocated by the Works Projects Administration, 1943.

STARR OCKENGA
b. Boston, Massachusetts, 1938
Education: Wheaton College, Wheaton, IL, BA, 1966; Rhode Island School of Design, MFA, 1974
Solo Exhibitions: 1976—Addison; Panopticon
Public Collections: Humboldt State University, Eureka, CA; Nebraska

*529. MOTHER & DAUGHTER, 1974
 silver print
 8³/₁₆" x 12³/₁₆" / 20.8cm. x 31cm.
 Reproduced: **Mirror After Mirror,** n.p.
 F. M. Hall Collection, 1975
 Acc. No. H-2047

PATRICK O'NEILL
b. Los Angeles, California, 1939
Education: University of California, Los Angeles, BA; MA, 1964
Public Collections: Nebraska

530. TWO FENDERS, LOS ANGELES, 1962
 silver print
 4½" x 7¹/₁₆" / 11.4cm. x 17.9cm.
 Signed, P. O'Neill, 1962, verso
 F. M. Hall Collection, purchased from the artist, 1966
 Acc. No. H-1020

531. CAR AND BUILDINGS, BRADLEY, CALIFORNIA, 1964
 silver print
 4⁷/₁₆" x 6½" / 11.3cm. x 16.5cm.
 Signed, P. O'Neill, 1964, verso
 F. M. Hall Collection, purchased from the artist, 1966
 Acc. No. H-1021

ELIOT F. PORTER
b. Winnetka, Illinois, 1901
Education: Harvard, BS (Engineering), 1924; MD, 1929
Awards: 1941, 1946—Guggenheim; 1950—International Exhibition Wild Life Photography, London; 1967—Silver Plaque Associate Fellow, Morse College, Yale University; Department Interior Conservation Award; 1968—Maine Commission on Arts & Humanities Award; 1969—Distinguished Son of Maine Award; Honorary DFA, Colby College, Waterville, ME; 1971—Fellow, American Academy Arts & Sciences; 1973—New House Citation, Syracuse; 1974—LLD, University

of Albuquerque; 1976—Governor's Award, NM Arts Commission
Solo Exhibitions: 1939—An American Place; 1940—New York Zoological Society, NYC; 1943—MOMA; 1953—AIC; 1960—SFMMA; Baltimore; IMP; Museum of Science, Boston; Nelson; Smithsonian; 1962—De Cordova Museum, Lincoln, MA; 1963—AIC; 1970—St. Petersburg; 1971—Princeton; 1973—Amon Carter; UNM; 1974—Roswell; Witte Memorial Museum, San Antonio, TX; 1975—Pensacola Art Center, Pensacola, FL; 1977—Cronin; Smithsonian (with Daniel Lang)
Public Collections: AIC; ENB; IMP; LC; MMA; Milwaukee Public Museum (permanent installation); MOMA; MNM; Nebraska; NOMA; Tucson; UNM; Worcester

*532.-543. PORTFOLIO ONE/THE SEASONS, 1963
 dye transfer prints (12), copy 38 of 100
 Published by the Sierra Club, San Francisco
 University Collection, 1965
 Acc. Nos. U-487.1 through U-487.12

DOUG PRINCE
b. Des Moines, Iowa, 1943
Education: University of Iowa, BA, 1965; MA, 1968
Awards: 1972—Le Prix de la Ville D'Avignon; 1977—NEA
Solo Exhibitions: 1973—Light; 1974—University of Tennessee, Knoxville, TN; 1975—SUNY-Geneseo; Print Maker, Lincoln, NE; Deja Vu Gallery, Toronto, Canada; Light
Public Collections: Addison; Alabama; Cleveland; ENB; Gainesville; IMP; KCAI; MOMA; NGC; Nebraska; Princeton; RISD; St. Petersburg; VMFA; VSW; UNM; Worcester

544. PHOTO BOX SCULPTURE, "Black Swan," 1973
 ortho film between plexiglas sheets
 5⅛" x 5⅜" x 2" / 13cm. x 13.7cm. x 5.1cm.
 Nebraska Art Association, purchased with the aid of funds from the National Endowment for the Arts, 1976
 Acc. No. N-420

LILO RAYMOND

b. Frankfrut am/Main, Germany, 1922
Education: Studied with David Vestal, 1961-63
Awards: 1972—Honorable mention, XVI Grand Prix, "le Provencal" du Festival d'Avignon
Solo Exhibitions: 1971—University of Toronto, Canada; Floating Foundation, NYC; 1977—Marcuse Pfeifer Gallery, NYC
Public Collections: BN; Nebraska

545. BED, STRATFORD, 1972
 silver print
 9³/₁₆" x 13⅝" / 23.3cm. x 34.6cm.
 Signed, Lilo Raymond, lower right
 Reproduced: **Camera 35-MM,** n.p.; **NY Times,** April 24, **"Photography View,"** p. 36
 Nebraska Art Association, purchased with the aid of funds from the National Endowment for the Arts, 1976
 Acc. No. N-363

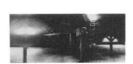

546. WHITE DOOR, CRETE, 1973
 silver print
 13⅜" x 9¹/₁₆" / 34cm. x 23cm.
 Signed, Lilo Raymond, lower right
 Reproduced: **The Village Voice,** May 9, 1977, p. 81
 Nebraska Art Association, purchased with the aid of funds from the National Endowment for the Arts, 1976
 Acc. No. N-364

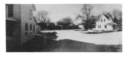

ROGER REJDA

b. David City, Nebraska, 1944
Education: University of Nebraska, Lincoln, BA, 1967; MA, (English) 1971
Solo Exhibitions: 1974—Nebraska Wesleyan University, Lincoln; Nebraska; Nebraska Union
Public Collections: Nebraska

547. MY FATHER, 1969
 silver print
 16¾" x 12⅜" / 42.5cm. x 31.4cm.
 Signed, Rejda, verso
 F. M. Hall Collection, purchased from the artist, 1974
 Acc. No. H-1986

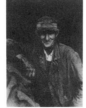

548. GRANDMOTHER IN BERLIN, 1970
 silver print
 8⁷/₁₆" x 19¾" / 21.4cm. x 50.2cm.
 Signed, Rejda, verso
 F. M. Hall Collection, purchased from the artist, 1974
 Acc. No. H-1983

549. INDICATION, 1970
 silver print
 7⅝" x 17⅞" / 19.4cm. x 45.4cm.
 Signed, Rejda, verso
 F. M. Hall Collection, purchased from the artist, 1974
 Acc. No. H-1984

550. BRAINARD, NEBRASKA, 1971
 silver print
 7⅞" x 17⅞" / 20cm. x 45.4cm.
 Signed, Rejda, verso
 F. M. Hall Collection, purchased from the artist, 1974
 Acc. No. H-1985

MURRAY RISS

b. Poland, 1940
Education: City University of New York, BA, 1963; Cooper Union School of Art, 1963-66; Rhode Island School of Design, MFA, 1968
Solo Exhibitions: 1964—City University, NYC; 1965—Pratt; 1968—Bezalel School of Art, Jerusalem, Israel; 1969—Southwestern University, Memphis, TN; 1971—AIC-School; Iowa; MIA; 1972—Loomis Institute, Windsor, CT; 1974—University of Rochester, NY; VSW
Public Collections: AIC; BN; CPS; IMP; LC; Louisville; MOMA; NGC; Nebraska; NOMA; VMFA; VSW

551. PROVIDENCE, RHODE ISLAND, 1966
 silver print
 6¹¹/₁₆" x 9¹⁵/₁₆" / 17cm. x 25.2cm.
 Signed, Murray Riss 1967, lower right
 University Collection, gift of Lawrence Reger, 1968
 Acc. No. U-588

552. RAILROAD STATION, PROVIDENCE, RHODE ISLAND, 1967
 silver print
 5¾" x 6¹⁵/₁₆" / 14.6cm. x 17.6cm.
 Signed, Murray Riss 1967, lower right
 University Collection, gift of Lawrence Reger, 1968
 Acc. No. U-589

553. WEDDING, ROCHESTER, NEW YORK, 1967
 silver print
 5⅛" x 7" / 13cm. x 17.8cm.
 Signed, Murray Riss 1967, lower right
 University Collection, gift of Lawrence Reger, 1968
 Acc. No. U-587

DAVID ROBBINS

Note: David Robbins is one of seven photographers whose work was allocated by the Work Projects Administration to the University of Nebraska Art Galleries in 1943. Extensive enquiry made in the interests of the

present publication has failed to produce information regarding place and date of birth, education and subsequent activity.

554. ALONG THE WATERFRONT #4, 1937
silver print
13¾″ x 10½″ / 34.9cm. x 26.7cm.
University Collection
Acc. No. U-1874

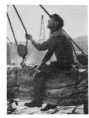

555. ALONG THE WATERFRONT #12, 1937
silver print
13½″ x 10¼″ / 34.3cm. x 26cm.
University Collection
Acc. No. U-1877

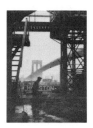

556. ALONG THE WATERFRONT #13, 1937
silver print
13″ x 10″ / 33cm. x 25.4cm.
University Collection
Acc. No. U-1876

557. ALONG THE WATERFRONT #15, 1937
silver print
13½″ x 10½″ / 34.3cm. x 26.7cm.
University Collection
Acc. No. U-1879

558. ALONG THE WATERFRONT #17, 1937
silver print
6¼″ x 6¼″ / 15.9cm. x 15.9cm.
University Collection
Acc. No. U-1878

559. ALONG THE WATERFRONT #11, 1937
silver print
13¾″ x 10½″ / 34.9cm. x 26.7cm.
University Collection
Acc. No. U-1875

JAMES ROBERTSON, English
b. circa 1813
d. after 1881
Note: Precise information concerning the association of Robertson and Felice A. Beato has not yet been established. Beato presumably began as an assistant to Robertson but the fact that he also signed Catalog No. 560 below would seem to indicate the collaboration of equals. Their pictures made in the Crimea are among the masterpieces of topographic photography. The two men also produced an important record of the British in India and, still later, Beato, in China and Japan, produced the first photographic record of those countries for western eyes.
Public Collections: AIC; IMP; MOMA; Nebraska; PMA; Texas; UNM

560. THE PYRAMIDS, EGYPT, c. 1855
albumen print
9⁹/₁₆″ x 11¹⁵/₁₆″ / 24.3cm. x 30.3cm.
Signed, Robertson and Beato, lower right
F. M. Hall Collection, 1968
Acc. No. H-1290

561. CONSTANTINOPLE, c. 1855
albumen print
9⅝″ x 10¾″ / 24.5cm. x 27.3cm.
Signed, Robertson, lower right
F. M. Hall Collection, 1968
Acc. No. H-1291

PATRICIA SAMPLE
b. Scottsbluff, Nebraska 1949
Education: University of Nebraska, Lincoln, BA, 1971; BFA, 1972; University of Florida, Gainesville, MFA, 1974
Awards: 1976—Ford
Solo Exhibitions: 1974—Gainesville; 1976—Northern Kentucky State College, Highland Heights, KY
Public Collections: Alabama; Lewis State Bank, Jacksonville, FL; Nebraska

562. UNTITLED (Lounge Chair and Trees), 1974
silver print
9¼″ x 12½″ / 23.5cm. x 31.8cm.
Signed, T. Sample 1974, lower right
Nebraska Art Association, gift of the artist, 1976
Acc. No. N-361

563. UNTITLED (Orange Trees), 1975
 silver print
 9½" x 12⅞" / 24.1cm. x 32.7cm.
 Signed, T. Sample 1975, lower right
 Nebraska Art Association, purchased from the
 artist, with the aid of funds from the National
 Endowment for the Arts, 1976
 Acc. No. N-362

AUGUST SANDER
b. Herdorf an der Sieg, Germany, 1876
d. Cologne, Germany, 1964
Education: Self taught in photography
Solo Exhibitions: 1927—Cologne Art Association;
1972—Sonnabend Gallery, NYC; 1976—Halsted; AIC;
Thackrey & Robertson; California State University,
Long Beach
Public Collections: AIC; Cincinnati; Cleveland; Detroit; Everson; ENB; High; IMP; LC; Michigan; MFA;
MOMA; NGC; Nebraska; NOMA; Princeton; Tucson;
UNM; VMFA; Worcester

*564. BAUERNPAAR (Farm Couple)
 silver print
 11⅜" x 8¹⁵/₁₆" / 39.4cm. x 22.7cm.
 Dry stamp, Aug. Sander/Köln/Lindenthal, lower
 left
 F. M. Hall Collection, 1975
 Acc. No. H-2048

565. DIE APOSTELNKIRCHE (The Church of the
 Apostles, Cologne)
 silver print
 6⁷/₁₆" x 8⁹/₁₆" / 16.4cm. x 21.7cm.
 Dry stamp, Aug. Sander/Köln/Lindenthal, lower
 left; Signed, Aug Sander, lower right
 F. M. Hall Collection, 1975
 Acc. No. H-2049

ENRICO SARSINI
b. Rome, Italy, 1939
Education: Self taught in photography
Solo Exhibitions: 1963—AIC; 1963-64—Kasha Heman
Gallery, Chicago; 1964—Libreria Einaudi, Rome;
1965—Miami Museum of Modern Art
Public Collections: AIC; Nebraska
566. UNTITLED (Two Boys Playing)
 silver print
 8¹⁵/₁₆" x 13½" / 22.7cm. x 34.3cm.
 F. M. Hall Collection, purchased from the artist,
 1964
 Acc. No. H-946

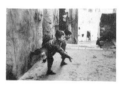

567. UNTITLED (Boy at Window)
 silver print
 8¹⁵/₁₆" x 13½" / 22.7cm. x 34.3cm.
 F. M. Hall Collection, purchased from the artist,
 1964
 Acc. No. H-947

568. UNTITLED (Boy in Rain)
 silver print
 8¹⁵/₁₆" x 13½" / 22.7cm. x 34.3cm.
 F. M. Hall Collection, purchased from the artist,
 1964
 Acc. No. H-948

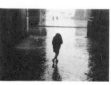

569. UNTITLED (Religious Procession)
 silver print
 8¹⁵/₁₆" x 13½" / 22.7cm. x 34.3cm.
 F. M. Hall Collection, purchased from the artist,
 1964
 Acc. No. H-949

570. UNTITLED (Boy with Bottles)
 silver print
 8¹⁵/₁₆" x 13½" / 22.7cm. x 34.3cm.
 F. M. Hall Collection, purchased from the artist,
 1964
 Acc. No. H-950

571. UNTITLED (Woman and Girl)
 silver print
 9" x 13½" / 22.9cm. x 34.3cm.
 F. M. Hall Collection, purchased from the artist,
 1964
 Acc. No. H-951

572. UNTITLED (Boy Carrying Pizzas)
 silver print
 8⅞" x 13½" / 22.5cm. x 34.3cm.
 University Collection, gift of the artist, 1964
 Acc No. U-481

573. UNTITLED (Woman and Store Window)
 silver print
 8¹⁵/₁₆" x 12⁷/₁₆" / 22.7cm. x 31.6cm.
 University Collection, gift of the artist, 1964
 Acc. No. U-482

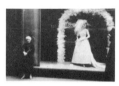

574. UNTITLED (Two Figures)
 silver print
 9" x 13⁹/₁₆" / 22.9cm. x 34.5cm.
 University Collection, gift of the artist, 1964
 Acc. No. U-483

575. UNTITLED (Statue in Yard)
 silver print
 8¹³/₁₆" x 13½" / 22.4cm. x 34.3cm.
 University Collection, gift of the artist, 1964
 Acc. No. U-484

576. UNTITLED (Woman with Shawl)
 silver print
 8⅞" x 13½" / 22.5cm. x 34.3cm.
 University Collection, gift of the artist, 1964
 Acc. No. U-485

577. UNTITLED (Old Woman with Cat)
 silver print
 12⁷/₁₆" x 8⅞" / 31.6cm. x 22.5cm.
 University Collection, gift of the artist, 1964
 Acc. No. U-486

LLOYD W. SCHNELL
b. New Richmond, Wisconsin, 1928
Education: Minneapolis College of Art & Design, BFA, 1959
Solo Exhibitions: 1968—International Design Center, Minneapolis, MN; 1969—Nasson College Art Gallery, Springvale, ME; 1972 — Topeka; 1977 — Galveston
Public Collections: KCAI; Nebraska
578. RAILROAD SWITCHING YARDS, 1975
 type C color
 7¹/₁₆" x 7¹/₁₆" / 17.9cm. x 17.9cm.
 Nebraska Art Association, purchased from the artist, with the aid of funds from the National Endowment for the Arts, 1976
 Acc. No. N-439

579. WHITE PARK BENCH, 1975
 R/500 color
 7¹/₁₆" x 7¹/₁₆" / 17.9cm. x 17.9cm.
 Nebraska Art Association, purchased from the artist, with the aid of funds from the National Endowment for the Arts, 1976
 Acc. No. N-440

580. STUDIO WITH RED & GREEN DOORS, 1976
 type C color
 7¹/₁₆" x 7¹/₁₆" / 17.9cm. x 17.9cm.
 Nebraska Art Association, purchased from the artist, with the aid of funds from the National Endowment for the Arts, 1976
 Acc. No. N-441

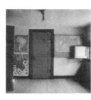

581. BLUE BOTTLES, UTENSILS ON SHELF, 1976
 R/500 color
 7¹/₁₆" x 7¹/₁₆" / 17.9cm. x 17.9cm.
 Nebraska Art Association, gift of the artist, 1976
 Acc. No. N-442

582. STORE FRONT "816," 1976
 R/500 color
 7¹/₁₆" x 7¹/₁₆" / 17.9cm. x 17.9cm.
 Nebraska Art Association, gift of the artist, 1976
 Acc. No. N-443

583. WATER TRICKLE IN STREET, 1976
 R/500 color
 7¹/₁₆" x 7¹/₁₆" / 17.9cm. x 17.9cm.
 Nebraska Art Association, gift of the artist, 1976
 Acc. No. N-444

CARL SESTO
b. Staten Island, New York, 1945
Education: Rochester Institute of Technology, BFA, 1968; Visual Studies Workshop, MFA, 1973; studied with Nathan Lyons, Minor White and Syl Labrot
Solo Exhibitions: 1970—Camera Work-Newport; UNH
Public Collections: AIC; Burpee; Davison; ENB; Fogg; IMP; MIT; MFA; MOMA; NGC; Nebraska; Polaroid; VSW
584. PARAGON PARK (Sculpture), 1971
 silver print
 9¹⁵/₁₆" x 12¾" / 25.2cm. x 32.4cm.
 Signed, Carl Sesto, verso
 F. M. Hall Collection, purchased from the artist, 1973
 Acc. No. H-1938

585. PARAGON PARK (Shooting Gallery), 1971
 silver print
 10" x 12¾" / 25.4cm. x 32.4cm.
 Signed, Carl Sesto, verso
 F. M. Hall Collection, purchased from the artist, 1973
 Acc. No. H-1939

586. PARAGON PARK (Caterpillar), 1971
 silver print
 9⅞″ x 12¹¹/₁₆″ / 25.1cm. x 32.2cm.
 Signed, Carl Sesto 1971, verso
 F. M. Hall Collection, purchased from the artist,
 1973
 Acc. No. H-1940

587. PARAGON PARK (Cup Form), 1971
 silver print
 9¹⁵/₁₆″ x 12¹¹/₁₆″ / 25.2cm. x 32.2cm.
 Signed, Carl Sesto 1971, verso
 F. M. Hall Collection, purchased from the artist,
 1973
 Acc. No. H-1941

588. PARAGON PARK (Plastered Wall), 1971
 silver print
 9¹⁵/₁₆″ x 12¾″ / 25.2cm. x 32.4cm.
 Signed, Carl Sesto 1971, verso
 F. M. Hall Collection, purchased from the artist,
 1973
 Acc. No. H-1942

589. PARAGON PARK (Carousel), 1971
 silver print
 9¹⁵/₁₆″ x 12¾″ / 25.2cm. x 32.4cm.
 Signed, Carl Sesto 1971, verso
 F. M. Hall Collection, purchased from the artist,
 1973
 Acc. No. H-1943

590.-601. SCREENLESS LITHOGRAPHS, 1973
 12 prints, all untitled images of rock forms,
 printed at the Visual Studies Workshop,
 Rochester, NY, No. 8 of 40
 7½″ x 9⅝″ / 19.1cm. x 24.5cm.
 Signed, Carl Sesto, title page
 Nebraska Art Association, purchased from the
 artist, gift of Lawrence Reger, 1973
 Acc. Nos. N-313.1 through N-313.12

180

CHARLES SHEELER
b. Philadelphia, Pennsylvania, 1883
d. Dobbs Ferry, New York, 1965
Education: Philadelphia School of Industrial Art, 1900-03; Pennsylvania Academy of the Fine Arts, 1903-06; began commercial photography, 1912
Solo Exhibitions: 1917—Modern Gallery, NYC; 1920—De Zayas, NYC; 1922—Daniel Gallery, NYC; 1926—Art Center, NYC; 1939—MOMA; 1946—Addison
Public Collections: Lane Foundation// AIC; IMP; MMA; MOMA; Nebraska; UNM

*602. INTERIOR, BUCKS COUNTY BARN
 silver print
 7¾″ x 9¹¹/₁₆″ / 19.7cm. x 24.6cm.
 F. M. Hall Collection, 1977
 Note: This photograph is apparently preparatory to the conté crayon drawing of the same subject in the collection of the Whitney Museum of American Art. The drawing is signed and dated, 1932.
 Acc. No. H-2164

STEPHEN SHORE
b. New York, New York, 1947
Education: Self taught in photography; studied with Minor White, 1970
Awards: 1974—NEA; 1975—Guggenheim
Solo Exhibitions: 1971—MMA; 1972—Thomas Gibson Fine Arts, London; Light; 1973—Pace Gallery, NYC; Light; 1975—Light; Phoenix Gallery, San Francisco; Gallerie Lichtropfen, Aachen, Germany; 1976—MOMA; MMA; Thomas Gibson Fine Arts, London; 1977—Light
Public Collections: Cornell; Delaware; Everson; IMP; Leiden University, the Netherlands; MMA; Minnesota; MFAH; MOMA; Nebraska; Northeastern University of Arts, Kalamazoo, MI; Princeton; Seagram; Seattle; Tucson; Vassar; Yale

*603. CHURCH STREET & SECOND STREET, EASTON,
 PENNSYLVANIA, 6/20/74
 ekta color R C print
 11⅞″ x 15″ / 30.2cm. x 38.1cm.
 Signed, Stephen Shore 76, verso
 Reproduced: **Photography Year 1977,** p. 116
 Nebraska Art Association, purchased with the aid of funds from the National Endowment for the Arts, 1976
 Acc. No. N-419

MICHAEL SIMON
b. Budapest, Hungary, 1936
Education: Budapest Technical University, 1954-56; Pennsylvania State University, University Park, 1957-58
Awards: 1971, 1972—Beloit; 1973—Beloit; SPE; 1976—Beloit; 1976-77—Mellon
Solo Exhibitions: 1964—Educational Alliance, NYC; 1970—Theodore Lyman Wright Art Center, Beloit, WI;

Center of the Eye; 1974—CPS; Burpee; Nebraska; 1975—Gustavus Adolphus College, St. Peter, MN; 1970—New Trier High School West, Winnetka, IL
Public Collections: IMP; Kansas; MIA; MOMA; Nebraska; Theodore Lyman Wright Art Center, Beloit, WI

604. BY THE APPLE TREE, 1971
silver print
4⁹/₁₆″ x 6¹³/₁₆″ / 11.6cm. x 17.3cm.
Signed, M. Simon, lower right
F. M. Hall Collection, purchased from the artist, 1975
Acc. No. H-2050

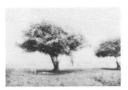

605. MY SON NICHOLAS & MYSELF, 1972
silver print
4⅛″ x 6″ / 10.5cm. x 15.2cm.
Signed, M. Simon, lower right
F. M. Hall Collection, purchased from the artist, 1975
Acc. No. H-2052

606. AMY, 1973
silver print
4⁷/₁₆″ x 6¹¹/₁₆″ / 11.3cm. x 17cm.
Signed, M. Simon, lower right
F. M. Hall Collection, purchased from the artist, 1975
Acc. No. H-2051

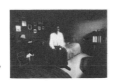

ANDREJS SINATS
b. 1943
Public Collections: ENB; Nebraska

607. STUDY FOR POTATO CHIPS, 1972
photo silkscreen, 6/60
14¹¹/₁₆″ x 22¼″ / 37.3cm. x 56.5cm.
Signed, A. Sinats, lower right
F. M. Hall Collection, purchased from the artist, 1972
Acc. No. H-2804

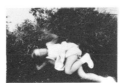

608. UNTITLED (Landscape), 1972
photo silkscreen, 5/50
15″ x 21⁹/₁₆″ / 38.1cm. x 54.8cm.
Signed, A. Sinats 1972, lower right
F. M. Hall Collection, purchased from the artist, 1973
Acc. No. H-2895

ART SINSABAUGH
b. Irvington, New Jersey, 1924
Education: Institute of Design; Illinois Institute of Technology, Chicago, BA, 1949; MA, 1967
Awards: 1964—Society of Typographic Arts; Art Director's Club of Indiana; Art Director's Club of Los Angeles; 1965—Society of Typographic Arts; 1966—Society of Typographic Arts; Illinois Arts Council; Graham Foundation; 1969—Guggenheim; 1972—Cen-

ter for Advanced Studies, University of Illinois
Public Collections: AIC; ENB; Indiana; IMP; MFAH; MOMA; Nebraska; NOMA; RISD; Seagram; Smithsonian; UCLA; VMFA; Williams

609. M.W. LA. #20, 1961
silver print, 2/3
3⅛″ x 19½″ / 7.9cm. x 49.5cm.
Signed, Art Sinsabaugh '61, lower right
F. M. Hall Collection, purchased from the artist, 1966
Acc. No. H-1570

610. M.W. LA. #33, 1961
silver print, artist proof #2
2¹¹/₁₆″ x 19⅜″ / 6.8cm. x 49.2cm.
Signed, Art Sinsabaugh '61, lower right
F. M. Hall Collection, purchased from the artist, 1966
Acc. No. H-1569

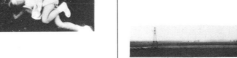

611. M.W. LA. #34, 1961
silver print, 9/20
2¾″ x 19½″ / 7cm. x 49.5cm.
Signed, Art Sinsabaugh '61, lower right
F. M. Hall Collection, purchased from the artist, 1966
Acc. No. H-1568

612. M.W. LA. #78, 1962
silver print, 1/5
4⅞″ x 19⁵/₁₆″ / 12.4cm. x 49.1cm.
Signed, Art Sinsabaugh '62, lower right
F. M. Hall Collection, purchased from the artist, 1966
Acc. No. H-1571

*613. CHI LA. #170, 1964
silver print
6¹/₁₆″ x 19½″ / 15.4cm. x 49.5cm.
University Collection, gift of the artist, 1966
Acc. No. U-511

614. CHI LA. #205, 1965
silver print
11¹¹/₁₆″ x 19⅜″ / 29.7cm. x 49.2cm.
Reproduced: *American Photography: The Sixties,* p. 35
F. M. Hall Collection, purchased from the artist, 1966
Acc. No. H-1143

Note: The artist's titles as given above are abbreviations for "Midwestern Landscape" (Nos. 609 through 612) and "Chicago Landscape" (Nos. 613 and 614).

AARON SISKIND

b. New York, New York, 1903
Education: College of the City of New York, BSS, 1926; self taught in photography
Awards: 1966—Guggenheim; 1969—Bingham Distinguished Professor in Humanities, University of Louisville; 1970—Gold Star of Merit, Philadelphia College of Art; 1971—Honorary Doctor of Arts, Columbia College, Chicago
Solo Exhibitions: 1940—Photo League; 1941—Photo League; Dukes County Historical Society, Edgartown, MA; MOMA; 1947—Egan; St. Paul Gallery, St. Paul, MN; California Palace of the Legion of Honor, San Francisco, CA; 1948—Santa Barbara; Delaware Gallery, New Hope, PA; Black Mountain; Egan; Queens College Library, Flushing, NY; 1949—Egan; ID; 1951—Egan; Seven Stairs Gallery, Chicago, IL; Black Mountain; 1952—Portland; 1954—Egan; Menemska Gallery, Martha's Vineyard, MA; IMP; 1955—Northwestern; Denver; AIC; Santa Barbara; 1956—Cincinnati; Evanston Township High School, Evanston, IL; Posman, Poland; 1957—American Cultural Center, Paris (with Harry Callahan); 1958—Alfred; SFSU; 1959—Martha Jackson Gallery, NYC; Siembab; Holland-Goldowsky Gallery, Chicago, IL; 1960—The Cliff Dwellers, Chicago, IL (with Harry Callahan); 1962—John Gibson Gallery, Chicago, IL; VII Photographer's Gallery, Provincetown, MA; Hanamura's, Detroit, MI; 1963—IMP; 1964—AIC; Michigan State University, East Lansing, MI; 1965—Pomona; IMP; Mankato State College, Mankato, MN; 1969—UNH; 1972—Light; Milwaukee; 1973—RISD; SFAI; 1974—Light; 1975—AIC; Smart Gallery, University of Chicago; 1976—Brown University, Providence, RI; Cronin; 1977—Halsted
Public Collections: Tuscon// Addison; AIC; BN; Burpee; Carpenter; Detroit; ENB; Fogg; High; IMP; Kalamazoo; Krannert; Louisville; MMA; Menil; MIA, Michigan; MFAH; MOMA; Milwaukee; NGC; Nebraska; Newark: NOMA; Oakland; Oklahoma; Pasadena; PMA; Princeton; RISD; SFMMA; Seagram; Smith; Smithsonian; St. Petersburg; UCLA; UNM; VMFA; VSW; Yale

615. JEROME, ARIZONA, 1949
silver print
13⁷/₁₆″ x 9⅛″ / 34.1cm. x 23.2cm.
Reproduced: **Aaron Siskind Photographs,** p. 45; **LLP: The Great Themes,** p. 89; **Time** Magazine, 1955, n.p.
F. M. Hall Collection, 1960
Acc. No. H-616

616. CHICAGO, 1952
silver print
15¹/₁₆″ x 19¼″ / 38.3cm. x 48.9cm.
Reproduced: **Photographers on Photography,** pl. 42
F. M. Hall Collection, 1960
Acc. No. H-619

617. TERRORS AND PLEASURES OF LEVITATION, #37, 1953
silver print
15″ x 15″ / 38.1cm. x 38.1cm.
Reproduced: **Aaron Siskind Photographer,** n.p.; **Art News,** Dec., 1955, p. 37; **Museum News,** Jan.-Feb., 1976, p. 29; **Print Collector's News Letter,** July-Aug., 1977, p. 69
F. M. Hall Collection, 1963
Acc. No. H-838

618. TERRORS AND PLEASURES OF LEVITATION, 1954
silver print
15″ x 15″ / 38.1cm. x 38.1cm.
Reproduced: **Aaron Siskind Photographer,** n.p.; **Art News,** Dec., 1956, p. 36; **Masters of the Camera,** p. 192; **Museum News,** Jan.-Feb., 1976, p. 29; **Print Collector's Newsletter,** July-Aug., 1977, p. 69
F. M. Hall Collection, 1963
Acc. No. H-839

619. MARTHA'S VINEYARD, 1954
silver print
10⁹/₁₆″ x 13⅜″ / 26.8cm. x 34cm.
F. M. Hall Collection, 1960
Acc. No. H-617

*620. URUAPAN, MEXICO, 1955
silver print
14⅝″ x 19³/₁₆″ / 37.1cm. x 48.7cm.
Reproduced: **Aaron Siskind—Photographs,** p. 50; **A Selection of Works,** pl. 92
F. M. Hall Collection, 1960
Acc. No. H-618

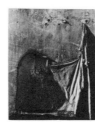

621. CHICAGO, #18, 1960
silver print
19⁵/₁₆″ x 15⁵/₁₆″ / 49.1cm. x 38.9cm.
Signed, Aaron Siskind, verso
Reproduced: **Afterimage,** March, 1973, p. 3
F. M. Hall Collection, 1963
Acc. No. H-840

182

622. CHICAGO, #71, 1960
 silver print
 14⁹/₁₆″ x 19½″ / 37cm. x 49.5cm.
 Signed, Aaron Siskind, verso
 Reproduced: **Aaron Siskind Photographer,** n.p.
 F. M. Hall Collection, 1963
 Acc. No. H-841

NEAL SLAVIN

b. New York, New York, 1941
Education: Lincoln College, Oxford University, England, 1961; Cooper Union, NYC, BFA, 1963
Awards: 1968—Fulbright; 1972—NEA; 1977—CAPS
Solo Exhibitions: 1967—Underground; 1968—National Museum of Ancient Art, Lisbon, Portugal; 1969—Museu de Conimbriga, Conimbriga, Portugal; 1970—Museu Machado de Castro, Coimbra, Portugal; 1971—Royal Ontario Museum, Toronto; Underground; 1972—Underground; Halsted; Foto & Film Centrum, Antwerp, Belgium; Focus; 1975—Light; 1976—Silver Image-Tacoma; Gallery of Photographic Art, Cleveland, OH; Light; Arizona; Wadsworth; Oakland; Photokina, Cologne, Germany; Maryland; 1977—Galerie Schurmann & Kichen, Aachen, West Germany
Public Collections: BN; IMP; Maryland; MMA; MOMA; National Museum of Ancient Art, Lisbon, Portugal; Nebraska; NYPL; Norwich Museum of Arts & Sciences, Norwich, CT; Oakland; Tuscon; UCLA; Yale
*623. NEW YORK CITY FIRE DEPARTMENT, ENGINE COMPANY #7, LADDER COMPANY #1, 1972
 type C color print
 10½″ x 13¹¹/₁₆″ / 26.7cm. x 34.8cm.
 Signed, Neal Slavin, verso
 Reproduced: **When Two or More Are Gathered Together,** n.p.; **Camera,** May, 1974, p. 23
 Nebraska Art Association, purchased with the aid of funds from the National Endowment for the Arts, 1976
 Acc. No. N-422

624. COMPANIONS OF THE FOREST OF AMERICA, JAMAICA, N.Y., 1973
 color print
 10½″ x 13⅜″ / 26.7cm. x 34cm.
 Signed, Neal Slavin, verso
 Reproduced: **When Two or More Are Gathered Together,** n.p.; **Camera,** May, 1974, p. 24
 Nebraska Art Association, purchased with the aid of funds from the National Endowment for the Arts, 1976
 Acc. No. N-421

HENRY HOLMES SMITH

b. Bloomington, Illinois, 1909
Education: Illinois State University, 1927-29, 1930-32; School of the Art Institute of Chicago, 1929-30; Ohio State University, BS, 1933; New Bauhaus, Chicago, studied and collaborated with Moholy-Nagy, Gyorgy Kepes and Nathan Lerner
Awards: 1968—Hon. DFA, Maryland Institute, College of Art
Solo Exhibitions: 1946—Illinois Wesleyan University, Bloomington, IL; 1947—Indiana; 1956—University of North Dakota, Grand Forks, ND; 1958—SUNY-New Paltz; 1959—Indiana Art Directors Association, Indianapolis; 1960—Akron; 1962—ID; 1964—SFSU; 1971—Skidmore; Polaroid; 1972—Phos/Graphos Gallery, San Francisco, CA; CPS; 1973—Indiana; 1974—FOP; 1975—Addison
Public Collections: AIC; CPS; Cincinnati; Indiana; IMP; Kalamazoo; LC; Louisville; MMA; MOMA; NGC; Nebraska; NOMA; Oakland; Princeton; SFMMA; St. Petersburg; UCLA; UNM

625. UNTITLED (Abstraction), 1946
 three color wash off relief print on black and white photograph
 9⅛″ x 5¾″ / 23.2cm. x 14.6cm.
 F. M. Hall Collection, purchased from the artist, 1969
 Acc. No. H-1354

626. PSEUDOFORM, 1950
 silver print, cameraless print, syrup directly on paper
 11″ x 9³/₁₆″ / 27.9cm. x 23.3cm.
 Signed, Henry Holmes Smith, verso
 Reproduced: **Seven Indiana Photographers,** n.p.
 F. M. Hall Collection, purchased from the artist, 1969
 Acc. No. H-1357

627. UNTITLED (Abstraction), 1950
 three color dye transfer print on black and white cameraless picture
 12½″ x 9½″ / 31.8cm. x 24.1cm.
 Signed, Henry H. Smith, verso
 F. M. Hall Collection, purchased from the artist, 1969
 Acc. No. H-1355

628. MAN AND WIFE, 1959/1960
 silver print, cameraless print directly on Kodak
 paper with syrup and water
 13⅜" x 9⅞" / 34cm x 25.1cm.
 Signed, Henry Holmes Smith 1960, lower right
 Reproduced: **Seven Indiana Photographers,**
 n.p.
 F. M. Hall Collection, purchased from the artist,
 1969
 Acc. No. H-1358

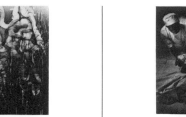

*629. DEATH OF PUNCH, 1960
 five color dye transfer print
 12⅝" x 9⅛" / 32.1cm. x 23.2cm.
 Reproduced: **Photographers on Photography,**
 pl. 45
 F. M. Hall Collection, purchased from the artist,
 1969
 Acc. No. H-1356

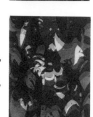

184

630. IKON, 1960
 five color dye transfer print from matrices made
 by cameraless photography
 12¹⁵/₁₆" x 9³/₁₆" / 32.9cm. x 23.3cm.
 Reproduced: **The Photographer's Choice,** p. 135
 F. M. Hall Collection, purchased from the artist,
 1969
 Acc. No. H-1359

W. EUGENE SMITH
b. Wichita, Kansas, 1918
Education: Self taught in photography; attended Notre
Dame University, 1936-37
Awards: 1956, 1957, 1968—Guggenheim
Solo Exhibitions: 1975—Oregon; 1976—Witkin; 1977—
Wichita
Public Collections: AIC; Carpenter; Fogg; IMP; Kan-
sas; LC; Louisville; Menil; Milwaukee; MFA; MFAH;
MOMA; NGC; Nebraska; NOMA; PMA; Princeton; St.
Petersburg; UNM; Yale

631. THE WALK TO PARADISE GARDEN, 1946
 silver print
 11⅞" x 10⅛" / 30.2cm. x 25.7cm.
 Signed, W. Eugene Smith, lower right in print
 Reproduced: **The Family of Man,** n.p.; **Pollack,**
 p. 610; **W. Eugene Smith,** n.p.; **Masters of the
 Camera,** p. 173
 Nebraska Art Association, purchased with the
 aid of funds from the National Endowment for
 the Arts, 1976
 Acc. No. N-411

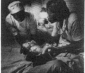

*632. NURSE-MIDWIFE MAUDE CALLEN, 1951
 silver print
 12⅞" x 9⅞" / 32.7cm. x 25.1cm.
 Signed, W. Eugene Smith, lower right in print
 Reproduced: **Pollack,** p. 616; **W. Eugene Smith,**
 n.p.; **Maddow (Faces),** p. 362; **U. S. Camera,**
 1953, p. 281
 Nebraska Art Association, purchased with the
 aid of funds from the National Endowment for
 the Arts, 1976
 Acc. No. N-410

633. JUANITA (Spanish Spinner or The Thread Maker,
 from "Spanish Village"), 1953
 silver print
 12¾" x 9" / 32.4cm. x 22.9cm.
 Signed, W. Eugene Smith, lower right in print
 Reproduced: **Photography in America,** p. 161;
 Pollack, p. 620; **Newhall,** p. 174; **W. Eugene
 Smith,** n.p.; **Life,** April 9, 1951; **U. S. Camera,**
 p. 155
 Nebraska Art Association, purchased with the
 aid of funds from the National Endowment for
 the Arts, 1976
 Acc. No. N-409

JOEL SNYDER
b. Brooklyn, New York, 1940
Education: University of Chicago, BA; MA (Philos-
ophy), 1971; self taught in photography
Solo Exhibitions: 1971—AIC; 1977—Garrett
Public Collections: AIC; ENB; IMP; MIA; MOMA; Ne-
braska; Smithsonian

634. ILLINOIS CENTRAL STATION—53RD STREET,
 CHICAGO, 1965
 calotype, overexposed and solarized
 7⅜" x 7¹³/₁₆" / 18.7cm. x 19.8cm.
 Signed, Joel Snyder/1967, lower right
 F. M. Hall Collection, purchased from the artist,
 1968
 Acc. No. H-1302

635. ROOKERY STAIRCASE, CHICAGO, 1966
 kallitype
 9⅜" x 6¹⁵/₁₆" / 23.8cm. x 17.6cm.
 Signed, Joel Snyder/1967, lower right
 F. M. Hall Collection, purchased from the artist,
 1968
 Acc. No. H-1305

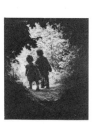

636. LE TOMBEAU DE BRUCE DAVIDSON, CHICAGO, 1966
calotype, platinum toning
6¾″ x 8¾″ / 17.1cm. x 22.2cm.
Signed, Joel Snyder/1967, lower right
F. M. Hall Collection, purchased from the artist, 1968
Acc. No. H-1297

637. 3937 LAKE PARK, CHICAGO, 1966
calotype, gold toning
7″ x 8⅜″ / 17.8cm. x 21.3cm.
Signed, Joel Snyder/1967, lower right
F. M. Hall Collection, purchased from the artist, 1968
Acc. No. H-1301

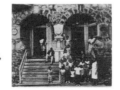

638. ENTRANCE TO ELEVATED—RANDOLPH AT LAKE, CHICAGO, 1967
wothleytype
8¹³⁄₁₆″ x 5⅞″ / 22.4cm. x 14.9cm.
Signed, Joel Snyder/1967, lower right
F. M. Hall Collection, purchased from the artist, 1968
Acc. No. H-1300

639. LE TOMBEAU DE DANNY LYON, CHICAGO, 1967
gum print on Whatman paper, presized with arrow root, finished with wax
9¹⁄₁₆″ x 5⅞″ / 23cm. x 14.9cm.
Signed, Joel Snyder/1967, lower right
F. M. Hall Collection, purchased from the artist, 1968
Acc. No. H-1299

640. LAKE SHORE DRIVE AT 52ND STREET—5 A.M., CHICAGO, 1967
platinotype
6³⁄₁₆″ x 13⅜″ / 15.7cm. x 34cm.
Signed, Joel Snyder/1967, lower right
F. M. Hall Collection, purchased from the artist, 1968
Acc. No. H-1298

641. BRIDGE HOUSE #2, CHICAGO SHIP CANAL, CHICAGO, 1967
ferroprussate print
8¼″ x 5½″ / 21cm. x 14cm.
Signed, Joel Snyder/1967, lower right
F. M. Hall Collection, purchased from the artist, 1968
Acc. No. H-1304

642. BRIDGE HOUSE #2, CHICAGO SHIP CANAL, CHICAGO, 1967
ferroprussate print
6½″ x 4½″ / 16.5cm. x 11.4cm.
Signed, Joel Snyder/1967, lower right
F. M. Hall Collection, purchased from the artist, 1968
Acc. No. H-1303

FREDERICK SOMMER
b. Angri, Italy, 1905
Education: Cornell University, MA (Landscape Architecture), 1927
Awards: 1974—Guggenheim
Solo Exhibitions: 1941—Howard Putzel Gallery, Hollywood, CA; 1946—Santa Barbara; 1949—Egan; 1957—ID; 1963—AIC; 1965—Washington Gallery of Modern Art, Washington, DC; Pasadena; 1969—PCA; 1972—Light; 1977—Light (with Michael Bishop and Carl Toth)
Public Collections: AIC; Dayton; Fogg; Indiana; IMP; Krannert; MFA; MFAH; MOMA; NCFA; Nebraska; NOMA; Pasadena; Princeton; RISD; SFMMA; St. Petersburg; Tucson; UCLA; UNM; VMFA

643. ARTIFICIAL LEG, 1944
silver print
9½″ x 7⅝″ / 24.1cm. x 19.4cm.
Signed, Frederick Sommer, verso
Reproduced: *Aperture,* 10:4, 1962, n.p.
Nebraska Art Association, purchased with the aid of funds from the National Endowment for the Arts, 1976
Acc. No. N-404

*644. SMOKE ON GLASS, 1965
silver print
13⅜″ x 10½″ / 34cm. x 26.7cm.
Signed, Frederick Sommer, verso
Nebraska Art Association, purchased with the aid of funds from the National Endowment for the Arts, 1976
Acc. No. N-403

WAYNE SOURBEER
b. Kansas City, Missouri, 1927
Public Collections: Nebraska

645. ENQUIRY AFTER SNOW
type C color print
6¼″ x 9¹⁄₁₆″ / 15.9cm. x 23cm.
F. M. Hall Collection, purchased from the artist, 1962
Acc. No. H-709

646. GREEN BIRD IN GLASS
type C color print
7⁵/₁₆″ x 8⅞″ / 18.6cm. x 22.5cm.
F. M. Hall Collection, purchased from the artist,
1962
Acc. No. H-708

JOHN SPENCE
b. Abilene, Texas, 1943
Education: University of Nebraska, BFA, 1969; MFA, 1972
Solo Exhibitions: 1970—One Loose Eye Gallery of Photography, Taos, NM; Wilber Cross Library, University of Connecticut, Storrs, CT; 1971—Blanden; 1972—Light Impressions; 1976—Nebraska; Nikon
Public Collections: Nebraska; UNM

*647. MIDGE HITCH, September, 1972/1975
silver print
15″ x 19″ / 38.1cm. x 48.3cm.
Signed, John Spence 1975, verso
University Collection, gift of the Nebraska Union,
1975
Acc. No. U-1714

648. SUE V, April, 1974/1976
silver print
15⅞″ x 20¹/₁₆″ / 40.3cm. x 51cm.
Signed, JS 76, lower right
Nebraska Art Association, purchased from the
artist, with the aid of funds from the National
Endowment for the Arts, 1976
Acc. No. N-471

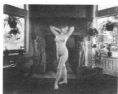

649. MORA C & FRIENDS, May, 1975/1976
silver print
32¼″ x 40⁹/₁₆″ / 81.9cm. x 103cm.
Signed, JS 76, lower right
University Collection, 1976
Acc. No. U-1896

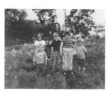

650. RITA K, July, 1976
silver print
16″ x 19⅞″ / 40.8cm. x 50.5cm.
Signed, JS 76, lower right
University Collection, 1976
Acc. No. U-1897

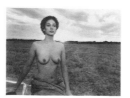

ROBERT STARCK
b. Lincoln, Nebraska, 1945
Education: University of Nebraska, Lincoln, BFA, 1972
Awards: 1975-76—Nebraska Bicentennial Commission; Nebraska Arts Council
Solo Exhibitions: 1975—Mark Four Gallery, Lincoln; 1976—Nebraska
Public Collections: Nebraska// NBC, Lincoln; Nebraska Humane Society; Smithsonian

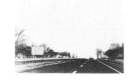

*651. GLADYS AND ERVIN ROOS, LORTON, NEBRASKA, 1976
silver print
7⅞″ x 9⁷/₁₆″ / 10cm. x 24cm.
Reproduced: *Images of Nebraska,* p. 109
University Collection, 1976
Acc. No. U-1848
Note: Ninety-nine additional prints by Robert Starck (U-2005 through U-2103), all part of the Nebraska Photographic Documentary Project, are the gift of the artist to the University Collection. Fifty-five of these prints are reproduced in *Images of Nebraska.*

LARRY STARK
b. Benton Harbor, Michigan, 1940
Education: University of Michigan, BS
Solo Exhibitions: 1970—Corcoran; Dartmouth; MIT; Amherst; Albright-Knox; MHdY; Oklahoma; Notre Dame; Addison; College of Idaho, Caldwell, ID; 1971—Richard Feigen Graphics, NYC; AIC; PPC; Currier; East Central State College, Ada, OK; Flint; Yakima Valley College, Yakima, WA; Oregon State University, Corvallis; Cuesta College, San Luis Opispo, CA; Center of the Eye; Tucson Art Center, Tucson, AZ; 1972—California State Polytechnic College, Pomona; ICA; 1973—Nebraska; 1976—Addison; Currier; Cornell; Simon Fraser University, Burnaby, BC; Dayton; ISU; 1977—Wichita
Public Collections: Addison; Albright-Knox; Amherst; AIC; Cornell; Currier; Dartmouth; Detroit; ENB; Flint; IMP; Kansas; MIA; MFAH; MOMA; NCFA; NGC; Nebraska; Notre Dame; Oklahoma; PMA; SUNY-Albany; Texas; UNH; UNM; Wisconsin; Yale

652. I DROVE THE NEXT MILE FOR A CAMEL, 1969
photo silkscreen, copy 1 of 15
15″ x 19⁷/₁₆″ / 38.1cm. x 49.4cm.
Signed, L. Stark 69, lower right
F. M. Hall Collection, purchased from the artist,
1970
Acc. No. H-1490

186

653. INTERSTATE HIGHWAY 91, CONNECTICUT,
1969
photo silkscreen, copy 1 of 15
14¾" x 19¼" / 37.5cm. x 48.9cm.
Signed, L. Stark 69, lower right
F. M. Hall Collection, purchased from the artist,
1970
Acc. No. H-1491

654.—703. PORTFOLIO—THE UNITED STATES OF
AMERICA IN THE 1970'S, 1972
photo silkscreen (50), copy 40 of 50
all prints, 20" x 24¹/₁₆" / 50.8cm. x 61.1cm.
Signed, L. Stark 72, lower right
F. M. Hall Collection, purchased from the artist,
1972
Acc. No. H-1588.1 through H-1588.50

EDWARD STEICHEN

b. Luxembourg, 1879
d. West Redding, Connecticut, 1973
Education: Self taught in Photography
Awards: 1942—Honorary MA—Wesleyan University,
Middleton, CT; 1945—Distinguished Service Medal;
Honorary Fellow, PSA; Medal, Art Directors Club;
1957—Honorary DFA, Wisconsin; 1960—Honorary
DFA, University of Hartford; 1961—Progress Medal,
RPS; Art in America Prize
Solo Exhibitions: 1902—Maison des Artistes, Paris;
1910—Montross Gallery, NYC; 1938—Baltimore;
1942—Exhibition, "Road to Victory" (MOMA); 1945—
Exhibition, "Power in the Pacific" (MOMA); (1947—
Relinquished personal photography); 1950—American
Institute of Architects, Washington, DC; 1955—Ex-
hibition, "The Family of Man" (MOMA); 1961—MOMA;
1976—Frumkin-Chicago
Public Collections: Albright-Knox; AIC; Baltimore;
CMB; Detroit; ENB; Fogg; High; Indiana; IMP; LC;
Louisville; Menil; Michigan; Milwaukee; MIA; MFAH;
MOMA; NCFA; NGC; NPG-Washington; Nebraska;
Newark; NOMA; Oberlin; PMA; RISD; SFMMA; Seattle;
Smith; Smithsonian; St. Petersburg; Texas; Tucson;
UNM
*704. PORTRAIT OF WILLIAM MERRIT CHASE
gravure, from **Camera Work,** special issue, 1906
8³/₁₆" x 6½" / 20.8cm. x 16.5cm.
F. M. Hall Collection, 1975
Acc. No. H-2053

RICHARD A. STEINMETZ

b. Lincoln, Nebraska, 1947
Education: University of Nebraska, BA, 1972
Solo Exhibitions: 1974—East Street
Public Collections: Gainesville; Nebraska
705. CAROLYN CITRIN, GESTURE, 1975
sepia print
9" x 11¹⁵/₁₆" / 22.9cm. x 30.3cm.
Stamped, Rich Steinmetz, verso
Nebraska Art Association, purchased from the
artist, with the aid of funds from the National
Endowment for the Arts, 1976
Acc. No. N-358

706. FLORIDA CLOUDSCAPE I, 1976
photo silkscreen, copy 2 of 12
10" x 14¼" / 25.4cm. x 36.2cm.
Signed, R. A. Steinmetz 1976, lower right
Nebraska Art Association, gift of the artist, 1976
Acc. No. N-360

187

707. FLORIDA CLOUDSCAPE III, 1976
photo silkscreen, copy 2 of 12
9³/₁₆" x 13½" / 23.3cm. x 34.3cm.
Signed, R. A. Steinmetz 1976, lower right
Nebraska Art Association, gift of the artist, 1976
Acc. No. N-359

JOHN STEWART, English

b. London, England, 1919
Education: University of Paris, BA, 1939; studied with
Alexey Brodovitch
Solo Exhibitions: 1975—Kornblee Gallery, NYC; BN;
Nebraska; Weatherspoon Art Gallery, Greensboro, NC;
1976—Daniela Palazzoli, Milan; Jacques Damase,
Brussels; Galerie Parallele, Geneva; Phyllis Kind, Chi-
cago; Knoll International, NYC; Cameraworks; Marl-
borough, Toronto & Montreal; 1976—Croquis Gallery,
NYC
Public Collections: CM; Nebraska; Oberlin
708. MELON AND SNAIL, 1974
charcoal print
17¼" x 23⁹/₁₆" / 43.8cm. x 59.9cm.
Signed, John Stewart, lower right
F. M. Hall Collection, 1975

Note: Charcoal printing, discovered in the 1860's, per-
fected in 1880, was abandoned due to its complexity
after a short life in photographic printing. In collabora-
tion with the inventor's son and grandson, it has been
revived by John Stewart. Basically, paper is coated
with black pigment (burned bones and grapevine
roots) and gelatin. After several hours of exposure
through a photographic negative, the gelatin and un-
absorbed pigment is washed off with water and saw-
dust. Extremely delicate in execution, editions are
limited to twenty and no two prints are identical. The

pigments provide absolutely stable prints and unalterable tonal qualities.
Acc. No. H-2064

ALFRED STIEGLITZ
b. Hoboken, New Jersey, 1864
d. New York, New York, 1946
Education: College of the City of NY; Real-gymnasium, Karlsruhe, Germany; Berlin Polytechnic Institute; University of Berlin
Awards: 1894—Elected to "The Linked Ring"; 1924—Progress Medal, RPS
Solo Exhibitions: 1899—Camera Club of New York; 1913—291 Gallery, NYC; 1921, 1923, 1924—Anderson Galleries, NYC; 1932, 1934—An American Place; MMA; 1944-45—PMA; 1958—NGA-Washington; 1965—MFA
Public Collections: AIC; Fisk University, Nashville, TN; LC; MMA; MFA; NGA-Washington; PMA; SFMMA// Addison; Albright-Knox; Baltimore; Cleveland; Cornell; ENB; Fogg; High; Indiana; IMP; Michigan; MIA; MWP; MFAH; MOMA; NCFA; NGC; Nebraska; Pasadena; Princeton; RISD; Seagram; Smith; Smithsonian; Texas; Tucson; UNM; VMFA; Wadsworth; Yale
*709. STEERAGE, 1907
gravure
13⅛" x 10⅜" / 33.3cm. x 26.4cm.
Reproduced: *Larkin,* p. 328; *Masters of Photography,* p. 61; *Photography 1839-1937,* pl. 47; *Photography from 1839 to the Present Day,* p. 112; *Photographers on Photography,* pl. 51; *Newhall,* p. 112; *Pollack,* p. 266; *Gernsheim,* pl. 306; *LLP: The Print,* p. 37; *Alfred Stieglitz,* n.p.; *Norman,* pl. XVI; *Swedlund,* p. 21; *Aperture,* 8:1, p. 60; *Aperture,* 14:2, n.p.
University Collection, gift of Lawrence Reger, 1968
Acc. No. U-642

MICHAEL STONE
b. Detroit, Michigan, 1945
Education: University of California, Los Angeles, BA, 1967; MA, 1970; MFA, 1971
Solo Exhibitions: 1972—Central Washington State College, Ellensburg, WA; 1973—Magic Theatre, Lafayette, IN; 1975—Addison
Public Collections: Indianapolis; Nebraska; Pasadena; UCLA
710. CADALLAC (sic), 1971
cyanotype, hand colored, muslin, vinyl
18½" x 23¾" / 46cm. x 60.3cm.
F. M. Hall, purchased from the artist, 1972
Acc. No. H-1587

PAUL STRAND
b. New York, New York, 1890
d. Paris, France, 1976
Education: Studied with Lewis Hine at the Ethical Culture School, 1909
Solo Exhibitions: 1916—291 Gallery, NYC; 1929—Intimate Gallery, NYC; 1932—An American Place; 1969—Kreis Museum, Feital, Germany; Traveling exhibition for Administration Culturelles Francaises of Belgium; 1970—Stockholm; Francaises of Belgium; 1971—PMA; 1972—St. Louis; MFA; 1973—MOMA; LACMA; MHdY
Public Collections: Tucson// Addison; Amon Carter; AIC; Baltimore; Burpee; CPS; Cleveland; Dayton; ENB; Fogg; High; Indiana; IMP; Kalamazoo; LC; Louisville; Menil; Michigan; MIA; Minnesota; MFA; MFAH; MOMA; NCFA; NGC; Nebraska; NOMA; Oklahoma; Pasadena; PMA; Princeton; RIT; SFMMA; Seagram; St. Petersburg; Texas; UNM; VMFA; VSW; Worcester; Yale

711. PORT LORNE, NOVA SCOTIA, 1919
silver print
9¼" x 7½" / 23.5cm. x 19.1cm. (sight)
Signed, Paul Strand, verso
Nebraska Art Association, purchased with the aid of funds from the National Endowment for the Arts, 1976
Acc. No. N-459

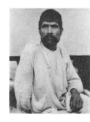

712.—731. THE MEXICAN PORTFOLIO, 1932-33
gravures (20), copy 131 of 1000
Reprinted by the Da Capo Press, 1967
Signed and numbered, Paul Strand, 131
University Collection, 1971
Acc. Nos. U-1745.1 through U-1745.20

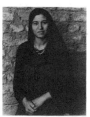

*732. KWATHAR, KALATA AL COBRA, DELTA, 1959
silver print
9¼" x 7½" /23.5cm. x 19.1cm. (sight)
Signed, Paul Strand, verso
Reproduced: *Paul Strand,* p. 287
Nebraska Art Association, purchased with the aid of funds from the National Endowment for the Arts, 1976
Acc. No. N-460

JOSEF SUDEK, Czechoslovakian
b. Kolin, Czechoslovakia, 1896
d. Prague, Czechoslovakia, 1976
Education: First instruction in photography, c. 1918, from fellow worker in a bookbindery. Lost his right arm during military service, 1915-17. Resumed photog-

raphy during convalesence in military hospitals, 1917-20. Began formal study of photography as a member of an amateur photography club, later at the Prague School of Graphic Arts. Studied for two years under Karel Novak; later, with Jaromir Funke.
Awards: 1961—Artist of Merit; 1966—Order of Labor; both by the Czech Government
Solo Exhibitions: 1933—Krasna Jizba, Prague; 1958—Alsova sin Umelecke besedy, Prague; 1961—Slezske Museum, Opava; Frenstat Pod Radhostem, Prague; 1964—Regional Galerie, Olomouc; 1966—Severoceske Museum, Liberec; 1971—Moravska Galerie, Brno; 1972—Neikrug; 1974—IMP; Light; Corcoran; 1976—Moravska Galerie, Brno; Museum of Decorative Arts, Prague; Neue Galerie, Aachen, West Germany; Museum Bochum, Bochum, West Germany; Kunsthaus, Zurich, Switzerland; Kunstlerhaus, Vienna, Austria; PG-London; Impressions; 1977—ICP; Light—**Note:** Nineteen photographs by Josef Sudek were included in the exhibition, **Five Photographers** presented at the Sheldon Gallery in 1968. This was Sudek's first American exhibition.
Public Collections: IMP; Museum of Decorative Art, Prague; Nebraska; SFMMA; UNM

733. VIEW FROM MY WINDOW, 1940/54
silver print
15½" x 11¼" / 39.4cm. x 28.6cm.
University Collection, 1970
Acc. No. U-1923

734. VIEW FROM MY WINDOW, 1940/54
silver print
15½" x 11⅜" / 39.4cm. x 28.9cm.
University Collection, 1970
Acc. No. U-1924

735. LITTLE GARDEN OF MRS. SOCHAR, 1957
silver print
11¼" x 9" / 28.6cm. x 22.9cm.
Signed, Sudek 1957, lower right
University Collection, 1970
Acc. No. U-1925

736. MAGICAL LITTLE GARDEN AT SUNSET, 1957
silver print
6¾" x 8⅞" / 17.2cm. x 22.5cm.
Signed, Sudek 1957, lower right
University Collection, 1970
Acc. No. U-1926

737. MAGICAL LITTLE GARDEN, 1959
silver print
6¾" x 9⅛" / 17.2cm. x 23.2cm.
Signed, Sudek 1959, lower right
University Collection, 1970
Acc. No. U-1927

738. MAGICAL LITTLE GARDEN, FALL, 1959
silver print
6¾" x 9⅛" / 17.2cm. x 23.2cm.
Signed, Sudek 1959, lower right
University Collection, 1970
Acc. No. U-1928

739. REMINISCENCES: LATE VISIT, 1961
silver print
15⅛" x 11⅛" / 38.4cm. x 28.3cm.
Signed, Sudek, lower right
Reproduced: **Josef Sudek,** pl. 38
University Collection, 1970
Acc. No. U-1929

740. LANDSCAPE IN BEZKYDE MOUNTAINS, 1967
silver print
3½" x 11³/₁₆" / 8.9cm. x 28.4cm.
Signed, Sudek 1967, lower right
University Collection, 1970
Acc. No. U-1930

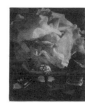

*741. LABYRINTH ON THE TABLE, 1967
silver print
11¹/₁₆" x 10" / 28.1cm. x 25.4cm.
Signed, Sudek 1967, lower right
Reproduced: **Five Photographers,** n.p.
University Collection, 1970
Acc. No. U-1931

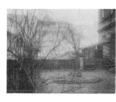

742. LITTLE GARDEN BEHIND OUR HOUSE
silver print
8⅝" x 11⅛" / 29.1cm. x 28.3cm.
Signed, Sudek, lower right
University Collection, 1970
Acc. No. U-1932

743. PHOTOGRAPHIC OBSERVATION
silver print
2⁷/₁₆″ x 5⁹/₁₆″ / 6.2cm. x 14.1cm.
Signed, Sudek, lower right
University Collection, 1970
Acc. No. U-1933

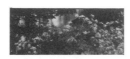

744. LAST ROSES
silver print
11″ x 9″ / 27.9cm. x 22.9cm.
Signed, Sudek, lower right
University Collection, 1970
Acc. No. U-1934

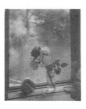

745. REMOTE PLACE WITH DRY LEAVES
silver print
8⁹/₁₆″ x 10¾″ / 21.8cm. x 27.3cm.
Signed, Sudek, lower right
University Collection, 1970
Acc. No. U-1935

746. SUNDAY AFTERNOON
silver print
3⅜″ x 11¼″ / 8.6cm. x 28.6cm.
University Collection, 1970
Acc. No. U-1936

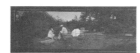

747. REMOTE PLACE ON THE WINDOW
silver print
9″ x 11⅛″ / 22.9cm. x 28.3cm.
Reproduced: *Five Photographers,* n.p.
University Collection, 1970
Acc. No. U-1937

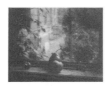

748. REMINISCENCES: COMING OF NIGHT
silver print
11¼″ x 15⅛″ / 28.6cm. x 38.4cm.
Signed, Sudek, lower right
University Collection, 1970
Acc. No. U-1938

749. REMINISCENCES: COMING OF EVENING
silver print
14½″ x 10¾″ / 36.8cm. x 27.3cm.
Signed, Sudek, lower right
University Collection, 1970
Acc. No. U-1939

750. REMINISCENCES: COMING OF SILENCE
silver print
11⁵/₁₆″ x 14⅞″ / 28.7cm. x 37.8cm.
Signed, Sudek, lower right
University Collection, 1970
Acc. No. U-1940

751. REMINISCENCES: NOT QUITE AFTERNOON
silver print
11″ x 14½″ / 27.9cm. x 36.8cm.
Signed, Sudek, lower right
Reproduced: *Five Photographers,* n.p.
University Collection, 1970
Acc. No. U-1941

752. REMINISCENCES: OF DREAMS
silver print
11″ x 15⅛″ / 27.9cm. x 38.4cm.
Reproduced: *Five Photographers,* n.p.
University Collection, 1970
Acc. No. U-1942

753. PHOTOGRAPHIC OBSERVATION
silver print
2⁷/₁₆″ x 5¹³/₁₆″ / 6.2cm. x 14.8cm.
University Collection, 1970
Acc. No. U-1943

754. PHOTOGRAPHIC OBSERVATION
silver print
2³/₁₆″ x 3¼″ / 5.6cm. x 8.3cm.
Signed, Sudek, lower right
University Collection, 1970
Acc. No. U-1945

755. SOLAMEN
silver print
3⁷/₁₆″ x 11³/₁₆″ / 8.7cm. x 28.4cm.
University Collection, 1970
Acc. No. U-1946

756. LANDSCAPE IN SOUTH BOHEMIA
silver print
3⅜″ x 11³/₁₆″ / 8.6cm. x 28.4cm.
Signed, Sudek, lower right
Reproduced: *Camera,* April, 1976, No. 4
University Collection, 1970
Acc. No. U-1947

757. SUNDAY, SIESTA
silver print
3⅜″ x 11³/₁₆″ / 8.6cm. x 28.4cm.
Signed, Sudek, lower right
Reproduced: *Five Photographers,* n.p.; *Camera,*
 April, 1976, No. 4
University Collection, 1970
Acc. No. U-1948

758. PHOTOGRAPHIC OBSERVATION
 silver print
 5⅞" x 2⁷/₁₆" / 14.9cm. x 6.2cm.
 Signed, Sudek, lower right
 University Collection, 1970
 Acc. No. U-1944

WILLIAM HENRY FOX TALBOT, English
b. Melbury, Dorset, 1800
d. Lacock, Wiltshire, 1877
Education: Harrow & Cambridge. Talbot's involvement with photography was part of his general interest in scientific matters. Elected a member of the Royal Astronomical Society (1822) and the Royal Society (1832). Working from experiments with the camera-obscura he developed 'photographic drawings' or photograms and ultimately achieved the first photographic negative (1845), thus moving one step beyond the unique image of the Daguerreotype
Solo Exhibitions: 1976 — Thackrey & Robertson
Public Collections: Fox Talbot Museum Lacock Abbey, Wiltshire; NGC; Royal Photographic Society, London; Science Museum, London// AIC; Baltimore; ENB; IMP; LC; Michigan; MIA; MOMA; Nebraska; NOMA; PMA; Princeton; Seattle, Smithsonian; Texas; Tucson; UNM; VMFA
759. LINCOLN'S INN, 1843
 calotype
 7¹⁵/₁₆" x 6¾" / 20.2cm. x 17.2cm.
 F. M. Hall Collection, 1967
 Acc. No. H-1173

760. COLISEUM, ROME, 2ND VIEW, 1846
 calotype
 7⅜" x 8⅞" / 18.7cm. x 22.5cm.
 F. M. Hall Collection, 1967
 Note: Possibly taken by the Rev. Calvert Jones and subsequently printed at Talbot's Reading Establishment.
 Acc. No. H-1172

761. BAIA, ON GULF OF POZZUOLI, ITALY, c. 1842-1850
 calotype
 6⅞" x 8½" / 17.5cm. x 21.6cm.
 F. M. Hall Collection, 1967
 Acc. No. H-1174

*762. CHESS PLAYERS, c. 1842-1850
 calotype
 7⅞" x 5⅞" / 20cm. x 14.9cm.
 Reproduced: *Jammes,* pl. 36
 F. M. Hall Collection, 1967
 Acc. No. H-1175

EDMUND TESKE
b. Chicago, Illinois, 1911
Education: Taliesin Fellowship; Hull House, Chicago; apprenticehip in commercial photography, 1934-36
Solo Exhibitions: 1961 — Pasadena; Santa Barbara; 1963 — Ceejee; SFMMA; 1970 — AIC; 1971 — Nebraska; IMP; Witkin; 1972 — Ohio Silver; 1973 — USC; 1974 — Focus; 1976 — Spiritus; 1977 — VSW
Public Collections: AIC; Krannert; IMP; MOMA; Nebraska; NOMA; Oakland; Pasadena; Princeton; SFMMA; Tucson; UCLA; UNM; VMFA

763. MY MOTHER'S KITCHEN WINDOW/CHICAGO, 1932
 silver print
 9¾" x 7⁷/₁₆" / 24.8cm. x 18.9cm.
 Signed, E. Teske, lower right
 Reproduced: *NAA Quarterly,* Spring, 1973, p. 19
 Nebraska Art Association, Nelle Cochrane Woods Collection, purchased from the artist, 1972
 Acc. No. N-268

764. TORSO, LEAVES ASCENDANT — IOWA 1942; COMPOSITE, CALIFORNIA, 1945
 silver print
 5¹⁵/₁₆" x 4⅛" / 15.1cm. x 10.5cm.
 Signed, E. Teske, lower left
 Reproduced: *NAA Quarterly,* Spring, 1973, p. 20
 Nebraska Art Association, Nelle Cochrane Woods Collection, purchased from the artist, 1972
 Acc. No. N-269

*765. KENNETH ANGER, TOPANGA CANYON, CALIFORNIA, 1954
 silver print, duotone solarization
 13⅝" x 9¹¹/₁₆" / 34.6cm. x 24.6cm.
 Signed, E. Teske, lower right
 Reproduced: *NAA Quarterly,* Spring, 1973, p. 20
 Nebraska Art Association, Nelle Cochrane Woods Collection, purchased from the artist, 1972
 Acc. No. N-270

766. PORTRAIT OF GERALDINE PAGE, 1962
 silver print
 5⅞" x 4⅝" / 14.9cm. x 11.8cm.
 Signed, E. Teske, lower left
 Reproduced: *Aperture,* 12:3, n.p.
 Nebraska Art Association, gift of Jon Nelson,
 purchased from the artist, 1972
 Acc. No. N-262

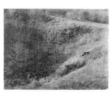

JERRY L. THOMPSON

b. Houston, Texas, 1945
Education: University of Texas, Austin, BA, 1967; The
Johns Hopkins University, Baltimore, 1968-69; Yale
University, MFA, 1973
Public Collections: MOMA; Nebraska; Seagram; Yale
767. CONEY ISLAND (Black Girl), 1973
 silver print
 8" x 9¹⁵/₁₆" / 20.3cm. x 25.2cm.
 Signed, Jerry L. Thompson, verso
 Nebraska Art Association, purchased with the
 aid of funds from the National Endowment for
 the Arts, 1976
 Acc. No. N-357

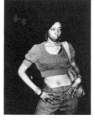

768. CONEY ISLAND (Black Boy), 1973
 silver print
 9¹⁵/₁₆" x 8" / 25.2cm. x 20.3cm.
 Signed, Jerry L. Thompson, verso
 Nebraska Art Association, purchased with the
 aid of funds from the National Endowment for
 the Arts, 1976
 Acc. No. N-356

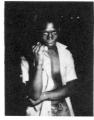

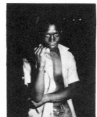

GEORGE TICE

b. Newark, New Jersey, 1938
Education: Training in commercial photography in
high school
Awards: 1973 — NEA; Guggenheim; Grand Prix-Arles
(for Paterson)
Solo Exhibitions: 1969, 1970 — Witkin; 1971 — AIC;
1972 — MMA; 1973, 1975 — Witkin, 1976 — New Jersey
State Museum, Trenton, NJ; Spiritus; 1977 — Witkin
Public Collections: Amon Carter; AIC; Baltimore; BN;
Cleveland; Denver; Detroit; High; IMP; Kalamazoo;
LC; MMA; Michigan; Milwaukee; MIA; MOMA; Nebras-
ka; New Jersey Historical Museum, Trenton; NOMA;
Oklahoma; RISD; Seagram; St. Petersburg; Tucson;
YMHA, West Orange, NJ

769. GARRET MOUNTAIN, PATERSON, N.J., 1967
 platinum print
 7⅝" x 9⅝" / 19.4cm. x 24.5cm.
 Signed, Geo A. Tice, lower right
 Reproduced: *Paterson,* n.p.; *George Tice,* p. 68
 Nebraska Art Association, purchased with the
 aid of funds from the National Endowment for
 the Arts, 1976
 Acc. No. N-447

*770. ROARING FORK RIVER, ASPEN, COLORADO,
 1969
 platinum print, hand sensitized on Rives BFK
 paper
 9⅝" x 7⅝" / 24.5cm. x 19.4cm.
 Signed, Geo A. Tice, lower right
 Reproduced: *Paterson,* n.p.; *George Tice,* p. 12;
 Museum News, Jan.-Feb., 1976 (cover)
 Nebraska Art Association, purchased with the
 aid of funds from the National Endowment for
 the Arts, 1976
 Acc. No. N-448

JERRY N. UELSMANN

b. Detroit, Michigan, 1934
Education: Rochester Institute of Technology, BFA,
1958; Indiana University, MS and MFA, 1960; studied
with Ralph Hattersley, Minor White and Henry Holmes
Smith
Awards: 1967 — Guggenheim; 1971 — NEA; Bertram
Cox Memorial Lecture, RPS, London; 1973 — Fellow,
RPS
Solo Exhibitions: 1960 — Indiana; 1961 — Tempe; ID;
SFSU; Gainesville; 1962 — SFSU; Jacksonville; In-
diana; AIC-School; 1963 — Kalamazoo; Florida Union,
Gainesville; Jacksonville; 1964 — Tempe; 1965 — Tam-
pa; 1966 — Pratt; Lowe Art Gallery, University of Miami,
Coral Gables; 1967 — MOMA; UNH; Ringling; 1968 —
MIT; Container Corporation of America; Chicago; N.W.
Ayer Gallery, Philadelphia; Phoenix; Oregon; ReFocus;
Ringling; 1969 — ICP; American Cultural Center, Paris;
PMA; Siembab; Camera Work-Costa Mesa; FOP; Tam-
pa; 1970 — IMP; Karyanna Gallery, Winter Park; PMA;
1971 — Boise State College, Boise; College of Idaho,
Caldwell; St. Lawrence University, Canton; 1972 — AIC;
Stetson University, Deland, FL; Witkin; 1973 — Halsted;
Soho; UNI; Western Carolina University, Cullowhee;
1974 — American Cultural Center, Paris; Art Academy
of Cincinnati; Eastern Washington State College,
Cheney; Murfreesboro; Photography Place; University
of Northern Florida, Pensacola; 1975 — RIT; Shado;
Washington; 1976 — Addison (with Bruce Davidson)
Public Collections: Tucson// Addison; Alabama; AIC;
Berkeley; Carbondale; CPS; Cleveland; Denver; De-
troit; ENB; Fogg; Gainesville; High; ICP; Kalamazoo;
Kansas; Krannert; LC; Louisville; MMA; MIA; MFA;
MFAH; MOMA; NGC; Nebraska; NOMA; Oklahoma;

Pasadena; PMA; Princeton; RISD; Ringling; Smithsonian; St. Petersburg; Tampa; Tempe; UCLA; UNM; V&A; VMFA; VSW; Worcester; Yale

*771. HOME IS A MEMORY, 1963
 silver print
 13³/₁₆" x 10¼" / 33.5cm. x 26cm.
 Signed, J. N.U. 1962, lower right; Jerry N. Uelsmann, verso
 Reproduced: *Aperture,* 15:4, n.p.
 F. M. Hall Collection, purchased from the artist, 1966
 Acc. No. H-1027

772. ROOM NUMBER 1, 1963
 silver print
 9¹/₁₆" x 13⅝" / 23cm. x 34.6cm.
 Signed, J.N.U. 1963, lower right; Jerry N. Uelsmann, verso
 Reproduced: *Aperture,* 15:4, n.p.
 F. M. Hall Collection, purchased from the artist, 1966
 Acc. No. H-1028

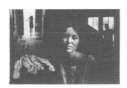

773. RITUAL GROUND, 1964
 silver print
 12¾" x 9¹/₁₆" / 32.4cm. x 23cm.
 Signed, J.N.U. '64, lower right; Jerry N. Uelsmann 1964, verso
 Reproduced: *Aperture,* 15:4, n.p.
 F. M. Hall Collection, purchased from the artist, 1966
 Acc. No. H-1030

774. UNTITLED (Tree), 1964
 silver print
 13½" x 9¼" / 34.3cm. x 23.5cm.
 Signed, J.N.U. 1965, lower right; Jerry N. Uelsmann, verso
 Reproduced: *American Photography, The Sixties,* p. 37; *Aperture,* 15:4, n.p.
 F. M. Hall Collection, purchased from the artist, 1966
 Acc. No. H-1029

DORIS ULMANN
b. New York, 1884
d. 1934
Education: School of Ethical Culture; Columbia University; Clarence White School of Photography
Solo Exhibitions: 1929, 1933—Delphic
Public Collections: LC// AIC; Berea College, Berea, KY; Detroit; Everson; ENB; Nebraska; NOMA; Oregon; PMA; RISD; UNM

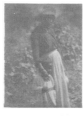

775. WOMAN & CHILD
 platinum print
 8" x 6⅛" / 20.4cm. x 15.6cm.
 Signed, Doris Ulmann, lower right
 F. M. Hall Collection, 1975
 Acc. No. H-2054

*776. MAN
 platinum print
 8¼" x 6⅛" / 20.6cm. x 15.4cm.
 Signed, Doris Ulmann, lower right
 F. M. Hall Collection, 1975
 Acc. No. H-2055

VINCENT VALLARINO
b. Austin, Texas, 1953
Education: Self taught in photography; studied with Steven Gersh; attended Apeiron Workshops; apprentice to Paul Caponigro
Solo Exhibitions: 1971—The Photography Gallery, Saskatoon, Saskatchewan; 1972—East Street; 1973—Photography Place; New England; 1974—Siembab; Scandesign, Cleveland, OH; Shado; 1975—UC-Santa Clara; Silver Image-Tacoma; Berkshire; Nebraska; Shado; 1976—Neikrug
Public Collections: BN; MFA; Nebraska; Polaroid; UC-Santa Clara

777. FOREST IN FOG, 1974
 silver print
 8½" x 12" / 21.6cm. x 30.5cm.
 Signed, Vincent Vallarino, lower right
 Nebraska Art Association, purchased from the artist, with the aid of funds from the National Endowment for the Arts, 1976
 Acc. No. N-399

JAMES VAN DERZEE
b. Lenox, Massachusetts, 1896
Education: Self taught in photography
Solo Exhibitions: 1969—MMA (largest contributor to the exhibition, "Harlem on My Mind"); 1970—Lenox Library, Lenox, MA; 1971—Studio Museum, Harlem; 1974—GI
Public Collections: Baltimore; Cleveland; Detroit;

High; LC; MMA; Michigan; MIA; MFAH; Nebraska; RISD; Tucson; UCLA

*778.-795. JAMES VAN DERZEE, EIGHTEEN PHOTOGRAPHS
 silver prints, printed by Richard Benson, copy 55 of 75
 Published by Graphics International Ltd., Washington, DC, in cooperation with the James Van Derzee Institute, Inc., NY, 1974
 Nebraska Art Association, purchased with the aid of funds from the National Endowment for the Arts, 1976
 Acc. Nos. N-423.1 through N-423.18

TODD WALKER
b. Salt Lake City, Utah, 1917
Education: Glendale Junior College, Glendale, CA, 1939-40; Art Center School, Los Angeles, with Edward Kaminski, 1939-41
Solo Exhibitions: 1963 — California Museum of Science & Industry, Los Angeles, CA; 1969 — Camera Work-Costa Mesa; 1970 — Focus; FOP; 1973 — UNI; 1975 — Oregon; Whitney; 1977 — VSW
Public Collections: Fogg; Gainesville; IMP; MIA; MFAH; MOMA; Nebraska; NOMA; Pasadena; St. Petersburg; Tucson; UCLA; VMFA; VSW

*796. UNTITLED (Seated Nude), 1970
 toned photograph
 9″ x 6⁷⁄₁₆″ / 22.9cm. x 16.4cm.
 Signed, Todd Walker 1970, lower right
 Nebraska Art Association, purchased with the aid of funds from the National Endowment for the Arts, 1976
 Acc. No. N-446

J. LAURIE WALLACE
b. Garvagh, Ireland, 1864
d. Omaha, Nebraska, 1934
Education: Pupil of Thomas Eakins at the Pennsylvania Academy
Public Collections: Joslyn; Nebraska

797. PORTRAIT OF A YOUNG MAN (Head)
 silver print
 8⅛″ x 6⁵⁄₁₆″ / 20.6cm. x 16cm.
 University Collection, 1971
 Acc. No. U-979

798. PORTRAIT OF A YOUNG MAN (Bust)
 silver print
 8¼″ x 6½″ / 21cm. x 16.5cm.
 University Collection, 1971
 Acc. No. U-980

799. PORTRAIT OF A YOUNG WOMAN
 silver print
 8¼″ x 6⁷⁄₁₆″ / 21cm. x 16.4cm.
 University Collection, 1971
 Acc. No. U-981
Note: Nos. 797, 798, 799 and twelve additional prints were printed by Roger Williams from original negatives in the collection of Joslyn Art Museum, Omaha.

JACK WELPOTT
b. Kansas City, Kansas, 1923
Education: Indiana University, BS, 1949; MS, 1954; MFA, 1959; studied with Henry Holmes Smith, Aaron Siskind and Minor White
Solo Exhibitions: Addison; AIC; MIA; Nebraska; NOMA; Oakland; Oklahoma; Pasadena; SFMMA; UCLA; UNM; VSW
Public Collections: Addison; AIC; Denver; IMP; MIA; MOMA; Nebraska; NOMA; Oklahoma; Pasadena; SFMMA; UCLA; UNM; VSW

800. ANNA IN HER ROOM (Anna Savoca), 1964
 silver print
 7½″ x 9⅝″ / 19.1cm. x 24.5cm.
 Signed, J. W. '63, lower right
 Reproduced: *LLP: The Print,* p. 145; *Women and Other Visions,* p. 24
 F. M. Hall Collection, purchased from the artist, 1966
 Acc. No. H-1013

*801. BOY, STEINSVILLE, MARYLAND, 1965
 silver print
 10½″ x 13½″ / 26.7cm. x 34.3cm.
 Signed, J. W. '65, lower right
 Reproduced: *Afterimage,* Jan. 1976, p. 20
 F. M. Hall Collection, purchased from the artist, 1966
 Acc. No. H-1014

HENRY WESSEL, JR.
b. Teaneck, New Jersey, 1942
Education: Pennsylvania State University, University Park, PA, 1965; SUNY-Buffalo—Visual Studies Workshop, MFA, 1972
Awards: 1971—Guggenheim; 1974—NEA
Public Collections: American Arts Documentation Center, Exeter, England; IMP; Maine; MOMA; NGC; Nebraska; Pasadena; Seagram; VSW

802. UNTITLED (Western Landscape)
silver print
8" x 11¹³/₁₆" / 20.3cm. x 30cm.
Signed, Henry Wessel, Jr., lower right
Nebraska Art Association, purchased with the aid of funds from the National Endowment for the Arts, 1976
Acc. No. N-405

*803. UNTITLED (Two Trees)
silver print
11¹³/₁₆" x 8" / 30cm. x 20.3cm.
Signed, Henry Wessel, Jr., lower right
Reproduced: *Camera,* May, 1974, p. 13
Nebraska Art Association, purchased with the aid of funds from the National Endowment for the Arts, 1976
Acc. No. N-406

BRETT WESTON
b. Los Angeles, California, 1911
Education: Studied photography under his father, Edward Weston
Awards: 1945—Guggenheim
Solo Exhibitions: 1930—Zeitlin; 1935—Julien Levy; 1975—Thackrey & Robertson; 1976—Hawkins; 1977—Cronin; San Francisco; Los Angeles; Mexico City; New York; Rochester, NY; Chicago; Boston; Ft. Worth; Portland; Eugene; Carmel; Germany; France; Netherlands; Canada; Sweden
Public Collections: Tucson// Amon Carter; AIC; Bowdoin; Burpee; Carpenter; Cleveland; ENB; Fogg; IMP; Kalamazoo; LC; Louisville; Michigan; MIA; Minnesota; MFAH; MOMA; Nebraska; NOMA; Oakland; Oregon; Pasadena; PMA; Polaroid; Princeton; SFMMA; Seagram; St. Petersburg; Tempe; Texas; UNM; VSW; Wadsworth; Worcester; Yale

804.-815. PHOTOGRAPHS—NEW YORK, 1945-47
silver prints (12) copy 1 of 50, Introduction by Beaumont Newhall
Signed, Brett Weston, verso, each print
Nebraska Art Association, gift of Lawrence Reger
Acc. Nos. N-349.1 through N-349.12

816. UNTITLED (Pine Needles & Snow), 1951
silver print
7⅝" x 9⁹/₁₆" / 19.4cm. x 24.3cm.
Signed, Brett Weston 1951, verso
F. M. Hall Collection, 1961
Acc. No. H-704

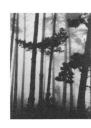

817. UNTITLED (Water Course), 1959
silver print
9½" x 7⅝" / 24.1cm. x 19.4cm.
Signed, Brett Weston 1959, verso
F. M. Hall Collection, 1961
Acc. No. H-705

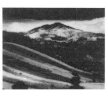

*818. MONTEREY PINES, 1963
silver print
13⁹/₁₆" x 10⁷/₁₆" / 34.5cm. x 26.5cm.
Signed, Brett Weston 1963, lower right
Reproduced: *Brett Weston Photographs,* p. 10; *LLP: The Great Themes,* p. 201; *U. S. Camera,* 1964, p. 105; *Camera,* June, 1973, p. 32
F. M. Hall Collection, 1966
Acc. No. H-1124

819. GUATAMALA, 1964
silver print
7⅝" x 9⁹/₁₆" / 19.4cm. x 24.3cm.
Signed, Brett Weston 1964, lower right
Reproduced: *Brett Weston Photographs,* p. 32
F. M. Hall Collection, 1966
Acc. No. H-1125

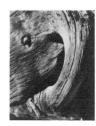

820. UNTITLED (Tree Form)
silver print
9⁹/₁₆" x 7⅝" / 24.3cm. x 19.4cm.
University Collection
Acc. No. U-1912

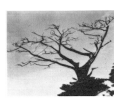

821. UNTITLED (Leafless Tree)
silver print
7½" x 9⁹/₁₆" / 19.1cm. x 24.3cm.
University Collection
Acc. No. U-1913

822. UNTITLED (Sand Dunes)
 silver print
 7½″ x 9⅝″ / 19.1cm. x 24.5cm.
 University Collection
 Acc. No. U-1914

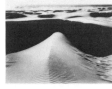

823. UNTITLED (Steel Structure)
 silver print
 7⅝″ x 9⅛″ / 19.4cm. x 23.2cm.
 University Collection
 Acc. No. U-1915
Note: Nos. 820, 821, 822, and 823 above, allocated by
the Work Projects Administration, 1943.

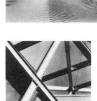

196

CHANDLER WESTON
Public Collections: Minnesota; Nebraska; Tucson
824. CARBURETOR
 silver print
 9⁷/₁₆″ x 7″ / 24cm. x 17.8cm.
 University Collection, allocated by the Work
 Projects Administration, 1943
 Acc. No. U-1911

EDWARD WESTON
b. Chicago, Illinois, 1886
d. Point Lobos, California, 1958
Education: Self taught in photography
Awards: 1937, 1938, Guggenheim
Solo Exhibitions: 1930, 1932—Delphic; 1937—Nieren-
dorf Gallery, NYC; 1973—traveling show organized by
FOP—Nebraska; 1976—Mirvish
Public Collections: Krannert; NGC; Pasadena;
SFMMA; Tucson// Achenbach; Addison; Albright-
Knox; Amon Carter; AIC; Baltimore; Berkeley; Bou-
doin; Carpenter; Cincinnati; Cleveland; Cornell;
Dayton; Denver; Detroit; ENB; Everson; Fogg; FOP;
High; Indiana; IMP; Iowa; Kalamazoo; LC; Louisville;
Michigan; Milwaukee; MIA; Minnesota; MFA; MFAH;
MOMA; Nebraska; Nelson; NOMA; Oakland; Oberlin;
Oklahoma; Oregon; PMA; Princeton; RISD; Ringling;
Seagram; Smith; Smithsonian; St. Petersburg; Tempe;
Texas; UNM; Worcester; Yale
825. GALVAN SHOOTING, MEXICO, D.F. (Manuel
 Galvan), 1924
 silver print from enlarged negative
 9″ x 7⁵/₁₆″ / 22.7cm. x 18.6cm.
 Signed, EW 1924, lower right
 Reproduced: *Masters of the Camera,* p. 75;
 Maddow, p. 111; *Maddow (Faces),* p. 420;
 Aperture, 6:1, p. 31; *Aperture,* 12:1, p. 11;
 Aperture, 12:2, p. 11
 F. M. Hall Collection, 1961
 Acc. No. H-702

826. NUDE (Standing Figure), 1927
 silver print
 9¼″ x 5½″ / 23.5cm. x 14cm.
 Signed, Edward Weston 1927, lower right
 Reproduced: *Maddow,* p. 95
 F. M. Hall Collection, 1958
 Acc. No. H-517

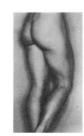

*827. KNEES, 1927
 platinum print
 6³/₁₆″ x 9³/₁₆″ / 15.7cm. x 23.3cm.
 Signed, Edward Weston 1927, lower right
 Reproduced: *Maddow,* p. 95
 F. M. Hall Collection, 1958
 Acc. No. H-515

828. SHELL: NAUTILUS, 1927
 silver print
 9³/₁₆″ x 7″ / 23.3cm. x 17.8cm.
 Signed, Edward Weston 1927, lower right
 F. M. Hall Collection, 1958
 Acc. No. H-513

829. PEPPER, 1930
 silver print
 9⁹/₁₆″ x 7⅝″ / 24.3cm. x 19.4cm.
 Signed, Edward Weston 1930, lower right; EW
 5/50, lower left
 Reproduced: *Maddow,* p. 146
 F. M. Hall Collection, 1958
 Acc. No. H-516

830. EGG SLICER, 1930
 silver print
 7″ x 9″ / 17.8cm. x 22.9cm.
 Signed, EW 1930, lower right; Edward Weston
 1930, verso
 Reproduced: *LLP: The Great Themes,* p. 77
 F. M. Hall Collection, 1961
 Acc. No. H-700

831. CYPRESS—POINT LOBOS, 1930
 silver print
 9⅝″ x 7⅝″ / 24.5cm. x 19.7cm.
 Signed, EW 1/50, lower left; Edward Weston
 1930, lower right
 Reproduced: *Maddow,* p. 129
 F. M. Hall Collection, 1958
 Acc. No. H-514

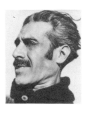

832. CHURCH AT "E" TOWN, NEW MEXICO, 1933
silver print
7⅝" x 9⅝" / 19.7cm. x 24.5cm.
Signed, Edward Weston 1933, lower right
Reproduced: *Maddow,* p. 158
F. M. Hall Collection, 1958
Acc. No. H-512

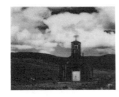

833. IGOR STRAVINSKY, 1935
silver print
4⅝" x 3¹¹/₁₆" / 11.8cm. x 9.4cm.
Signed, Edward Weston/1935, lower right
F. M. Hall Collection, 1961
Acc. No. H-696

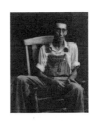

834. POTATO CELLAR—LAKE TAHOE, 1937
silver print
7⅝" x 9⁹/₁₆" / 19.4cm. x 24.3cm.
Signed, Edward Weston 1937, lower right
Reproduced: *California,* n.p.; *A Selection of Works,* pl. 103; *Aperture,* 12:1, p. 50; *Aperture,* 12:2, p. 50
F. M. Hall Collection, 1961
Acc. No. H-697

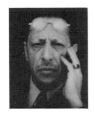

835. DAVID H. MC ALPIN, 1937
silver print
9⅝" x 7⅝" / 24.5cm. x 19.4cm.
Signed, EW 1941, lower right
Reproduced: *Maddow,* p. 239; *U. S. Camera,* 1959, p. 57; *Saturday Review,* June 17, 1961, p. 48
F. M. Hall Collection, 1961
Acc. No. H-701

836. GHOST TOWN, RHYOLITE, NEVADA, 1938
silver print
7⅝" x 9⅝" / 19.4cm. x 24.5cm.
Signed, Edward Weston 1938, lower right
Reproduced: *California,* n.p.; *Masters of Photography,* p. 127; *Maddow,* p. 217
F. M. Hall Collection, 1961
Acc. No. H-703

837. HONEYMOON (Jean and Zohmali Charlot), 1939
silver print
7⅝" x 9⅝" / 19.4cm. x 24.5cm.
Signed, Edward Weston 1939, lower right
Reproduced: *Family of Man,* p. 131
F. M. Hall Collection, 1961
Acc. No. H-699

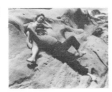

838. DILLARD TENNESSEE, 1941
silver print
9⁹/₁₆" x 7⅝" / 24.3cm. x 19.4cm.
Signed, EW 1941, lower right
F. M. Hall Collection, 1961
Acc. No. H-698

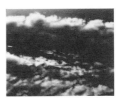

839. MONUMENT ON WILSHIRE BLVD.
silver print
9½" x 7⁹/₁₆" / 24.1cm. x 19.2cm.
University Collection
Acc. No. U-1907

840. STUMP, CRESCENT CITY
silver print
9⁹/₁₆" x 7⁹/₁₆" / 24.3cm. x 19.2cm.
University Collection
Acc. No. U-1908

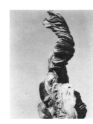

841. CACTUS
silver print
7½" x 9⁷/₁₆" / 19.1cm. x 24cm.
University Collection
Acc. No. U-1909

842. CLOUDS
silver print
7⁹/₁₆" x 9⁹/₁₆" / 19.2cm. x 24.3cm.
University Collection
Acc. No. U-1910

Note: Nos. 839, 840, 841 and 842 above, allocated by the Work Projects Administration, 1943.

CLARENCE WHITE
b. Newark, Ohio, 1871
d. Mexico City, Mexico, 1925
Education: Self taught in photography
Solo Exhibitions: 1968 — Nebraska; 1971 — MOMA;
1977 — Janet Lehr, NYC
Public Collections: LC// Albright-Knox; AIC; Cincinnati; Cornell; Dayton; Detroit; IMP; MMA; MIA; MFA;
MOMA; NGC-Washington; Nebraska; NOMA; PMA;
Princeton; RISD; RPS; SFMMA; Smithsonian; Texas;
UNM

*843.-858. CAMERA WORK NO. XXIII MDCCCCVIIII
gravures (16)
F. M. Hall Collection, 1976
Acc. Nos. H-2159.1 through H-2159.16

MINOR WHITE
b. Minneapolis, Minnesota, 1908
d. Boston, Massachusetts, 1976
Education: Minnesota, 1928-33; Columbia University
Extension Division; MOMA with Beaumont & Nancy
Newhall, 1945-46
Awards: 1970 — Guggenheim
Solo Exhibitions: 1939-41 — Traveling WPA Exhibition; 1942-YMCA, Portland, OR; 1948 — SFMMA;
1950 — Photo League; 1952 — SFMMA; 1954 — IMP;
1967 — Siembab; 1968 — Ringling
Public Collections: PMA; Tucson// Addison; Amon
Carter; AIC; Carpenter; CPS; Cincinnati; Cleveland;
Dayton; Detroit; ENB; Fogg; Gainesville; High; IMP;
Kalamazoo; Krannert; LC; Louisville; MIT; Michigan;
MIA; MFAH; MOMA; NGC; Nebraska; NOMA; Oakland;
Oregon; Pasadena; Polaroid; Princeton; RISD; Ringling; Roswell; SFMMA; Seagram; Smith; Smithsonian;
St. Petersburg; Tampa; Tempe; UCLA; UNM; VMFA;
VSW; Worcester; Yale

859. SAND BLASTER, SAN FRANCISCO, 1948
silver print
7⅝" x 8¹/₁₆" / 19.4cm. x 20.5cm.
Signed, Minor White, lower right
Reproduced: *The Photographer's Eye,* p. 61;
Aperture, 1, p. 52; *Aperture,* 1:3, p. 15, 16;
Camera, Nov. 1975, p. 23
F. M. Hall Collection, purchased from the artist,
1966
Acc. No. H-1133

*860. SOLSTICE CAPITAL REEF, UTAH, 1962
silver print
9¹⁵/₁₆" x 13" / 25.2cm. x 33cm.
Signed, Minor White, lower right
F. M. Hall Collection, purchased from the artist,
1966
Acc. No. H-1131

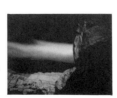

861. JUNIPER LAKE, TENAYA, CALIFORNIA, 1964
silver print
11⁹/₁₆" x 9⅛" / 29.4cm. x 23.2cm.
Signed, Minor White, lower right
F. M. Hall Collection, purchased from the artist,
1966
Acc. No. H-1132

862. MOENKOPIE LAYER, CAPITAL REEF, UTAH,
1964
silver print
12¹³/₁₆" x 9⅝" / 31cm. x 24.5cm.
Signed, Minor 1962, lower right
Reproduced: *American Photography, The Sixties,* p. 39
F. M. Hall Collection, purchased from the artist,
1966
Acc. No. H-1130

ROGER WILLIAMS, English
b. Coventry, England, 1946
Education: Alfred University, BFA, 1968; MS, 1970;
University of Nebraska, MFA, 1973; studied at the
School of the Art Institute of Chicago
Solo Exhibitions: 1973 — Bradford College, Haverhill,
MA; 1974 — Shado; 1975 — Murfreesboro; Beloit; Panopticon; Edison Street; Maine; Focal Point Photographic Gallery, Madison, WI; 1975-76 — RISD; 1976 —
Discovery Gallery at Modernage, NYC; Sioux City
Public Collections: Nebraska

863. OMAHA, NEBRASKA, 1972
silver print
6⁵/₁₆" x 7⅝" / 16cm. x 19.4cm.
Signed, 1972, RW, verso
University Collection, purchased from the artist,
1974
Acc. No. U-1192

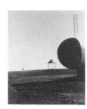

864. PLEASANT DALE, NEBRASKA, 1972
silver print
7⅝" x 6¼" / 19.4cm. x 15.8cm.
Signed, 1972, RW, verso
University Collection, purchased from the artist,
1974
Acc. No. U-1194

865. PANAMA, NEBRASKA, 1973
 silver print
 7⁹⁄₁₆″ x 6¼″ / 19.2cm. x 15.9cm.
 Signed, 73, RW, verso
 University Collection, purchased from the artist,
 1974
 Acc. No. U-1191

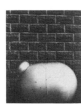

866. HASTINGS, NEBRASKA, 1973
 silver print
 7⁹⁄₁₆″ x 6¼″ / 19.2cm. x 15.9cm.
 Signed, 1973, RW, verso
 University Collection, purchased from the artist,
 1974
 Acc. No. U-1193

GARRY WINOGRAND
b. New York, New York, 1928
Education: City College of New York, 1947-48; Columbia University, 1948; New School for Social Research, with Alexey Brodovitch, 1951
Awards: 1964, 1969—Guggenheim; 1971—NY State Council on the Arts; 1975—NEA
Solo Exhibitions: 1960—Image; 1969—MOMA; 1975—Light; 1976—Cronin
Public Collections: Baltimore; IMP; Kalamazoo; LC; Michigan; MFAH; MOMA; NGC; Nebraska; Princeton; Seagram; Tucson; UCLA; VMFA

*867. PARIS, 1967
 silver print
 9″ x 13½″ / 22.9cm. x 34.3cm.
 Reproduced: *Five Photographers,* n.p.
 F. M. Hall Collection, purchased from the artist,
 1970
 Acc. No. H-1455

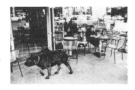

868. WINDSOR, ENGLAND, 1967
 silver print
 9″ x 13½″ / 22.9cm. x 34.3cm.
 Reproduced: *Five Photographers,* n.p.
 F. M. Hall Collection, purchased from the artist,
 1970
 Acc. No. H-1456

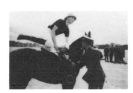

869. LONDON (Dog and Birds), 1967
 silver print
 9″ x 13½″ / 22.9cm. x 34.3cm.
 F. M. Hall Collection, purchased from the artist,
 1970
 Acc. No. H-1457

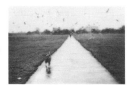

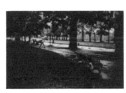

870. LONDON (Park), 1967
 silver print
 9″ x 13½″ / 22.9cm. x 34.3cm.
 Reproduced: *Five Photographers,* n.p.
 F. M. Hall Collection, purchased from the artist,
 1970
 Acc. No. H-1458

KELLY WISE
b. New Castle, Indiana, 1932
Education: Purdue University, BSA, 1955; Columbia University, MFA, 1959
Solo Exhibitions: 1973—UNH; 1974—Carbondale; Washington; Portland; Art Gallery, Language Institute of Mexico, Mexico City, D.F.; 1975—Silver Image-Ohio; Enjay Gallery, Boston; 1976—Addison; 1977—Shado
Public Collections: Addison; BN; Colorado Photographic Center, Denver, CO; Fogg; IMP; Lawrence General Hospital, Lawrence, MA; Maryland; MFA; Nebraska; Polaroid; Portland; Yale

199

871. HAT ON COAT RACK, 1976
 type C, copy 1 of 10, color
 4⅞″ x 5¾″ / 12.4cm. x 14.6cm.
 Signed, Kelly Wise, lower right
 Nebraska Art Association, purchased with the
 aid of funds from the National Endowment for
 the Arts, 1976
 Acc. No. N-398

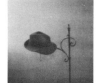

JOHN WOOD
b. Delhi, California, 1922
Education: University of Colorado, Boulder; Illinois Institute of Technology, BS, 1954
Solo Exhibitions: 1965—SUNY-Brockport; 1966—SUNY-Cortland; Edinboro State College, Edinboro, PA; Kendall Gallery, Wellfleet, MA; 1968—Schuman; 1969—MIT; 1972—VSW; 1976—Portland State University, OR; 1977—VSW
Public Collections: Fogg; MFAH; NGC; Nebraska; Pasadena; UCLA; VSW

872. UNTITLED (#80), 1966
 transfer & drawing
 10¹⁵⁄₁₆″ x 14″ / 27.8cm. x 35.6cm.
 Signed, John Wood, lower right
 F. M. Hall Collection, purchased from the artist,
 1970
 Acc. No. H-1460

*873. UNTITLED (#84), 1966
 silver print, pencil and watercolor
 10" x 21" / 25.4cm. x 53.3cm.
 Signed, John Wood/1966, lower right
 Reproduced: *Five Photographers,* n.p.
 F. M. Hall Collection, purchased from the artist,
 1970
 Acc. No. H-1461

874. UNTITLED (#73), 1968
 photo collage
 9⅝" x 7¼" / 24.5cm. x 18.4cm.
 Reproduced: *Five Photographers,* n.p.
 F. M. Hall Collection, purchased from the artist,
 1970
 Acc. No. H-1459

MYRON WOOD

200

b. Wilson, Oklahoma, 1921
Education: Oklahoma State University, BFA, 1943;
Yale University, Graduate School of Music; studied
with Edward Weston, 1949-50; Roy Stryker, 1967-73
Awards: Bonfils Foundation
Solo Exhibitions: 1974, 1977—CSFAC
Public Collections: Pueblo Public Library, Pueblo,
Co.// CSFAC; Denver; IMP; Louisville; MMA; MOMA;
Nebraska

*875. KITCHEN SHELF, TAOS PUEBLO, N.M., 1965
 silver print
 6⅜" x 9½" / 16.2cm. x 24.1cm.
 Signed, Myron Wood, verso
 Nebraska Art Association, purchased with the
 aid of funds from the National Endowment for
 the Arts, 1976
 Acc. No. N-378

876. SHEEP: SOUTH PARK, COLORADO, 1967
 silver print
 8³⁄₁₆" x 12¼" / 20.8cm. x 31.1cm.
 Signed, Myron Wood, verso
 Nebraska Art Association, purchased with the
 aid of funds from the National Endowment for
 the Arts, 1976
 Acc. No. N-379

877. SNOW STORM, TRAMPAS, N.M., 1970
 silver print
 3¹⁄₁₆" x 4¾" / 7.8cm. x 12.1cm.
 Signed, M. W., lower right; Myron Wood, verso
 Nebraska Art Association, purchased with the
 aid of funds from the National Endowment for
 the arts, 1976
 Acc. No. N-380

878. AT THE COUNTRY CLUB, 1973
 silver print
 8¼" x 12¼" / 21cm. x 31.1cm.
 Signed, Myron Wood, verso
 Nebraska Art Association, purchased with the
 aid of funds from the National Endowment for
 the Arts, 1976
 Acc. No. N-381

879. MASONIC LODGE, VICTOR, COLO., 1974
 silver print
 9½" x 7½" / 24.1cm. x 19.1cm.
 Signed, Myron Wood, verso
 Nebraska Art Association, purchased with the
 aid of funds from the National Endowment for
 the Arts, 1976
 Acc. No. N-382

LUCIA WOODS

b. Chicago, Illinois, 1937
Education: Sweetbriar College, Sweetbriar, VA, BA,
1959; studied with Alexey Brodovitch and Arthur Siegel
Awards: 1972—Musée Calvet, Avignon, France; MNM,
Architectural Photography Competition
Solo Exhibitions: 1971—The Green Ear Moon, Edgar-
town, MA; 1973—Nebraska; f/22 Gallery; 1973-74—
Newberry Library, Chicago; 1974—College of New
Rochelle, NY; Dartmouth; Princeton Library; 1974-75—
Nebraska Touring Show; Princeton Library; 1975—AIC;
Architectural Association, London; Impression; Dart-
ington College of Arts, Devon, England; 1976—Sweet-
briar College, Sweetbriar, VA
Public Collections: AIC; Nebraska; Princeton Library

*880. SEMINARY, QUEBEC CITY, 1971
 silver print
 9¼" x 6½" / 23.5cm. x 16.5cm.
 Signed, Lucia Woods, verso
 Reproduced: *Willa Cather,* p. 121
 Nebraska Art Association, purchased from the
 artist, 1974
 Acc. No. N-324

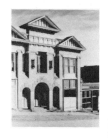

881. SHADOWS ON ADOBE WALL, SANTUARIO DE
 CHIMAYO, NEW MEXICO, 1972
 silver print
 9" x 13⅜" / 22.9cm. x 34cm.
 Signed, Lucia Woods, verso
 Nebraska Art Association, purchased from the
 artist, 1974
 Acc. No. N-325

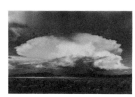

882. WILLA CATHER'S BEDROOM WINDOW, RED
 CLOUD, NEBRASKA, 1972
 silver print
 10¹⁵/₁₆" x 7⁵/₁₆" / 27.8cm. x 18.6cm.
 Signed, Lucia Woods, verso
 Reproduced: **NAA Quarterly,** Fall, 1973, p. 7
 Nebraska Art Association, purchased from the
 artist, 1974
 Acc. No. N-326

883. EVENING AND THE FLATLAND, NEAR RED
 CLOUD, NEBRASKA, 1972
 silver print
 8³/₁₆" x 12" / 20.8cm. x 30.5cm.
 Signed, Lucia Woods, verso
 Nebraska Art Association, purchased from the
 artist, 1974
 Acc. No. N-327

DON WORTH
b. Hayes County, Nebraska, 1924
Education: Manhattan School of Music, M. Mus.,
1951; self taught in photography
Awards: 1974—Guggenheim
Solo Exhibitions: 1967—Santa Barbara; 1968—Law-
son Galleries, San Francisco; 1973—SFMMA; Addison;
1974—Witkin; 1976—Camerawork Gallery, San Fran-
cisco, CA; 1976-77—Falkirk Gallery, San Rafael, CA;
1977—Silver Image-Ohio
Public Collections: SFMMA// Addison; AIC; BN; IMP;
MOMA; Nebraska; NOMA; Oakland; Pasadena; St.
Petersburg; Tucson; UCLA
*884. OLD CAR, SAN FRANCISCO, 1962
 silver print
 8¹³/₁₆" x 9¹¹/₁₆" / 20.8cm. x 24.6cm.
 Signed, Don Worth, lower right
 Reproduced: **American Photography: The Six-
 ties,** p. 39
 F. M. Hall Collection, purchased from the artist,
 1966
 Acc. No. H-1022

885. TREES AND FOG, SAN FRANCISCO, 1962
 silver print
 11⅝" x 9⅛" / 29.5cm. x 23.2cm.
 Signed, Don Worth, lower right
 F. M. Hall Collection, purchased from the artist,
 1966
 Acc. No. H-1023

PETER J. WORTH
b. Ipswich, England, 1917
Education: St. Michael's College, Yorkshire, England;
Ipswich School of Art; Royal College of Art, London;
A.R.C.A. (London), 1946
Solo Exhibitions: 1953—Nebraska

Public Collections: Denver (sculpture); Joslyn (Paint-
ing); Nebraska
886. FENCE POST WITH COILED WIRE
 silver print
 9⁷/₁₆" x 6⁵/₁₆" / 24cm. x 16cm.
 F. M. Hall Collection, purchased from the artist,
 1972
 Acc. No. H-2806

*887. TRUCK WITH MILKWEED PODS
 silver print
 6¼" x 9⁵/₁₆" / 15.9cm. x 23.7cm.
 F. M. Hall Collection, purchased from the artist,
 1972
 Acc. No. H-2807

888. DARK BARN WITH DISTANT TREE
 silver print
 9⁵/₁₆" x 6⅜" / 23.7cm. x 16.2cm.
 F. M. Hall Collection, purchased from the artist,
 1972
 Acc. No. H-2808

889. WHITE BARN WITH PUMP-SHED
 silver print
 9⁵/₁₆" x 6¼" / 23.7cm. x 15.9cm.
 F. M. Hall Collection, purchased from the artist,
 1972
 Acc. No. H-2809

STEVE YATES
b. Chicago, Illinois, 1949
Education: University of Nebraska, BFA, 1972; Uni-
versity of New Mexico, MA, 1974; MFA, 1977
Awards: 1972—Vreeland; 1977—Art Department Fel-
lowship, Ford Foundation, UNM
Solo Exhibitions: 1975—ASA Gallery, UNM (with Don
Neal)
Public Collections: Nebraska; UNM
890. MOVIE WALL, 1975
 silver print
 7¼" x 9⅞" / 18.4cm. x 25.1cm.
 Nebraska Art Association, gift of the artist, 1976
 Acc. No. N-412

*891. SILO 1A, HIGHWAY 54, OKLAHOMA, 1975
 silver print
 9¹⁵/₁₆″ x 7⁵/₁₆″ / 25.2cm. x 18.6cm.
 Nebraska Art Association, purchased from the
 artist, with the aid of funds from the National
 Endowment for the Arts, 1976
 Acc. No. N-413

ROBERT ZELM
b. Owen, Wisconsin, 1944
Education: University of Wisconsin, Madison, MFA,
1971
Public Collections: Nebraska
 892. TO THE RIGHT OF JUNCTION K
 silver print
 5⁷/₁₆″ x 12⅝″ / 13.8cm. x 32.1 cm.
 F. M. Hall Collection, purchased from the artist,
 1972
 Acc. No. H-1585

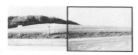

ADDENDA — Cartes de visite

MAITLAND, G. F. (Nationality unknown)
 893. PORTRAIT OF SEATED MAN AND WOMAN
 albumen print
 4″ x 2⁷/₁₆″ / 10.2cm. x 6.2cm.
 University Collection, gift of Jim Alinder, 1976
 Acc. No. U-2207

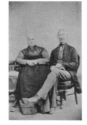

WOOD, A. W., American, dates unknown
 894. PORTRAIT OF TWO MEN
 albumen print
 4″ x 2½″ / 10.2cm. x 6.4cm.
 University Collection, gift of Jim Alinder, 1976
 Acc. No. U-2208

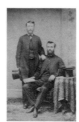

ANONYMOUS
 895. PORTRAIT OF A MAN
 albumen print
 4″ x 2½″ / 10.2cm. x 6.4cm.
 University Collection, gift of Jim Alinder, 1976
 Acc. No. U-2209

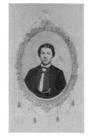

EZRA STOLLER
b. Chicago, Illinois, 1915
Education: New York University, BFA, 1938
Awards: 1955 — Gold Medal, Architectural League of
NY; 1960 — 1st Medal for Architectural Photography,
American Institute of Architects
Solo Exhibitions: 1960 — Pepsi Cola Gallery, NYC;
1967 — Graham Foundation for Advanced Studies in
the Fine Arts, Chicago.
Public Collections: Nebraska
Note: Two volumes, containing thirty views of the ex-
terior and interior of the Sheldon Memorial Art Gallery
were commissioned by the University of Nebraska in
1963.
Acc. Nos. U-1920.1 and U-1920.2

ALFRED STIEGLITZ: PHOTOGRAPHER by Doris Bry, Boston, Museum of Fine Arts, 1965

A LONG THE RIVERRUN by John Brook, San Francisco, The Scrimshaw Press, 1970

AMERICAN PHOTOGRAPHS by Walker Evans with an essay by Lincoln Kirstein, N.Y., The Museum of Modern Art, 1938 (reprint by East River Press, 1975)

AMERICAN PHOTOGRAPHY: PAST INTO PRESENT, prints from the Monsen Collection of American Photography, Seattle Art Museum, distributed by the University of Washington Press, 1976

AMERICAN PHOTOGRAPHY: THE SIXTIES, Sheldon Memorial Art Gallery, University of Nebraska-Lincoln, Feb. 22-Mar. 20, 1966

AN EARLY VICTORIAN ALBUM—The Hill/ Adamson Collection, edited and with an introduction by Colin Ford and a commentary by Roy Strong, London, Jonathan Cape, 1974

ANDRE KERTESZ (Paragraphic Books), N.Y., Grossman Publishers, 1966

ANDRE KERTESZ PHOTOGRAPHER, N.Y., The Museum of Modern Art, 1964

ANDRE KERTESZ—SIXTY YEARS OF PHOTOGRAPHY, N.Y., Grossman Publishers, 1972

AARON SISKIND: PHOTOGRAPHS, introduction by Harold Rosenberg, N.Y., Horizon Press, 1959

AARON SISKIND PHOTOGRAPHER, edited and with an introduction by Nathan Lyons, N.Y., Horizon Press, 1965

ANSEL ADAMS, Hastings on Hudson, N.Y., Morgan & Morgan, 1972

ANSEL ADAMS: IMAGES 1923-1974, Boston, New York Graphic Society, 1974

ANSEL ADAMS: PHOTOGRAPHS 1923-1963, with essay, "The Eloquent Light" by Nancy Newhall, San Francisco, M. H. de Young Museum, 1963

ARTISTS OF SUFFOLK COUNTY—Part VIII, Photographers, Huntington, L.I., N.Y., Heckscher Museum, June 30-Aug. 11, 1974

BARBARA MORGAN, Dobbs Ferry, N.Y., Morgan & Morgan, 1972

BEATON/BUCKLAND—The Magic Image, The Genius of Photography from 1839 to the Present Day by Cecil Beaton and Gail Buckland, Boston & Toronto, Little Brown & Co., 1975

THE BEST OF BEATON by Cecil Beaton, with notes on the photographs by Cecil Beaton, introduction by Truman Capote, N.Y., Macmillan Co., 1968

BRASSAI, with an introductory essay by Lawrence Durrell, N.Y., The Museum of Modern Art, 1968

BOORSTIN—Portraits from the Americans: The Democratic Experience by Daniel J. Boorstin, N.Y., Random House, 1975

BRETT WESTON PHOTOGRAPHS, introduction by Nancy Newhall, Fort Worth, Amon Carter Museum, Jan. 2-March 29, 1966

BULLETIN—UNM-Bulletin, University of New Mexico, University Art Museum, No. 5-6, 1971-72, 1973

BULLOCK PHOTOGRAPHER—Wynn Bullock: Photographer, San Francisco, The Scrimshaw Press, 1971

BULLOCK A WAY OF LIFE—Wynn Bullock: Photography, A Way of Life, Dobbs Ferry, N.Y., Morgan & Morgan, 1973

CALIFORNIA, California and the West, by Charis Wilson Weston and Edward Weston, N.Y., Duell, Sloan and Pearce, 1940

CHANGING NEW YORK, N.Y., E. P. Dutton & Co. Inc., 1939 (reprint by Dover Publications under the title, "New York in the Thirties," 1973)

CONCERNED PHOTOGRAPHER, N.Y., Grossman Publishers, 1968

A CONCISE HISTORY OF PHOTOGRAPHY by Helmut and Allison Gernsheim, N.Y., Grosset & Dunlap, 1965

CONSEQUENCES, Panoramic Photographs by Jim Alinder, privately printed, 1974

CONTEMPORARY PHOTOGRAPHY, Sheldon Art Gallery, University of Nebraska, Feb. 22-Mar. 19, 1972

CRYING FOR A VISION, A Rosebud Sioux Trilogy, 1886-1976, Dobbs Ferry, N.Y., Morgan & Morgan—Mid-America Arts Alliance, 1976

THE DEERSLAYERS, A limited edition folio by
Les Krims, 1972

DIANE ARBUS, Millerton, N.Y., "Aperture," 1972

DIARY OF A CENTURY by Jacques Henri
Lartigue, edited by Richard Avedon, N.Y.,
Viking Press, 1970

DIESELS AND DINOSAURS/Photographs from
the American Highway by Steve Fitch,
Berkeley, CA, Long Run Press, 1976

DOROTHEA LANGE, N.Y., The Museum of
Modern Art, 1966

E. J. BELLOCQ: Storyville Portraits, N.Y., The
Museum of Modern Art, 1970

EMMET GOWIN PHOTOGRAPHS, N.Y., Alfred
A. Knopf, 1976

THE ENDURING NAVAJO by Laura Gilpin,
Austin, The University of Texas Press, 1968

THE FAMILY OF MAN, N.Y., The Museum of
Modern Art, 1955

FIVE PHOTOGRAPHERS, Sheldon Memorial
Art Gallery/University of Nebraska/Lincoln,
May 7-June 2, 1968

FACES OF DESTINY by Yousef Karsh, London,
George H. Harrap, 1946

FACES OF OUR TIME by Yousef Karsh, Toronto,
University of Toronto Press, 1971

GOD'S COUNTRY AND MY PEOPLE by Wright
Morris, N.Y., Harper and Row, 1968

GERNSHEIM—The History of Photography from
the Camera Obscura to the Beginning of the
Modern Era by Helmut and Allison Gernsheim,
N.Y., St. Louis, San Francisco, McGraw-Hill
Book Company, 1969

GEORGE A. TICE PHOTOGRAPHS 1953-1973,
Brunswick, N.J., Rutgers University Press,
1975

*GUTMAN—Lewis W. Hine and the American
Social Conscience* by Judith Mara Gutman, N.Y.,
Walker and Company, 1967

HARRY CALLAHAN, N.Y., The Museum of
Modern Art, 1967

HARRIMAN ALASKA EXPEDITION, 1899,
Washington, Smithsonian Institution, 1910-14

HOME PLACE by Wright Morris, N.Y., Scribners,
1948

IMAGES OF NEBRASKA, Nebraska Photographic
Documentary Project, 1975-77, introductions by
Arthur Rothstein and Wright Morris, Lincoln,
University of Nebraska Press, Mar. 8-Apr. 3, 1977

IMOGEN CUNNINGHAM/PHOTOGRAPHS,
Seattle & London, University of Washington
Press, 1970

*IMOGEN CUNNINGHAM (Stanford)—Imogen
Cunningham/Photographs 1921-1967*, Stanford
University, Mar. 31-Apr. 23, 1967

IMOGEN!, Photographs 1910-1973,
Seattle & London, University of Washington
Press, 1974

IN THIS PROUD LAND, America 1935-43, As
Seen in the FSA Photographs by Roy Emerson
Stryker and Nancy Wood, N.Y., Galahad
Books, 1973

*DANZIGER AND CONRAD—Interviews with
Master Photographers* by James Danziger and
Barnaby Conrad III, N.Y. & London,
Paddington Press, 1977

INTO THE 70's, Photographic Images by Sixteen
Artists/Photographers, Akron Art Institute, 1970

JAMES VAN DERZEE, edited by Liliane de Cock
and Reginald McGhee, introduction by Regina
A. Perry, Dobbs Ferry, N.Y., Morgan & Morgan,
1974

JAMMES—William H. Fox Talbot, inventor of the
negative-positive process by Andre Jammes, N.Y.,
Macmillan Publishing Co., 1972

JIM ALINDER, N.Y., The Once Gallery, Dec. 14,
1974-Jan. 9, 1975

JOSEF SUDEK, Aachen, Edition Lichttropfen,
1976

KANSAS ALBUM, published by the Kansas
Banker's Association, 1977

*GERNSHEIM (Cameron)—Julia Margaret
Cameron/Her Life and Photographic Work* by
Helmut Gernsheim, Millerton, N.Y., "Aperture,"
1975

KARSH PORTFOLIO by Yousef Karsh, Camden,
N.J., Thomas Nelson & Sons, University of
Toronto Press, 1967

KARSH PORTRAITS by Yousef Karsh, Toronto,
University of Toronto Press, 1976

KIPTON KUMLER PHOTOGRAPHS, Boston, David R. Godine, 1975

LANGUAGE OF LIGHT, A survey of the Photography collection of the University of Kansas Museum of Art, Feb. 3-24, 1974

LARKIN – Art & Life in America by Oliver W. Larkin, N.Y., Rinehart & Co. Inc., 1949

LLP: THE CAMERA – Life Library of Photography: The Camera, N.Y. Time-Life Books, 1970

LLP: GREAT PHOTOGRAPHERS – Life Library of Photography: Great Photographers, N.Y., Time-Life Books, 1971

LLP: THE GREAT THEMES – Life Library of Photography: The Great Themes, N.Y., Time-Life Books, 1970

LLP: LIGHT & FILM – Life Library of Photography: Light & Film, N.Y., Time-Life Books, 1971

LLP: PHOTOJOURNALISM – Life Library of Photography: Photojournalism, N.Y., Time-Life Books, 1971

LLP: THE PRINT – Life Library of Photography: The Print, N.Y., Time-Life Books, 1970

LIGHT AND SUBSTANCE, Albuquerque, University Art Museum, University of New Mexico, 1974

THE LITTLE PEOPLE OF AMERICA 1971, A limited edition folio by Les Krims, 1972

LOOKING AT PHOTOGRAPHS, 100 Pictures from the Collection of The Museum of Modern Art by John Szarkowski, N.Y., The Museum of Modern Art, 1973

LORANT – Lincoln, A Picture Story of His Life by Stefan Lorant, N.Y., W. W. Norton, 1969

LORANT (Life) – "A Day in Lincoln's Life" by Stefan Lorant, Life Magazine, Feb. 9, 1948, p. 111

MADDOW – Edward Weston, Fifty Years by Ben Maddow, Millerton, N.Y., "Aperture," 1973

MADDOW (Faces) – Faces, A Narrative History of the Portrait in Photography by Ben Maddow, Boston, New York Graphic Society, 1977

MANUEL ALVAREZ BRAVO by Fred R. Parker, Pasadena Art Museum, 1971

MARGARET BOURKE-WHITE/PHOTOJOUR-NALIST by Theodore M. Brown, Andrew

Dickson White Museum of Art, Cornell University, 1972

MARIE COSINDAS/POLAROID COLOR PHOTOGRAPHS, N.Y., The Museum of Modern Art, Apr. 12-July 4, 1966; Boston, Museum of Fine Arts, Nov. 9-Dec. 11, 1966; Art Institute of Chicago, Jan. 21-Mar. 5, 1967

MASTERS OF MODERN ART, N.Y., The Museum of Modern Art, 1954

MASTERS OF PHOTOGRAPHY by Beaumont and Nancy Newhall, N.Y., George Braziller, Inc., 1958

MASTERS OF THE CAMERA by Gene Thornton, N.Y., Holt, Rinehart & Winston, 1976

MEMENTO MORI – Photographs by Van Deren Coke from the Series/Memento Mori, Tempe, Arizona State University, 1962

MESERVE – The Photographs of Abraham Lincoln by Frederick Hill Meserve, N.Y., Harcourt Brace, 1944

MIRROR AFTER MIRROR, Reflections on Women by Starr Ockenga, Garden City, N.Y., Amphoto, 1976

NEWHALL – The History of Photography from 1839 to the Present Day by Beaumont Newhall, N.Y., The Museum of Modern Art, 1964

THE NEW WEST, Landscapes Along the Colorado Front Range, written & photographed by Robert Adams, Colorado Associated University Press, 1974

NICKEL – David Octavius Hill, Wurzeln Und Wirkungen Seiner Lichtbildkunst by Dr. Heinrich L. Nickel, Halle, Fotokinoverlag, 1960

NO MOUNTAINS IN THE WAY Kansas Survey: NEA, Photographs by James Enyeart, Terry Evans, Larry Schwarm, Lawrence, University of Kansas Museum of Art, 1975

OSTENDORF & HAMILTON – Lincoln in Photographs by Lloyd Ostendorf and Charles Hamilton, Norman, University of Oklahoma Press, 1963

OVENDEN – Pre-Raphaelite Photography by Graham Ovenden, London, Academy Editions; N.Y., St. Martins, 1972

PATERSON by George A. Tice, New Brunswick, N.J., Rutgers University Press, 1972

PAUL CAPONIGRO, Millerton, N.Y., "Aperture," 1967

PAUL STRAND A Retrospective Monograph: The Years 1915-1946; The Years 1950-1968, Millerton, N.Y., "Aperture," 1972

PERSPECTIVE OF NUDES by Bill Brandt, London, Bodley Head, 1961

THE PHOTOGRAPHER AND THE AMERICAN LANDSCAPE, N.Y., The Museum of Modern Art, 1963

THE PHOTOGRAPHERS CHOICE, edited by Kelly Wise, Danbury, N.H., Addison House, 1975

PHOTOGRAPHERS/MIDWEST INVITATIONAL, Minneapolis, Walker Art Center, Sept. 9-Oct. 21, 1973

THE PHOTOGRAPHER'S EYE by John Szarkowski, N.Y., The Museum of Modern Art, 1966

PHOTOGRAPHERS ON PHOTOGRAPHY, a critical anthology edited by Nathan Lyons, Englewood Cliff, N.J., Prentice-Hall, in collaboration with The George Eastman House, Rochester, 1966

PHOTOGRAPHS FROM THE COKE COLLECTION, Des Moines Art Center, 1970

PHOTOGRAPHS/HARRY CALLAHAN, Santa Barbara, El Mochuelo Gallery, 1964

PHOTOGRAPHY AT MID-CENTURY, Rochester, N.Y., The George Eastman House, 1959

PHOTOGRAPHY IN AMERICA, edited by Robert Doty; introduction by Minor White, N.Y., Ridge Press, Random House, 1974

*PFA—Photography in the Fine Arts—*Note: These references are to the catalogs which accompanied the five successive exhibitions presented between 1959 and 1967

THE PHOTOGRAPHS OF MARGARET BOURKE-WHITE, edited by Sean Callahan, N.Y., Bonanza Books, 1972

THE PHOTOGRAPHY OF RALSTON CRAWFORD by Norman A. Geske, Sheldon Memorial Art Gallery, University of Nebraska-Lincoln, Jan. 15-Feb. 10, 1974

*PHOTOGRAPHY 64/*An International Exhibition, co-sponsored by the New York State Exposition and The George Eastman House, 1964

PHOTOGRAPHY IN THE TWENTIETH CENTURY by Nathan Lyons, N.Y., Horizon Press in collaboration with The George Eastman House, Rochester, 1967

PHOTOGRAPHY 1839-1937, with an introduction by Beaumont Newhall, N.Y., The Museum of Modern Art, 1937

PHOTOGRAPHY YEAR 1975, N.Y., Time-Life Books, 1975

PHOTOGRAPHY YEAR 1976, N.Y., Time-Life Books, 1976

PHOTOGRAPHY YEAR 1977, N.Y., Time-Life Books, 1977

POLLACK—The Picture History of Photography by Peter Pollack, N.Y., Harry N. Abrams, 1969

PORTRAITS OF GREATNESS by Yousef Karsh, Camden, N.J., Thomas Nelson & Sons, Ltd., University of Toronto Press, 1959

POWELL—Victorian Photographs of Famous Men and Fair Women by Julia Margaret Cameron by Tristram Powell, Virginia Woolf & Roger Fry, Boston, Godine, 1973

PUEBLO ARCHITECTURE OF THE SOUTHWEST, photographs by William Current, text by Vincent Scully, Austin & London, University of Texas Press, 1971

THE PUEBLOS—The Pueblos: A Camera Chronicle by Laura Gilpin, N.Y., Hastings House, 1941

QUALITY—Quality: Its Image in the Arts, edited by Louis Kronenberger, N.Y., Athanaeum, 1969

ROY DE CARAVA PHOTOGRAPHER, Photographs selected from an exhibition at the Sheldon Memorial Art Gallery, University of Nebraska-Lincoln, April 28-May 24, 1970

ROY DE CARAVA: PHOTOGRAPHS, Houston, The Museum of Fine Arts, Sept. 12-Oct. 26, 1975

SCHWARZ, David Octavious Hill, Master of Photography by Heinrich Schwarz, N.Y., The Viking Press, 1931

A SELECTION OF WORKS—A Selection of Works of Art from the Art Collections of the University of Nebraska-Lincoln, 1963

SEQUENCES, Duane Michaels, Garden City, N.Y.,

Doubleday & Co., Inc., 1969

SEVEN INDIANA PHTOGRAPHERS, Muncie, Indiana, Art Gallery, Ball State University, July 11-Aug. 29, 1976

SHADOW OF LIGHT by Bill Brandt, N.Y., The Viking Press, 1966

SWEET FLYPAPER OF LIFE by Roy de Carava and Langston Hughes, N.Y., Hill & Wang, 1974

SWEDLUND — Photography, A Handbook of History, Material and Processes by Charles Swedlund, N.Y., Holt Rinehart & Winston, 1974

THE TETONS AND THE YELLOWSTONE by Ansel Adams, Redwood City, Five Associates, 1970

THESE WE INHERIT — These We Inherit, The Parklands of America by Ansel Adams, San Francisco, Sierra Club, 1962

TIME PRESERVED — Time Preserved. A Photographic Essay by Thomas Clyde, Southampton, L.I., N.Y., The Parrish Art Museum, Sept. 28-Oct. 25, 1963

THIS IS THE AMERICAN EARTH, text by Nancy Newhall, San Francisco, Sierra Club, 1960

TOWARD A SOCIAL LANDSCAPE, Bruce Davidson (and others) edited by Nathan Lyons, in collaboration with The George Eastman House, N.Y., Horizon Press, 1966

TRAVELOG by Charles Harbutt, Cambridge, Mass. & London, England, The MIT Press, 1973

12 PHOTOGRAPHERS OF THE AMERICAN SOCIAL LANDSCAPE, Waltham, Massachusetts, Rose Art Museum, Brandeis University, Jan. 9-Feb. 12, 1967

VAN DEREN COKE, Boston, Carl Siembab Gallery, May 1-31, 1963

VAN DEREN COKE/PHOTOGRAPHS 1956-1973, Albuquerque, University of New Mexico Press, 1973

VISION AND EXPRESSION, edited by Nathan Lyons, N.Y., Horizon Press, in collaboration with The George Eastman House, Rochester, 1969

WALKER EVANS: PHOTOGRAPHER, edited by John Szarkowski, N.Y., The Museum of Modern Art, 1971

WALKER EVANS (FSA) — Walker Evans, Photographs for the Farm Security Administration, 1935-1938, introduction by Jerald C. Maddox, N.Y., Da Capo Press, 1973

W. EUGENE SMITH, Afterward by Lincoln Kirstein, Millerton, N.Y., "Aperture," 1969

WHEN TWO OR MORE ARE GATHERED TOGETHER by Neil Slavin, N.Y., Farrar, Strauss and Giroux, 1976

WILLA CATHER — Willa Cather, A Pictorial Memoir, photographs by Lucia Woods and others, text by Bernice Slote, Lincoln, University of Nebraska Press, 1973

THE WOMAN'S EYE, edited with an introduction by Anne Tucker, N.Y., Alfred A. Knopf, 1973

WOMEN AND OTHER VISIONS: Photographs by Judy Dater, Jack Welpott; introductory essay, Henry Holmes Smith, Dobbs Ferry, N.Y., Morgan & Morgan, 1975

WOMEN OF PHOTOGRAPHY/AN HISTORICAL SURVEY, San Francisco Museum of Art, April 18-June 15, 1975

WORK FROM THE SAME HOUSE, Lee Friedlander & Jim Dine: Photographs & Etchings, London, Trigram Press, 1969

THE WORLD OF JAMES VAN DERZEE: A visual record of Black Americans, compiled and with an introduction by Reginald McGhee, N.Y., Grove Press, 1969

WRIGHT MORRIS — Wright Morris, Structures and Artifacts, Photographs 1933-1954, Sheldon Memorial Art Gallery, University of Nebraska-Lincoln, Oct. 21-Nov. 16, 1975

YOUNG BRITISH PHOTOGRAPHERS (exhibition catalog, no place or date given)

APPENDIX A

The following persons have served as consultants in the purchase of photographs for the F. M. Hall Collection and the Nelle Cochrane Woods collection:

Tom Barrow, University of New Mexico; Edgar Breitenbach, Library of Congress; Peter Bunnell, Princeton University; Van Deren Coke, University of New Mexico; Hugh Edwards, Art Institute of Chicago; Jim Enyeart, Friends of Photography; Alan Fern, Library of Congress; Alfred Frankenstein, San Francisco Chronicle; Thomas Garver, H. M. de Young Museum; Frank Gohlke, photographer; Richard Grove, University of Washington; Carroll Hartwell, Minneapolis Institute of Arts; Harold Joachim, Art Institute of Chicago; Nathan Lyons, Visual Studies Workshop; Jerald Maddox, Library of Congress; Thomas Maytham, Denver Art Museum; George Moldovan, Art Institute of Zanesville; William McGonagle, Burpee Art Museum; Beaumont Newhall, University of New Mexico; Sam Olkinetzky, University of Oklahoma; Fred Parker, Pasadena Art Museum; Joseph Stuart, South Dakota Memorial Art Center; John Szarkowski, Museum of Modern Art; David Travis, Art Institute of Chicago; Minor White, Rochester Institute of Technology

APPENDIX B

The following invitational exhibitions have been presented at the Sheldon Gallery since its opening in 1963. An asterisk indicates a catalog published for that exhibition.

1964-65 — Walker Evans/Paul Strand; *Photography 64; The Photographer and the American Landscape; 1966-67 — American Photography The Sixties;* Ara Guler; 1967-68 — Michael McLoughlin; 1968-69 — Clarence White*; *Architectural Photography; Five Photographers*; 1969-70 —* James Alinder; Keith Jacobshagen; *Photography as Printmaking;* Roy de Carava*; 1970-71 — Edmund Teske; 1971-72 — Thomas Eakins; J. Laurie Wallace; 1972-73 — Roger Williams; Tom Piper; Peter David Tyler Monson; 1973-74 — Larry Stark; Jim Alinder; Lucia Woods; Ralston Crawford*; Keith Jacobshagen; Roger Rejda; 1974-75 — Michael Simon; Robert Grier; John Stewart; Carl Sesto; Thomas Clyde; Ellen Land-Weber; Richard Faller; 1975-76 — Vincent Vallarino; Margaret McKichan; Wright Morris*; Michael Whye; Robert Starck; Ron Geibert; 1976-77 — Robert Adams; Michael Smith; *Nebraska Photographic Documentary Project*;* David Melby; Christopher James; Stephen Cromwell; Peter de Lory; *Crying for a Vision*.*